Art, Inspiration & Counter Culture

DAY OF THE DEAD

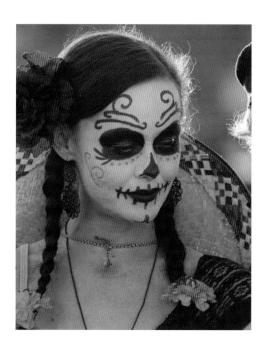

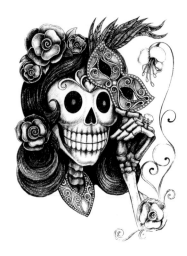

Publisher and Creative Director: Nick Wells
Senior Project Editor: Laura Bulbeck
Assistant Editor: Josie Mitchell
Picture Research: Gillian Whitaker and Josie Mitchell
Layout Design: Jane Ashley
Copy Editor: Karen Fitzpatrick
Proofreader: Dawn Laker
Indexer: Helen Snaith

FLAME TREE PUBLISHING
6 Melbray Mews
London SW6 3NS
United Kingdom

www.flametreepublishing.com

First published 2015

15 17 19 18 16
1 3 5 7 9 10 8 6 4 2

ISBN 978-1-78361-609-1

Printed in China | Created, Developed & Produced in the United Kingdom

Art, Inspiration & Counter Culture

DAY OF THE DEAD

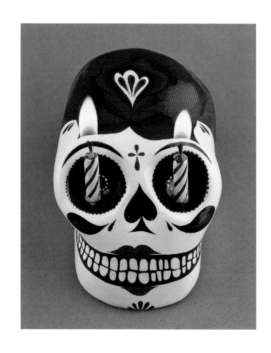

Russ Thorne

Foreword by David Lozeau

**FLAME TREE
PUBLISHING**

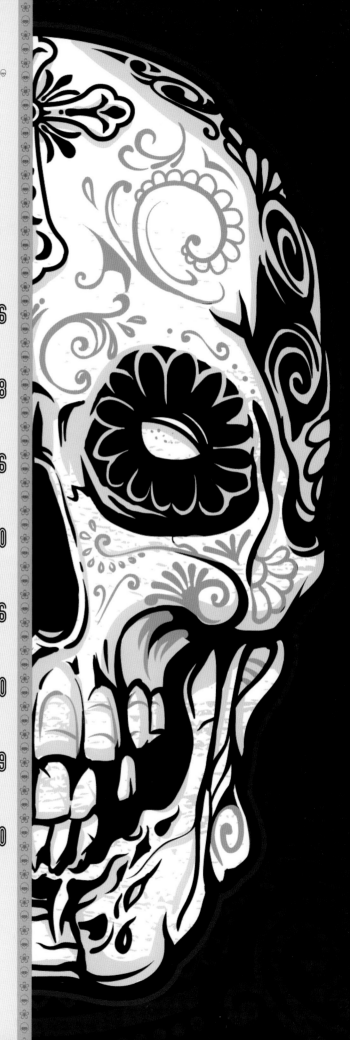

CONTENTS

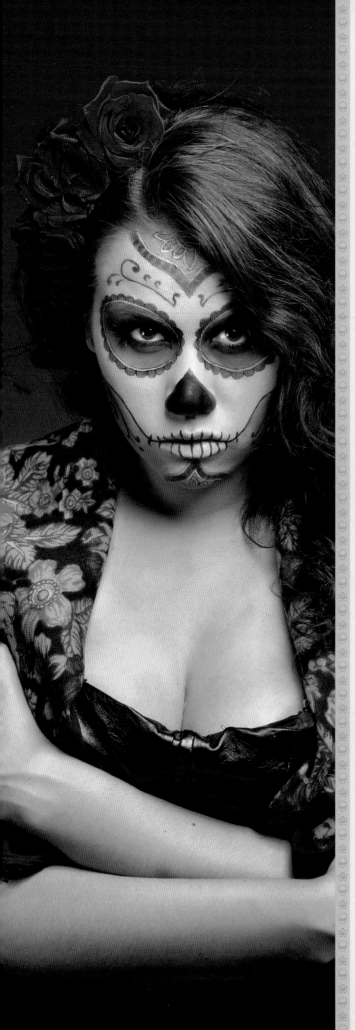

FOREWORD

In life, there is one inevitable and undeniable truth: everyone dies. Not to say that the concept is simple, but it is definitive.

Throughout the world's history, we've attempted to understand and outrun death. We've spent **lifetimes questioning** who we are, what we're doing here, and where we go after that final breath. *El Dia de los Muertos* is not the intellectual pursuit of those whys and hows. Rather, it is a joyous occasion to raise a glass to lives well lived and, in stark contrast to a funeral, celebrate those who have passed rather than mourn them.

The origins of the Day of the Dead go back to the pre-Columbian **Aztec era**. The traditions have evolved over hundreds of years and the playful imagery has grown in popularity. The etchings of **José Guadalupe Posada**, a cartoonist who satirized corrupt politicians and an audacious upper class in the 1800s, have become synonymous with the holiday. In fact, his **fancy skeleton "Catrina"** character is even something of its unofficial mascot. In modern times, Day of the Dead symbolism and **sugar skull motifs** are common in tattoo designs, street murals, and hot rod paint schemes.

Moreover the Day of the Dead customs are no longer determined by location, culture, or race; **millions of people around the world** now view 2 November as a time to honour loved ones through art, music, dance and food. Friends and family unite to adorn personal altars with old pictures, colourful candies, pungent

flowers, and flickering candles to summon memories and evoke laughter. Life goes on and if you're lucky, you are remembered.

For me, *El Dia de los Muertos* is more of a philosophy than a holiday. My art can be categorized as Figurative, Lowbrow, Representational, and even Surrealist, but at the core of almost all of my paintings is imagery that depicts an **active, vibrant skeleton world** that has no physical or racial barriers. Underneath, we are all skeletons – all worthy of **eternal recognition**.

The art in this book represents a vast array of images that **alternatively honours and mocks death** and, perhaps more importantly, celebrates the continuation of life.

David Lozeau

www.davidlozeau.com

INTRODUCTION

Every culture has a long history of dancing with death. The dance may be defiant and lusty; awkward and shuffling; stricken and sombre; or very often all of the above. Even the idea of a 'Day of the Dead' carries different interpretations in twenty-first century popular culture. For those steeped in Western horror movie lore, for example, it conjures images of vengeful revenants in Romero's 1985 film of the same name – all hanging strips of flesh tormenting a world where death offers no peace.

But in Mexico on the 1 & 2 November it's a very different story. The Day of the Dead – *Dia de Muertos* (or *Dias de Muertos*; Days of the Dead) – is no nightmare of disinterred ghouls. Also known as **All Souls' Day** (*Todos Santos*), it's a festival of respect and reverence for the dead; a period when the souls of the departed visit the living and have their lives celebrated with food, drink, song and art.

Accompanied by a **riot of colour** from decorations, flowers and costumes, what was originally a Mexican festival built on the foundations of the Catholic feasts of **All Saints** and **All Souls** has crossed physical and cultural borders. It's now celebrated the world over and has developed its own distinctive iconography of sugar skulls, flowers and skeletons.

ABOUT THIS BOOK

The purpose of this book is to offer an introduction to the **global phenomenon** of the Day of the Dead. We'll be looking at the way it's celebrated in Mexico and beyond, as well as considering the ways in which it's influenced the

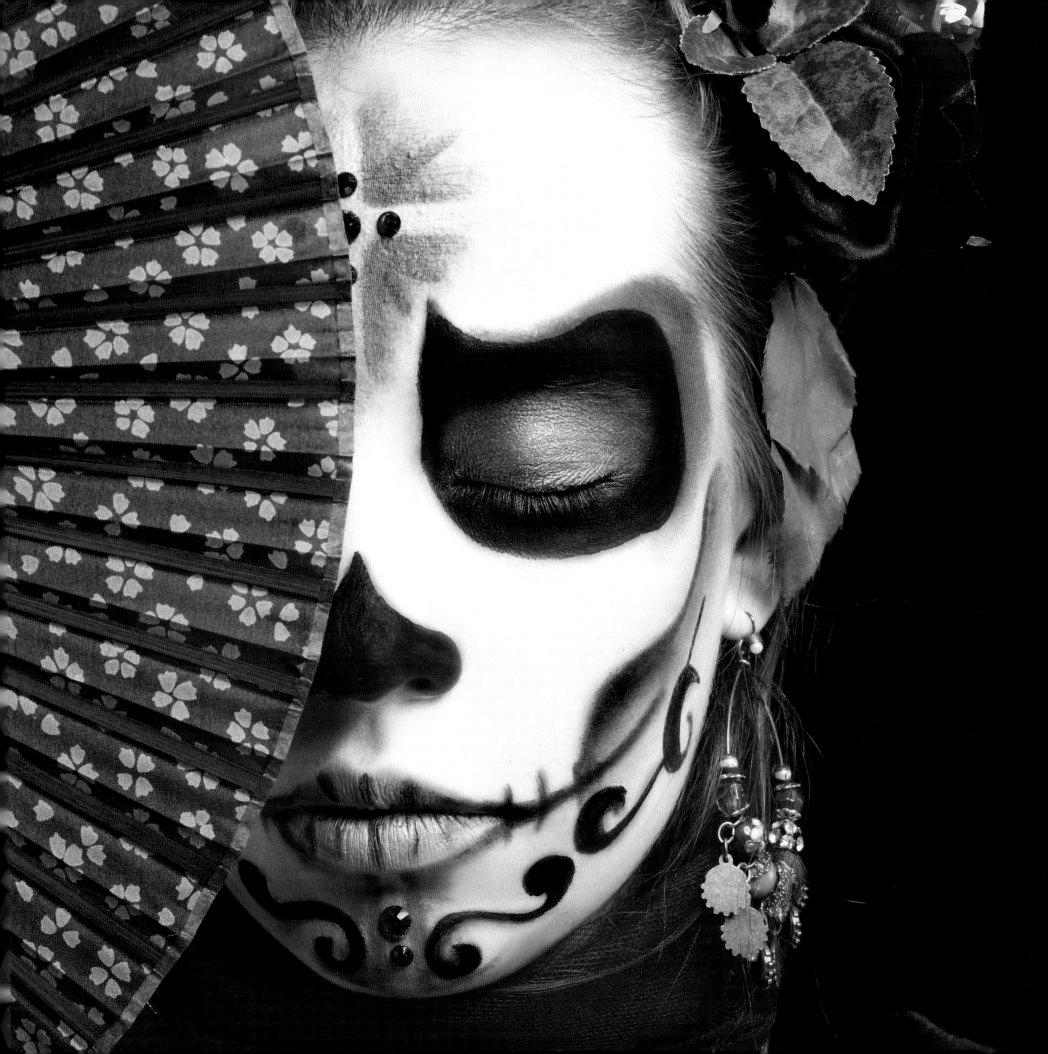

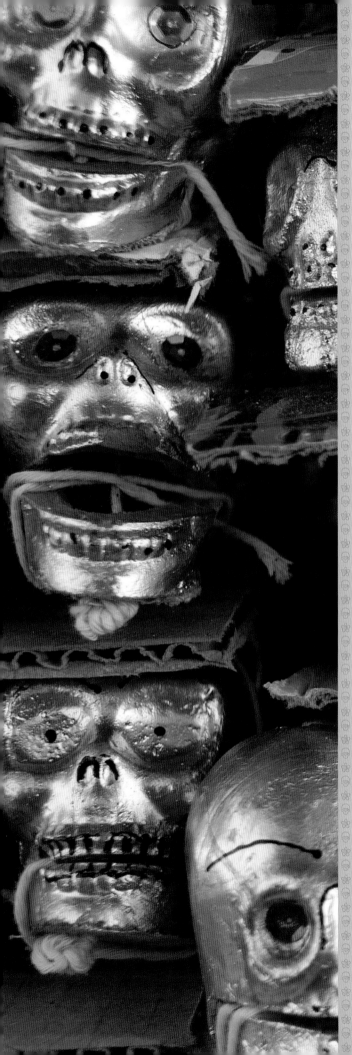

wider culture, from skull pencil cases and Day of the Dead-inspired tattoos to the work of **contemporary artists**.

Along the way, we'll take in some of the history of this complicated and alluring mortuary rite and consider how it has evolved over time, from its origins in **Mesoamerican tradition** to the appearance of *calaveras* – the distinctive decorative skulls associated with the Day of the Dead – on t-shirts in major retail outlets worldwide.

DAWN OF THE DAY OF THE DEAD

Following hard as it does on the heels of **Halloween** on 31 October, it's easy to think of the Day of the Dead as an extension of that **costume and candy fright-a-thon**; an inevitable, grim consequence of the summoning of demons the night before. Indeed, there is some overlap in **contemporary celebrations**, with Halloween costumes popping up during the Day of the Dead and sugar skull makeup hitting the sidewalks of the trick-or-treat fashion show.

However, while both have shared roots in Europe, the Day of the Dead's complex origin story, played out in Mesoamerica following the **Spanish conquest** in the early sixteenth century, is quite distinct to that of Halloween (more on the comparison between the two later). The modern incarnation is the result of **centuries of evolution**, religious syncretism – the merging of different beliefs into one – and tradition, all forged in the crucible of what is now Mexico.

It's simply not possible to provide a definitive account of the beginning of the Day of the Dead, as it remains

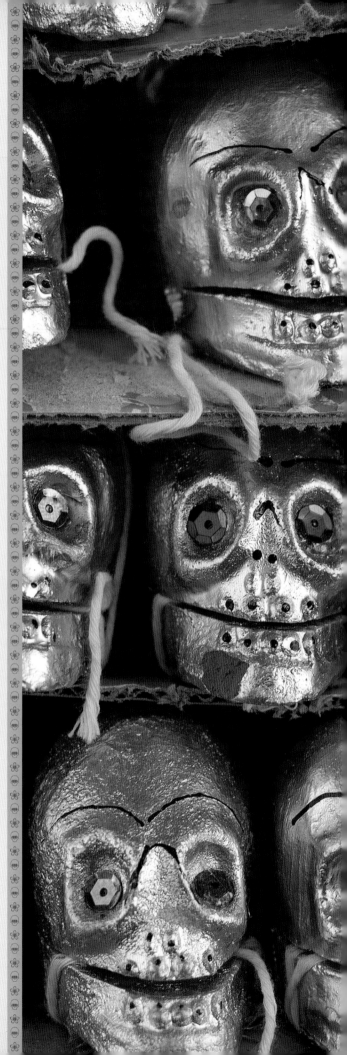

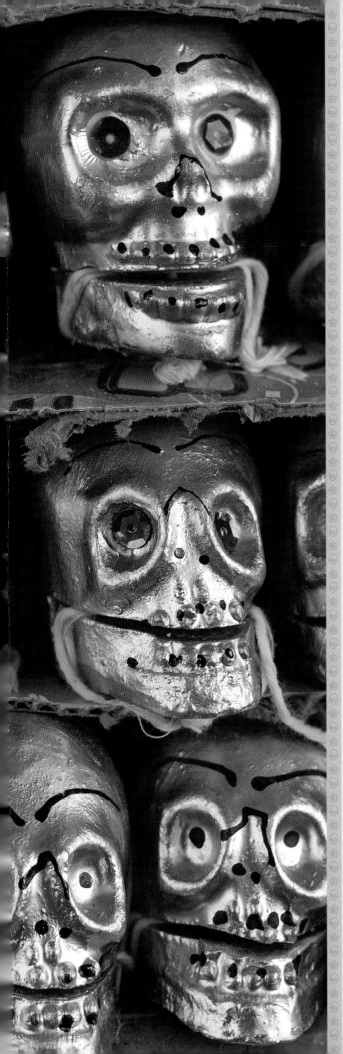

a subject of much debate. Instead, it's worth taking a tour through some of the **events and customs** that may have shaped it – beginning at the end of life, as it was viewed by the indigenous people who first encountered Europeans in 1519.

THE LANDS OF THE DEAD

The Mesoamerican region is a cultural area that – at the time of the Spanish conquest – extended from Central Mexico to **Belize, Guatemala, El Salvador**, Honduras, Nicaragua and northern **Costa Rica**. It was home over the centuries to a shifting roll call of societies, beginning with the **Olmec culture** around 1500 BC and ending with the Aztecs, whose demise at the hands of the *conquistadores* marked the close of the post-Classic period (AD 900–1520).

Thanks to the writings of **Spanish missionaries** and travellers, along with archaeological records and the **pre-Hispanic codices** (painted books created by contemporary artists), we know that the religious world-view of the Aztecs was vast and vivid. It encompassed many regional variations and was built on layer upon layer of preceding creed and custom, either through subtle cultural inheritance or through a more deliberate Aztec policy of incorporating the gods of other peoples into their own pantheon as their empire expanded (regional gods even had their own sacred site in the temple of Huitzilopochtli, in the **Aztec city of Tenochtitlán**).

This **rich stew of belief** is recorded differently by writers depending on the time and place of their accounts, so there are **variations**, but some of the underlying base ingredients and flavours are fairly consistent: an on-going relationship with the gods, for example, and a plethora of realms of the dead.

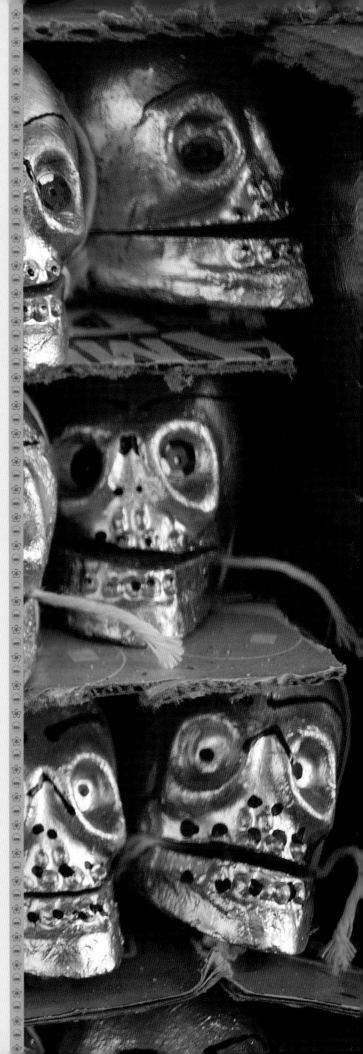

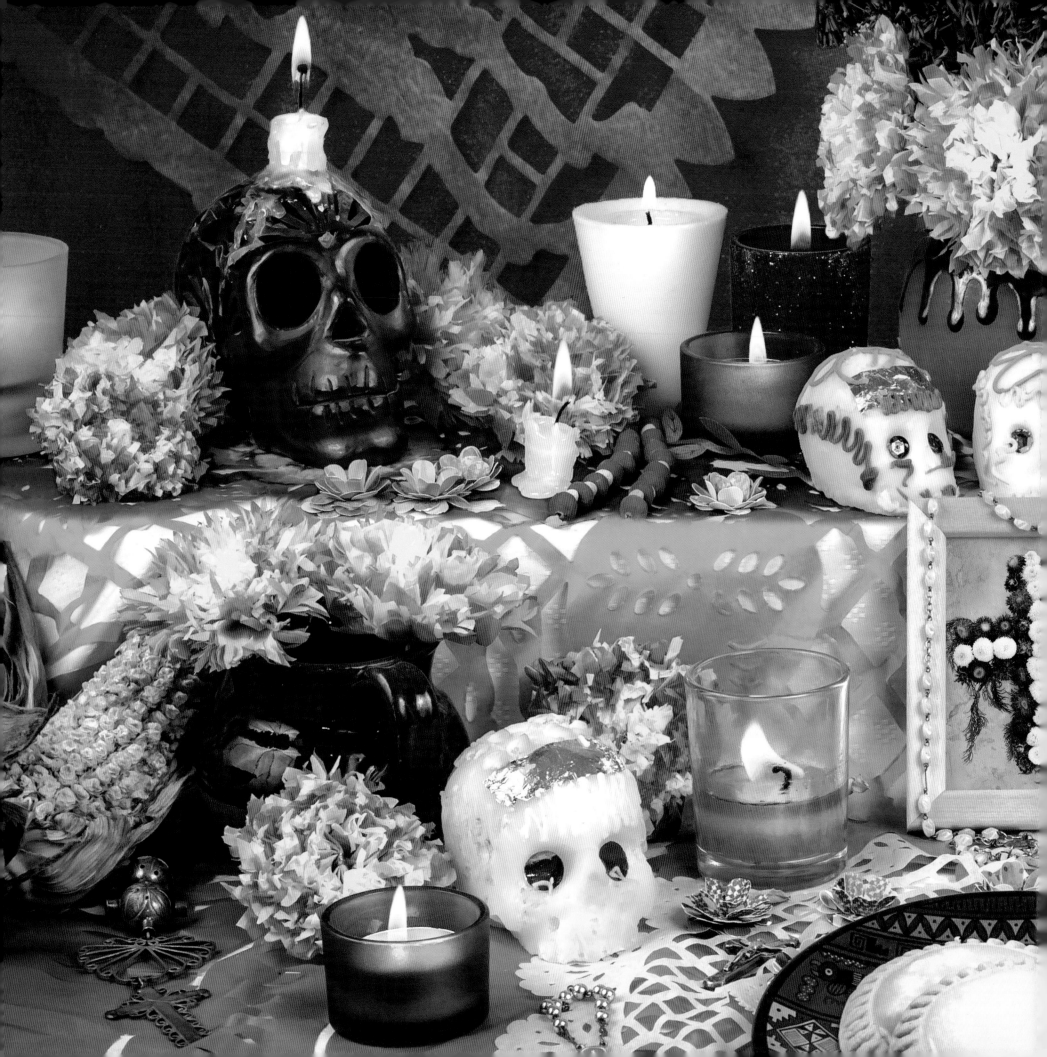

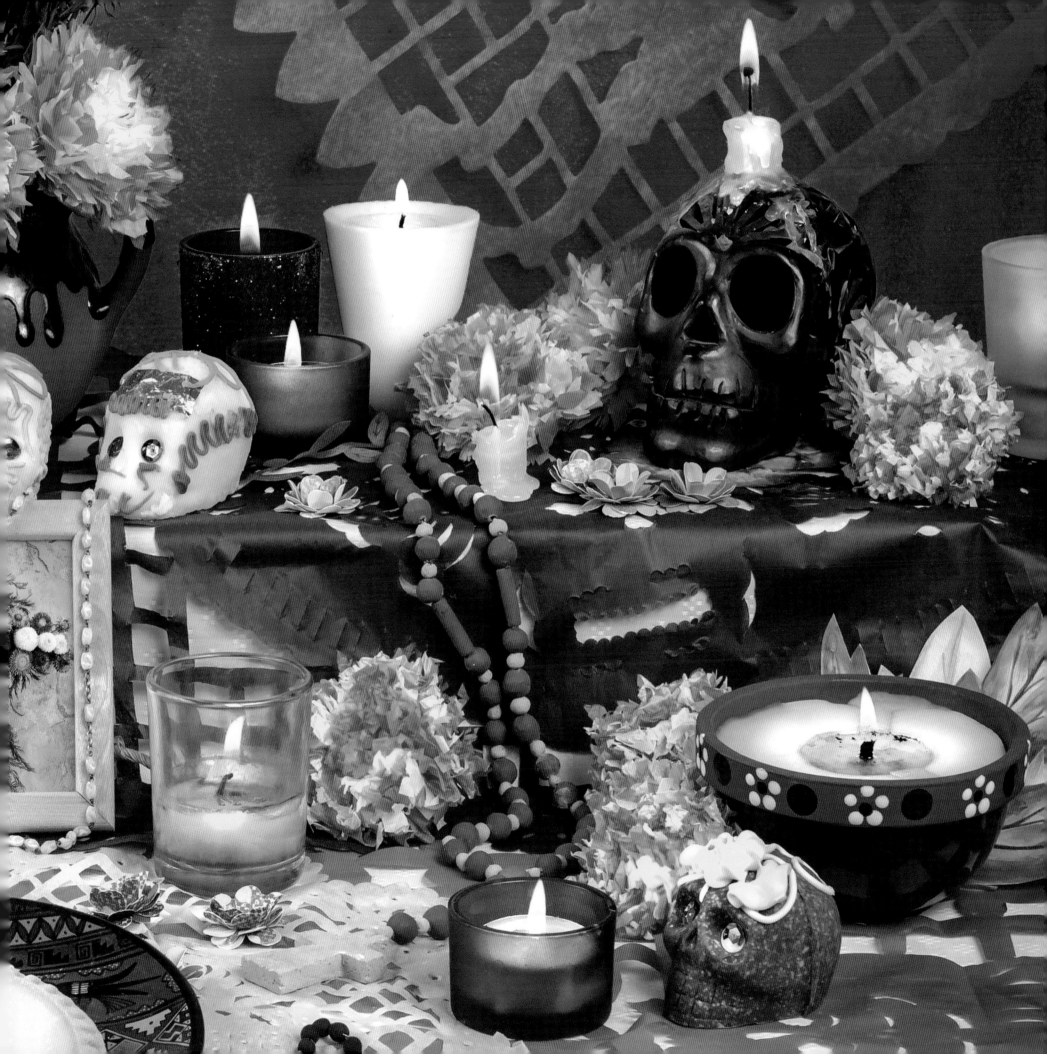

AFTER THE END

The souls of the ordinary departed had to navigate through **nine levels of the underworld**, in fact, before they reached the realm of **Mictlan**, home of the death god **Mictlantecuhtli**. This was no restful transition: they travelled for four years and could expect brutal mountains, cutting winds, no fewer than eight deserts, a great river and – adding insult to the existing injury of being dead – to be **shot at random with arrows**. On arrival they would be guided across the final river by a yellow dog, which was hopefully nice to them after all that trouble.

Although the Aztec conception of the afterlife was shadowy, it had no equivalent of a hell for **damned souls**. There were separate afterlives for some: warriors accompanied the sun god across the sky; the infant dead rested by a milk-giving tree, **awaiting resurrection** at the end of the world; and women dying in childbirth became powerful, celestial beings with skull faces.

To help these various souls on their journeys, the Aztec calendar was filled with **feast days** and rites to honour both the **gods of death** and the dead themselves. Children were venerated in the ninth month, adults in the tenth and warriors in the fourteenth, for example.

FEASTS OF THE DEAD

In the dead realm of **Mictlan**, souls continued to live much as they had in the world above, so were buried with things that they would need. Meanwhile, as they endured their four-year journey, rites were carried out on earth for a corresponding period of time, to aid them along the way.

According to the *Codex Telleriano-Remensis*, one such feast in August saw celebrants place food and drink on tombs to sustain the travelling souls. The dead were buried fully clothed, because 'by the end of the four years, the souls would have suffered much **toil, cold and fatigue** and passed through places where there was much snow and thorns'.

The codices and accounts of religious writers provide other tantalizing glimpses of these occasions. The **Dominican Friar Bernardino de Sahagún** (1499–1590) writes of offerings including sweet *tamales* (a steamed maize cake, wrapped in leaves) and stews of fowl or dog meat, which families would gather together and present to the dead 'where they laid buried'. He also writes of pottery incense burners, **pine torches, wine and song** – clearly these feasts were carnivals for all the senses, and while there can never be a direct link proven between such celebrations and the modern *Todos Santos*, they nonetheless share a similar gastronomic exuberance and an emphasis on family.

THE EUROPEAN DEPARTED

Revering ancestors and dedicating days to the dead wasn't unique to **pre-Christian Mesoamerica**, though. Feast days devoted to the dead were an important part of European culture long before **Catholicism** rose to prominence – in Spain and beyond – or boarded ships and sailed over the Atlantic with Cortés and company.

Celtic festivals provided the foundations for many of these ritual days, including Halloween, which began life as the Celtic festival of fire, *Samhain*. It originated

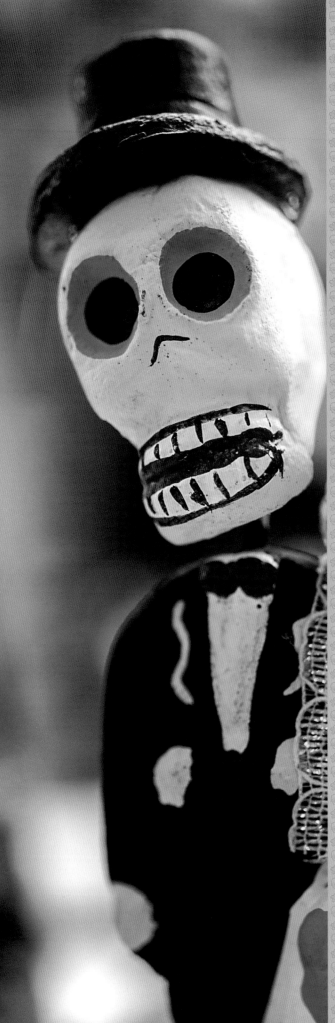

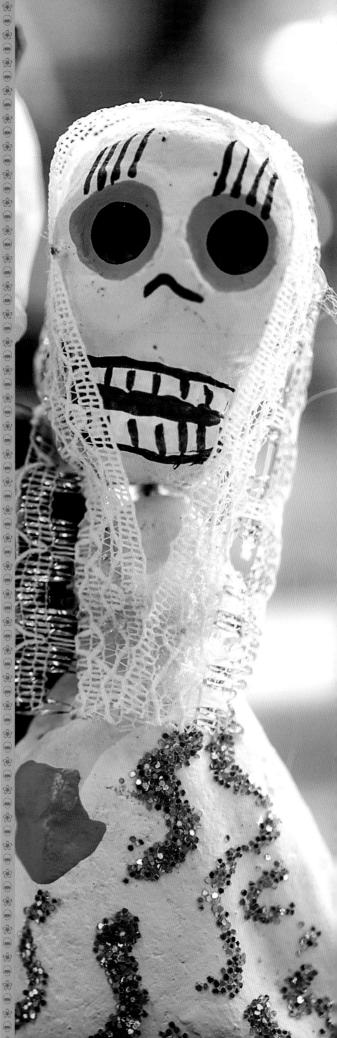

in what is now the UK on 31 October and was timed to coincide with the **end of the harvest**; it was also a time when malign spirits were thought to roam the world, a **superstition** that has lingered over the centuries.

SOUL SURVIVORS

Along with terrorizing children and **wreaking general havoc**, more benign spirits – the souls of ancestors and relatives – were also thought to visit family homes in search of love. Beyond **Samhain**, feast days honouring the dead existed throughout pagan custom, involving funerary rites and gatherings at graves and tombs, with offerings.

One theory suggests that a particular festival of the dead was eventually transmuted into a Christian feast honouring the saints and martyrs, perhaps by **Pope Boniface IV** in the seventh century; it was later moved to 1 November by **Pope Gregory III**, where it settled as **All Saints' day**. It has remained there ever since.

The church also set out to establish an office to honour all departed Catholics. **All Souls' Day**, as it was widely known by the thirteenth century, was intended to venerate the faithful dead but nonetheless presented a problem to a church reluctant to allow 'pagan' practices – such as ancestor worship – to continue.

Perhaps the hope was that by smothering these funerary rites in a **Christian robe**, they would slink away into folk memory and then obscurity. They proved remarkably tenacious, however, surviving as traditions that travelled alongside the Spaniards as they journeyed to the **New World**, partly assimilated into the Catholic doctrine yet still displaying an enduring life of their own.

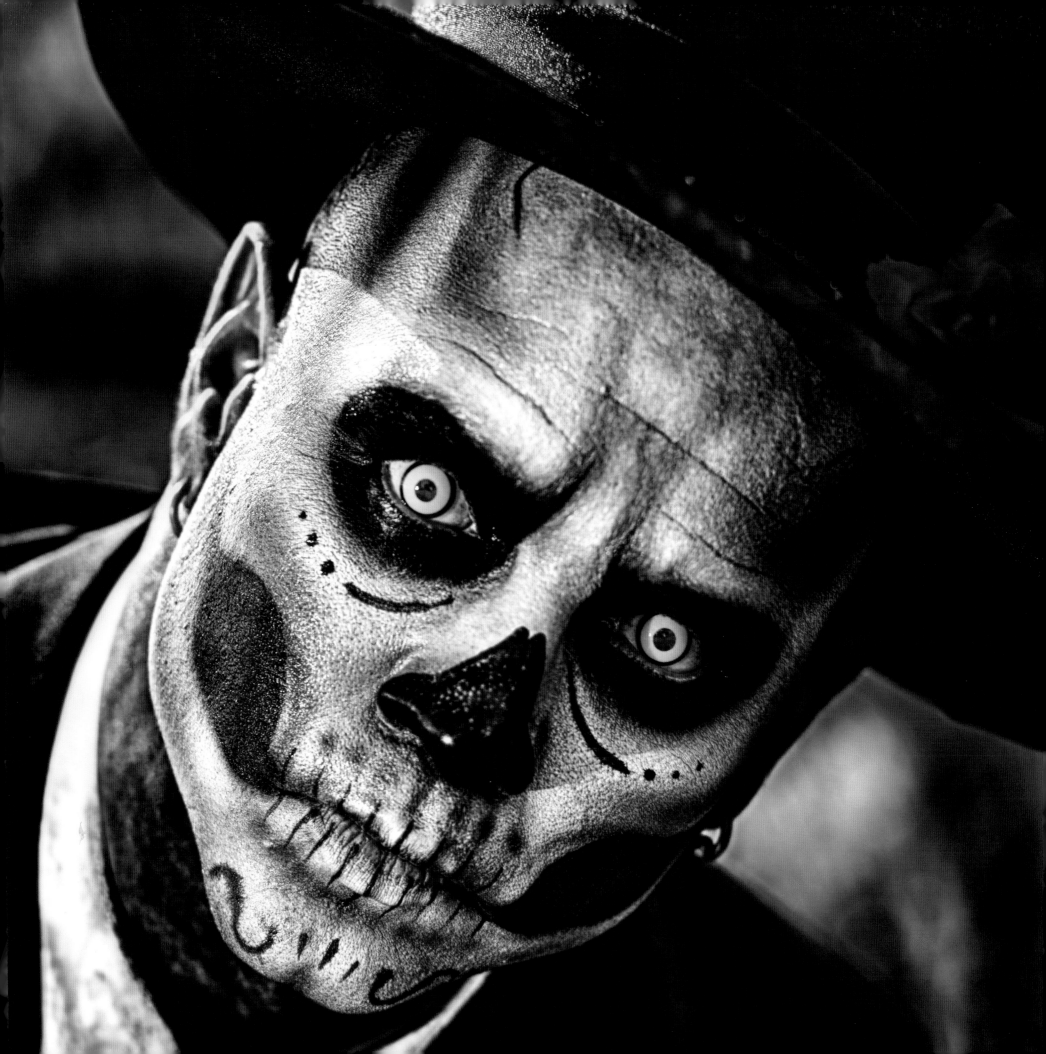

WORLDS COLLIDE

The more pagan elements of the European All Saints' and All Souls' celebrations – carried over not by priests, but by the **secular settlers** who followed them – would surely have struck a familiar chord with the indigenous population of Mesoamerica. Grave rites, **family feasts** and other rituals designed to honour spirits or ease their passing into the **lands of the dead** had evolved in parallel in the two cultures, even though they were separated by a vast swathe of ocean.

Compare, for example, the faintly disapproving tones of **Augustine of Hippo** (354–430), writing on pagan practices in Europe, and Sahagún's later accounts from the New World. 'Pagans who wished to come to Christianity were held back because their feast days with their idols used to be spent in an abundance of eating and drinking,' notes Augustine. Meanwhile, **Sahagún** writes: 'After having placed images on their altars they offered them foods, and sang songs of praise and drank wine in their honour.'

While there are superficial similarities, exactly how much the respective folk customs of the European arrivals and their **native counterparts intermingled** to form the basis of the Mexican Day of the Dead is unknown. Whole volumes are dedicated to unpicking the separate threads, so naturally there's too much to cover here; it's simply worth acknowledging that the threads exist and could well have been interwoven on the grand loom of history in the region.

APOCALYPTO

While there may well have been a peaceful co-mingling of folk customs around the departed in Mesoamerica

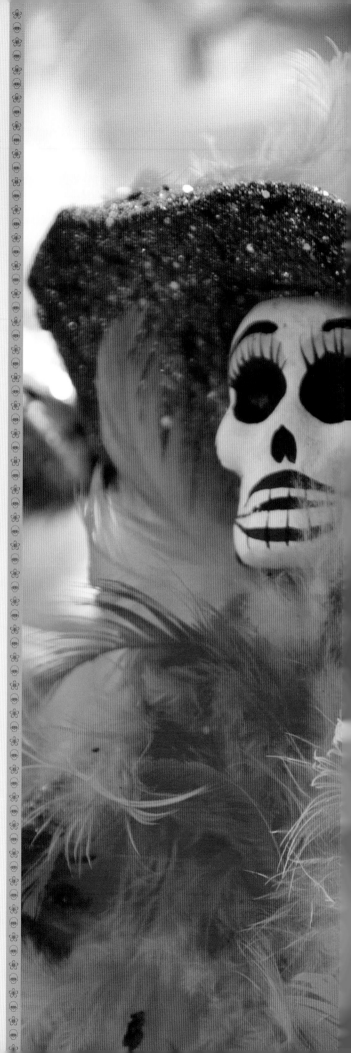

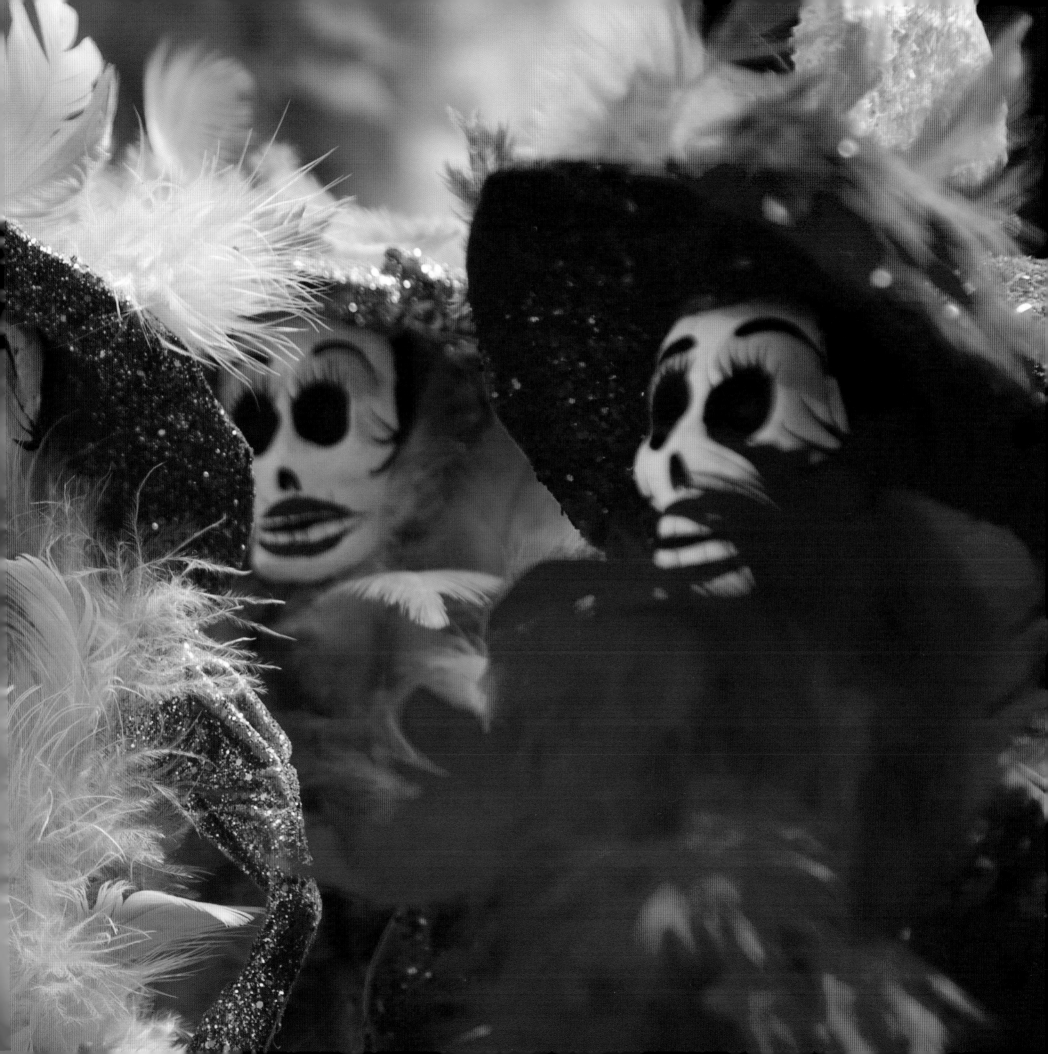

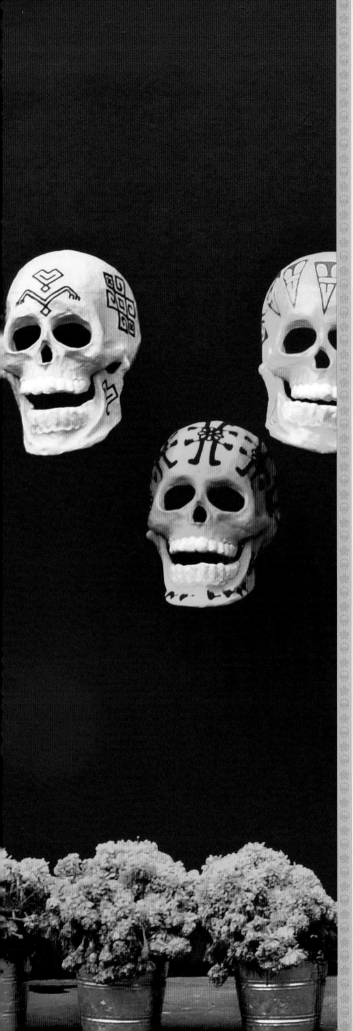
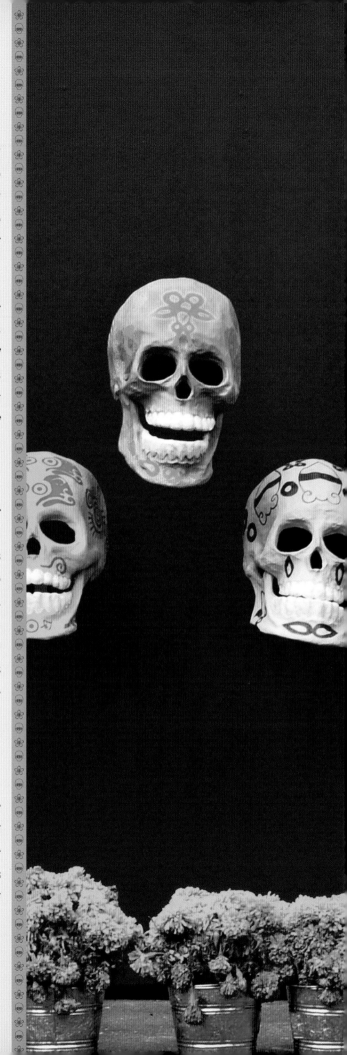

as a result of the Spanish conquest, their arrival also unarguably brought death in a much more **visceral, savage form**. 'Broken spears lie in the roads; we have torn our hair in our grief,' wrote one contemporary poet, now anonymous. 'The houses are roofless now, and their walls are red with blood.'

The *conquistadores* produced their own accounts of their campaign in the New World. Taken along with the records of the Aztecs themselves, a **horrifying narrative** of violent suppression emerges. Within a few short years of Cortés' arrival the Aztec empire fell in 1521, following a bloody struggle that culminated in the siege of Tenochtitlan, which lasted eight months and was initially provoked by the Spanish massacre of Aztec nobles.

The entire subjugation of the continent took rather longer, with wars flaring for more than a century afterwards. Throughout that time the Spaniards pursued a **vigorous evangelical campaign**, designed to convert the native Indian populations to Catholicism. Aztec icons and temples were smashed and Christian symbols put in their place, while the friars charged with overseeing the process of conversion set about learning the local languages to better communicate with their new flocks.

HARD TALK

As the friars improved their knowledge of the native *Náhuatl* language, they rapidly discovered a few troubling things. Among them was the true extent to which the natives had understood or embraced their teachings; and the inexplicable similarities between their existing beliefs and those of the **European invaders**.

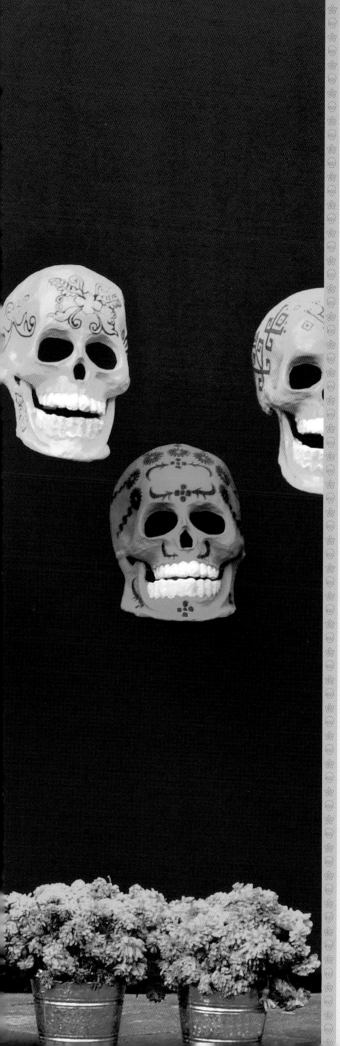
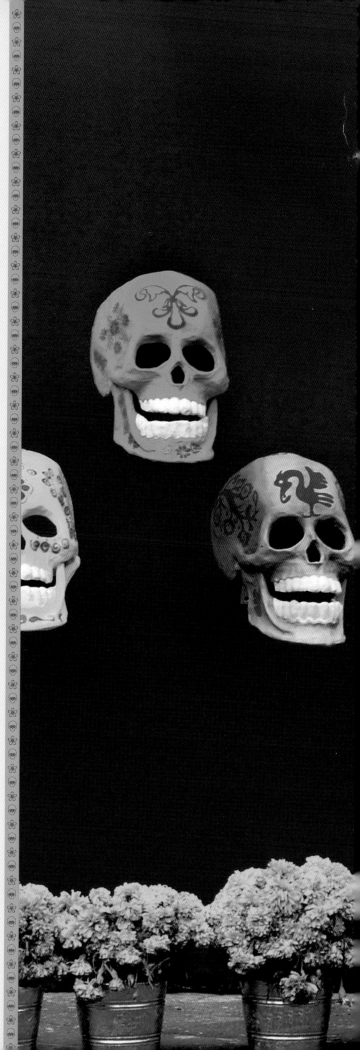

Once they could better converse with the local population, the friars found numerous **theological niceties** were either being lost in translation, for example, or being ignored in favour of existing parts of their own religion.

Although superficially celebrating All Saints' and All Souls' days, one friar noted, the Aztecs were making offerings to the dead – almost sneaking their ancient rites in under cover of the Catholic format. 'The feast has been passed to the **Feast of Allhallows** in order to cover up the ancient ceremony,' wrote **Friar Diego Duran** (1537–88).

There was also the disconcerting fact that many aspects of the Aztecs' beliefs bore a striking resemblance to parts of the friars' own Catholic faith. These included **baptism-like water ceremonies** for infants and **bread-eating** that echoed communion. Was it the mysterious will of God? And how could they reconcile these apparently similar beliefs with more markedly different ones, such as human sacrifice and the veneration of the dead?

DRESSING UP

Needless to say there was **no simple answer** and the debate went on – and probably still does among students of comparative religion. But the Catholic church was nothing if not creative in bringing the faiths together, sometimes appropriating Aztec **song, dance and even costume** into their missionary work. Revised songs (all in the native language) spoke of the Christian faith and deity, while dances and processions slowly morphed into religious events tied into the Catholic calendar.

The process of enveloping pre-existing beliefs and rituals into Christian celebrations is one that has been repeated the world over – **Easter and Christmas**, for example, both carry elements of earlier pagan festivals of **fertility and light** – and was certainly effective in the New World. The old gods were quickly swapped for the saints, with the goddess **Tonantzin** superseded by the **Virgin Mary**, now the patron saint of all Mexico.

Not everything was achieved through creative acts. For every gradual syncretic process there was a sharp, destructive one: **temples fell, idols were smashed** and records destroyed. The broken pieces of idols were even used in the foundations of new churches – the irony being that this gave the **old gods** power in the eyes of the Aztecs, as the usurping faith was literally being supported by them.

TOWARDS THE MODERN WORLD

Just as the **hidden idols** remained embedded in the structures of the Catholic church, so the practices of the Aztecs (and through them, **older cultures** that they had assimilated) were lodged in its rites and rituals. Folklore (both Spanish and Indian) combined with faith to create unique mortuary rites – and as time marched on the customs and practices surrounding them solidified.

Writers in the later **colonial period** described events on the Day of the Dead in detail. From them we know that items such as **hot chocolate and cocoa beans** were important and that offerings included bread, candles and a lot of food; all things still seen during modern-day celebrations.

Another arrival that came with the **Spanish settlers** changed the entire face of the national culture, in particular the face of the Day of the Dead: sugar. Not native to the Americas, **sugar cane** and its sweetening properties were **enthusiastically embraced** (those hot chocolates quickly tasted different) and became an integral part of the Day of the Dead celebrations.

By the eighteenth century celebrants could buy **coffins, horses, monks, nuns** and even sheep made of sugar. The rise of the **sugar skull** would surely follow, which will be discussed in more detail in chapter two.

GLOOM AT THE PARTY

For a festival often held up as a **uniquely uplifting** occasion, the Day of the Dead as it evolved in Mexico is not without its **sombre side**. The levity in the city was not (and is not) always echoed in the more subdued celebrations in the countryside, for example; and the festivities have caused their fair share of friction in the past.

Discontent around Day of the Dead celebrations played its part in Mexico's eventual independence from Spain in 1821. By the end of the eighteenth century, the festival had become a **boisterous affair** that exposed the fault lines between the **urban Spanish elite** and the lower classes and indigenous people.

The authorities' attempts to restrict access to the cemeteries only served to unite the people behind their religions and customs, **fuelling the fire** that led to the struggle to break from Spain.

An economic factor also came into play over the years, as the expense of fulfilling a family's obligations to the dead became potentially more and more onerous. In *The Skeleton at the Feast* (1991), Elizabeth Carmichael and Chloe Sayer reveal that these pressures remained at the turn of the century (and likely remain today). 'Expenditure for *Todos Santos* can be a **heavy burden** for a family,' they write, 'perhaps especially so in rural communities where the *ofrendas* for those who have died within the last year can be especially costly and elaborate.'

GRATEFUL DEAD

Yet despite such a turbulent origin story mired in blood, struggle, conquest and religious tanglings, the Day of the Dead has emerged into the modern world as an **overwhelmingly positive** event. Equally reverent and joyful, sombre and silly, it fuses the austere ceremonials of Catholicism with older, more **mystical elements** that somehow manage to sit side by side. The **wandering spirits of the dead** are appeased just as the Catholic saints and souls are venerated.

Far from the nihilistic leanings of horror movies, the real world Day of the Dead is **relentlessly celebratory** – even its more macabre elements are born not of a lust for death, but for life.

The march to the cemetery isn't intended to fetishize mortality in some kind of **hallucinatory death-fest**, but to acknowledge the lives of those who have gone before. It's time to don the masks and explore it all in more detail.

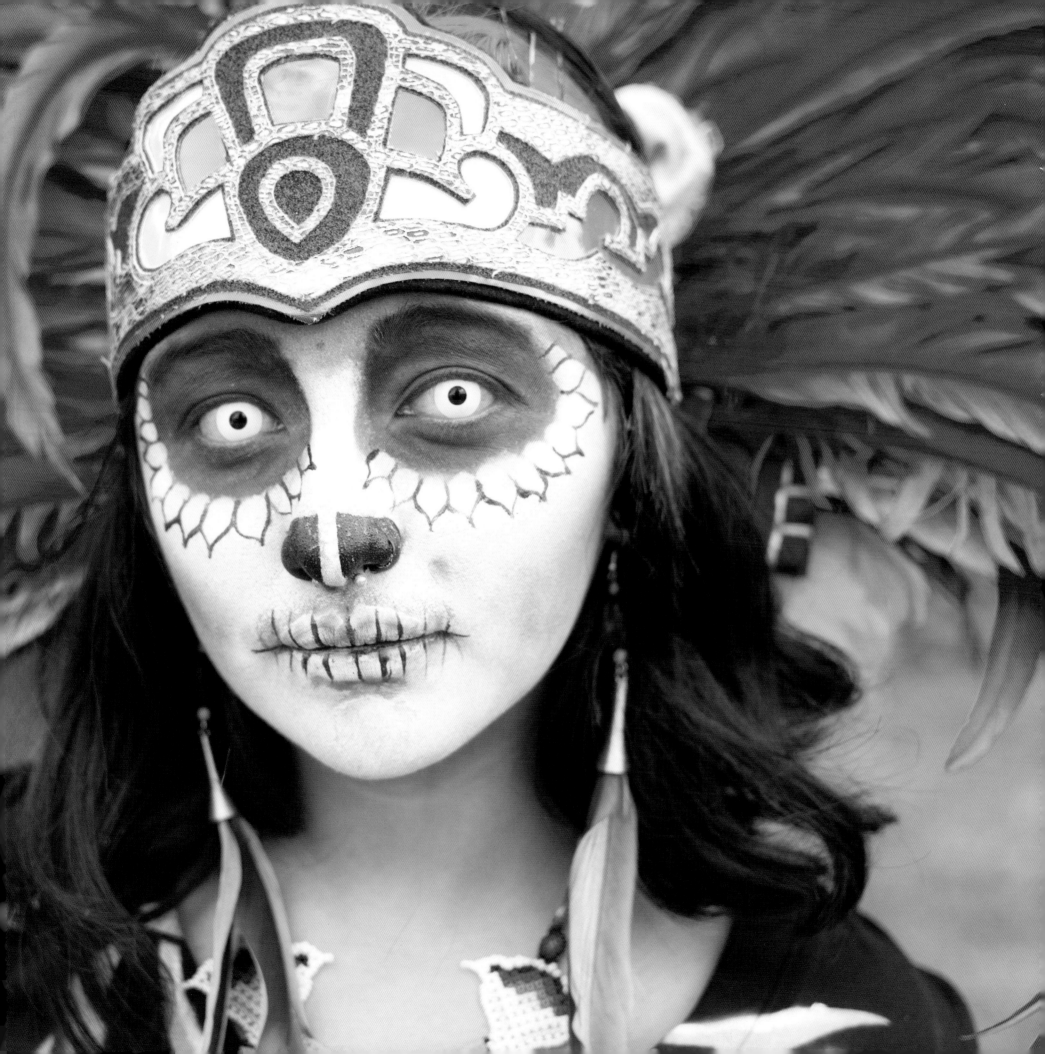

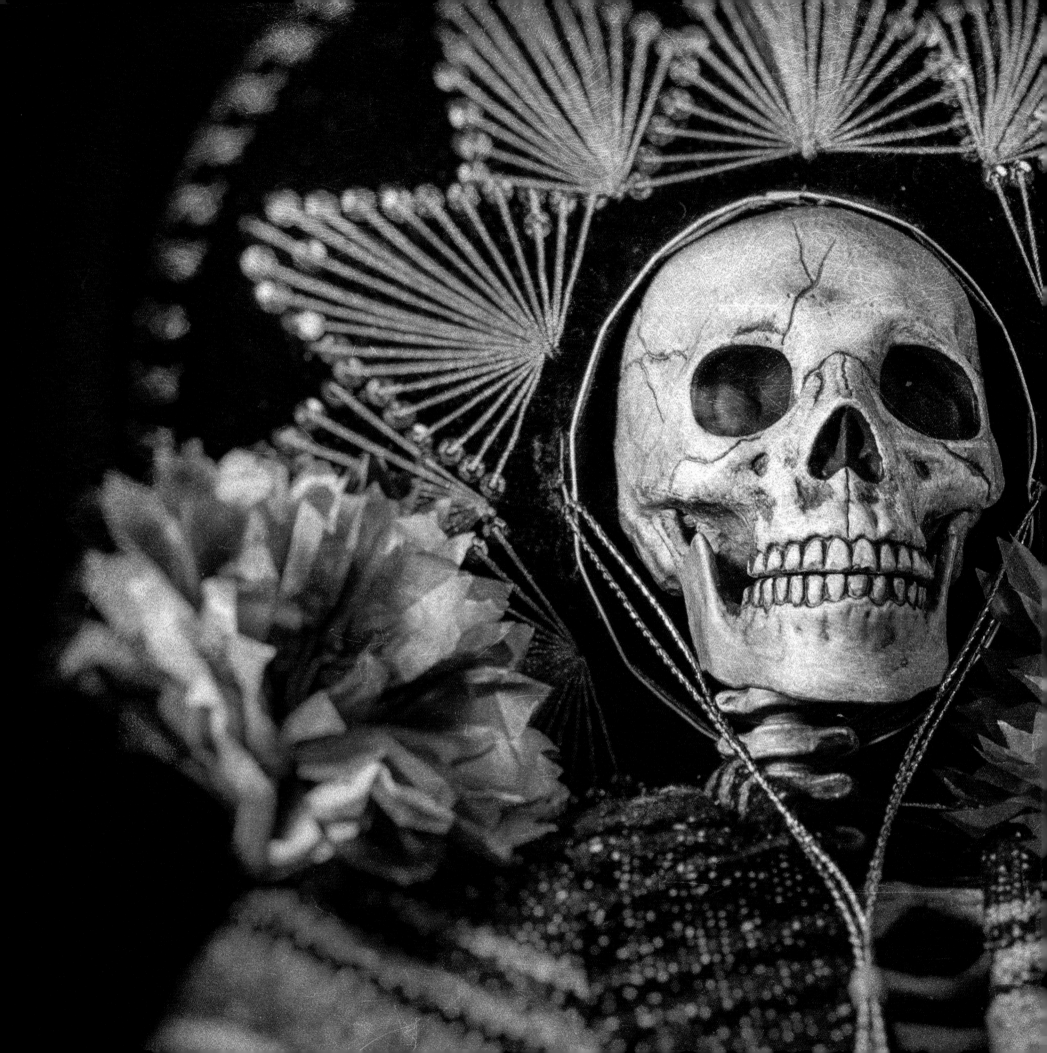

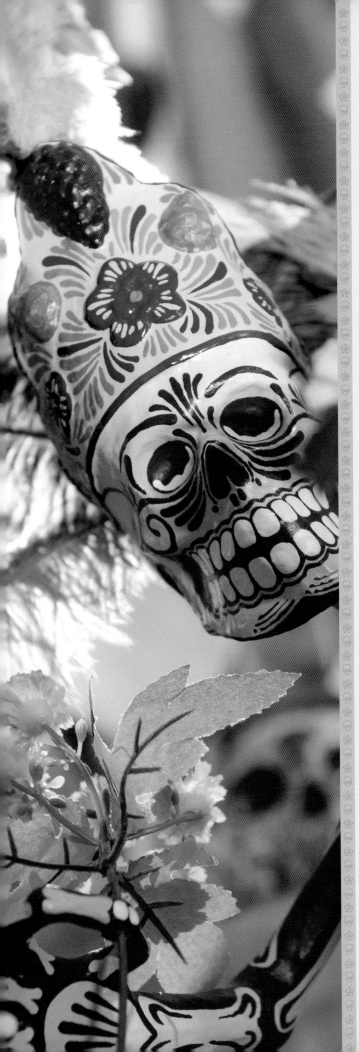

SMILING AT DEATH

There's nothing like a public holiday to send a nation – any nation – into a frenzy. Witness the annual mass hysteria surrounding the end of year 'holiday season' in the US and UK, with budgets blown, waistlines abused, TVs run until molten hot and children whipped into an extravagant consumerist bloodlust (often by the cheekbones of the newest Disney princess). And that's before adding any kind of religious sentiment or devotion into the mix; small wonder people need a holiday to recover from the holidays.

Like these other public holidays, the Day of the Dead in Mexico comes with its own attendant obligations of family **gatherings, expense, toys, food** and a strained period of preparation that can begin many months in advance. It doubtless provokes similar arguments in various households over the precise function of organized religion on such occasions, the risk of **festival fatigue** and cynical dismissals of the whole exercise as one run for the sole benefit of shops and tourists.

Yet it is also **like no other celebration**, differing even from the other religious holidays – All Saints' and All Souls' days – observed simultaneously elsewhere in the world, despite ostensibly sharing the same function of honouring the departed.

DEATH AND THE MEXICAN

It's often suggested that there is an innate difference between the way the people of Mexico regard death and the way in which other societies regard it. A

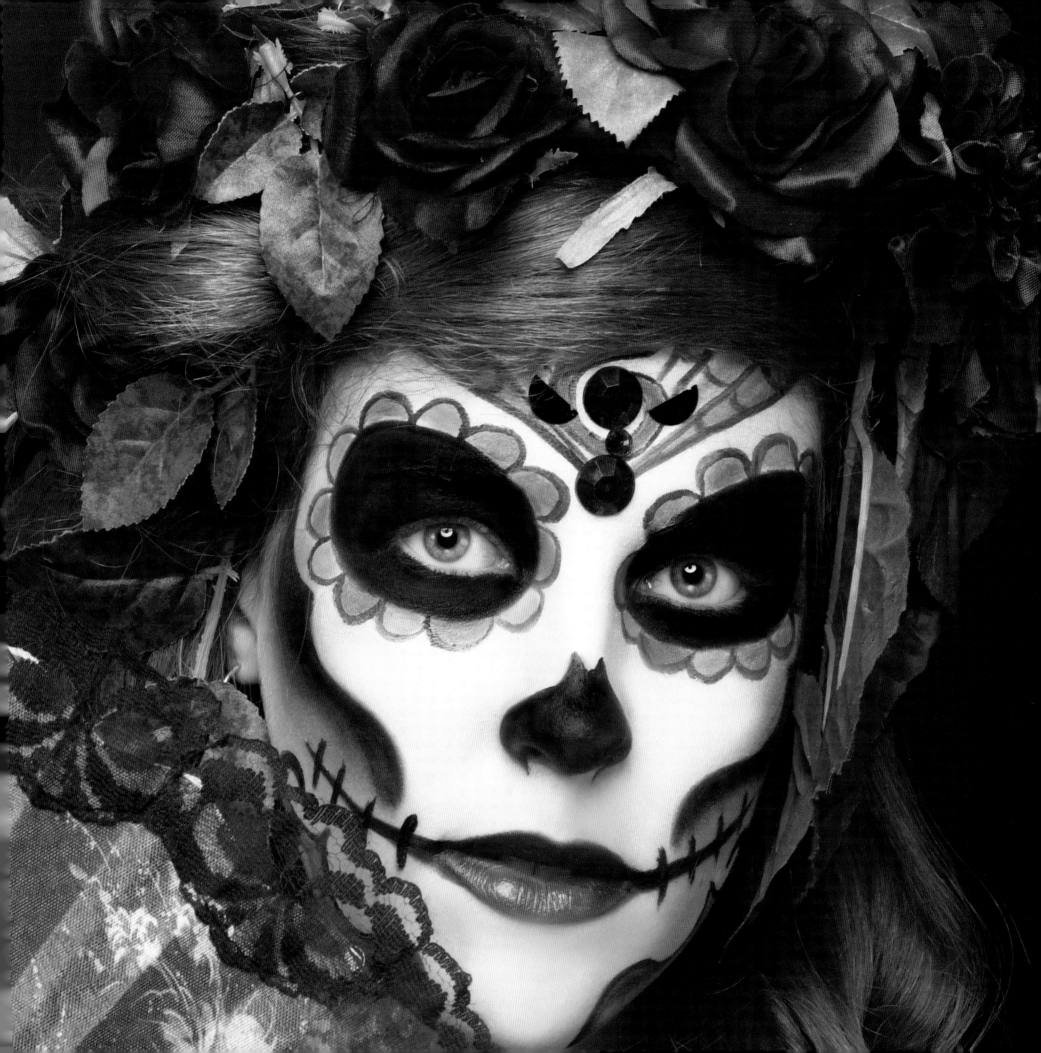

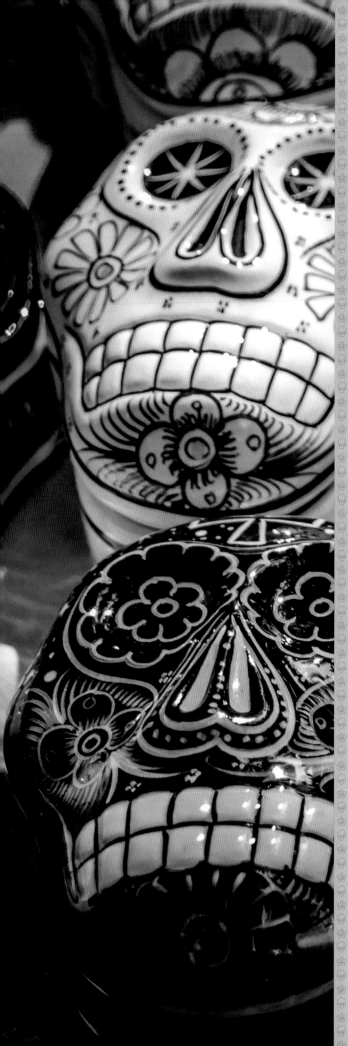
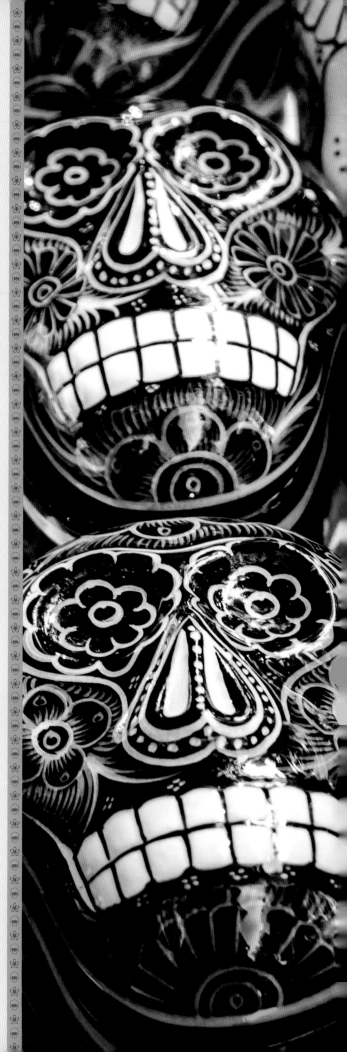

famous passage from Mexican writer Octavio Paz (1914–98), published in *The Labyrinth of Solitude* (1961), addresses this very issue:

The word 'death' isn't vocalized in New York, in Paris, in London, because it sears the lips. The Mexican, in contrast, is familiar with death, makes jokes about it, caresses it, sleeps with it, celebrates it; it is one of his toys and his truest love. Yes, there is perhaps much fear in his attitude … but at least death is not hidden in a corner; he looks at it face to face, with impatience, with disdain or with irony.

Paz's meditation on Mexican national identity has been **highly influential** and has been reinforced by academics and the press over the subsequent generations. A report in national newspaper *Excelsior* in 1995 referred to 'the typical idiosyncratic feeling of the Mexican, which causes him to **joke at death**, coexist with it, look at it straight on' – an attitude the paper saw as the opposite of the European attitude of 'profound respect and serenity'.

MORBID MEXICO

As with every attempt to characterize a nation with **broad brush strokes** these depictions run the risk of becoming mere cultural stereotypes. There will of course be countless Mexicans who feel far from able to caress or celebrate death, and certainly don't view it as their truest love; as there will be Europeans for whom death is to be regarded neither respectfully nor serenely.

However, the events surrounding the Day of the Dead in Mexico do seem to suggest an **underlying attitude** towards death that may well be more celebratory and

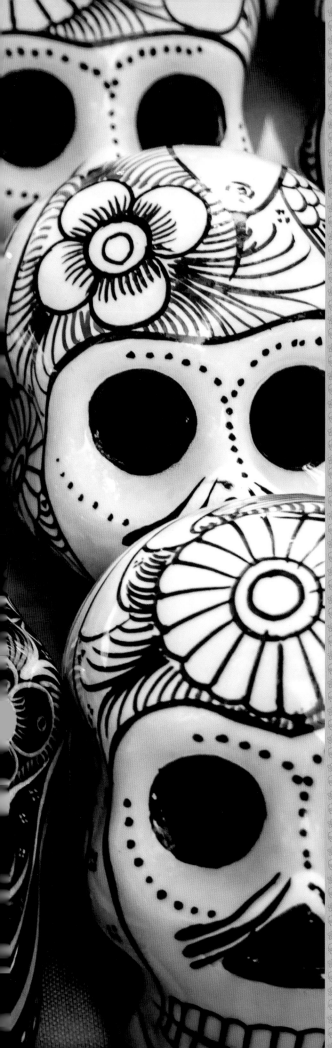

more willing to confront the dying of the light with a raised eyebrow or a **gleam of humour**. As this chapter unfolds we'll encounter practices that have a clear sense of *Mexicanidad* – 'Mexican-ness' – that support the idea of a Mexico, if not **morbidly fascinated** with death, at least engaged with it.

Where does this attitude come from? Is it something merely put on, like a mask, for the Day of the Dead and left unused in a drawer of the **national psyche** for the rest of the year? Or is it born of something altogether **real and traumatic**, particular to the region, which colours the relationship of Mexicans with death so distinctively?

THE DAMAGE DONE

One theory puts the prominent **presence of death** as a concept in the cultural life of Mexico down (in part) to the **tragically high death rate** of the indigenous population as a result of the Spanish conquest. Population numbers fell dramatically through death in battle, but that was far from the only cause of death: the settlers brought diseases with them against which the Indians had no immunity, with **terrible consequences**.

These pathogens included **smallpox, measles and typhoid**; a particularly virulent outbreak of smallpox in the Aztec capital of **Tenochtitlan** is widely credited as helping bring about its eventual fall, as the number of warriors was so severely depleted.

Estimates vary as to the precise death toll the invaders inflicted on the native population. Some figures suggest a decline of some 22 per cent during the sixteenth and

seventeenth centuries; others put it at close to 95 per cent. Research by **Sherburne Cook** (1896–1974) and **Woodrow Borah** (1912–99) controversially suggests that the population of what is now central Mexico plummeted from 25.2 million to 730,000 between 1519 and the 1620s. Whatever the true number, it's clear that the loss of life was **catastrophic** and left a **decimated society** in its wake.

IN THE FACE OF DEATH

Faced with loss on this scale, it's easy to conceive that the **stricken survivors** would not only attach more importance to rituals around death, but that their entire attitude towards it would alter. The aftershocks of such a **holocaust** could well encourage a discrete relationship with death that would echo through the ages and settle into the patterns of national life we see in modern-day Mexico.

Another take on the origins of the Day of the Dead points to this almost **total annihilation** as an argument for the festival itself being purely based around the European feast days. The Indians' rituals were lost in the chaos and a new tradition grew on top of All Saints' and All Souls' days, incorporating **folk traditions** brought in by the Spanish settlers. Similarities to pre-Hispanic practices are simply coincidental and reflect the fact that every culture throughout history seems to have developed feast days for the dead; it is Spanish blood, not Aztec, that runs in the veins of the *Todos Santos* revels.

Be that as it may (and a definitive view is sadly impossible), the **grim reality** of the conquest and the centuries of strife that followed may well form the basis of the

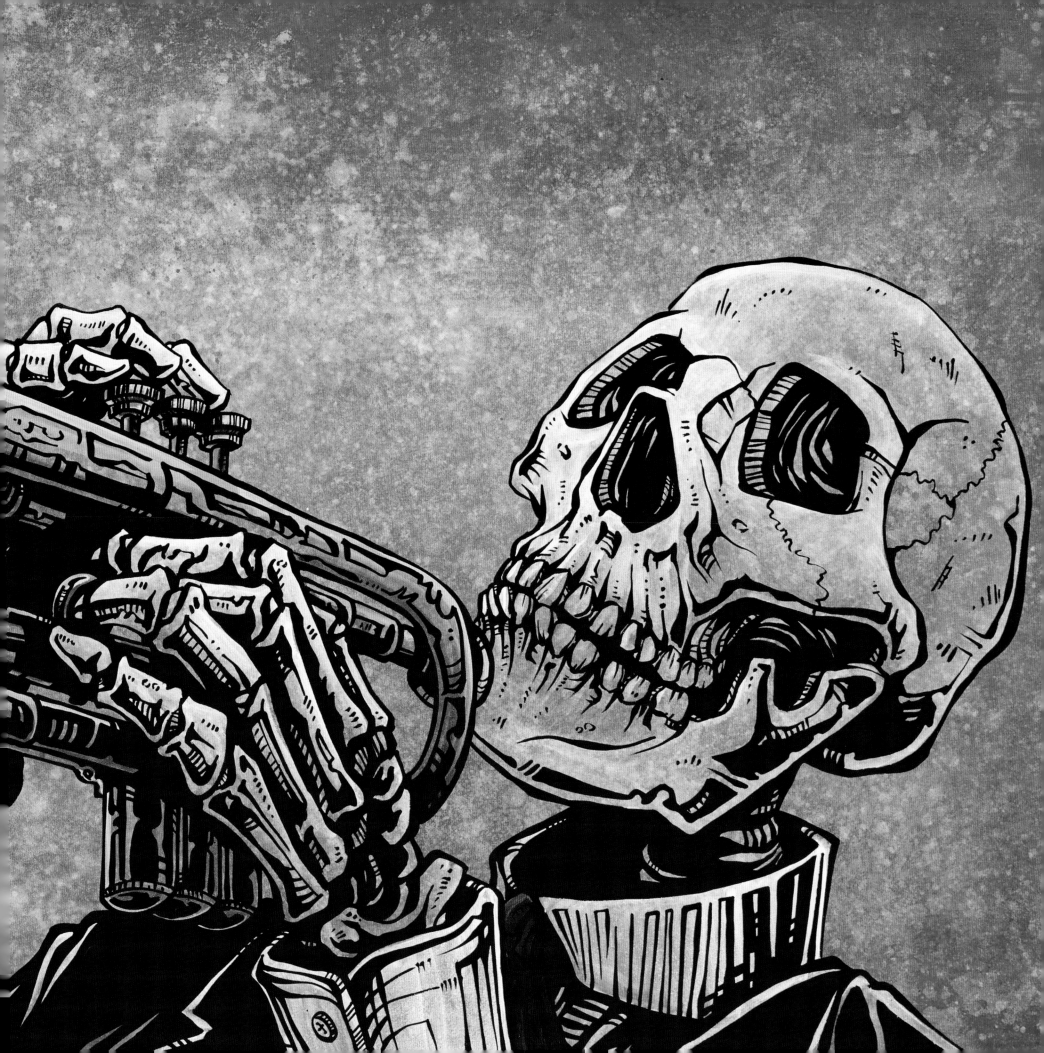

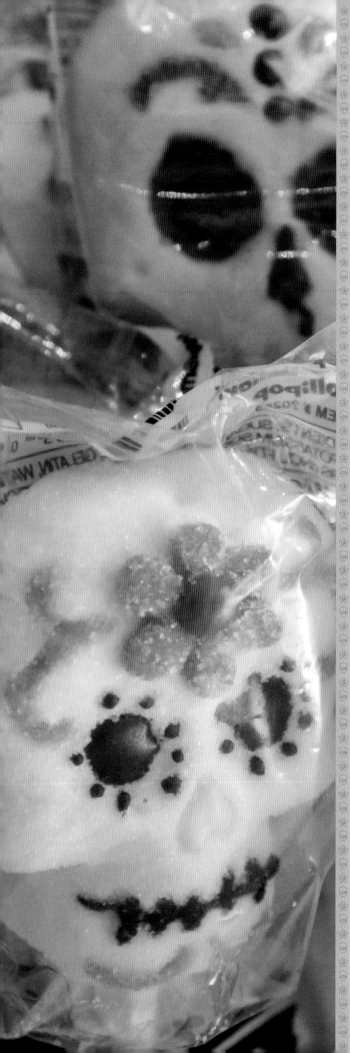

attitude – complex, contradictory as it is – to mortality running through Mexican culture. If there is a 'face to face' relationship with the end, as Paz suggests, it could be born of the weight of **all that death** pressing against the veil of time.

THE DAYS OF THE DEAD

How, then, to express this attitude? Enter the Day of the Dead. The term itself has a few varying definitions and can refer to a single day and also a sequence of days; both are accurate.

Confusing? Never fear. Essentially the 'Day of the Dead' is a **uniquely Mexican holiday** held at the same time as the Roman Catholic All Souls' Day, usually celebrated on 2 November. While elements of **Catholic ritual** – such as attending mass – may be observed in some areas and religious iconography incorporated into **altar displays**, the Day of the Dead exists largely independently of the Catholic holiday. The term has also, over time, become shorthand for the days between 31 October and 2 November, hence the occasional use of 'Days of the Dead' or *Dias de Muertos / Dias de los Muertos*.

The **Roman Catholic church** specifies that 1 November is All Saints' Day, intended to honour the blessed; 2 November is All Souls' Day, for the **Catholic departed** in general. Masses are held for the two groups on their respective days. Various complementary Day(s) of the Dead traditions have grown up throughout Mexico around this group of days, though, with 1 November sometimes regarded as a day for the **spirits of deceased children** – *Día de los Inocentes* ('Day of the Innocents') or *Día de los Angelitos* ('Day of the Little Angels').

HERE'S LOOKING AT YOU, DEATH

Of course, there may be no innate fascination with death or dying within Mexican life. Individuals will have their own, **highly personal views** and theories of the afterlife that will vary massively between different regions, religions, and within friendship groups and families.

Yet the Mexican Day of the Dead nevertheless conveys a particular approach to death, and to the souls of the dead. It is not ancestor worship; nor is it a **death cult**. The departed are not being worshipped and the three-day period is not intended as one of deep mourning (although it can be a **respectful, quiet affair** in some areas); it is something else entirely. It is about the living, and the lives that have been lived.

In fact, every element of the Day of the Dead could almost have been conceived deliberately by celestial event planners as something to defy grief, **impart joy** and bring a transcendent positivity to the inevitable end of this life. The intention is to celebrate the lives of the departed, remember them affectionately, call their spirits home to spend time with their loved ones and to win a **resounding triumph over death** by laughing in the face of it.

CEREMONIALS

The activities carried out around the Day of the Dead are almost **entirely separate** from any officially sanctioned Catholic celebrations, which are generally limited to the special masses on the days in question. Preparations begin **months in advance** and there is substantial regional variation when it comes to the specific activities carried out and traditions observed.

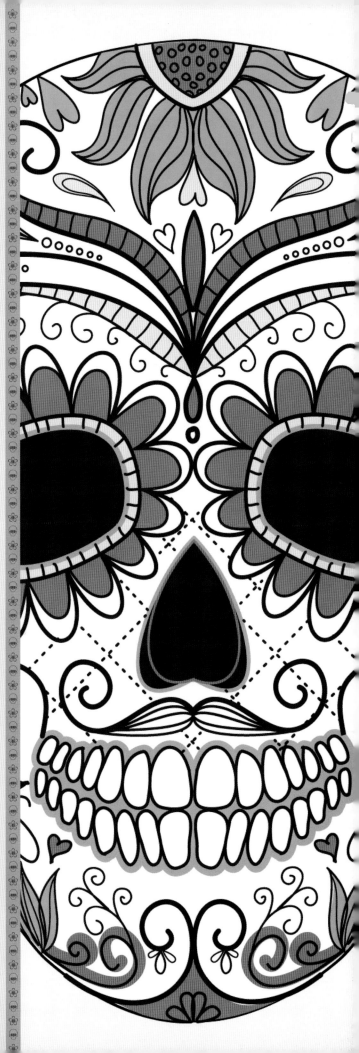

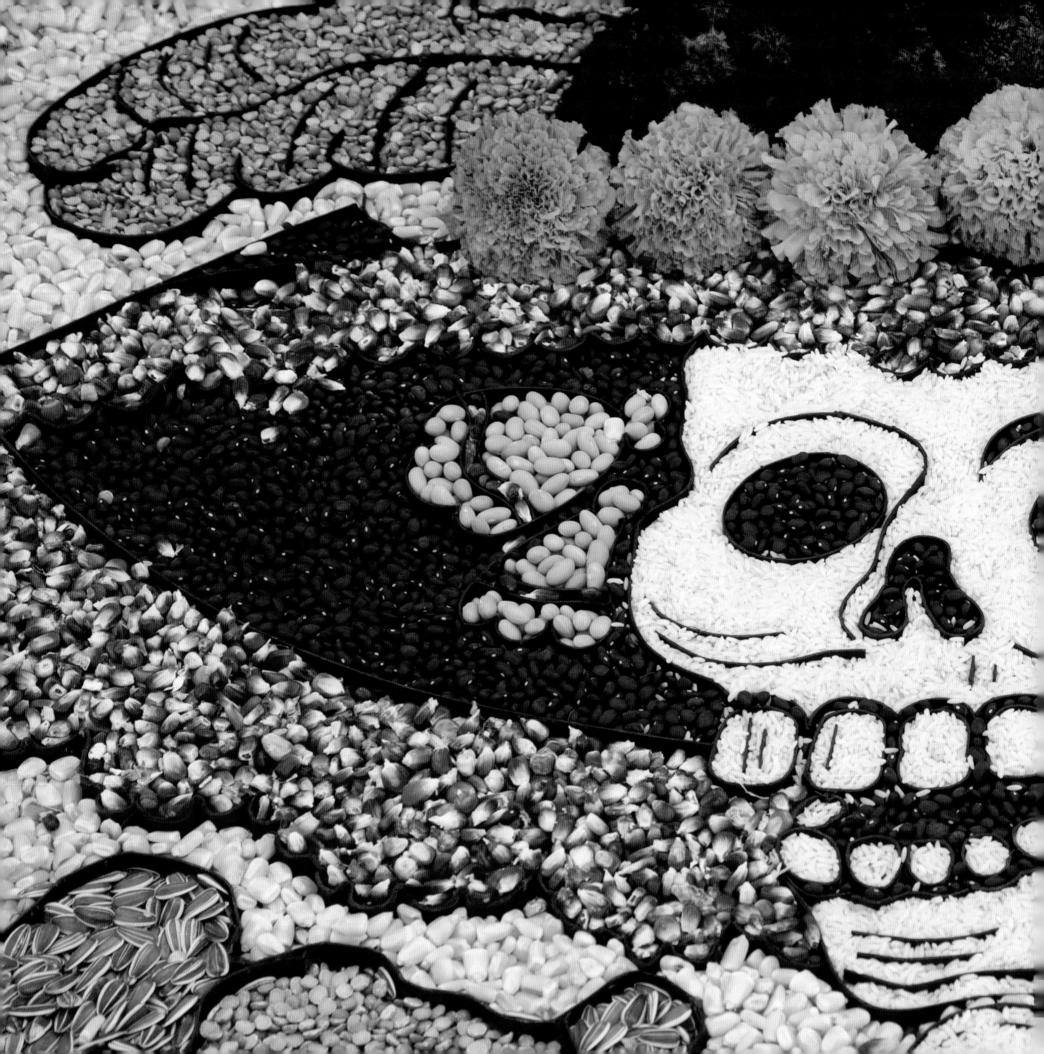

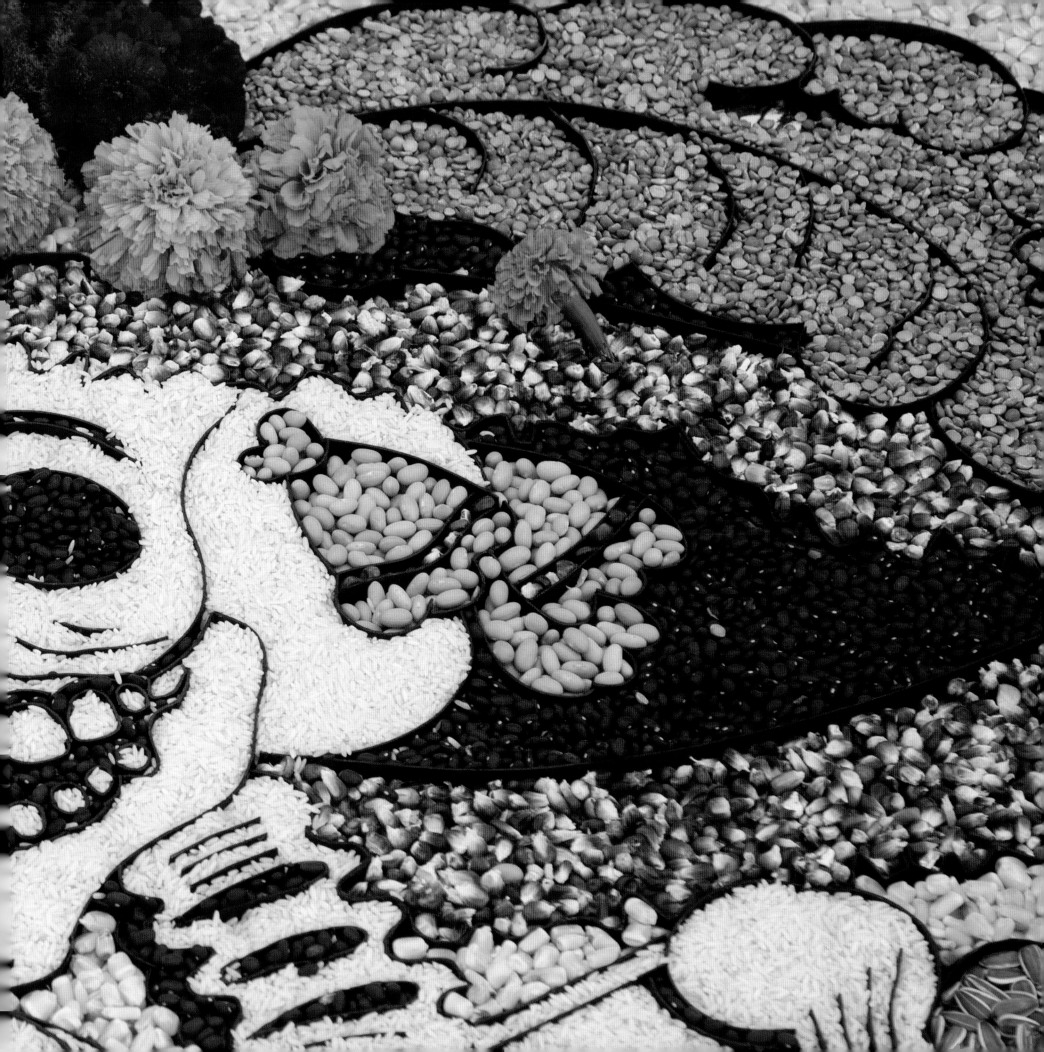

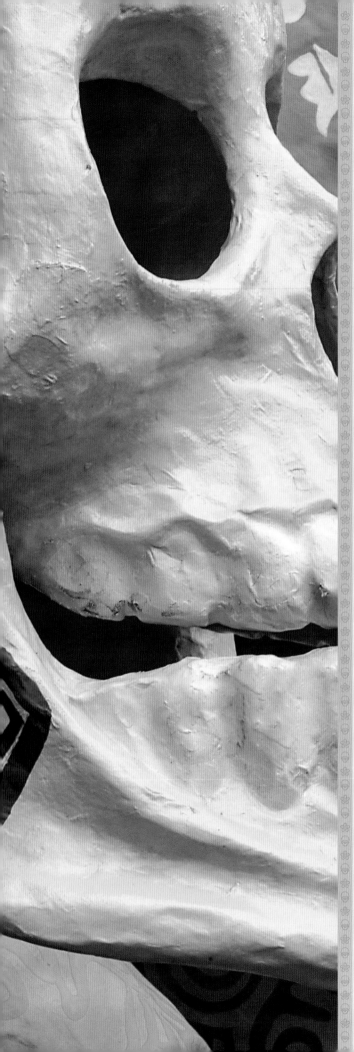
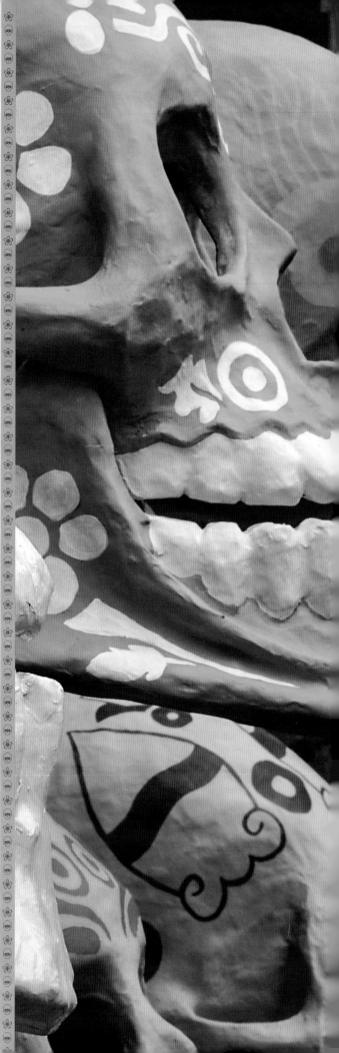

In general, however, Mexicans observe a three-day fiesta filled with **flowers, art, creative expression and colour**. It often begins on 31 October with visits to altars dedicated to deceased children, and ends with a night-time vigil on 2 November.

Celebrations usually involve **visiting cemeteries** to clean and decorate the graves of loved ones. People may build private altars (*ofrendas*) on the site and spend time at the graveside **telling stories and reminiscing** about the departed, as well as leaving offerings of food and flowers; everything is designed to encourage the souls to pay a visit.

Not everything is restricted to the cemetery, though, as altars are also set up in homes and even public buildings. Families may begin at the cemetery and journey home, **leading the souls** with them. Music can often play a part in this – the cemeteries may ring with the sound of **mariachi bands**, traditional folk songs and special dances at the cemetery gates.

ALTAR EGOS

As the centrepiece of Day of the Dead celebrations, altars (or *ofrendas*, 'offerings') are hugely important (their origins and development are discussed in more detail in the next chapter). They provide a focal point around which the family can gather to tell their stories and pray; they may also dance, in some areas **wearing shells on their clothes** to wake up the spirits of the dead. In others, altars (or sometimes decorated graves) will be complemented by **pillows and blankets** to help the souls rest when they arrive: it's a long way back from the underworld, after all.

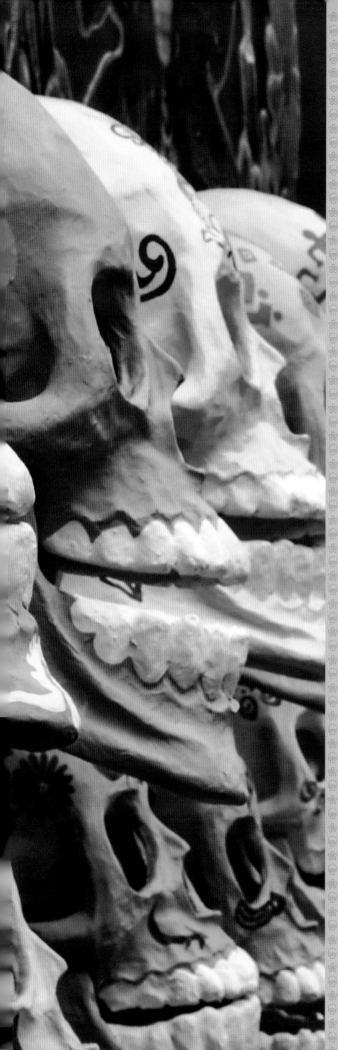

As well as acting as a meeting point, altars serve a spiritual function as the **gateway between life and death**. They are also a repository for the food and other gifts left out for the dead, and will be laden down with them over the course of the fiesta. Often they'll be **covered with flowers** and bear photographs of the departed, both to honour them and as a comfort and conversation starter for the celebrants themselves; they'll also bear items that belonged to the deceased, for them to enjoy when they visit.

Reflecting the curious blend of pagan and Catholic practices that characterizes the Day of the Dead, altars will also bear **images of the saints**, the Virgin Mary (in portrait or statue form) and perhaps crosses.

THERE IS A LIGHT THAT NEVER GOES OUT

There's no rulebook when it comes to constructing an altar or preparing offerings, but two items – **candles and flowers** – are invariably present. Candles form a part of mortuary rites and other religious ceremonies all over the world. Their role in the Day of the Dead can be seen as a **wholly practical** one, on one level: it's common to spend the entire night of 2 November in a vigil beside the graves of the departed, so a little portable light will be required.

But they may fulfil other functions as well. Where there is a Christian aspect to proceedings, albeit one intermingled with other elements, they may represent **Christ's light** in the world and the associations with love, hope, **compassion and forgiveness** that it brings. For the souls of the dead, coming back from an underworld of shade and shadow, they will also act as a guiding beacon.

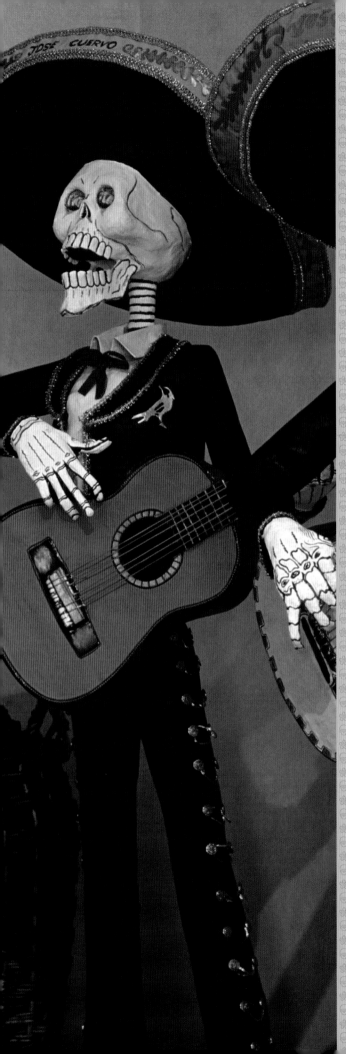

Equally important are *cempasuchil* (yellow marigold) flowers or petals. Their harvest in late October signals the beginning of preparations for the Day of the Dead and they appear in markets throughout Mexico. Sometimes called the Flower of the Dead, their use as a **grave ornament** dates back to pre-Hispanic times and is thought to attract the **souls of the dead** to participate in the fiesta.

BREAD TO THE DEAD

Altars needn't be elaborate: a simple collection of candles and flowers may be all that is required to constitute a complete *ofrenda*. Indeed, in crowded homes and cemeteries, that may be all that can be squeezed in. However, food and drink can also play a significant part in the Day of the Dead – so significant, in fact, that ethnographer **Stanley Brandes** writes in *Skulls to the Living, Bread to the Dead* (2006), 'These comestibles have become world famous, a symbol of Mexico itself.'

Food prepared for the Day of the Dead includes seasonal fruit and vegetables as well as **tamales** and chicken or turkey **mole** (a thick, spicy sauce, of which there are many varieties in Mexican cuisine), **nuts and fish** … always taking into account any preferences that the deceased may have had in life.

Even more prominent is the *pan de muerto* (bread of the dead), which takes over stalls, kitchens and bakers' shops throughout the Day of the Dead. It is sweet, unlike bread in the US and UK, and is shaped into **human forms, bones, shapes of the cross**, or even skulls. Usually it's a round loaf with a cross shape across the top – particularly good for dipping in **Oaxacan hot chocolate**.

THE SWEETEST THING

Sweetness is at the heart of many *ofrendas*. Sculpted sugar appears everywhere in the form of skulls, skeletons, coffins and other **deathly apparitions** – often given as gifts as well as being placed on altars.

Reports of sugar figures of this ilk being used in Day of the Dead celebrations begin as early as the eighteenth century. Some links have even been suggested to Aztec rituals involving **sweetened sacred figures** (not sweetened with sugar which only arrived with the Spanish), although it's hard to know to what extent the current practices reflect these ancient ones.

As with the flowers and candles, there is a symbolic significance to these sweet offerings that goes beyond **respecting and honouring** the departed. The specific symbolism of the shapes themselves – skulls, skeletons and so on – will be covered in the next chapter but what about the act of eating them?

Sugar skulls etc. are not saved until after the fiesta but also consumed during it, by children and adults alike. Eating is a **vital process for life**, so in and of itself having dedicated foods around a festival of the dead speaks to the triumph of life over death. Plus, swallowing a sugar skull – which may be inscribed with your name – is a clear way of **swallowing and banishing death**. Where is death's sting? Dissolving harmlessly on your tongue.

TABLE MANNERS

It's also common to leave alcohol of some kind out for the spirits – usually a brand or a kind that they enjoyed

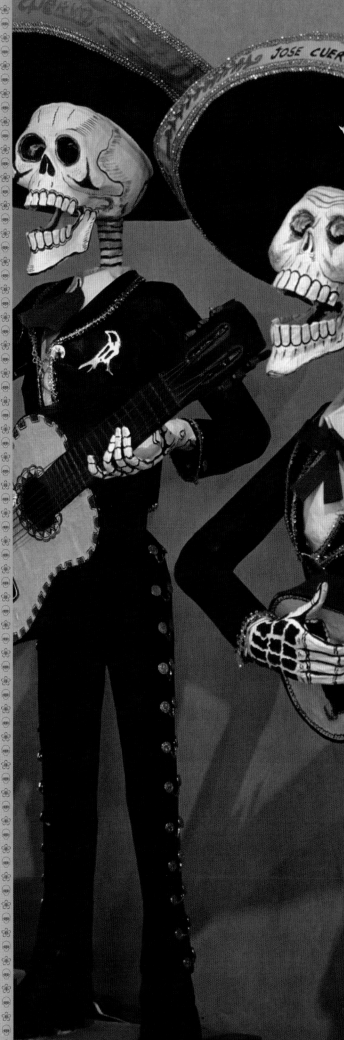

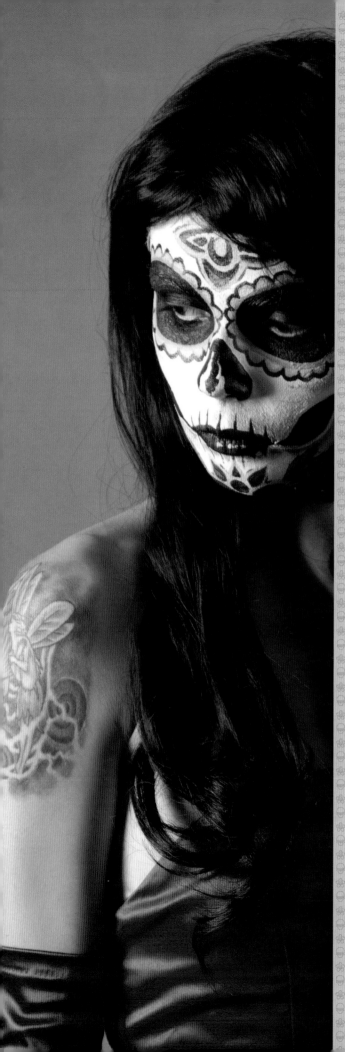

in life. But what happens to all this food and drink? Are the spirits expected to clear it away, and what do they gain from it?

Food and drink in *ofrendas* are not literally intended to be 'eaten' by the dead. Exact beliefs vary from region to region in terms of the pleasure they do derive from it: in some areas it's simply the act of offering that sustains them; in others, the smell of the offerings provides nourishment and happiness, or their flavourful 'essence'.

With this in mind the food and drink – and even flowers – that are offered up to the departed must be as fresh as possible in order to attain **maximum potency** (doubtless making for stressful times in busy kitchens all over the country), as the **visiting spirits** will depend on their essence. During the festival, it's certainly not permitted to eat from the *ofrendas*, whatever they may be: they are for the dead. When the revels are ended and the souls have eaten their fill, the food can be eaten – only it's believed to have little nutritional value now, as the dead have taken their share.

AROUND MEXICO

As well as preparing *ofrendas*, different regions in Mexico will have their own customs surrounding the Day of the Dead. They're too numerous to list here in full, but it's possible to experience the essence of them, like a soul at the feast, with a few examples.

On the islands of Janitzio and **La Pacanda in Lake Patzcuaro**, young girls take part in the Vigil of the Little Angels on 1 November. Wearing traditional white pinafores, they stand in the cemeteries while their parents observe

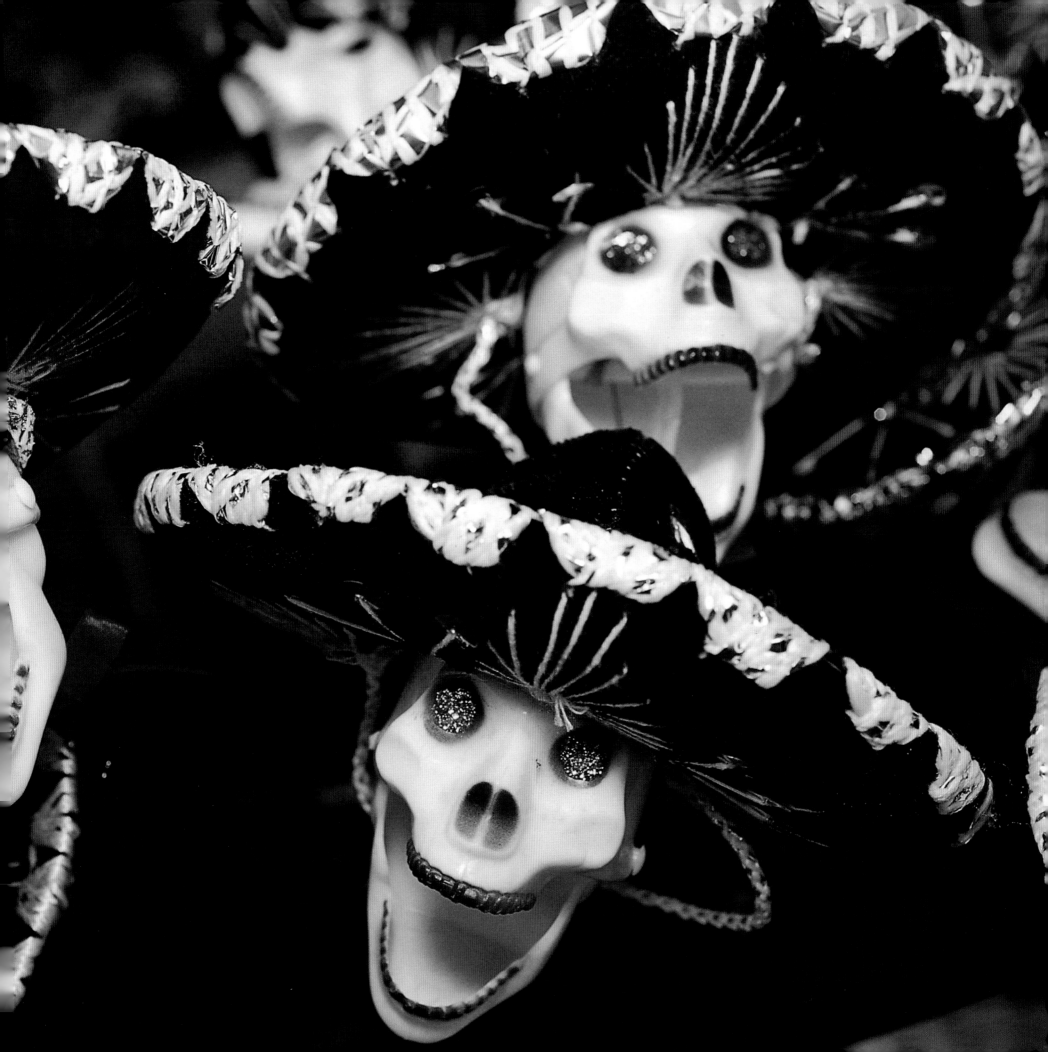

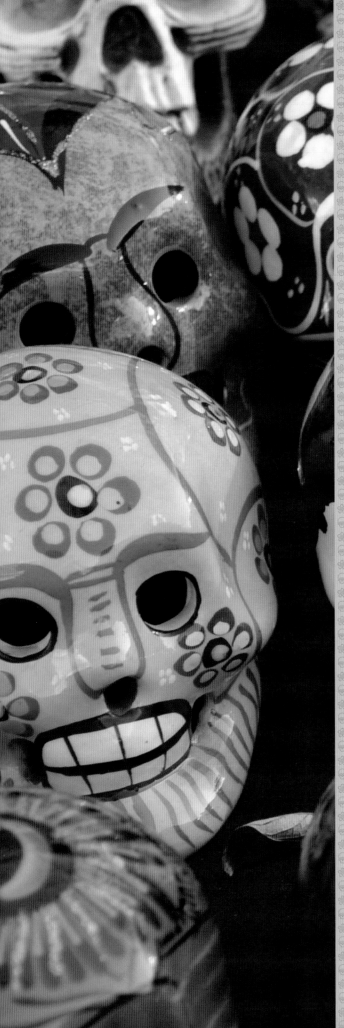
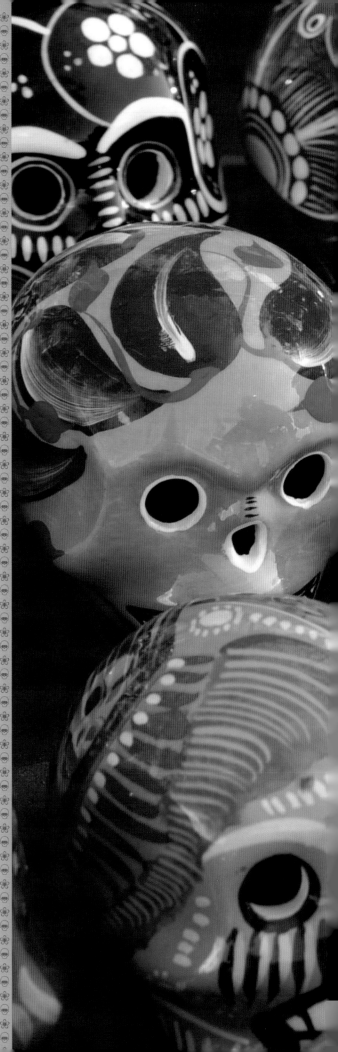

from a distance. Meanwhile in Ocotepec, visitors to homes where someone has died in the previous year pay their respects with the gift of a small wax candle; in return they receive food, usually *tamales*.

In other places, the *ofrendas* take on a unique character. In San Angel Zurumucapio there is a tradition of making small horses, decorated with roses, which are dedicated to the recently deceased. On the night of 1 November they accompany people to the **cemetery vigils** and are slowly decorated with flowers as the night passes. Getting in touch with the dead rather more literally, the indigenous Maya population of Pomuch follow the tradition of retrieving and **cleaning the bones** of the deceased three years after their death. They are then dressed in clothes the departed wore in life and exhibited in an open casket in the cemetery as part of a ritual held in the build-up to the Day of the Dead itself.

BEYOND THE BORDER

Although the Day of the Dead is a uniquely Mexican institution, it has nonetheless spread to other nations. It may appear as a facsimile of the Mexican celebration, or be a nation's own version based on **rites and rituals** from its history; or it may, appropriately for such a **syncretic celebration**, combine elements of the Mexican mortuary ritual with those of the 'host' country.

In the United States of America, the fiesta is growing in popularity year on year. Its relevance to communities with Mexican populations (or residents of Mexican ancestry) is obvious, the degree to which it is celebrated often tying in to the immigrant population in an area, looking to assert their **ethnic identity** and maintain

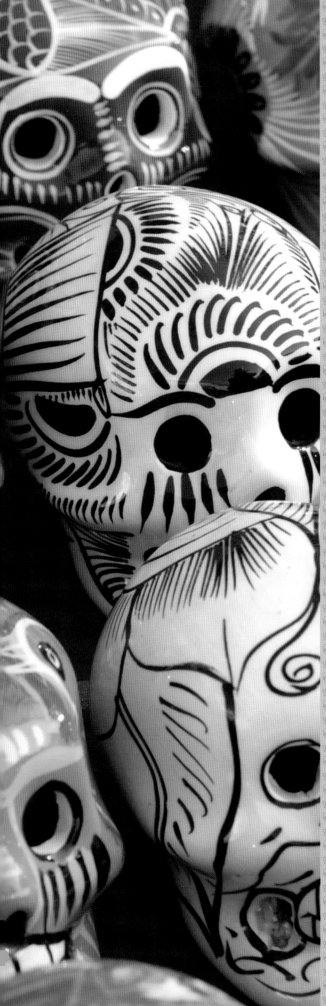
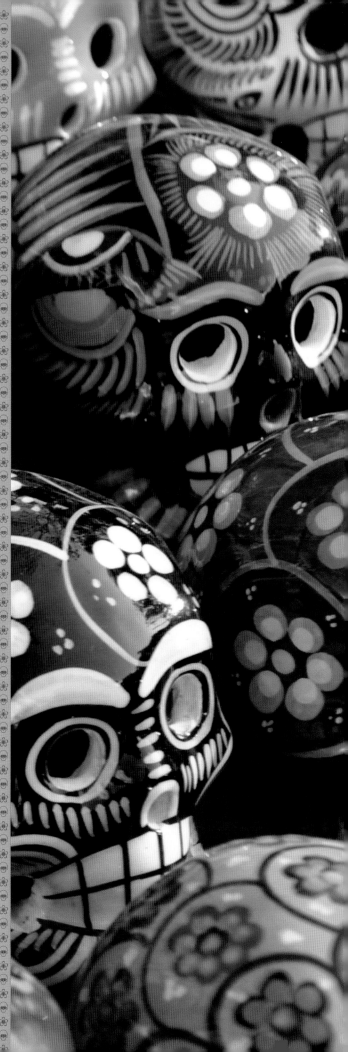

their traditions and customs. People being people, this can lead to tensions in the **complex racial landscape** of the US – a subject too vast to even attempt to tackle here.

In communities closer to the Mexican border the festivities are quite traditional. Tucson, Arizona hosts an All Souls Procession combining aspects of the Mexican fiesta with pagan harvest festival rites; in San Diego, California, a traditional two-day celebration ends with a **candlelit vigil** in a cemetery, just as it would across the border.

DEAD MODERN

Elsewhere in the US, the Day of the Dead is given a fresh interpretation in cities from coast to coast. In Los Angeles, California, it has a decidedly **political tone**: one celebration included an altar dedicated to the **Latino soldiers** killed in the Iraq War. At Hollywood Forever Cemetery, meanwhile, traditional altars sit alongside those dedicated to the **celebrity dead** and there is a blend of traditional and contemporary music and performance.

Further up the West Coast in Oakdale, the Fruitvale district hosts an annual *Dia de Muertos* festival. Here, ancient Aztec and Mexican elements combine, with **traditional dances** and artisanal crafts forming essential parts of the festivities.

Further East, Missoula, Montana sees a **parade of surreal skeletons** (on bikes, skis and stilts), while in Forest Hill Cemetery in Boston a more traditional celebration involving flowers, food and other offerings takes place among the graves.

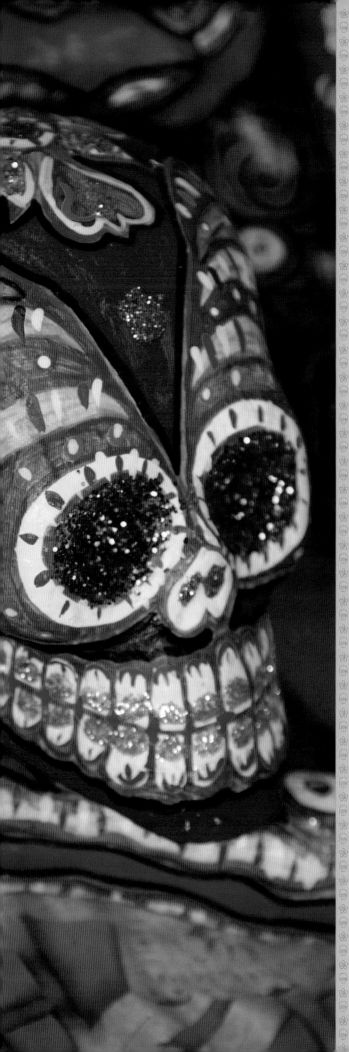

Never a place to be left out for long, **New York** has seen a rise in Day of the Dead celebrations, particularly in the last couple of decades. Brandes points out that celebrations have been **largely instructional** – held at museums and galleries – and 'bore a completely non-sectarian, if not entirely secular character' (*ibid*).

The US incarnation of the Day of the Dead is altered, more public (with less emphasis on private celebration at home) and **constantly shifting** – but then, the Mexican fiesta has never stood still either.

LATIN AMERICA

Similarly, there are different days of the dead throughout **Latin America**. The Brazilian *Finados* (Day of the Dead), observed on 2 November, has much in common with the Mexican fiesta and involves cemetery vigils and offerings of flowers and candles to honour the dead. In **Guatemala** things are much the same, only with the addition of giant kites and the sharing of *fiambre* – a collision of multiple salads that incorporates meats, pickled corn, beets, eggs, cheeses, salad leaves and potentially Brussels sprouts. Every family has their own recipe.

Ecuador's celebrations, especially among the indigenous **Kichwa people**, follow a similar pattern of gathering in the cemetery to make offerings in honour of the dead. As with everywhere else, it's a uniquely gastronomic affair, featuring spiced porridge dyed purple by **Andean blackberries** and *guagua de pan*: bread in the shape of a swaddled infant, stuffed with cheese or guava paste.

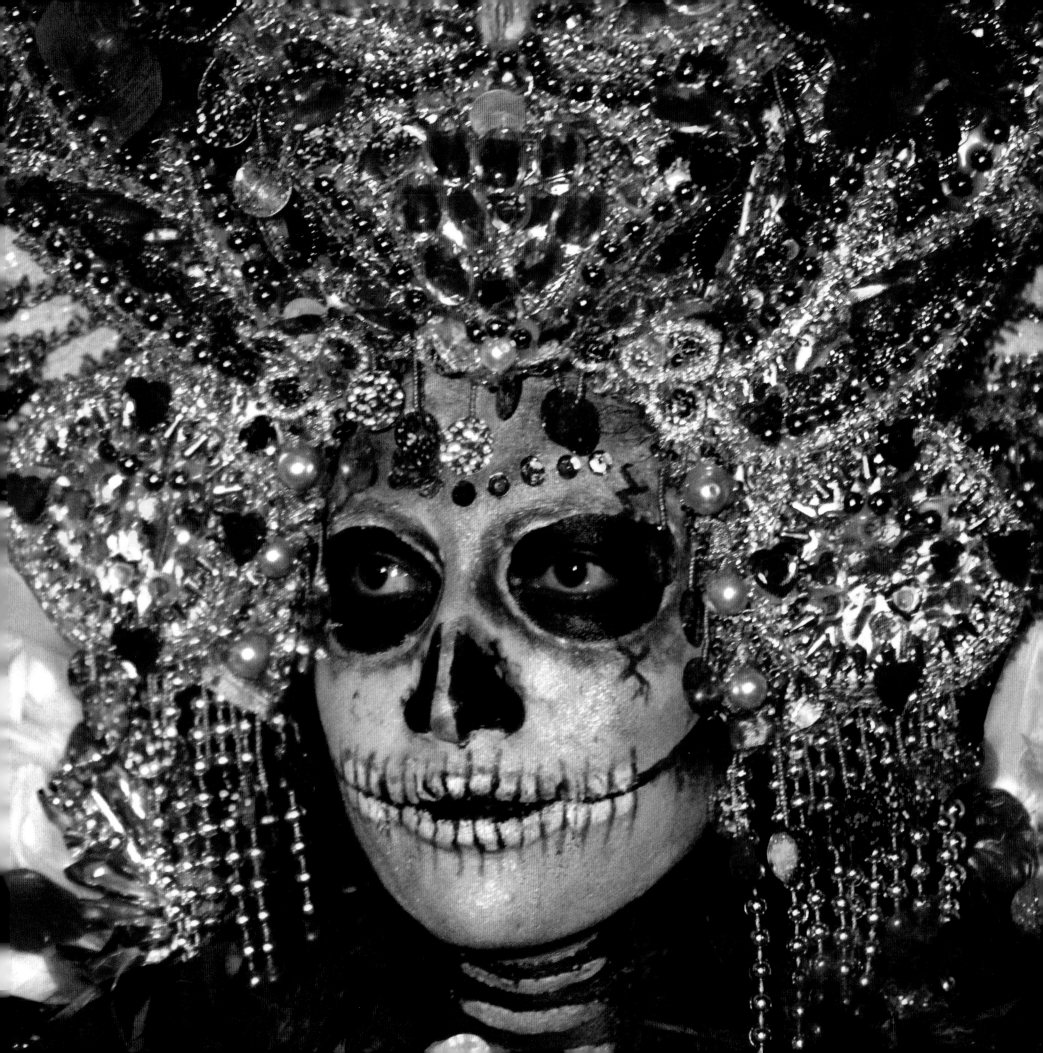

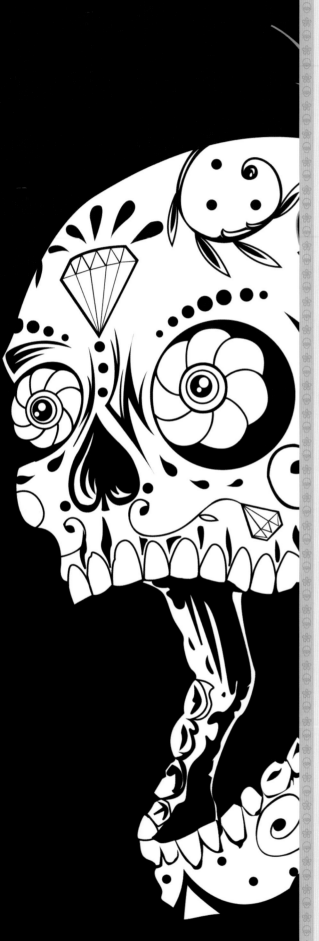

The people of **La Paz, Bolivia**, take things back to bare bones. Literally: their *Día de los Ñatitas* ('Day of the Skulls') involves decorating the skulls of family members (which watch over the house all year round) with crowns of flowers and making offerings of **alcohol and coca leaves** in gratitude for their protection. Usually held on 9 November it's very different to the Mexican idea of the Day of the Dead, but serves to show that the concept exists separately in unrelated cultures.

EUROPE

The European traditions of All Saints' Day and All Souls' Day have already been mentioned as contributing their **Catholic DNA** to the Day of the Dead, along with influences from the various pre-Christian autumnal rites of the dead that they swallowed up over time.

The Roman Catholic heritage of many European countries leads to superficially similar celebrations on All Saints Day and All Souls Day, with visits made to graves and offerings made, as well as special masses said, in **France, Spain, Italy** and beyond. In Brittany, Celtic tradition sees people bless graves with holy water or milk, leaving food on the table at nightfall for the souls of the dead.

Many of these celebrations are entirely rooted in the Catholic doctrine and consequently have a different ethos to the **partying Mexican incarnation**. Yet there are anecdotal signs that the Mexican fiesta has crossed the Atlantic.

The UK is yet to see gleeful cemetery vigils and **ofrendas,** but the increasing presence of sugar skulls

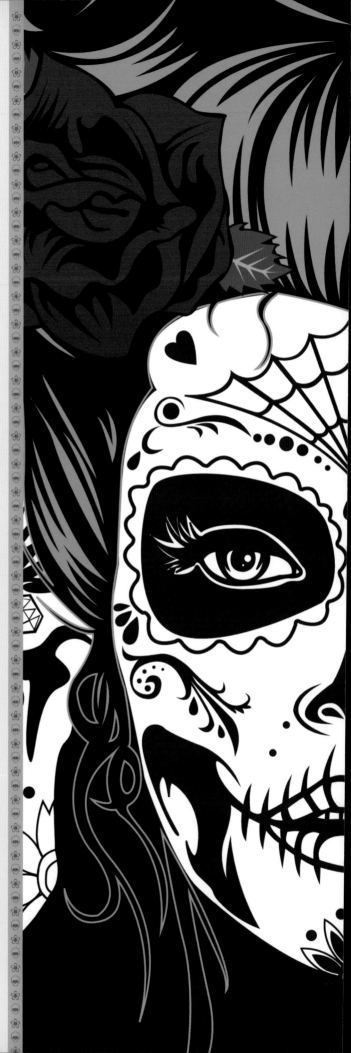

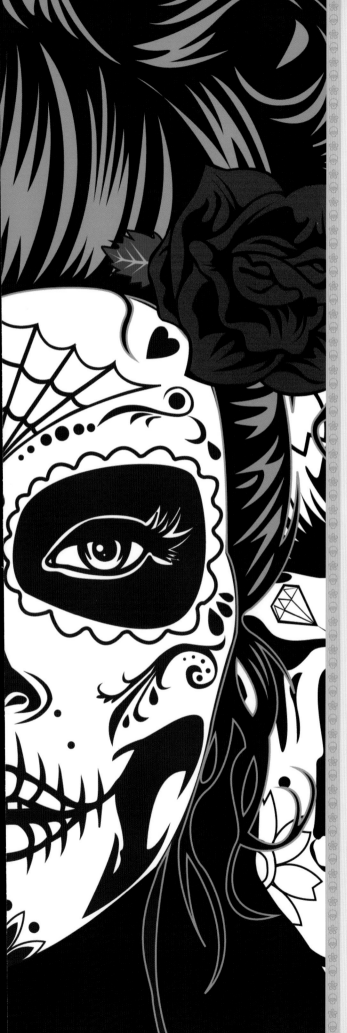

and other *calaveras* in the media, shops, fashion and even tattoos reflects both a **growing curiosity** about and awareness of the festival. In time the pagan rites may come full circle and encourage an anglicized version of the Mexican fiesta they may originally have inspired.

THE BEYOND

Elaborate rituals to prepare and honour the dead are as old as we are as a species – we only need glance towards **ancient Egypt** for a sense of how long we have been observing mortuary customs. Yet nowhere in the modern world offers anything as malleable as the Mexican Day of the Dead, which can be both **sacred and secular**, raucous and reverent.

Small wonder then that other nations may embrace it. The Day of the Dead offers a way of **gracefully acknowledging death** that can be kept quite separate from funerals (which are as sombre in Mexico as they are everywhere else). It can encompass **multiple views** of the afterlife and offers a way of communing with **departed family members** without resorting to snake-oil spiritualism or revenant black magic – the presence of the spirits can be literal or metaphorical, depending on the individual's take on things.

Mexican-style celebrations are now carried out in **Australia, Fiji, New Zealand** and many other nations, as we've seen. Beneath the flowers, song, colour and crazy bread, perhaps the seductive appeal of the fiesta really comes down to a simple **human desire**: to come together and remember the ones we have loved and lost, not with numb grief but with a **glad heart**.

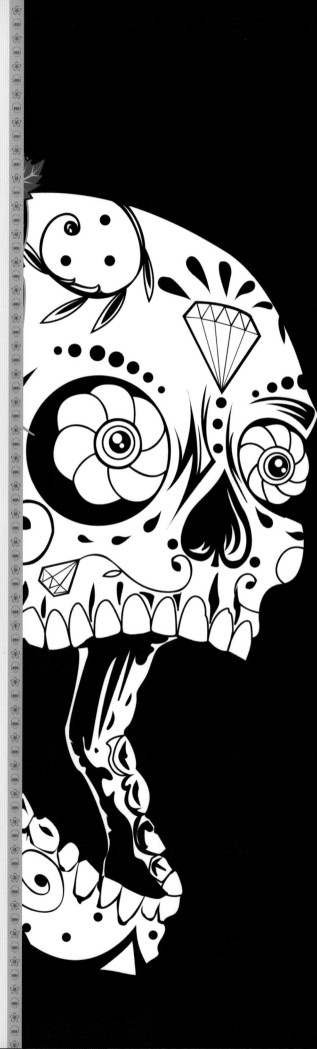

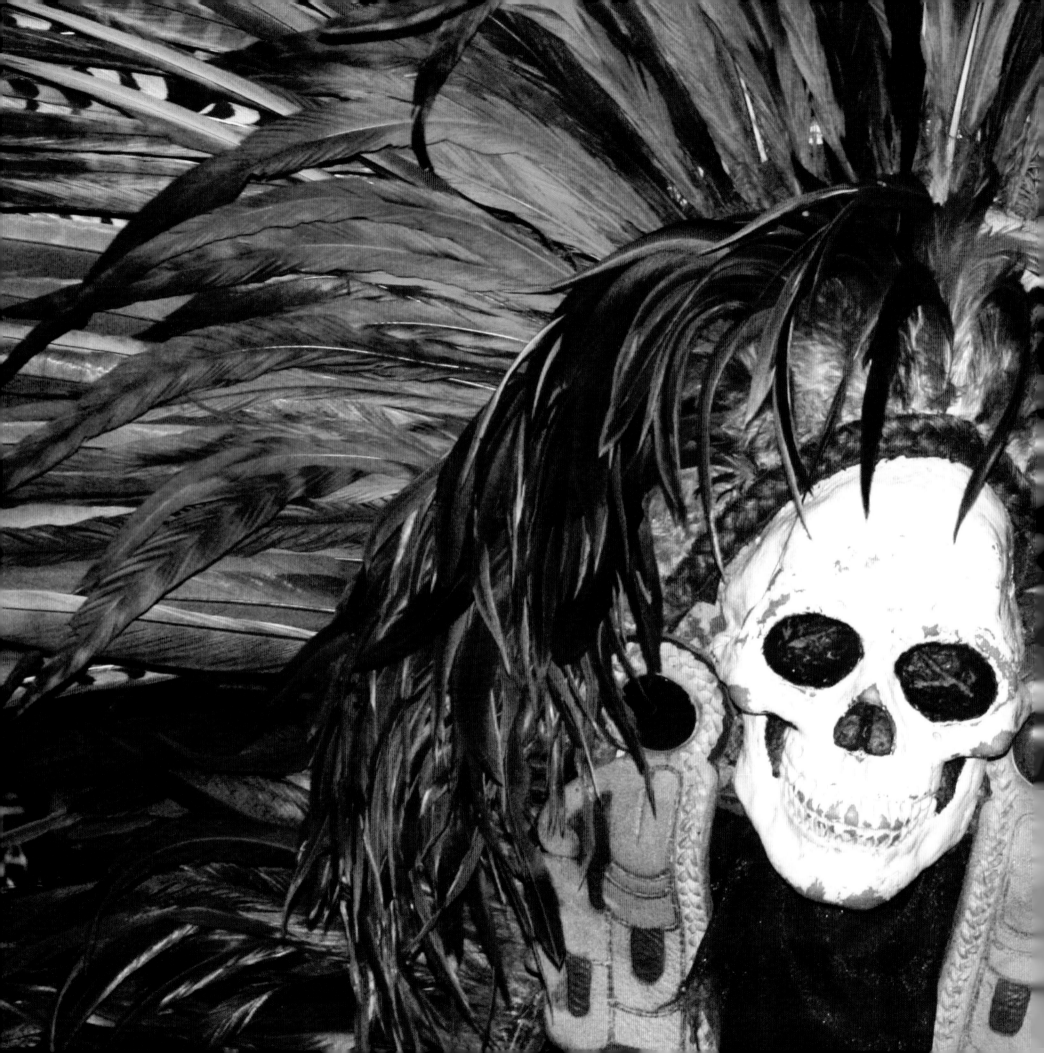

SUGAR AND SKULLS

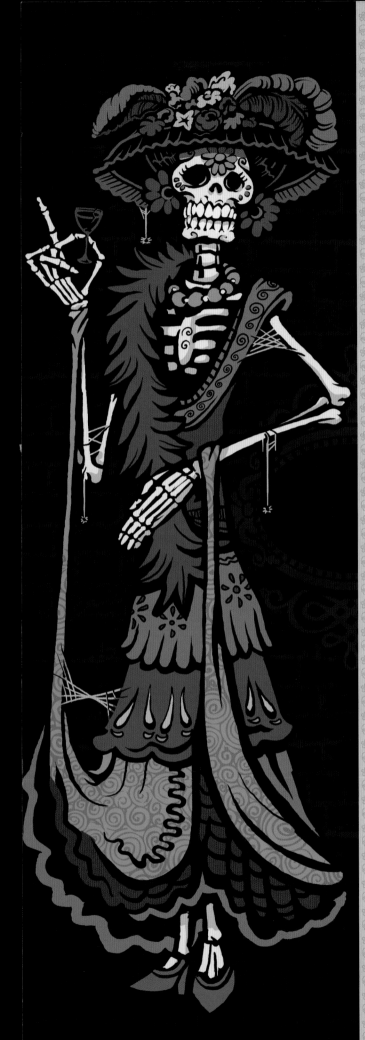

SUGAR AND SKULLS

O ur exploration into the customs and characters of the Day of the Dead continues with something to sweeten the palette. To truly appreciate the long-term role sugar has played in the fiesta, let's take a journey back in time with a few accounts from travellers. (Feel free to eat some candy while you're at it.)

In the 1760s, Capuchin Friar Francisco de Ajofrín (1719–89) journeyed to what is now Mexico and gave an account of his travels in his *Diary of a Voyage to New Spain*. He described the scene in a market in Mexico City:

Before the Day of the Dead they sell a thousand figures of little sheep, lambs, etc. of sugar paste (alfeñique), and it is a gift which must be given obligatorily to boys and girls of the houses where one has acquaintance. They also sell coffins, tombs, and a thousand figures of the dead, clerics, monks, nuns and all denominations, for which there is a great market … it is incredible to see the crowd of men and women from Mexico City on the evening before and on the day of All Saints.

Later in 1826, British naval captain **George Francis Lyon** (1795–1832) visited the market in Xalapa on the days leading up to the Day of the Dead. In his diary, he recorded seeing 'nondescripts of painted sugar which were always surrounded by **open-mouthed children**. Xalapa is indeed celebrated for its sweets.'

THE SWEETEST THINGS

Clearly, the Day of the Dead has been a festival for families (and presumably departed souls) with a sweet

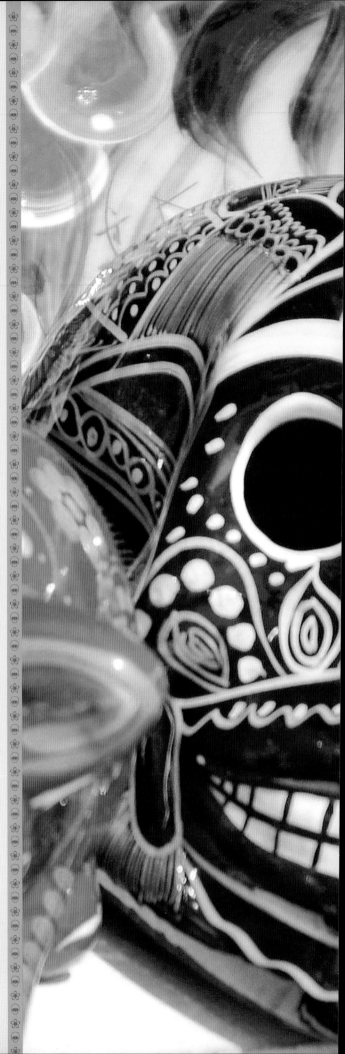

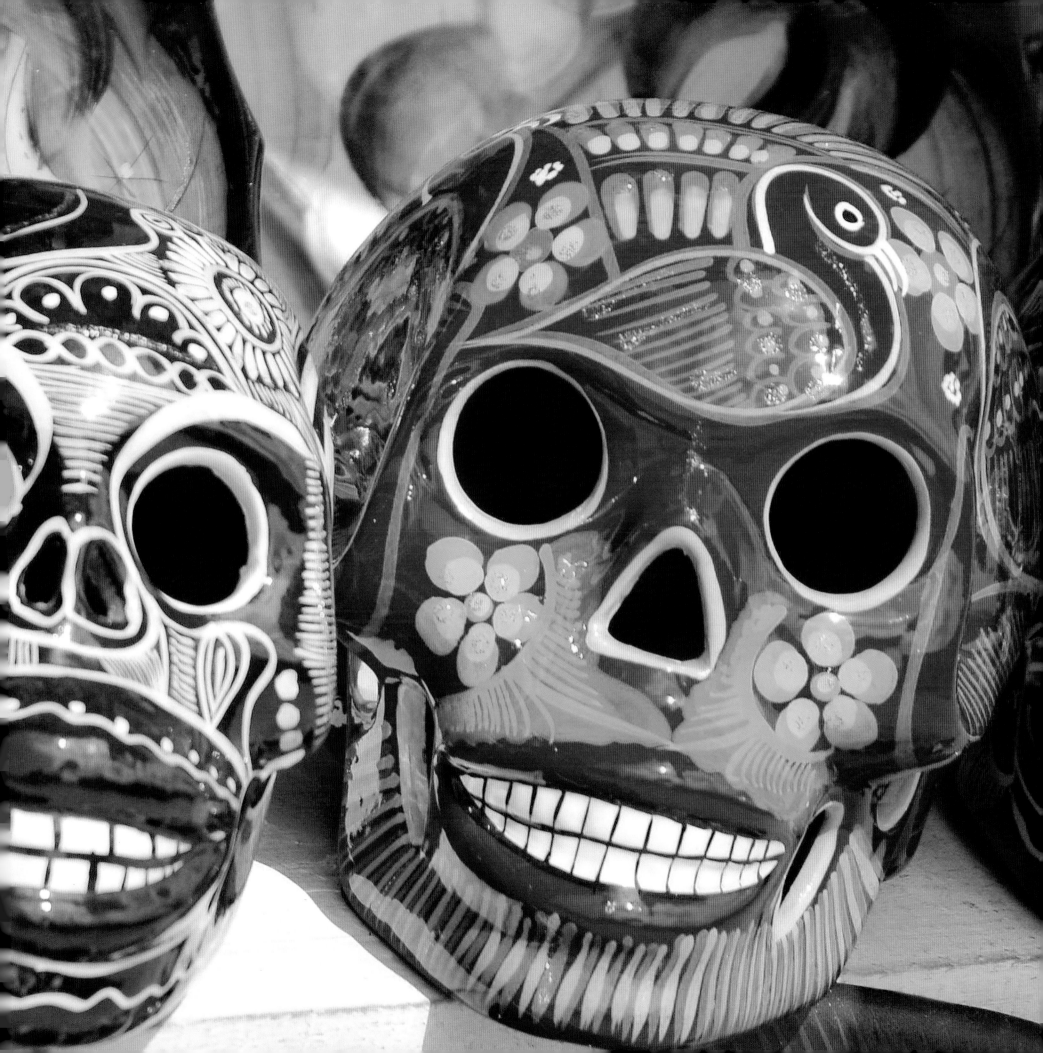

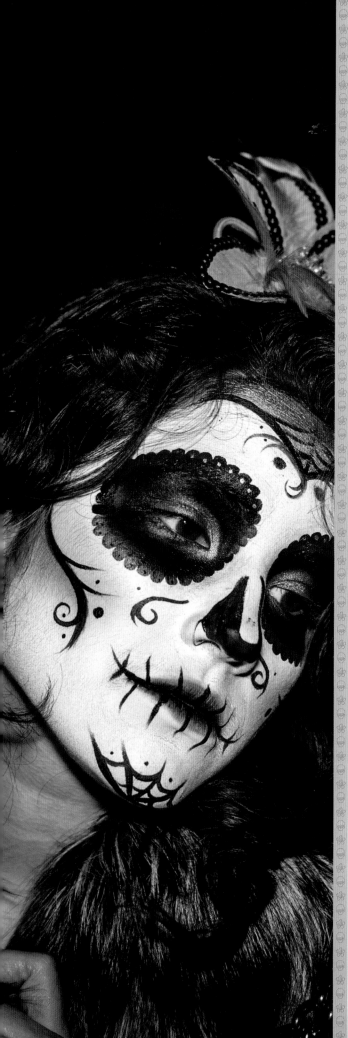

tooth for some time. While some of the clerical figures described by **Ajofrín** are these days rendered in wood or pottery during the celebrations, usually as toys offered to children, the animals and coffins have barely changed.

Nor has the means of obtaining them. In towns and cities throughout Mexico grocery stores and market stalls fill up to **bursting point** with sugar creations in the days leading up to the Day of the Dead. Groups of **sugar animals** are common and still include sheep and lambs – which understandably carry Christian associations with the lamb of God and **Christ's flock** – as well as extending the menagerie to include dogs, donkeys, chickens and bulls.

A tour through a sugar market (*feria del alfeñique*) in cities like Toluca will reveal sights such as rank upon rank of tiny, **perfect coffins** rendered in sugar. They usually sport a genial-looking skull peeping out from inside and are brightly coloured and patterned – the overall effect is like looking at a sweetly scented kaleidoscope, which, courtesy of the coffins' occupants, has the curious ability to look back.

GETTING MOULDY

Ajofrín described the process of making these **quirky, wryly humorous** objects as something done rapidly by skilled artisans. Modern mass production methods have inevitably encroached on **artisanal practices** over time, but much of the work is still done by hand – fuelled in part by the insatiable hunger of Day of the Dead tourists for traditional sugar creations.

Some of the production methods may even have remained the same for hundreds of years. Moulds for

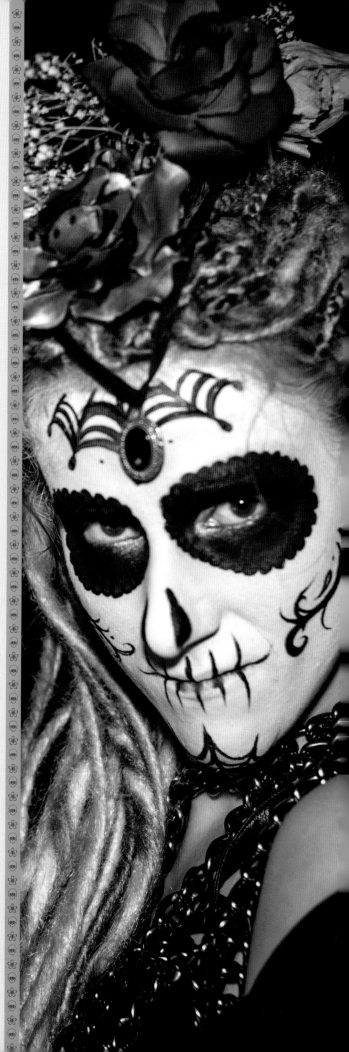

sugar creations – everything from the smallest lamb to the largest bull – have been passed down through families, along with **secret recipes** and techniques.

Like every craft, there can be a purity of intent in creating the pieces, balanced with the **ruthless glint** of either **commercial necessity** or a competitive, creative pride: everyone wants to be known for making (and selling) the best *alfeñique*. Even in a rite intended to honour the dead, the living can squabble over status, whether it's over the finest altar, sweetest treat or tastiest *tamale*. We are, in the end, only human.

But of all the sugared creations crafted for the Day of the Dead, one has risen to become the **most famous**, the most enduring and the one that seems to inspire the most curiosity and copycat culture around the world: **the skull.**

THE CALAVERA

Sugar skulls are often dubbed *calaveras*, a term that also applies to any other artistic representations of skulls over the period of the Day of the Dead. They may be made from **sugar or clay**, or feature as drawings and illustrations; literary pieces including poems and satirical writing are also known as *calaveras* (more on them later in this chapter).

In their **sugary incarnation** the skulls are generally made from sugar cane and formed using moulds. They are then decorated in bright colours, with **distinctive patterns** covering the surface and ornamenting the eyes in particular. The precise shape of the skulls and nature of the embellishments can evolve from year to

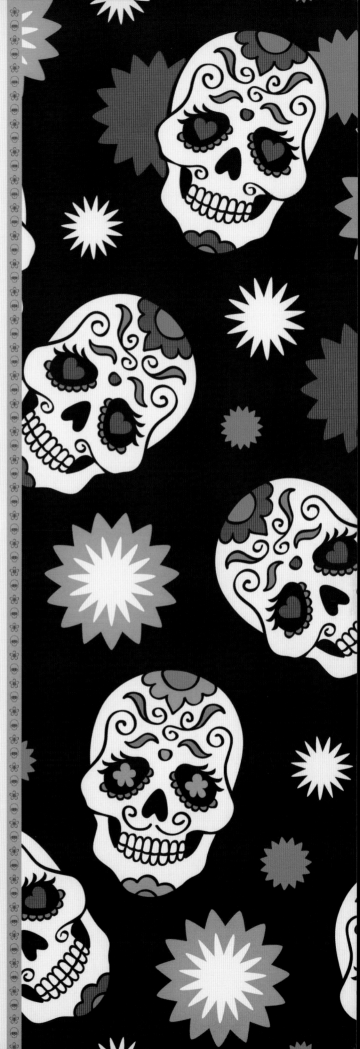

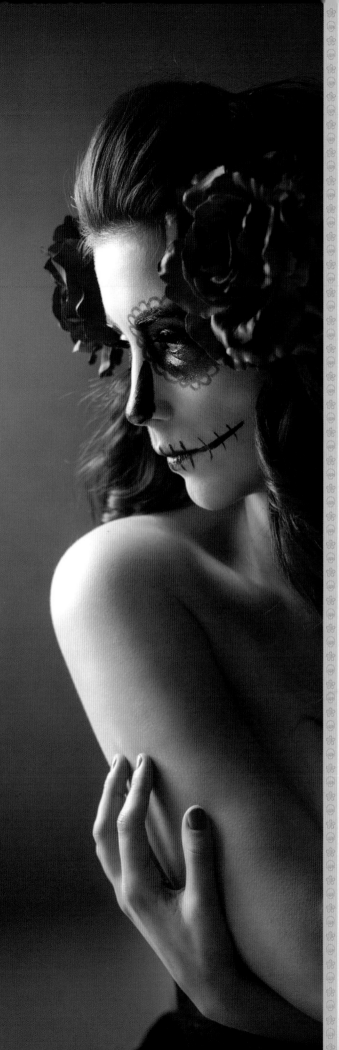

year, each successive season producing **calaveras** with slightly different looks – even skulls aren't immune to the whim and will of fashion.

The **calaveras** pop up away from the sweet stand, too. Shops will use images of **grinning skulls** to advertise their wares for the Day of the Dead; they have appeared in children's books to educate and inform the next generation about the fiesta and its meaning; and of course they're something of a **fashion icon**, smiling away from clothing or painstakingly rendered as lurid face paintings among the living during the more boisterous celebrations.

NAME THAT SKULL

But it's the sweet candy skulls that command much of the attention. They are a standout feature of the fiesta and have commanded the attention of children for hundreds of years: various **nineteenth-century travellers** wrote accounts of journeys through Mexico around the Day of the Dead, all describing the crowds of children gaping at the rows of **brightly coloured skulls**.

Giving small skulls to children, friends and relatives may seem a **little ghoulish**, especially if seen through the filter of Halloween, the other seasonal celebration in which skulls feature heavily. Even more so since sugar skulls are often given with the name of the – living – recipient painted or piped on to them.

This might initially seem like a fairly malign act intended to mark someone for the attention of death, but like everything else surrounding the Day of the Dead, it's more to do with the fiesta's **sardonic sense of humour**:

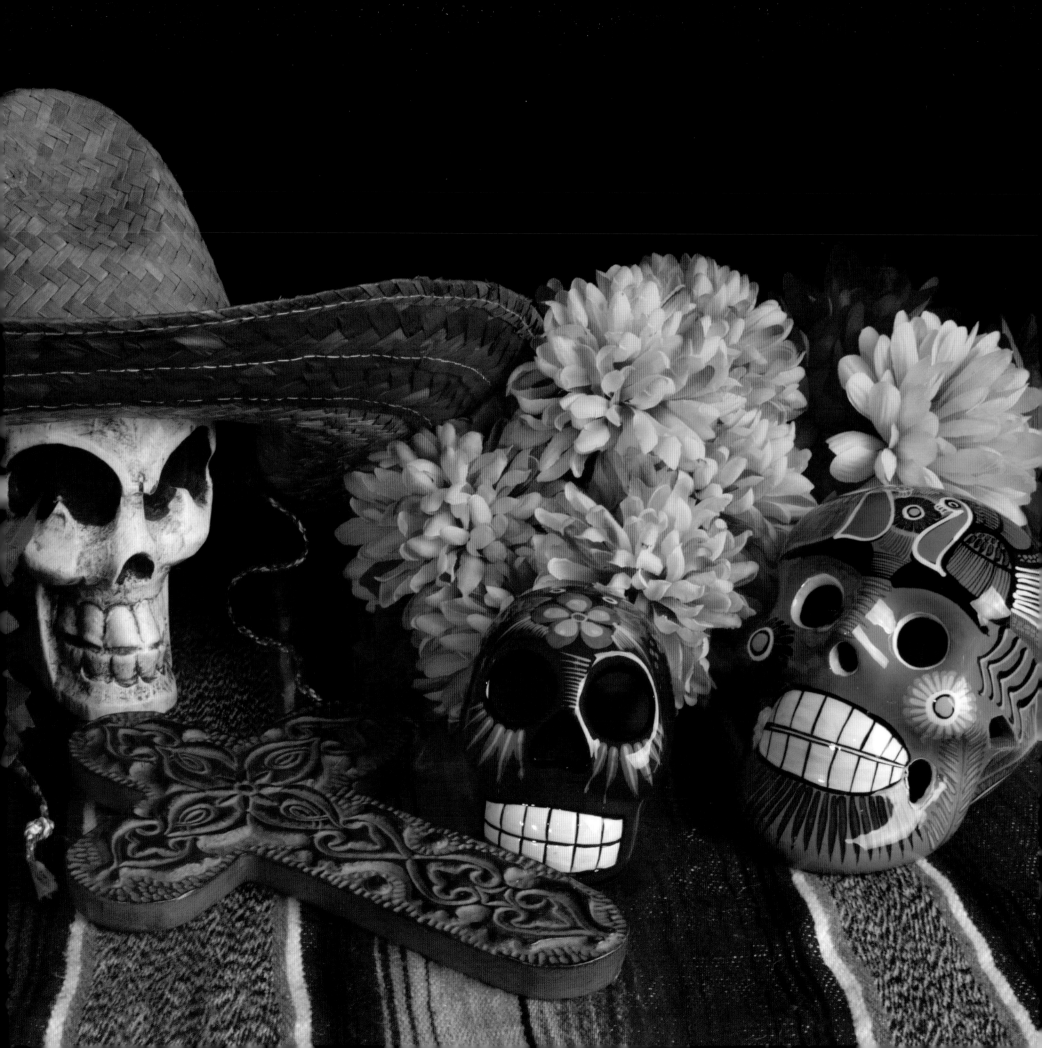

the skulls are offered as a wry reflection of the **ofrendas** left out for the souls to eat. In keeping with the fiesta's whimsical approach, the skull also offers an opportunity to eat your own death – in other words, to render its terror meaningless and to consume it with pleasure.

THE DISAPPEARING SKULL

Sudden dissolution isn't the fate of sugar skulls alone: their destiny as momentary pleasures reflects the generally ephemeral nature of all **calaveras**. Be they clay or **wooden models, sugar and chocolate treats**, pictures or – inevitably – face paints, these are not items intended to be kept and hoarded over time. They exist, briefly, for the Day of the Dead; and then vanish.

Could there be a **larger metaphor** for the fleeting passage of life here? Possibly, but given that many other ornaments for seasonal events share the same fate, it's just as likely to be a tale of **disposable trinkets** as one of existence itself. Sometimes a sugar skull is just a delicious diversion, and nothing more.

Yet the Day of the Dead skull does carry its fair share of mystery. It is an almost entirely cheery entity, for a start: smiling, not sneering. It is **colourful, mischievous** and carries an air of good humour about it that can seem at odds with other depictions of skulls in popular culture. The gloomy **signposting of death** is reserved for their more sombre brethren – they signify good times, not bad.

PRE-HISPANIC SKULLS

The skull as a universal signifier of death has featured in virtually **every civilization** in some shape or form. To what

extent its role in pre-conquest **Mesoamerica** informs the modern Mexican sugar skull is hard to measure; but skulls certainly played their part in the art, architecture and customs of various societies in the region.

Early examples appear as far back as the **pre-Classic period** (around 2000–200 BC) and include figurines from Tlatilco in the Valley of Mexico, which display heads that are half flesh, half skull (happy nightmares). However, their appearance is scattered – skull imagery became much more commonplace in the post-Classic period (900–1520 AD) among the **Maya, Toltec and Aztec people.**

If any civilization could lay claim to producing art and imagery that would influence the modern sugar skull, it is probably the Aztecs. Closest in time to the modern age of all the pre-Hispanic cultures, their iconography does seem to place an **emphasis on skulls** that may well have transcended the destruction meted out by the *conquistadores*. Stone sculptures of *Mictecacihuatl*, goddess of the underworld and of the dead, show a skull-faced figure; the Aztecs also left skull offerings in the **Great Temple of Tenochtitlan.** They were (charmingly) adorned with flint knives inserted into the mouths to represent tongues, showing a definite predilection for skulls as decorative artefacts.

RACK 'EM UP

Then there are the Aztec *tzompantli* or skull racks, which could almost be the rows of modern-day sugar skulls seen through a **black mirror.** In battle, Aztec warriors did not kill their captured enemies: instead, they were brought – presumably dragged – before the priests, as sacrificial offerings. The victims' **hearts were ripped** from their

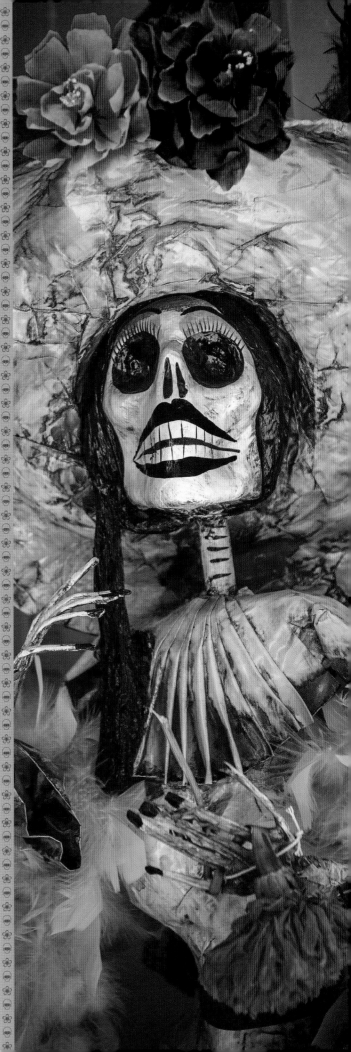

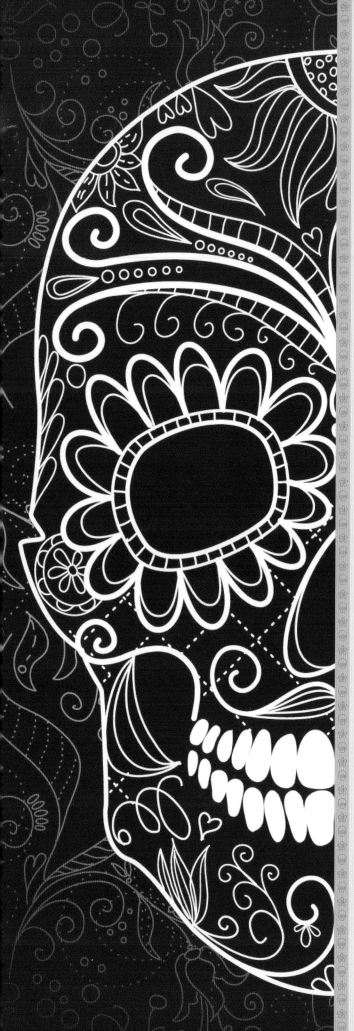

chests and they were **decapitated**, at which point their captors took the remainder of the body home to eat. The bones would later be **displayed as trophies**, once the family had had their fill.

The heads were duly **skinned, dried and stacked** up on the skull rack. It's easy to imagine the horror of the Spanish arrivals when they first encountered this practice, existing as it did in such stark contrast to the austere practices of Europe, where bones might be displayed but never vaunted in such a **grisly fashion**.

The importance of the role of the *tzompantli* in Aztec culture can be seen in the scale of the architectural efforts surrounding them. At **Tenochtitlan** the stone base of the Great Temple's skull rack is 60 m (197 ft) long and 30 m (98 ft) wide, covered with horizontal **rows of stone skulls**. A forbidding enough sight now, but consider how it looked in its heyday when topped with a **gargantuan** wooden frame holding, according to conservative estimates, some 60,000 enemy skulls.

SHOW SKULLS

The *tzompantli* also featured in the earlier Toltec and Maya civilizations, suggesting an **enduring fascination** with skulls as trophies in the region. There were also customs that saw skulls brought into households and displayed or **offered to gods**. It's not inconceivable, therefore, that these traditions inform the contemporary *calavera*, albeit with a little sweetening of the medium and the message over time.

The function of skulls certainly changed in the centuries immediately following the Spanish conquest. By the

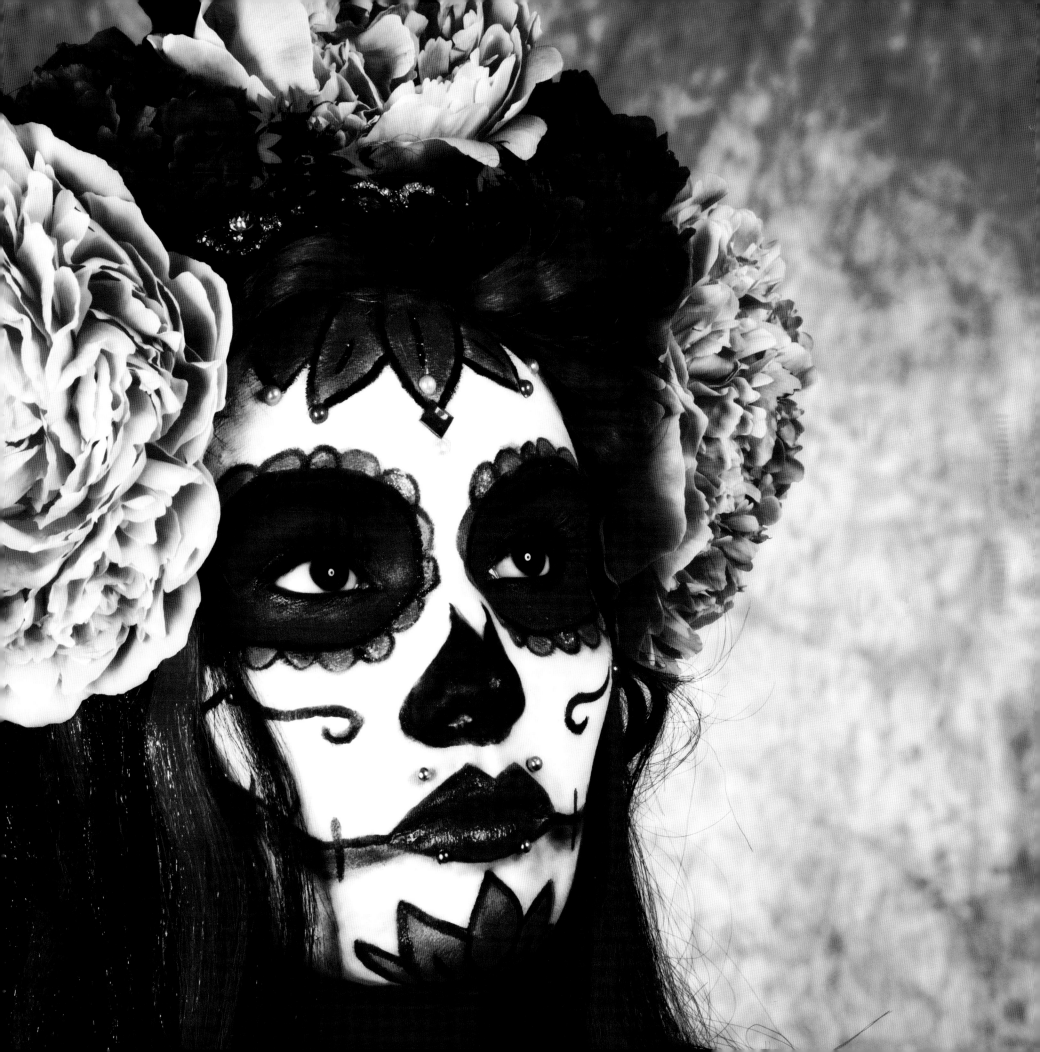

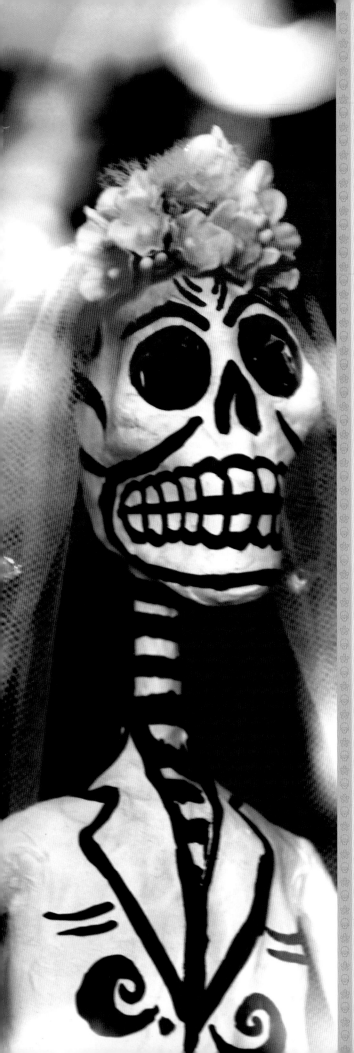

nineteenth century the Day of the Dead was well established and instead of enemy heads **leering from a skull rack**, public displays involved the skulls of family members being taken from their resting places and put on show.

These skulls would often have the names they bore in life inscribed on them. Tellingly, as **Brandes** points out, the names were written in the same spot in which today's sugar skulls sport the names of their intended recipients, perhaps offering 'a hint of the origins of the practice that the sugar skulls may represent' (*Skulls to the Living, Bread to the Dead*, 2006).

Travellers' accounts tell us that sugar skulls were already commonplace around this time, so it's entirely possible that they took over this **memorial function**, which is slightly more hygienic than disinterring the heads of the dead every year, before evolving over the decades into the **cheery visions** we see today – bearing not the names of the dead, but of the living.

TALKING HEADS

The use of skulls in this way points to another potential example of **European influence** melding with Aztec custom. Day of the Dead ceremonies in the nineteenth and early twentieth centuries incorporated the Aztec propensity for handling and displaying the remains of the departed without a trace of the **squeamishness** that their European counterparts evidently felt when viewing them. 'It grated harsh upon the feelings,' admitted American explorer **John Lloyd Stephens** (1805–52) in his *Incidents of Travel in Yucatán* (1843), which described his experiences around the Day of the Dead.

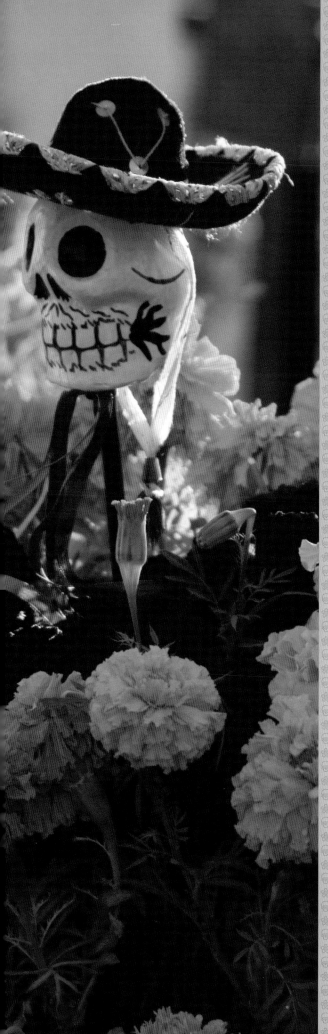

Recovering from a fever Stephens was unsettled by this unflinching presentation of skulls, 'accustomed as we were to hold sacred the bones of the dead'. He was confronted with **skull after skull**, each bearing a name, but also a message to those observing them: usually asking the passerby to offer up an Ave Maria, an Our Father or other prayer.

Similarly heady blends of solemn Catholic dogma and visceral **Mesoamerican custom** were described elsewhere in Stephens' account, variously talking of skulls **sprinkled with holy water**, or gathered together on a great bier draped in black cloth and illuminated by candles. It's hard to imagine a more gothic sight than a mass of gleaming, polished skulls, **shadowy eye sockets** shifting in flickering candlelight, bearing messages pleading with the living.

MEMENTO MORI

Stephens begged an explanation from a priest, who reassured him that rather than springing from **'wantonness or disrespect'**, the exhibition was instead an act of memory. In the grave the dead can be forgotten: face to face, though, they remind the living of the departed, asking that they pray for them.

These events took place on 2 November and show that there were more gloomy spectacles of commemoration taking place alongside the **livelier celebrations** that were – even at this point – an established part of the Day of the Dead. They also involved more recognizable elements of **Catholic ritual**, which was not always present in other festivities.

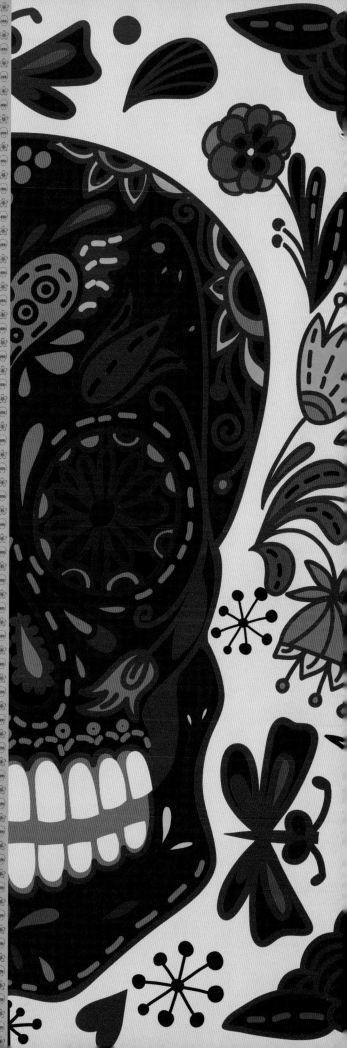

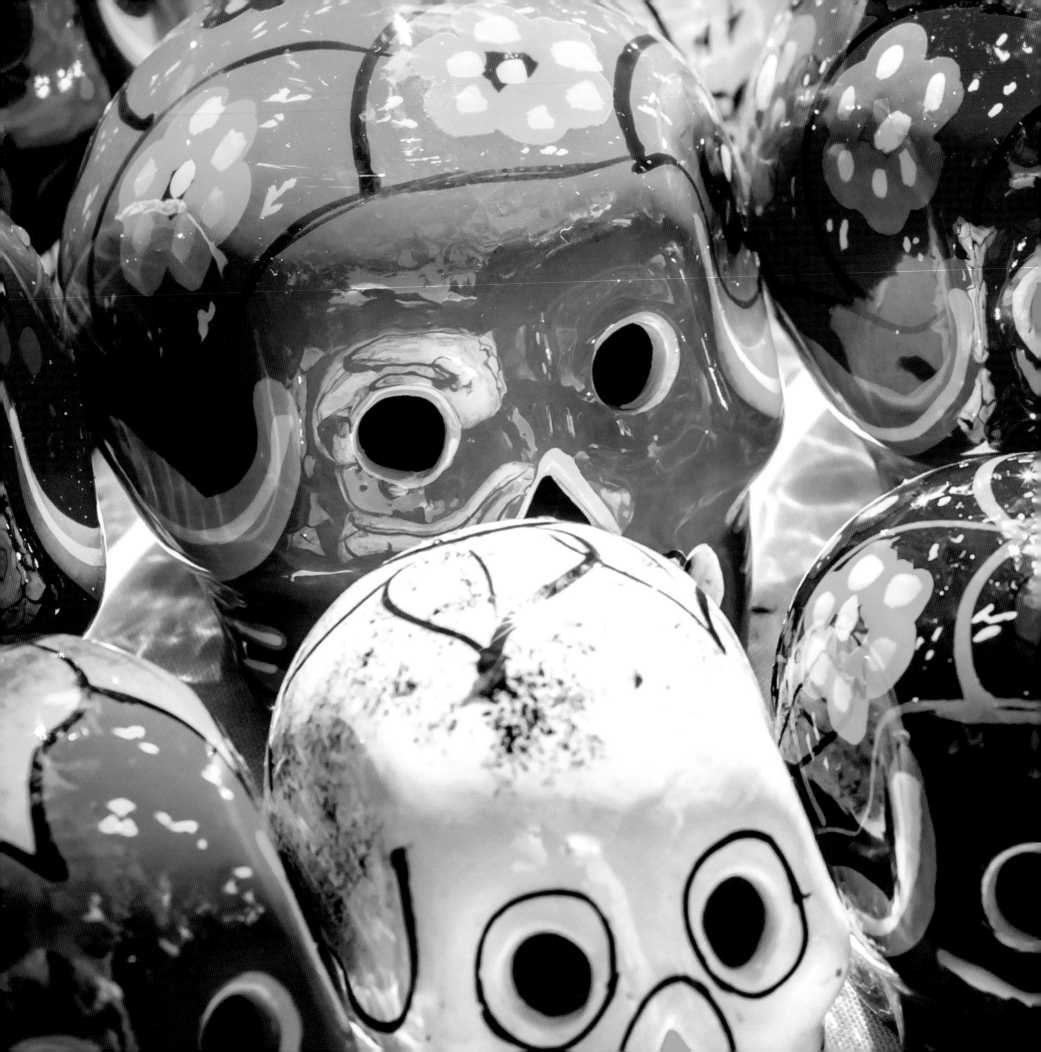

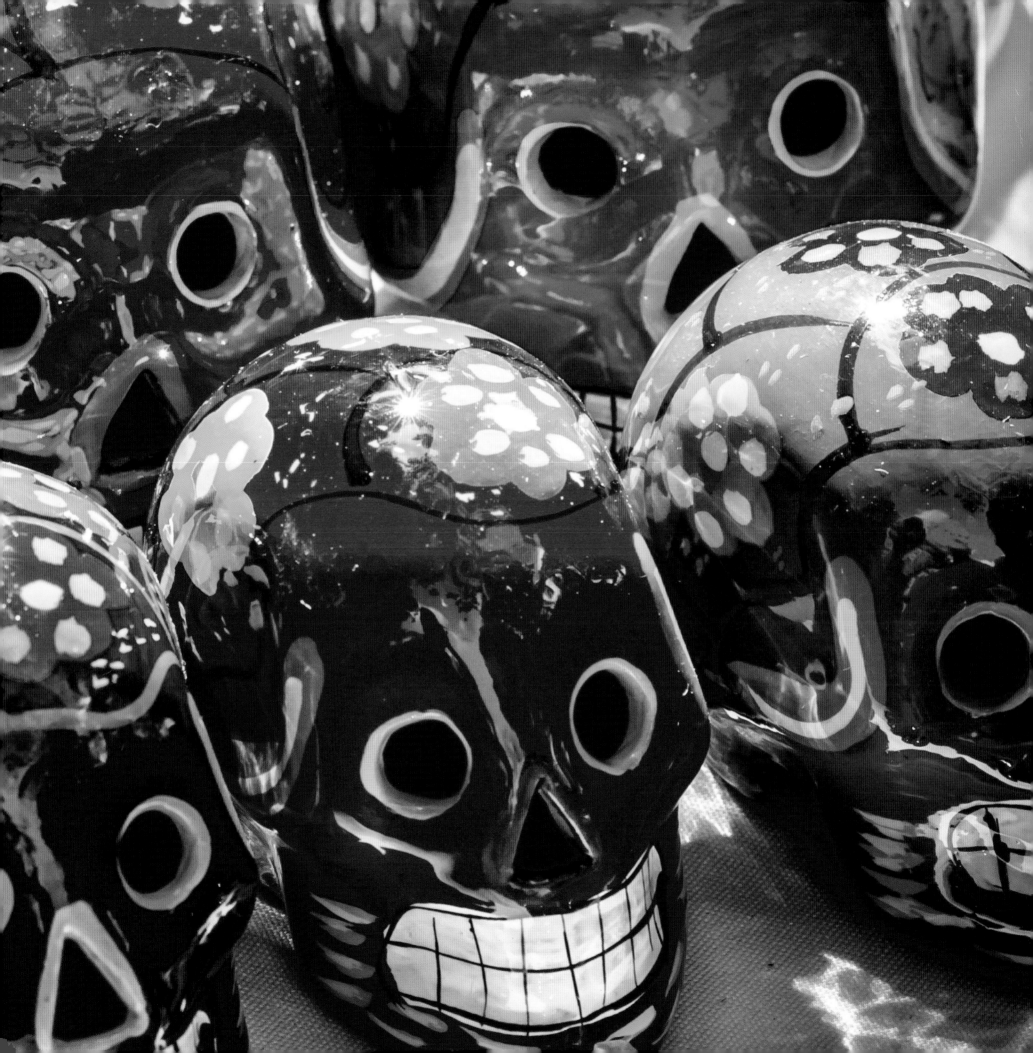

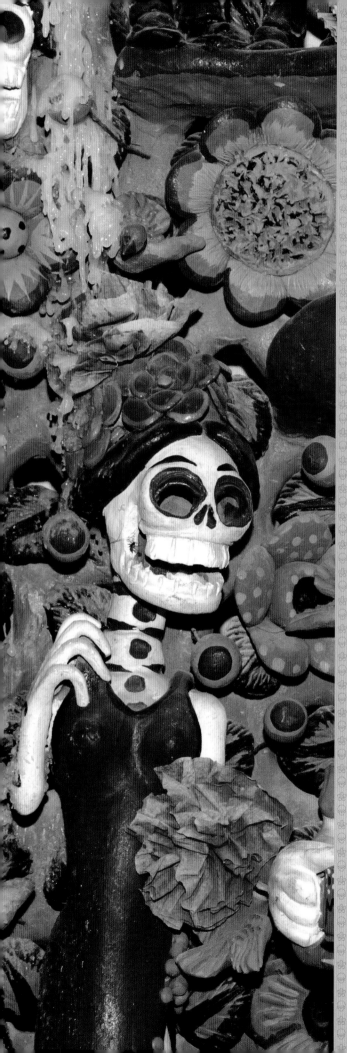
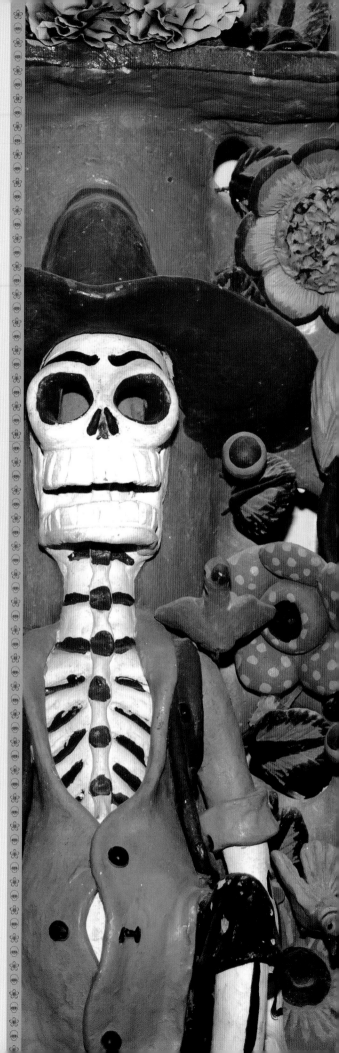

Some of the more frivolous, or at least more light-hearted accessories that were being created for the Day of the Dead centuries ago have survived. Sugar skulls from the late nineteenth century exist as museum pieces, along with other eccentric, oddly charming skeletal figures and skulls. The passage of time has seen the gradual falling off of the use of true skulls and explicitly Christian ritual in the Day of the Dead as it is celebrated in Mexico, replacing it with sugar skulls and a more secular (or less specifically spiritual) philosophy of souls and spirits. The piles of skulls remain, but only made from sugar cane – and lit by electric bulbs.

DEAD ART

These accompaniments to the Day of the Dead are different in another significant way: where the bone skulls staring at Stephens were real and dreadfully long lasting, whereas today's sugary knick-knacks are short-lived creations.

The temporary nature of calaveras is perhaps one of the things – along with not being the product of brutal human sacrifice, of course – that marks them out as folk art. They may be part of a flow of fascination with skulls that has wound its way through Mexican history, but they are some way downstream, no longer trophies to be venerated and gloated over, nor stark reminders to pray for the dead, but amusing, distracting treats to be savoured, enjoyed and then forgotten until the next time.

Of course, we all bring our personal interpretations to any skull that we see. There's nothing to stop the bright, breezy rows of sugar skulls calling up dark

fantasies or visions of the kind of murder spectacles – such as the **Aztec skull racks** – that they may have descended from. The skull retains its iconographic weight precisely because it can remind us of the **sorrow of death**, exhort us to live well as our eventual demise is certain, or simply **give us the creeps** with its unblinking stare.

THE WALKING DEAD

However, while all these feelings are valid – and there must surely be at least some tickle of a mortal thrill among celebrants from time to time – **fear and loathing** is avowedly not the intention of skulls involved in the modern Day of the Dead. Exactly why they acquired their sense of humour around the eighteenth or nineteenth century, given their stern and sometimes **savage history**, is an ethnographic riddle; but they're here for the party now, just like everyone else.

To prove this 'party' point it's helpful to recruit the rest of the **skull's bony crew** to provide a little context. The Day of the Dead isn't just concerned with the head: the body joins in too. Skeletons are a major part of the celebrations, offering an even more clear sense of the **mirth and mischief** that runs through the proceedings.

These skeletons are sometimes referred to as *calacas*, a **colloquial Mexican term** for 'skeleton' (it can also refer to skulls). The informal nickname hints at their status as **objects of merriment** around the Day of the Dead, and also perhaps at the wider relationship some Mexicans have with death: a popular phrase referring to a recent death is *se lo llevó la calaca* meaning 'the *calaca* / death took him'.

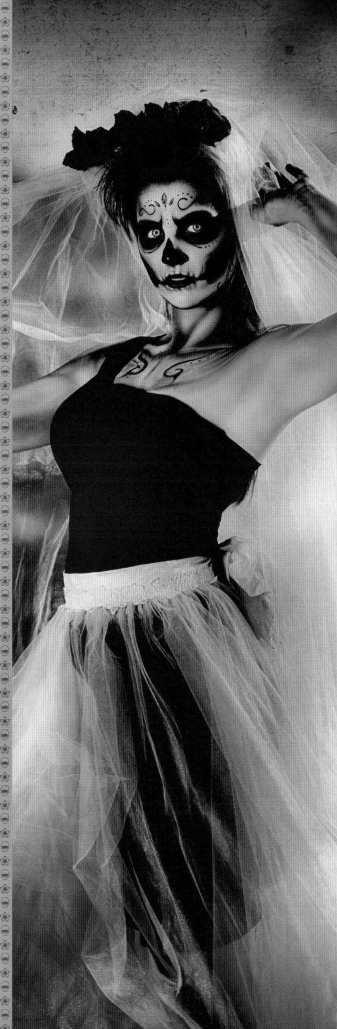

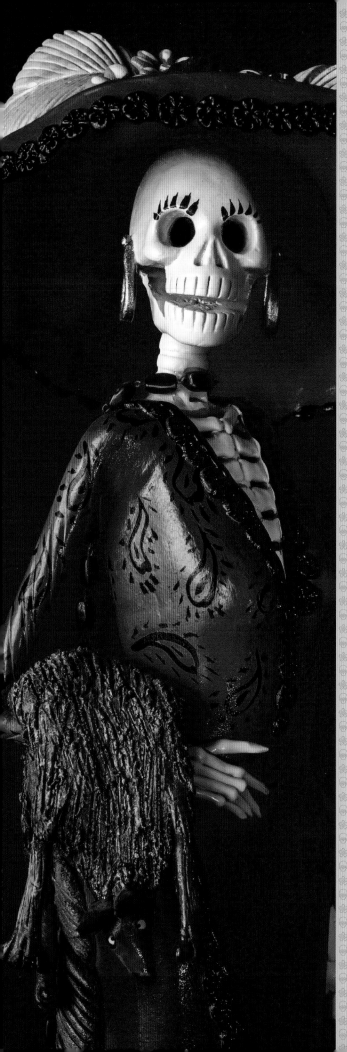

THE SKELETON AT THE FEAST

Skulls and skeletons do not ordinarily form part of the funerary art around **Mexican tombstones**, graves or cemeteries. But they definitely take leading roles on the Day of the Dead, appearing in their jocular form for this one occasion throughout the year. Like **flying reindeer at Christmas** in the US or UK, they presumably spend the rest of the year slumbering somewhere else.

Come the end of October though, they burst into the streets. The *calacas* can come in different guises: some are little wooden or **clay toy figures**, often with articulated limbs, which are given to children. Cardboard versions also spring up alongside skeleton masks and even costumes, as well as **papier-mâché models** of all shapes and sizes, from the diminutive to the life-sized.

They have many functions. Some **modern folk art** versions are created for galleries, while others go to market for the everyday revellers to enjoy. Others lounge around as part of the *ofrenda* (perhaps mirroring the form of the souls they are calling home – a **skeletal barber** for a barber's soul, and so on) or form displays created for the Day of the Dead. In the past, cane and paper skeletons were carried from house to house in some regions, to aid with the collection of alms and **food offerings**.

PRE-HISPANIC SKELETONS

Others appear as designs painted on to shop windows, often bakeries, bickering and capering as they draw attention to the *pan de muertos* on sale. They are not limited to human form: you might see skeletal dogs accompanying their **bony masters**, for example, yapping for scraps.

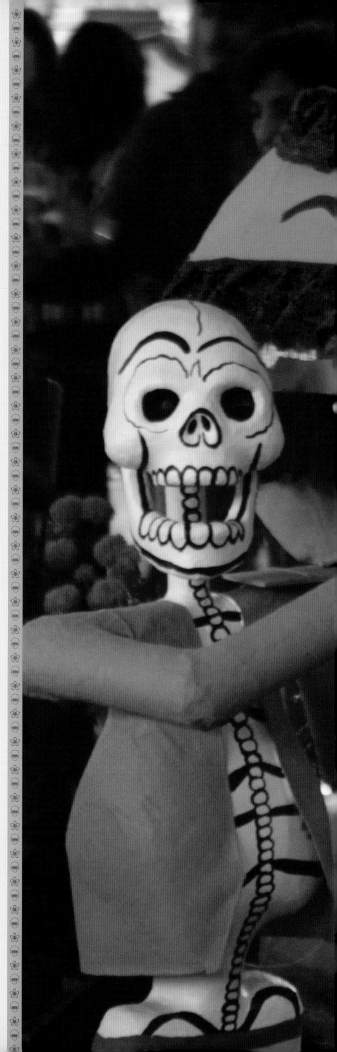

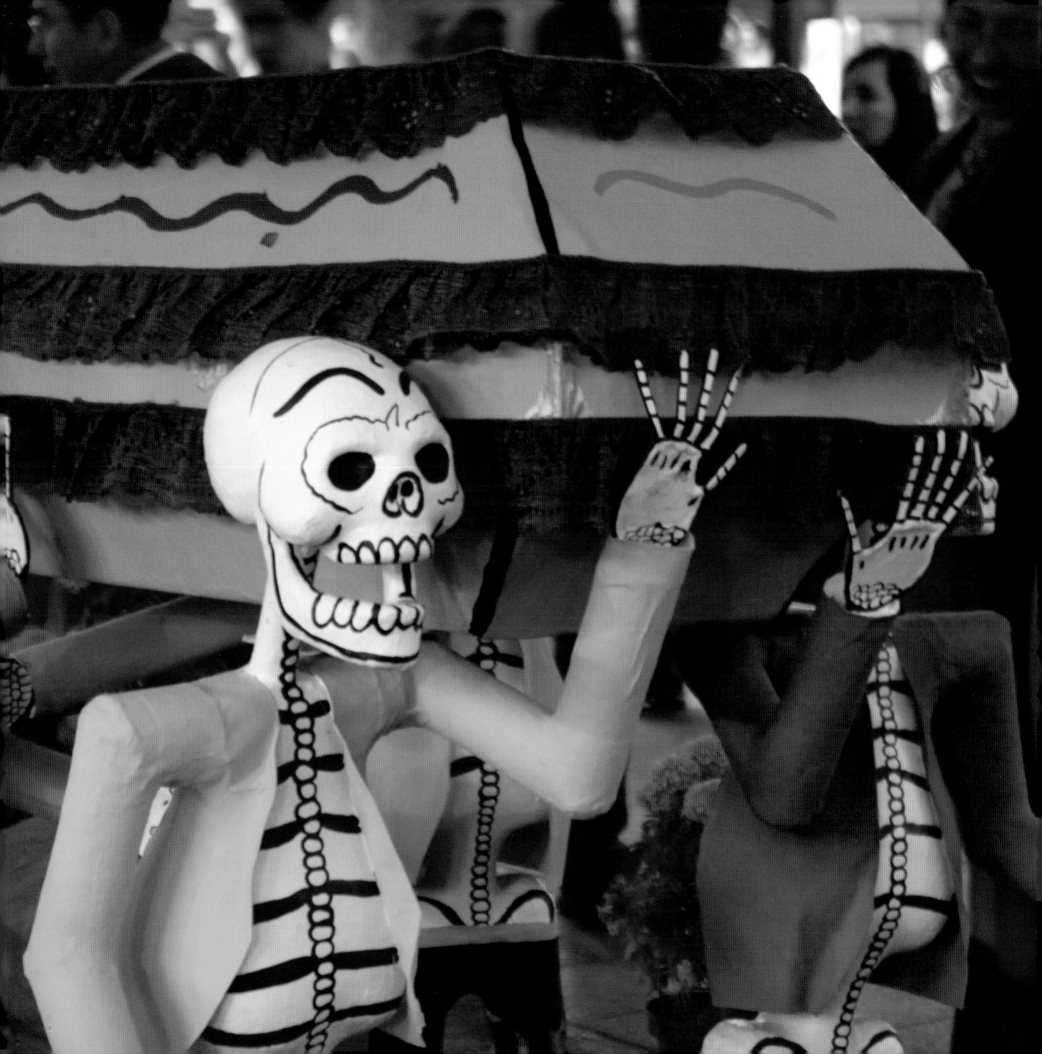

Staying with the food theme, other edible **calacas** spring up – literally – alongside the sugar skulls. They appear in **miniature sugar coffins**, lying down, but can be quickly animated by a little thread that will make them sit upright, **grinning away** at the world.

These jovial sorts are far removed from the early examples of skeletons to be found on surviving **Mesoamerican architecture**. Skeletons decorate Classic-period ball courts, carrying with them multiple associations with death from the figures themselves, but also the events that would take place on the courts. Different versions of the Mesoamerican ballgame were played over time, but more formal games are thought to have included **ritual human sacrifice** (and you thought squash was brutal).

Elsewhere, stone panels carved by the Maya show **grimacing skeletal figures**, while skeletons make regular appearances on Aztec pottery. There is no trace of the humorous **calaca** here: these are highly symbolic renderings forming just one part of an all-encompassing iconography of death, intended to remind humanity of its obligations to the gods and of the **necessity of sacrifice** in order to maintain life.

EUROPEAN INFLUENCES

Skeletons were not the only visual device employed to **represent death** in Mesoamerica and the same was true in Europe. But they were nonetheless a **significant presence** and appeared regularly in European art during the baroque era, which spans a similar period of time (*c.*1600–*c.*1725) to the beginning of the Spanish colonial period.

Some of these **skeletal forms** bore clear messages for the living. One anonymous copperplate print from around 1570, titled *Mors ultima linea rerum* ('Death, the final boundary of things') features the profile of a skeleton, **mouth wide open** as if shouting from the plate. Flanked by hourglasses and more skulls – further **vivid reminders** of mortality – the skeleton is accompanied by an inscription from **Saint Prosper of Aquitane** (*c.*390–*c.*455) reading: 'Consider yourself, that you are mortal, that you are earth, and **into the earth you shall go**.'

This lofty composition is a far cry from the cheeky *calacas*, as are compositions such as the 1643 oil painting *Vanitas Still Life with a Bouquet and a Skull* by **Adriaen van Utrecht** (1599–1652). It also features a prominent skull and hourglass, as well as a laurel wreath, balancing the **fleeting pleasures** of life with the inevitable triumph of death.

THE DANCE OF DEATH

While European (and more explicitly Spanish) cultural practices – offering food to the dead, a Catholic ritual – may well have influenced the Day of the Dead as we know it, it's hard to see **similar echoes** of this kind of **European art** in any of its customs.

However it's much easier to draw parallels with the *Danse Macabre*, or 'Dance of the Dead', which existed in European art from the Middle Ages onwards. The clue is in the name: a typical composition would include skeletons, representing death, cavorting around the living. They may be depicted as **playing instruments**, **bearing scythes**, grabbing at the hapless mass of humanity around them, speaking to them, and generally leading them in a **grotesque, mocking waltz**.

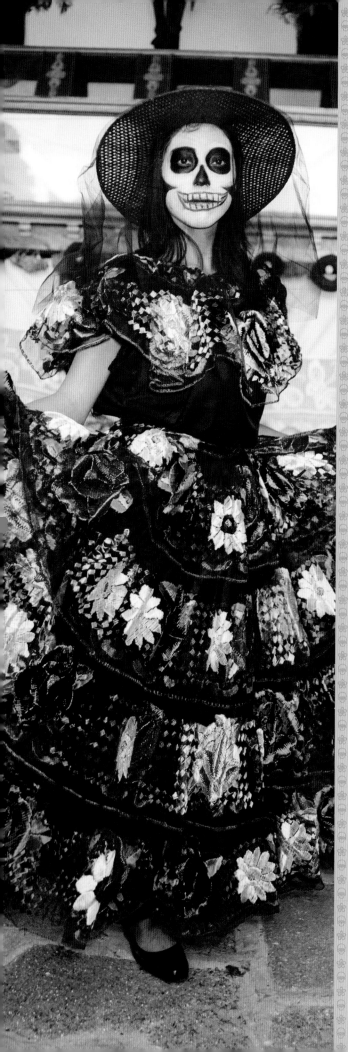

Particularly famous examples come from woodcuts produced by **Hans Holbein the Younger** (1497–1543). Published in 1538, they show death intervening in the daily lives of people from all levels of society. The skeleton displays **remarkable liveliness**, dragging souls irresistibly away with an undeniably comic gait. If not for these figures we would not see the inanimate horror of skulls and skeletons in other **baroque art**: they have a motion and energy that seems to have much more in common with their **bony brothers and sisters** taking part in the Day of the Dead.

THE GREAT LEVELLER

Death in the *danse macabre* is not a picky character: the skeleton is shown taking **popes, paupers, kings, nuns** and everyday folk, illustrating once and for all the indiscriminate nature of mortality. The end will come to all of us, at which point our **petty concerns** for this world will be revealed as futile, even though they will likely remain appealing right up to the moment of death – such is human nature.

The world into which the **dance of death** first whirled in the Middle Ages was well acquainted with the reaper. In an age of plague, high infant mortality, poor understanding of **medicine, war and famine**, death was the only constant companion; little wonder the *danse macabre* proved such a popular formula with artists.

There are no clearly analogous artistic works from **New Spain** that definitively show the influence of the dance of death on the Day of the Dead, at least in the colonial period. However the humour present in the various examples throughout the ages makes it tempting to see

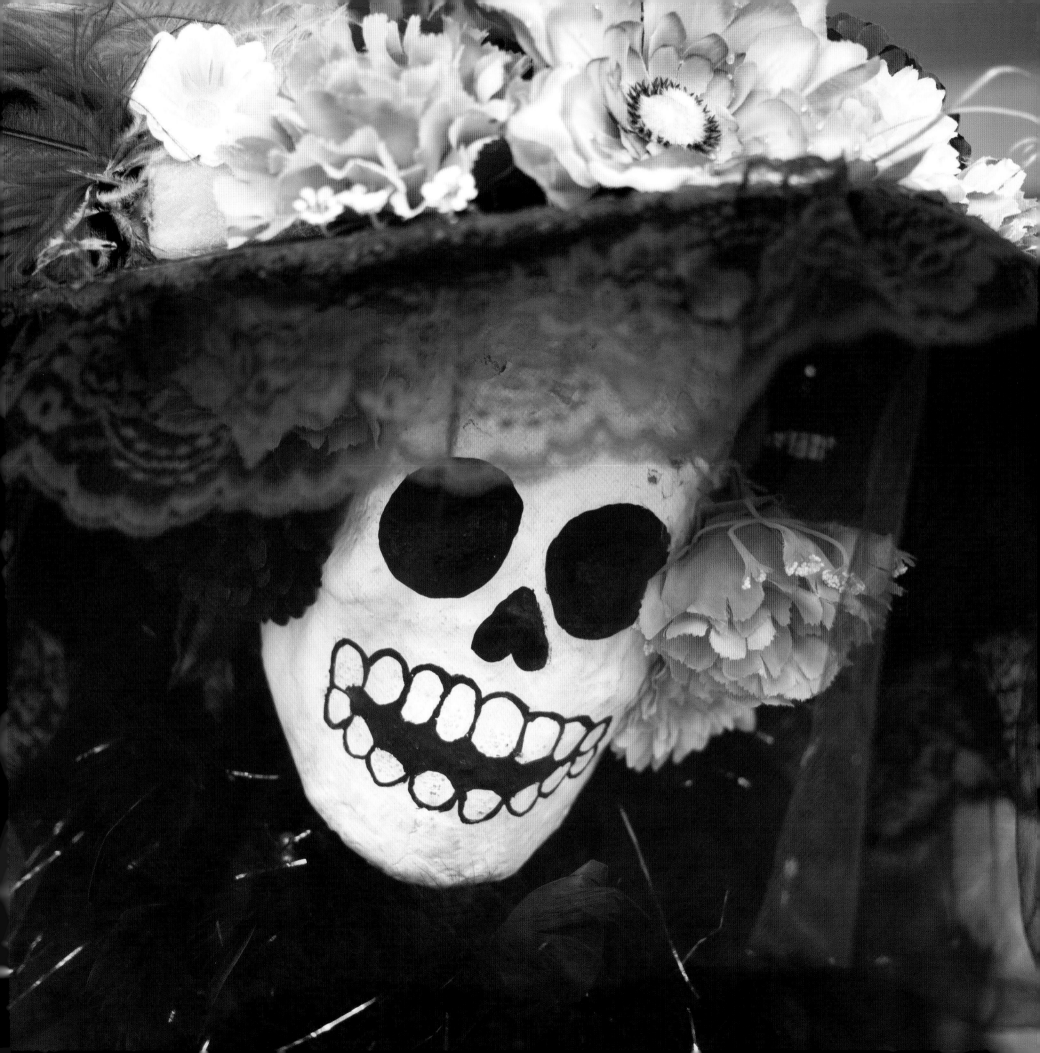

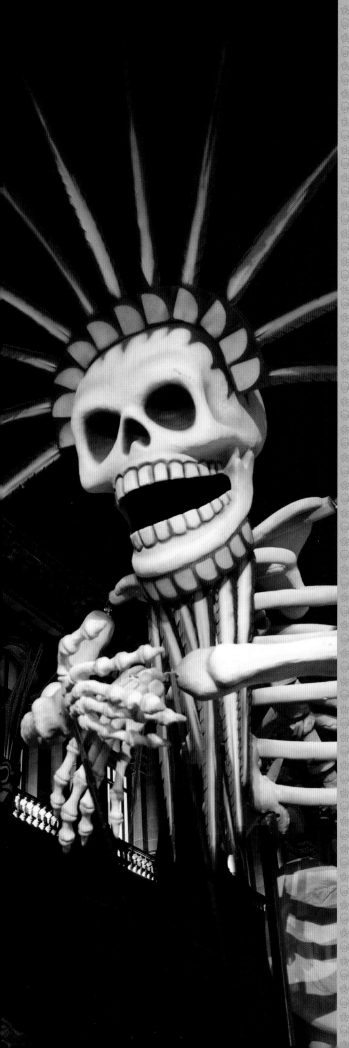

it as at least a forerunner of today's *calacas* – Holbein's work could easily have crossed the Atlantic and made an impact on popular art, difficult though it may be to measure that impact.

HOLLOW LAUGHS

In one important respect, the skeletons seen during Day of the Dead celebrations differ from those of the *danse macabre*: they exist purely in their own **realm of bones**. These *calacas* do not intrude into our world, and they certainly do not carry us from it. Whether they appear as illustrations, models, pottery toys or candy treats, the skeletons live in an **alternative reality** populated only by other skeletons.

Rather than interacting with us, they in fact replace us, to comic effect. We see **skeletal monks, judges, taxi drivers** … all human life is there, only rendered in bones. The inherent absurdity of these figures, grinning as they go about their *calacas* business, removes any trace of morbidity and instead makes them **quixotically funny**, their errands **strange and silly** for those who are dead. Rather than mirthful avatars of death laughing at our puny lives, the skeletons themselves are the objects of fun – we are invited to **laugh at death** for once.

The trend for humorous skeletons was well established by the mid to late nineteenth century. As an interesting counterpoint, to show how differently death was being treated elsewhere, an 1851 German engraving from **Alfred Rethel** (1816–59) was entitled *Death the Strangler*. It shows a malevolent robed skeleton, Death, mockingly **playing a bone as a violin**, as the living flee in terror.

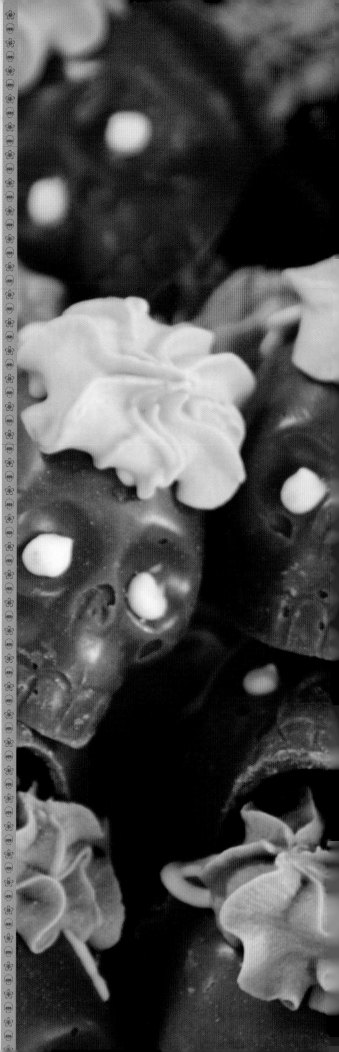

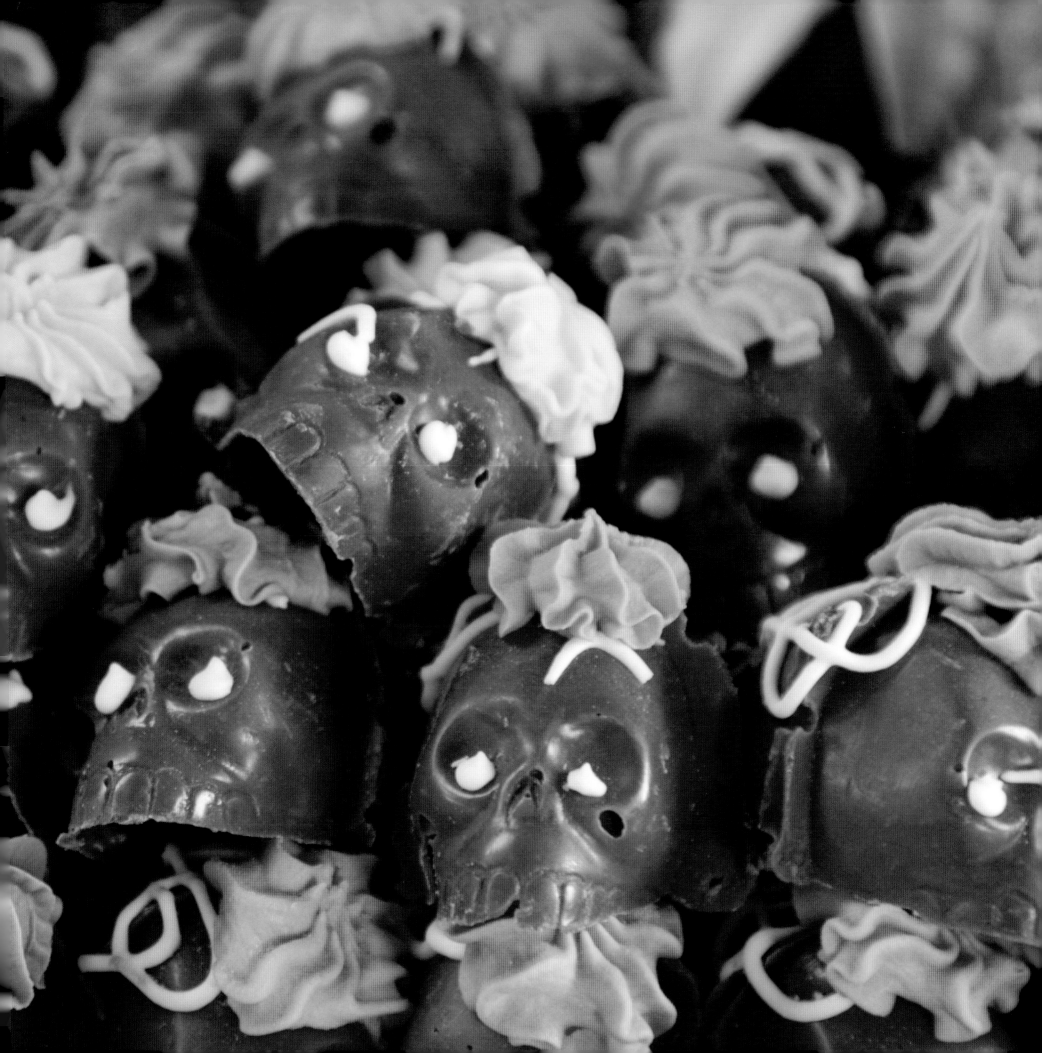

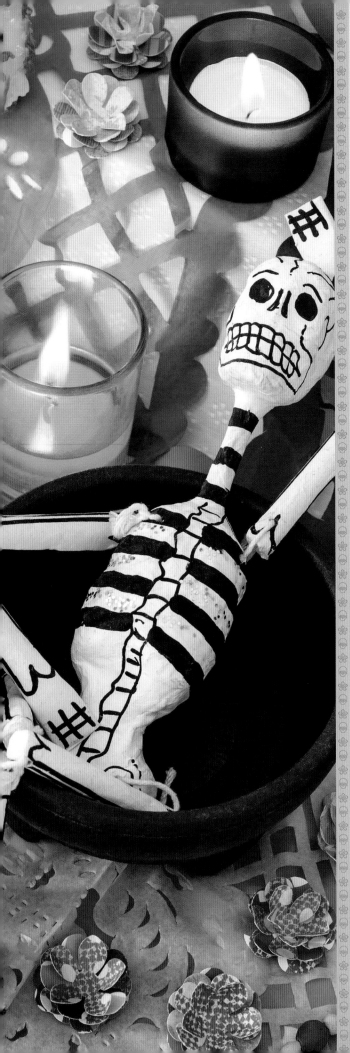

PAPERING OVER DEATH

Far better perhaps, to spend some time being amused by the antics of the Day of the Dead's *calacas* than the forbidding death imagined by Rethel (an image that so disturbed the artist's friends that he created a second print, showing a more **benevolent death** coming to peacefully claim the soul of an old man).

As well as their 3D formats and appearance in illustrations or **window paintings**, skeletons are regular fixtures of the tissue paper (*papel picado*) banners made for the Day of the Dead. These are as much a kind of folk art as sugar skulls and are a relatively **recent tradition** compared to the potentially pre-Hispanic roots of some Day of the Dead practices, arriving within the last 150 years or so according to some of the artisans interviewed by Carmichael and Sayer (*The Skeleton at the Feast*, 1991).

The banners are hand-cut from an original template, sometimes using hammers and specialized chisels (*fierritos*) to punch holes through the paper. When completed they are both **bold and intricate**, the look closely resembling linotype prints – but of course existing in a single perforated sheet of fragile tissue. Designs might show *calaveras* and their lively decorations, or *calacas* going about their business, and may be cut into plain white paper or **a host of bright colours** before adorning homes and altars.

THE FUNNY PAPERS

Paper played a further significant role in the development of the Day of the Dead's personality in the form of **subversive journalism**. From the moment

DIA D
MUE

Mexico gained its independence from Spain in 1821, the more relaxed rules around publishing allowed for the creation and distribution of **political satire** on a scale that was previously impossible. New **printing techniques** and improved processes also contributed to the written revolution.

Mexico's first illustrated newspaper was, appropriately, *El Calavera*. First published in 1847 it ran for just 31 editions before it was **suppressed by the government**, but in that time the public had developed a taste for the concoction of drawings, essays and satirical articles – also known as 'broadsides' – the paper had served up.

Responding to this demand, journalists would create their **satirical ballads** (more on them to follow) and sell them at fairs, markets and other public occasions. Although broadsides – which themselves later became known as *calaveras*, just to make things more confusing – were originally printed throughout the year, over time their appearances became restricted to the Day of the Dead. This may have been a bluntly commercial process: perhaps by restricting access, the creators **guaranteed demand** at a fixed time.

BEGINNINGS OF THE BROADSIDES

There are a few possible points of origin for the broadsides, stemming from **popular art practices** from the nineteenth and early twentieth centuries; all involved publicly addressing someone through a mixture of text and images. One such practice involved dedicating *ex voto* images (from the Latin *ex voto suscepto*, 'from the vow made') to the saints. These depicted events such as accidents or disasters being averted by divine intervention

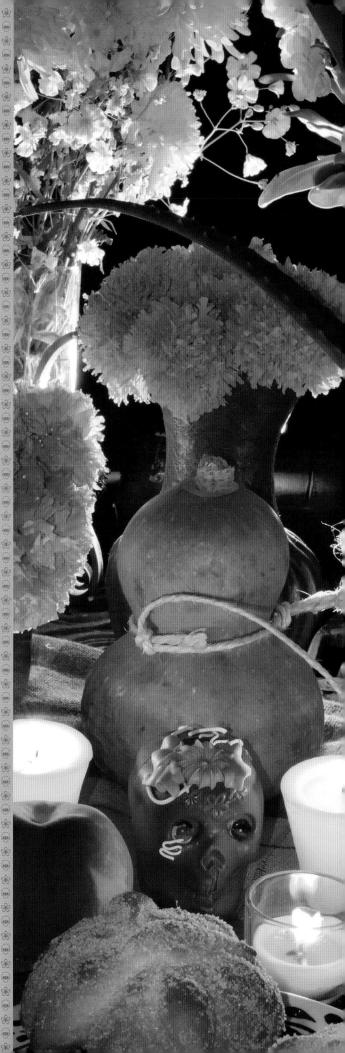

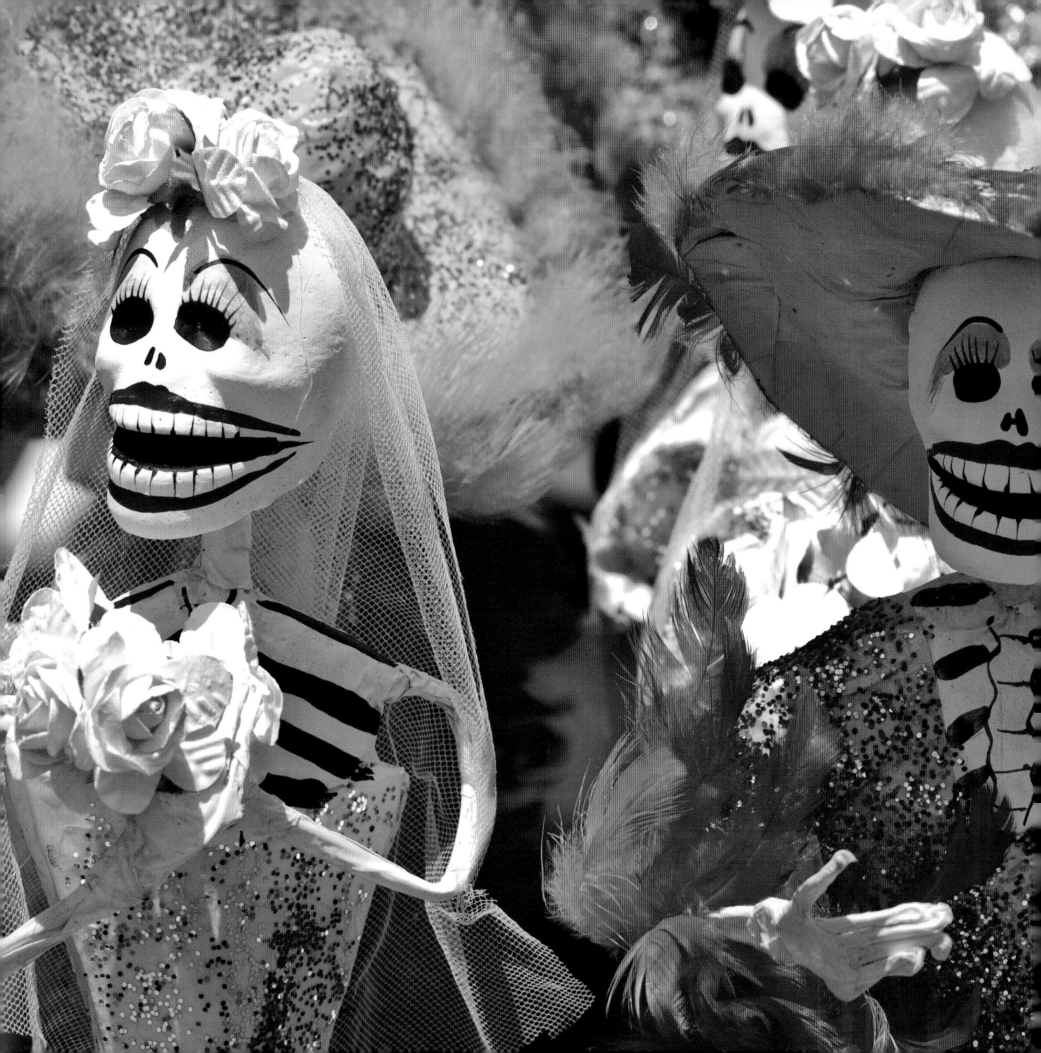

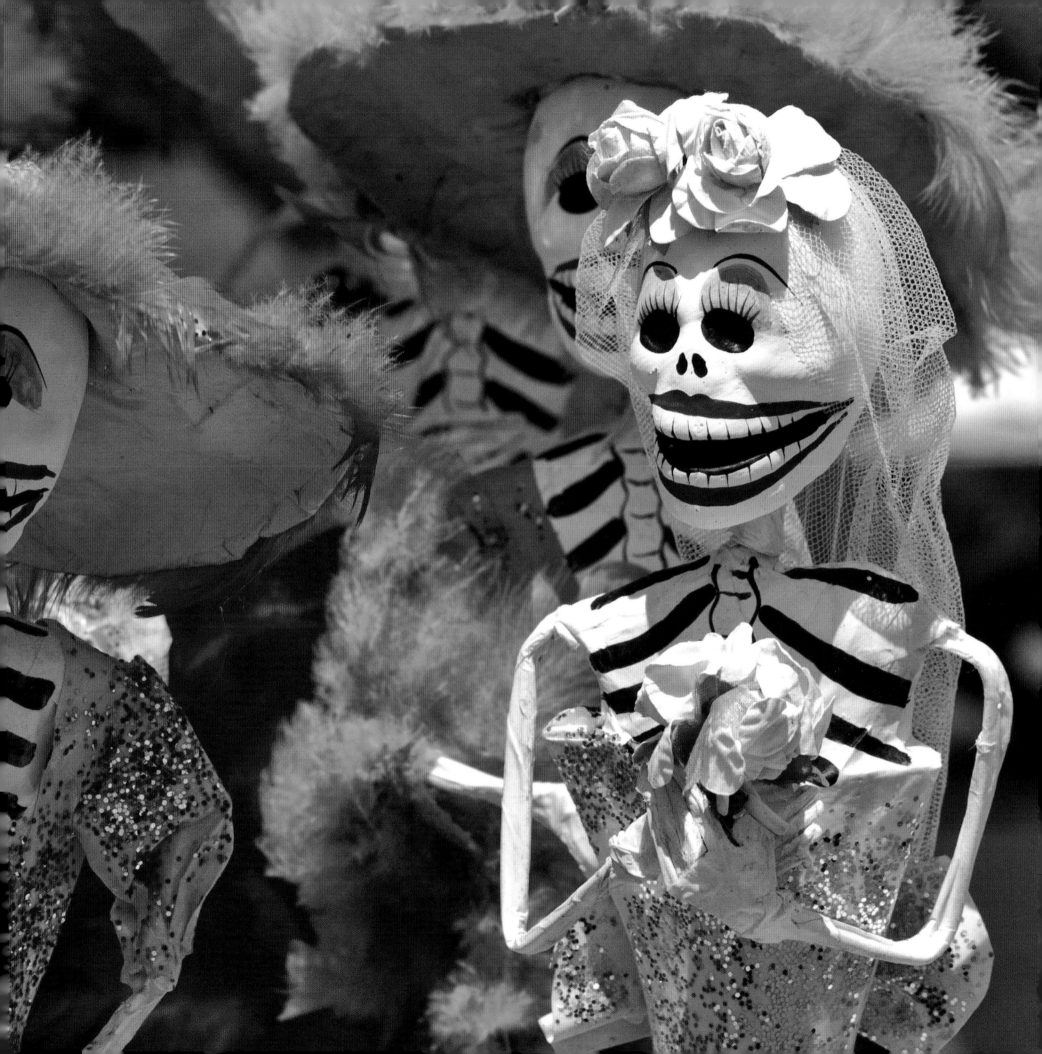

and were painted on cheap metal panels (such as tin), along with some devotional text from the supplicant, offering their **gratitude to God**.

In Spain, a trend for **satirical epitaphs** – written about the living, supposedly by the dead – grew up in the baroque period. They were popular in the first two centuries of **Spanish colonial rule**, so it's not impossible that they influenced the fledgling Mexican culture. The tradition of lampoons – *pasquins* – seems to have had a more direct impact, however These were satirical pieces pasted up or **written on walls** (a forerunner of street artist Banksy by many centuries), to which others could add comments.

In addition, the twin artistic influences of **European cartoonists** and the skeleton figures prevalent on tombs and catafalques may have combined to offer both an illustrative style and a subject matter for artists composing *calaveras*, all adding to their look.

JOSÉ GUADALUPE POSADA

Satire and skeletons in the form of printed *calaveras* remain a fixture of Day of the Dead celebrations. The beginnings of their development into a significant part of the fiesta can be traced back to *El Calavera* and other popular publications, even though – as seen above – the concept had probably been around in some form before then.

Shortly after the end of the newspaper's run, Mexico City journalist and publisher **Antonio Vanegas Arroyo** (1850–1917) needed an artist to illustrate his topical ballads – the **satirical political blogs** of the mid-nineteenth century. This was an era of low literacy, so accompanying

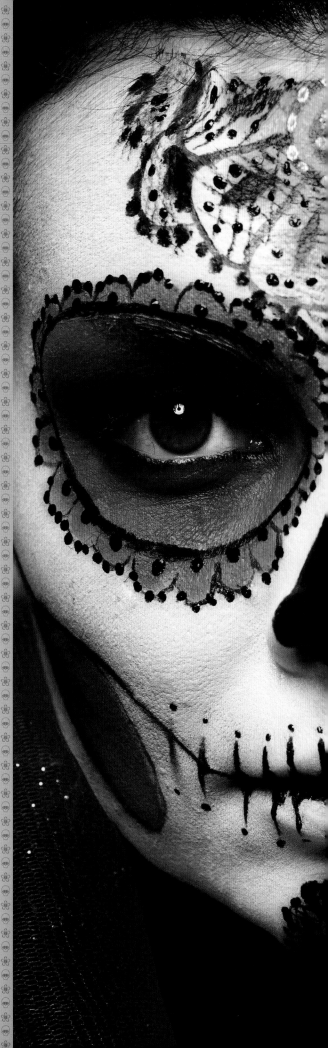

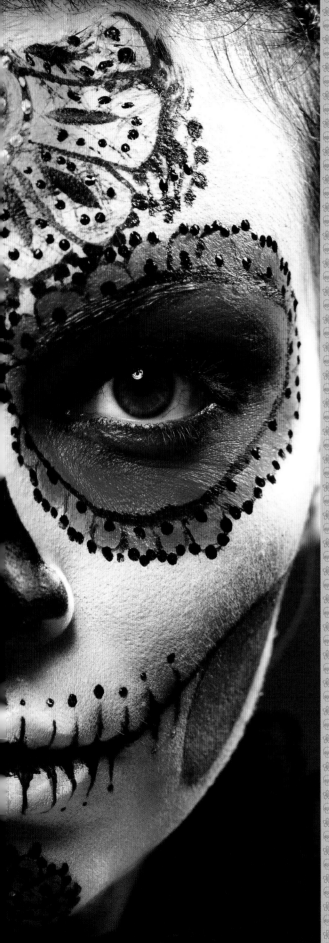

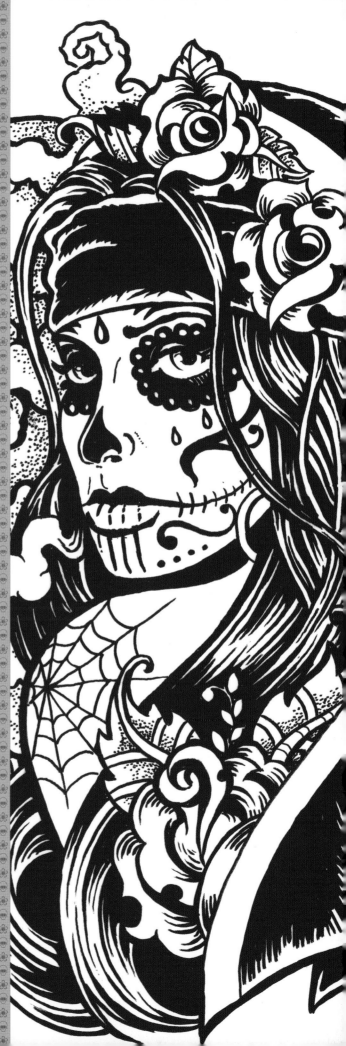

illustrations were important and he turned to artist and engraver **José Guadalupe Posada**, who had previously worked as a political cartoonist, commercial illustrator and teacher, to do the honours.

Posada more than obliged him, creating work of such **merciless satirical accuracy** and insightful social awareness that it has gone on to effectively define and symbolize the revolutionary strain in Mexican art. His sharp wit skewered politicians, church figures, **leading thinkers** and the civic population as a whole, using his own unique spin on the skulls and skeletons of the Day of the Dead.

Although largely unrecognized in his lifetime, Posada's work influenced a generation of artists and continues to do so now – it can be seen in **lowbrow art** around the world as well as imitation **calacas** produced during the Mexican fiesta itself.

FUNNY BONES

Of course **Posada** himself didn't invent the humorous imagery surrounding the Day of the Dead – much of it was already there in the form of sugar skeletons, skulls and so on. But he was the master of telling the joke, dreaming up vivid, **anarchic skeletons** with a crazed energy and letting them loose on the page, surrounded by their skeletal kin.

To the modern viewer there is an almost 'punk' aesthetic to Posada's skeletons, with their flapping feet, **oversized heads** and energetic motion. It's a further example of how far his influence has travelled, making its way into the **street and skate art** canon; even artwork for psychedelic rock legends **The Grateful Dead** features surfing skeletons, who have a distinctly Posada-esque look.

His creations have all manner of themes. In his *Gran Calavera Eléctrica* ('Grand Electric Skull'), a skeleton addresses a **crowd of skulls and skeletons**, and seems to be hypnotizing them with the strength of its oratory – a futile exercise for the dead, of course, and one that could be seen as mocking the efforts of public speakers, such as politicians. Elsewhere, a **calaca** appears as **Old Father Time**, ringing a bell and bearing an hourglass: an image more in keeping with the European tradition of representing skeletons in art, pointing to Posada's own artistic influences.

WHO'S THAT GIRL

Sometime between 1910 and 1913 Posada created a broadside intended to **poke fun** at those among the indigenous population of Mexico who denied their **native ancestry**, preferring instead to imitate European fashion. These people were colloquially dubbed *garbancera*, the nickname giving rise to the title of Posada's etching, *La Calavera Garbancera* (see page 102 for a modern replica).

The picture shows a giddy skeleton wearing a gigantic wide-brimmed hat, which is **topped with flowers**, in the style favoured by upper-class Europeans – and the Mexican women who imitated them – at the time. Posada's intent was to satirize those **denying their true identity** (another futile act as we are all simply skeletons, in the final analysis) and attempting to hide it under a hat: the image works as a specific swipe at Posada's contemporaries, but also as a more general comment on the folly of humanity.

The skeleton in the image has proved to be an enduring creation. Reprinted in the 1930s and retitled *Calavera Catrina* (Dapper Skeleton) it now exists as a visual shorthand for the **dry, mocking wit** synonymous with the Day of

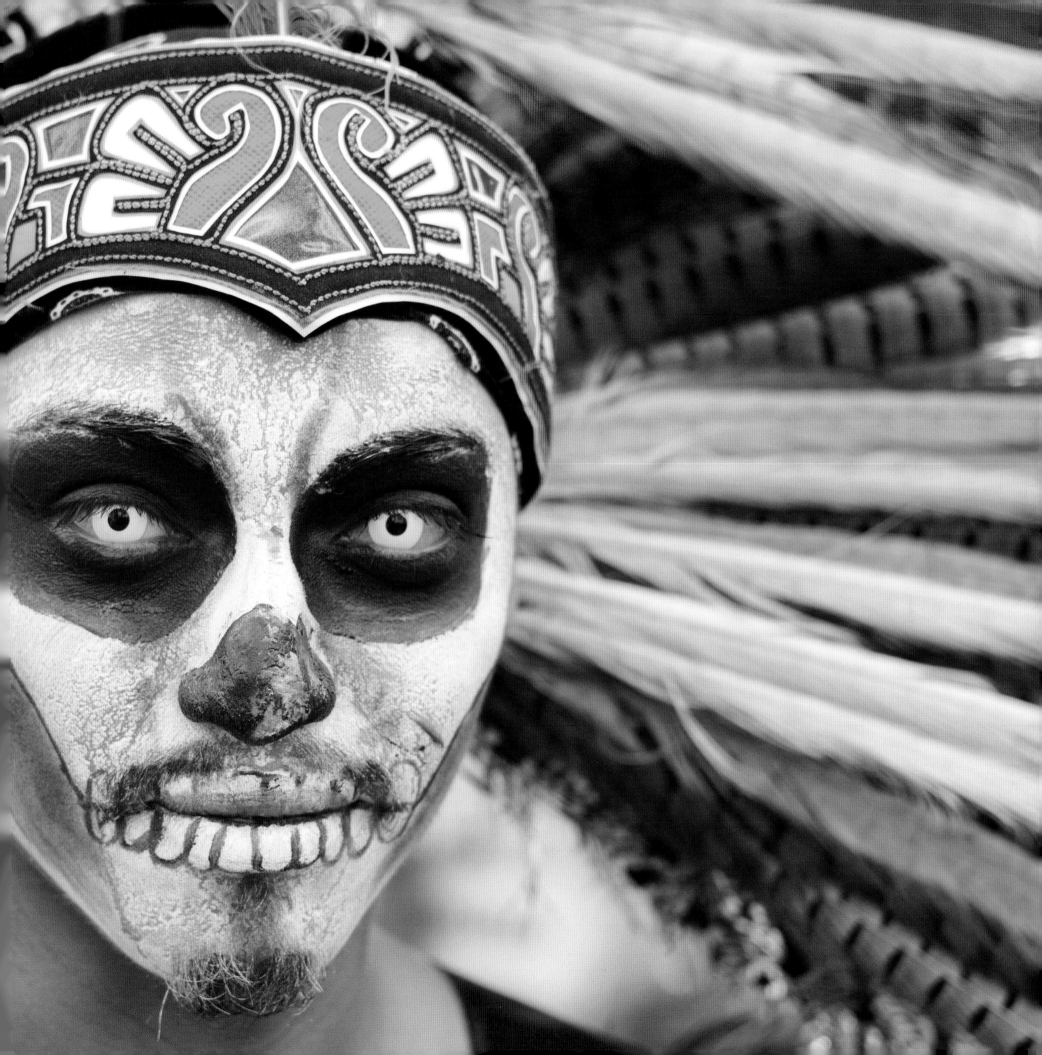

the Dead. Catrina has taken on a life of her own – mainly thanks to her headlining appearance in the **Diego Rivera** (1886–1957) mural *Sueño de una Tarde Dominical en la Alameda Central* ('Dream of a Sunday Afternoon along Central Alameda', see page 120) – strolling through processions, recreated in toys and models and forming an **integral** part of the imagery of the fiesta.

SERIOUSLY FUNNY

Humour around the Day of the Dead is **big business**, particularly when it comes to the literary *calavera*. They remain a popular part of the proceedings and are **consumed enthusiastically** by a (largely urban) readership that is now far more literate than the populace would have been during Posada's lifetime. Written forms of the *calavera* – poetic incarnations in particular – cluster around the Day of the Dead in the calendar and tend not to be seen for the rest of the year.

Consequently when they arrive, there is money to be made (the irony of commoditizing an art form created to expressly criticize worldly conceits like **commoditizing art** is probably not lost on anyone). The *calaveras* carry advertisements as well as their satirical pieces, which in the twenty-first century tend to favour the written word over drawings, and are widely read.

Elsewhere there are *calavera* competitions, the traditional **broadsides, newspaper articles** and more, all targeted at current events, those in the public eye, or even casting a wry gaze over the events of the Day of the Dead itself, gently reminding participants of the **imperfections or inconsistencies** of an occasion that is above politics yet deeply political, unifying yet also **potentially divisive**.

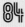

TOWN AND COUNTRY

Inconsistencies come from the fact that there is actually not one Day of the Dead. There are certain universal themes and **visual motifs** that percolate through into the modern cultural consciousness as signifiers of the occasion – *ofrenda*, sugar skulls, *calacas* – but within Mexico itself those component parts vary a great deal.

Some of this is down to the disparity – observable **anywhere in the world** – between life in the city and life in rural communities. Urban celebrations of the Day of the Dead may be more **boisterous**, while those in some parts of rural Mexico could be more circumspect, for example.

There are also **huge differences** from region to region, not just in the way the Day of the Dead is observed but in the specific blend of belief and custom that drives those observances. Specific views of the **afterlife** and where the souls have returned from may vary, or the extent to which spirits are truly present to **consume the offerings** of food and drink.

There may be differing views on the consequences of failing to offer enough to the **souls of the departed**, too. Many community legends predict dire outcomes for the forgetful – usually ill fortune or death – and people see the Day of the Dead as a **ritual obligation**; others observe it more out of tradition and custom than because of a sincerely held belief.

LAUGHING MATTERS

Similarly, it's important to distinguish between the humorous tone to community life around the Day of the Dead and

attitudes to death more generally. While the Day of the Dead may have given rise to an idea of a national identity that chuckles in the face of death, contemporary accounts of **Mexican funerals** show that this attitude has its limits. Funerals themselves are solemn and enrobed with sadness, just as they would be in communities anywhere in the world.

Naturally there will be laughter on such occasions. Levity and humour are essential human coping mechanisms that we rely on to navigate the **complex emotional labyrinths** of our funerary rites. They are the thread that helps to guide us, hopefully avoiding the **Minotaur of despair** that snorts and **prowls around the grieving**.

The humour of the Day of the Dead is quite separate to this. Again allowing for significant **regional variation**, it is not aimed at the departed. They are remembered affectionately and their return visits are a cause for celebration; although some **wisps of grief** must surely be allowed to drift among the photos and the altars, with much effort put into their comfort. Generally, the dead are not being laughed at: it is the living.

WORDS AND WIT

We've already seen some of the ways in which **playful teasing** goes on between the living on the Day of the Dead. Artistic skeletons send us all up, **mocking our pretences**; sugar skulls with our names on banter with us about our eventual demise, while giving us an **easy way out** (namely, by eating them); we can enjoy toys and trinkets shot through with quirky humour

The written **calavera** provides another way to tease and taunt one another. It can be a different, sharper kind of

Day of t

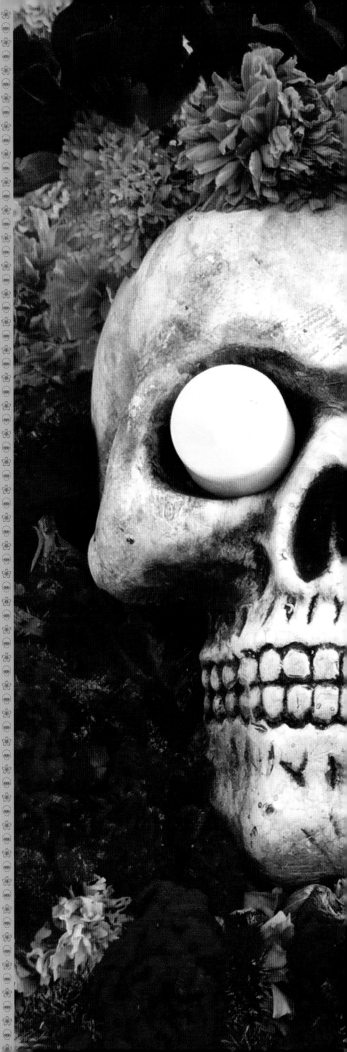

humour than the gentle ribbing between friends and family, but the Day of the Dead, as we know, is easily elastic enough to accommodate these differences.

Not that the written word is entirely unkind. One custom is for friends and associates to write **mock epitaphs** for one another as if they are already departed. Harsh though this initially sounds (especially to more reserved British or US audiences), the intention is to proclaim the **strength of a relationship** by demonstrating that it can take such mockery in good grace; perhaps similar to the way in which a Best Man's speech at a wedding is born of affection for the groom, however **cruel or mocking** the content.

EQUAL WRITES

Such **calaveras** may be presented in person and bear the name of their intended 'target' as their title. Other, more political pieces, may be **published anonymously**, however, to protect the identity of their creator – a prudent tactic from the turbulent political past of Mexico that has endured to the present day.

Some positive pieces are published for general consumption, too; the **fake 'epitaphs'** intended to highlight the regard felt for the target. One example was dedicated to journalist and author **Elena Poniatowska** (born in 1932, and still very much alive at the time of writing), in praise of her abilities: *The hairless one [Death], although with rheumatism is still able to read – she left us without the agile pen of Elenita Poniatowska. (El Metiche, 1995)*

Here, it is the 'agile pen' that is worthy of praise, the diminutive 'Elenita' a **term of affection** that underlines the good intentions of this **calavera**

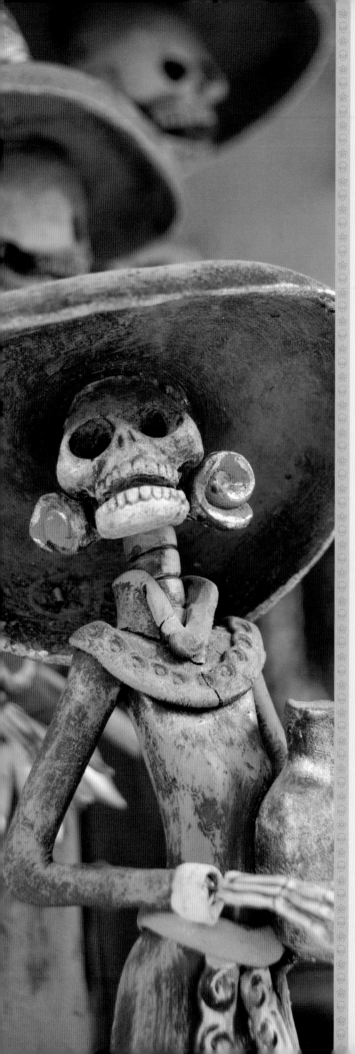

Other examples take on more metaphysical themes and use the medium of the *calavera* to address topics such as the **inevitability of death** and its levelling effect on every stratum of society. A verse from an anonymous *calavera* from 1905 (quoted in Brandes, *Skulls to the Living, Bread to the Dead*, 2006) writes of death:

In mixed-up confusion
Will be the skulls,
And even the straw mat makers
Will enjoy the occasion.

In this widening world
Gold perverts everyone
But after death
There are neither classes nor rank.

PROTEST PAPERS

This theme of death as an **equalizing state**, removing all arbitrary notions of class, runs throughout the Day of the Dead and in the literary and poetical *calaveras* in particular. And while a *calavera* can be friendly or positive, they're much more likely to be critical or come from a place of protest – although hopefully in a **peaceful way**, in keeping with the spirit of the fiesta.

Birthed in a period of turmoil – a **war for independence** followed by the **revolutionary period** (1910–17) – it's hardly surprising that this literary form would sing songs of resistance. In the twenty-first century the *calaveras* continue this tradition: while there is no war, displeasure and cynicism towards those in power certainly rumbles on.

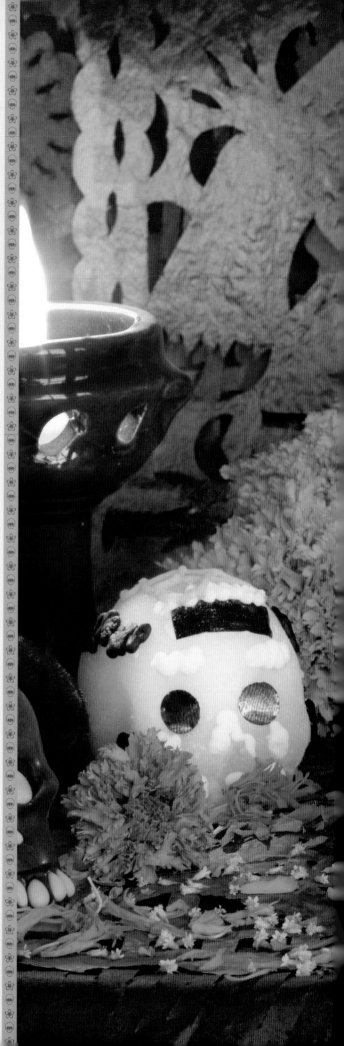

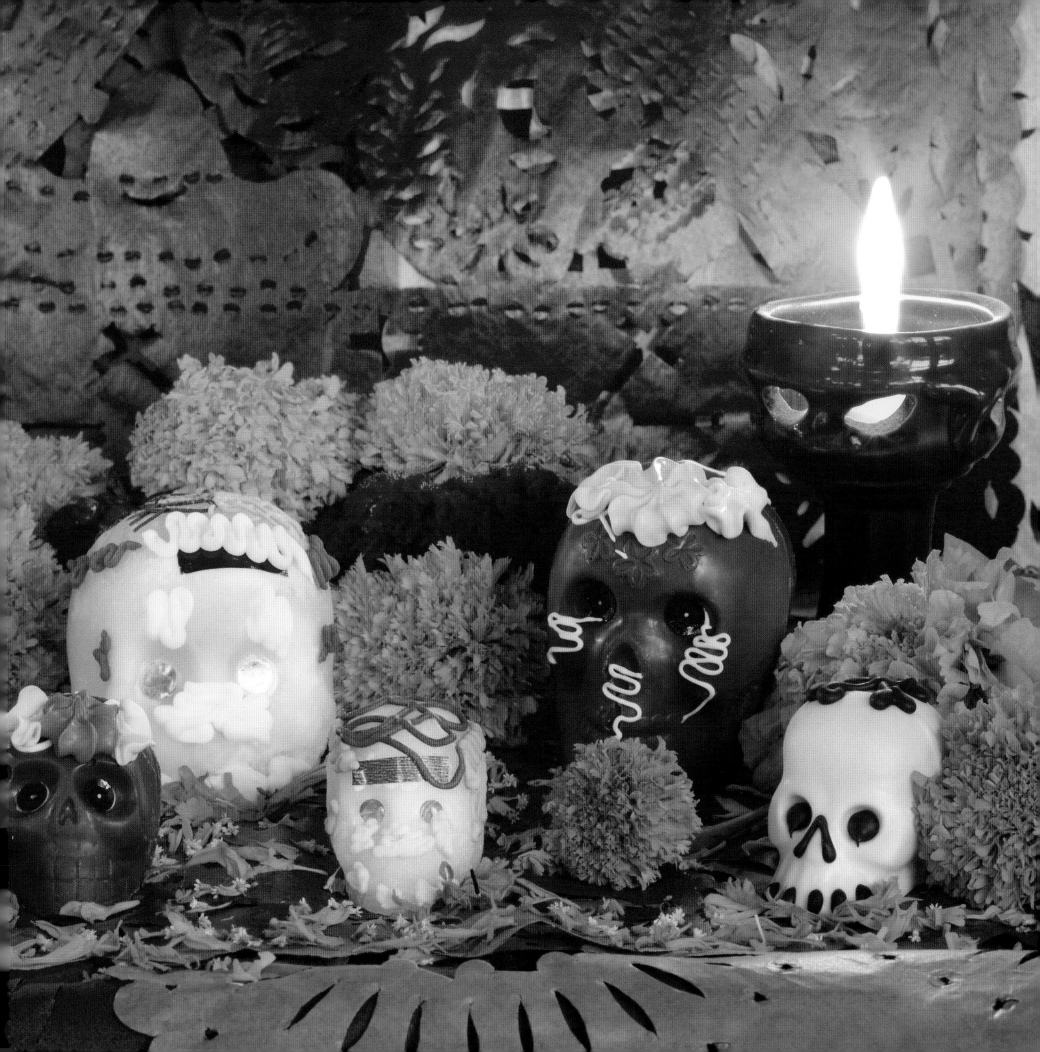

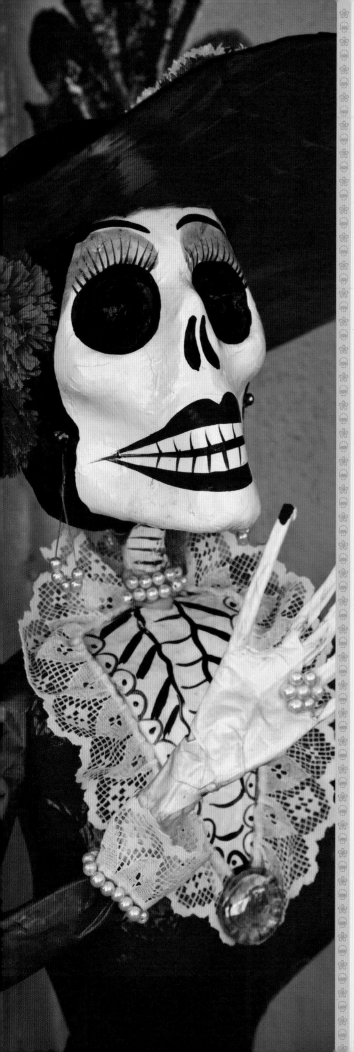

For instance **calaveras** published around the elections of 2000, which saw the government fall amid a cacophony of **corruption and scandal**, were unsurprisingly merciless. Of the outgoing PRI party, one epitaph noted: 'It was the great important party ... It was taken away by death.' Whether taking down corrupt politicians or **slyly mocking** the flaws of celebrities, Death is a constant in the **calaveras**, as a concept and as an anthropomorphized character. During the festival death *lives*: participating, dancing and being engaged with. All to remind us that death, after all, is only **another stage in life.**

IN BLOOM

For the **Japanese samurai death** was a similarly ever-present companion and a part of the process of life. To symbolize the **transience of existence** in this world they used the image of the cherry blossom, fleetingly beautiful and swiftly gone; likewise flowers form an important part of the rituals of the Day of the Dead.

Marigolds, both real and paper, are the star **flowers of the fiesta** and their use is believed to extend back to the Aztec and even earlier civilizations. They come loaded with symbolic and practical purpose: the bright blooms are **reminiscent of sunlight** and thus life, while their strong aroma coupled with their colours are thought to be pleasing to the dead, who will be guided to their family's altar by the fragrance.

As well as **decorating the altar**, the blooms are a useful sensory satnav for the souls of the deceased. They are often placed in a trail from the door of the house to the altar itself to help them find their way; there may even

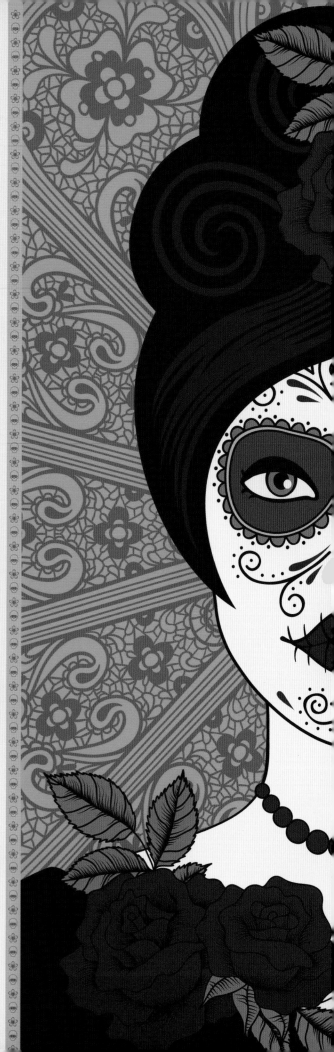

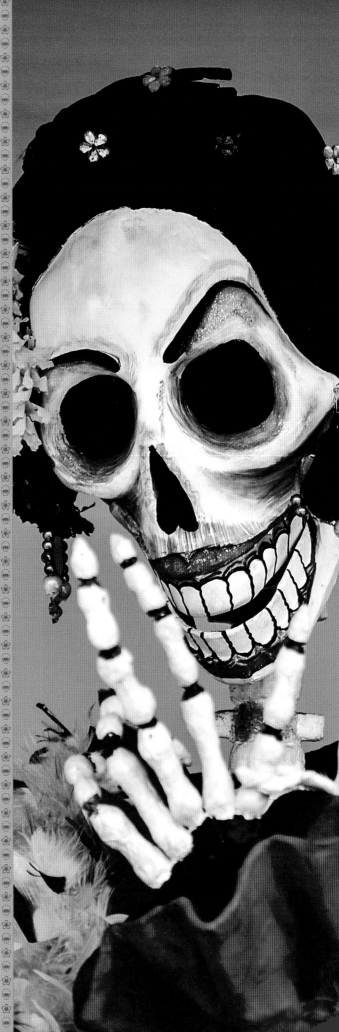

be a trail from the home towards the cemetery to help them return to the **realm beyond**, once the party is over. Nothing worse than the dead overstaying their welcome and getting in the way of the tidying up operation (or more seriously, **tormenting the living**).

FURTHER FLORALS

Other blooms play an important role throughout Day of the Dead celebrations, the red cockscomb in particular. It is often paired with the **marigold** to create **striking red and yellow** altar displays; as its colour also represents the blood of Christ to Mexican Christians, the flower can carry another layer of religious meaning and shows once more the **melding of beliefs** within the fiesta.

White flowers are also important, with the *matthiola incana* or 'hoary stock' offering a sweet fragrance. Native to the Mediterranean coast, its white petals signify **purity or innocence** – as a result, it often features on altars dedicated to children on the Day of the Innocents (1 November). **Chrysanthemums** can serve a similar purpose, but carry further spiritual associations as they are used in abundance for All Souls' Day celebrations in Spain and also at Mexican funerals.

Altars also carry sprays of **baby's breath** to enhance their appearance and may feature arrangements of gladiolai, too, as these are thought to symbolize **remembrance and faithfulness**, making their relevance to Day of the Dead rituals clear.

Combined with fresh fruits and festooned across **decorative arches** (sometimes made of bamboo cane), these floral displays bring the souls to the party and

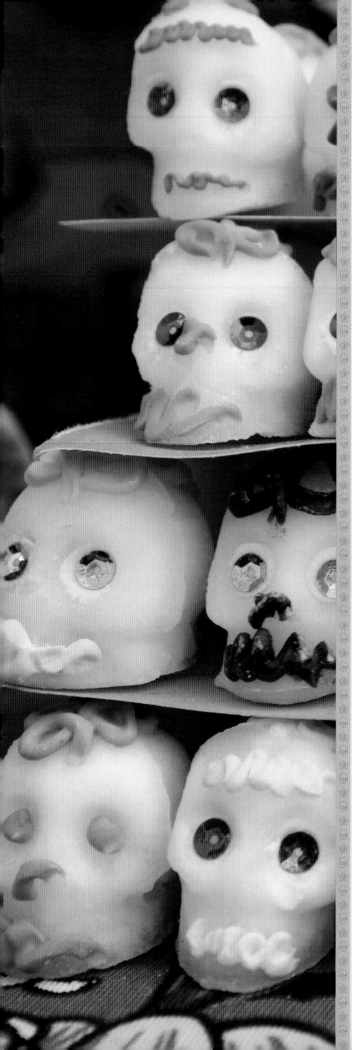
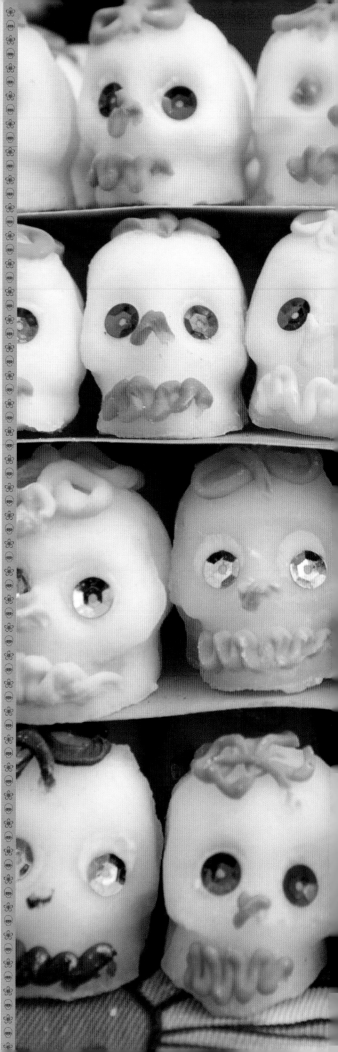

look beautiful in their own right – and of course act as a constant reminder of the abundance and joy of life, rather than dwelling on the shade and solitude of death.

AT THE ALTAR

As the calm centre around which the excitement and energy of the Day of the Dead spins, it's worth concluding this section with a more detailed look at the origin and appearance of the **ofrenda**, the private altar and collection of objects offered to the **returning souls**. As well as flowers, food and candles, the altars can bear many other items, some traditional, some personal.

Photographs fall into both categories. They may depict only the **recently departed** or bring the faces of the long passed to the feast, but they are regular fixtures of altars throughout Mexico during the Day of the Dead. Surrounded by flowers and **flickering candlelight**, it can be hard to see these pictures as not forming a memorial shrine to the deceased. It's also challenging to look at an altar on 2 November even in the midst of a **riot of colour**, and not acknowledge the smallest frisson of spiritual solemnity or even sadness at the passing of a life. Those who have lost a loved one in the year since the previous **Day of the Dead**, in particular, may find their sorrow brought into sharp focus – but the fiesta is a step along the way to coming to terms with their loss.

Ultimately, **light and life triumph**, and the pictures and other items are celebratory, there to welcome the spirits of the dead and make them feel at home and happy during their visit. Personal effects might include toys for children, **favourite photos** and even drinks for adults, but the intent is certainly not to wallow in

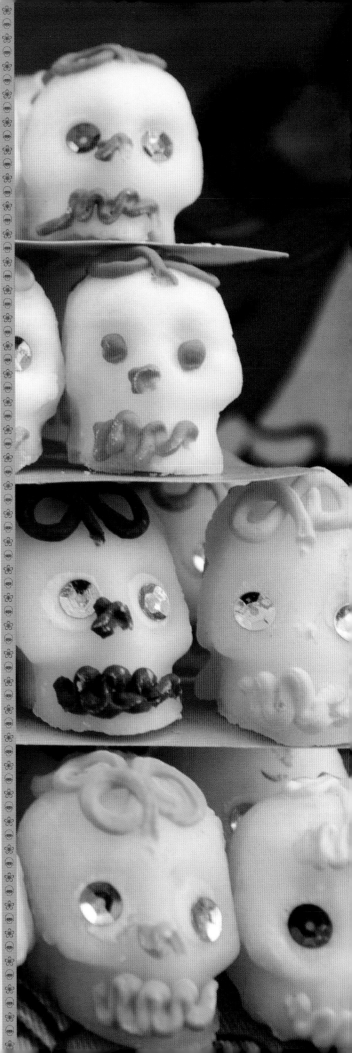

mourning: it's to prepare the house and **spirit guests** for good times.

ALTAR JOYS

With that in mind, the altar may feature a **mirror and washbasin** to allow the returning spirits to refresh themselves on arrival. They may be offered clothes, either ones worn in life or **newly bought**, to dress in. The same applies to the living: while there is no official dress code or **fashion** for the Day of the Dead (although there are elaborate costume balls in some towns and cities), custom in some areas dictates the buying of new clothes for the occasion; in reality this is dictated by household budgets.

The size and shape of the *ofrenda* varies between regions and could be anything from a small table near the home's **permanent altar** to a bier suspended from the ceiling; those in the town of Huaquechula can reach 3.7 m (12 ft) to 4.5 m (15 ft) tall in the high-ceilinged homes of residents. Civic *ofrendas* in public buildings may be enormous and there are contests to choose the 'best' one; families may also prepare altars at the graves of their loved ones.

The use of altars is common to almost all faiths and all nations throughout time; the friars arriving with the Spanish *conquistadores* noted that the Aztec natives made use of home altars, on to which figures of the saints crept as the influence of the Catholic church spread. In Mexico the specific custom of the altar for the Day of the Dead is unique, however, perhaps reflecting the same blend of **pagan and Catholic practices** as much of the rest of the fiesta. Its beauty and bounty is at the heart of this reverential, fun-loving and **generous tribute** to the souls of the departed.

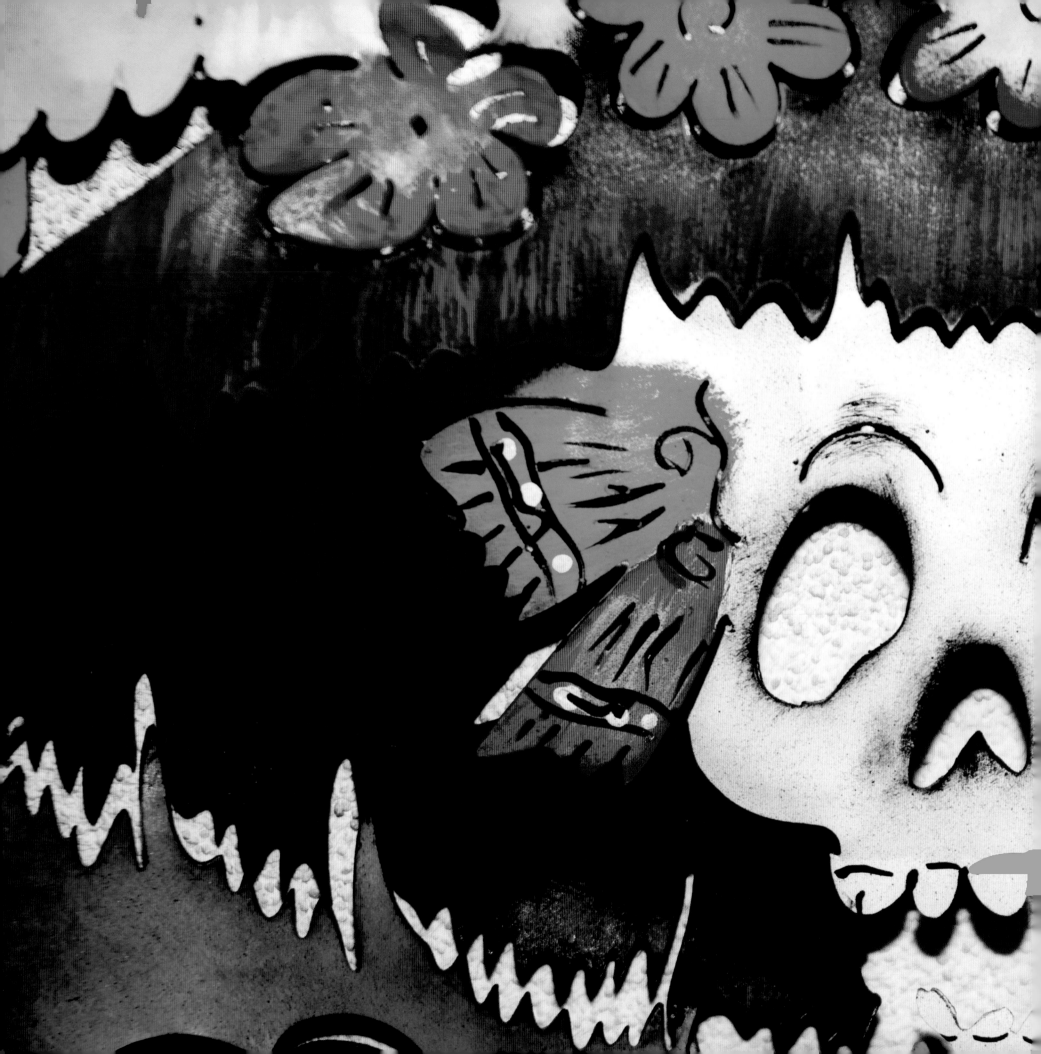

HAUNTINGLY BEAUTIFUL

HAUNTINGLY BEAUTIFUL

This chapter looks at the Day of the Dead as it's represented by and influences contemporary artists. Death and all its friends, it seems, have always been something of a muse for creative souls. The anthropomorphized idea of death can be found in art throughout the ages and arrives in many forms. **Albrecht Dürer** (1471–1528) created a chilling vision of death as one of the **Four Horsemen of the Apocalypse** (c.1497–98): the woodcut imagines him as an old man, **gaunt, wild-eyed and riding roughshod** over the living on an equally wild-eyed horse.

Thomas A.E. Chambers (1724–89) portrayed death as different characters depending on the soul he came to take, as a meditation on the importance of living well as a means to dying well. His works from 1783 show *The Good Man at the Hour of Death* and *The Bad Man at the Hour of Death*. The lesson? Live well and death will come as a **kindly, solemn angel**, gently bearing you away as the hourglass runs out. Live not so well and a hell zombie from the **inky smoke of the pit** will burst into your study and stab you with a giant arrow. So that's good to know.

O, DEATH

Other artists produced more figurative renderings of death. **Barthel Bruyn the Elder** (1493–1555) created a serious-looking *Portrait of a Man* (1533–55) in oils, but went even more serious on the reverse side of the panel, with a melancholy *Skull in a Niche*. The point was to remind the subject of their own inevitable demise; whether the advice earned Bruyn a decent tip is uncertain.

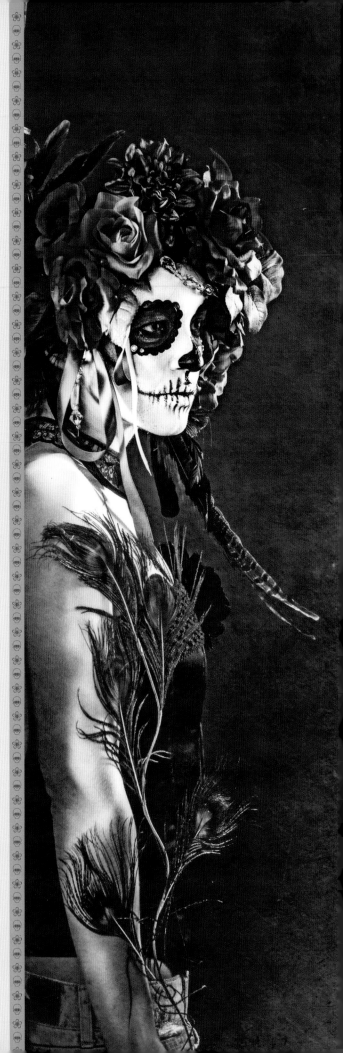

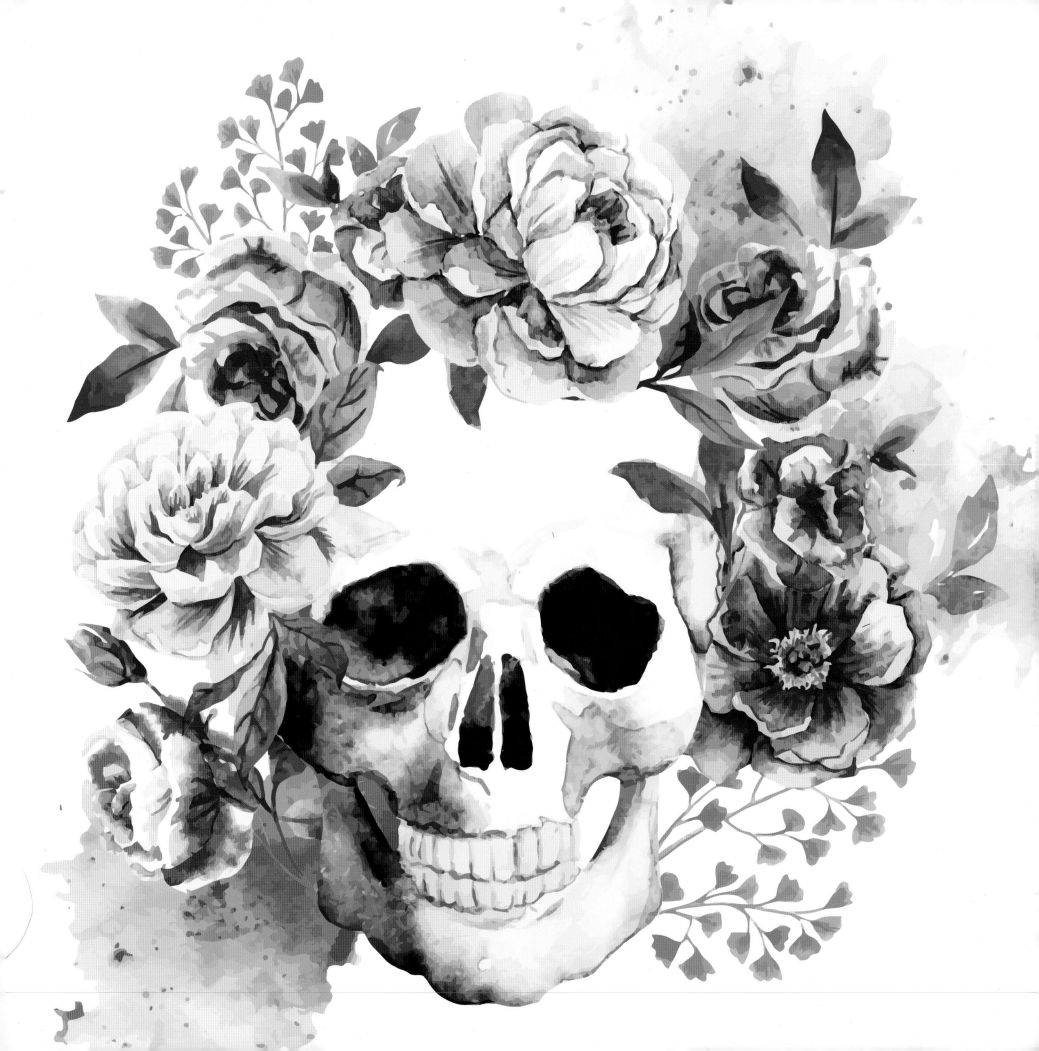

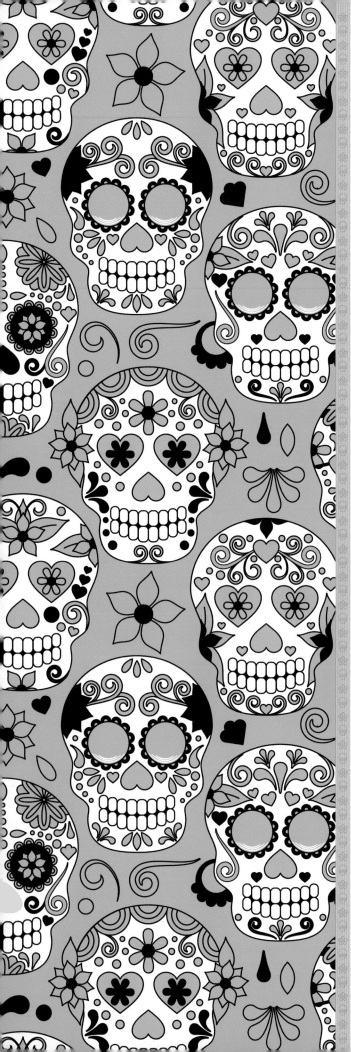

Later artists took a more light-hearted approach. In *Faces of Death* (1958) **George Grosz** (1893–1959) brought some humour to the subject by pasting grinning skull faces over various found photographs. The disconcerting result is **blackly funny**, revealing the universality of death but also teasing the earnest zeal and pointless vanity of advertising and promotional shots, given that death is underneath it all in the end.

František Drtikol (1883–1961) used nude dancers posing with skulls in a series of images (c.1925) to suggest that a life lived physically and intimately in the present could triumph over the constant reminder of death; **Andy Warhol** (1928–1987) stitched together photographs of skeletons (1987), meanwhile, creating a **bony crowd** that reflects a preoccupation with death we can all share.

DEATH IN MEXICO

This brief interlude hopefully shows that depictions of death and dying in art around the world is far from unusual: it's not the only subject, but nor is it ignored. Yet in Mexican art there is often said to be a **preoccupation with death**, perhaps as a result of the country's colonial history, its revolutionary struggles and its journey towards creating a **national identity**.

To what extent that is the case is a question too large to be pondered here. Instead of making a case for or against death as a driving force in Mexican art, this section simply looks at examples of it with a view to providing some context and background to **modern works** inspired by the Day of the Dead (and of course death is only one part of the **imagery of the fiesta** – it is as much to do with life). They may be totally unrelated to the cultural history

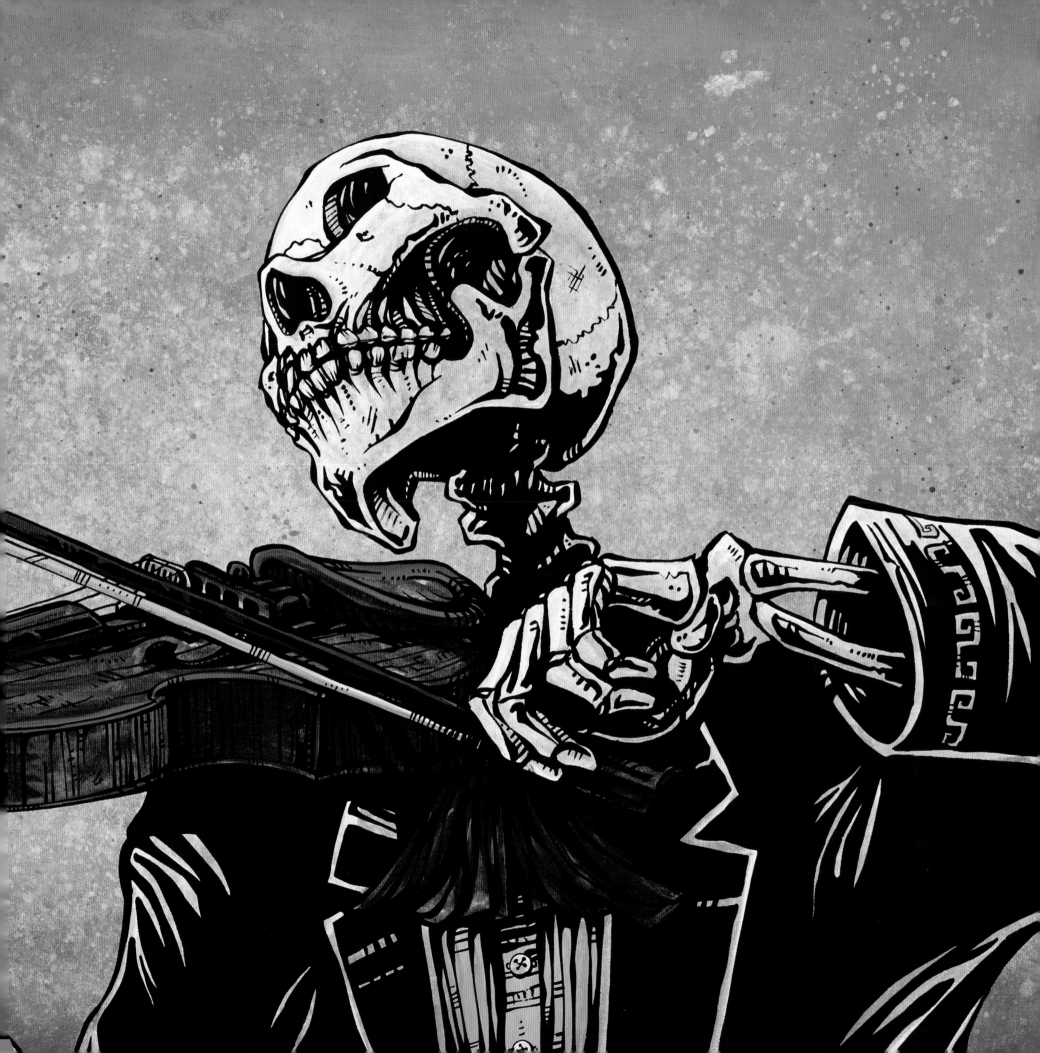

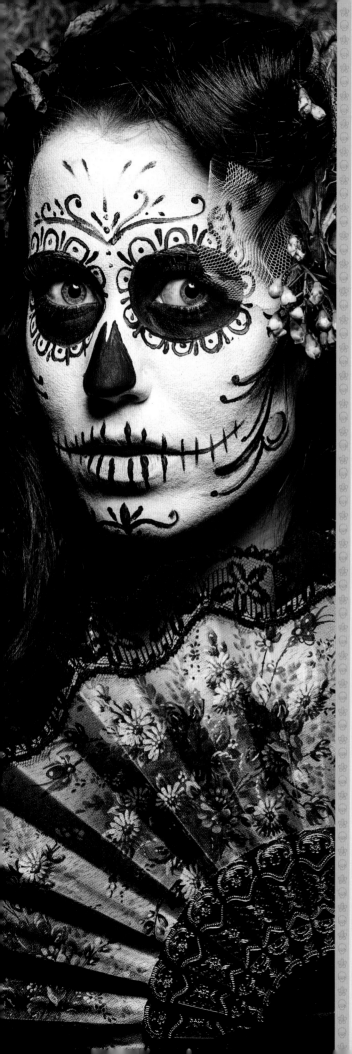

that has gone before; they may be intimately bound up with it. As we've seen, **death gets everywhere** and comes in all shapes and sizes.

The section concludes with a look at the artists creating work today, in a **range of mediums**. The latest in digital art is represented, as are traditional techniques from **paint and pastel** to linocut and **good old ink** on paper. From comics to calendars, Mexican Day of the Dead iconography inspires a lot of people in a lot of different ways.

DEATH IN THE PRE-HISPANIC PERIOD

We already know that skulls and skeletons were regular fixtures in the art and **monumental architecture** of pre-Hispanic Mesoamerica. However, death appears in other ways and in forms that could well have influenced artists once the works were more **widely disseminated** centuries later.

Of our guides to the beliefs and religious practices of the pre-Hispanic civilizations, the codices offer some of the most **enigmatic glimpses** into the world of the Aztecs. They are not a definitive account, they are merely the records that survived the arrival of the **conquistadores** (and of course the ensuing centuries of wear and tear). What else was lost will never be known and remains one of the **cultural tragedies** of the conquest.

The *Codex Borgia* (date unknown) is believed to have been created prior to the arrival of the Spaniards. It is made of folded animal skins, painted and then sealed with **white gesso** (a white paint mixture of a binding agent, such as glue made of animal fat, and pigment or chalk). Its use is

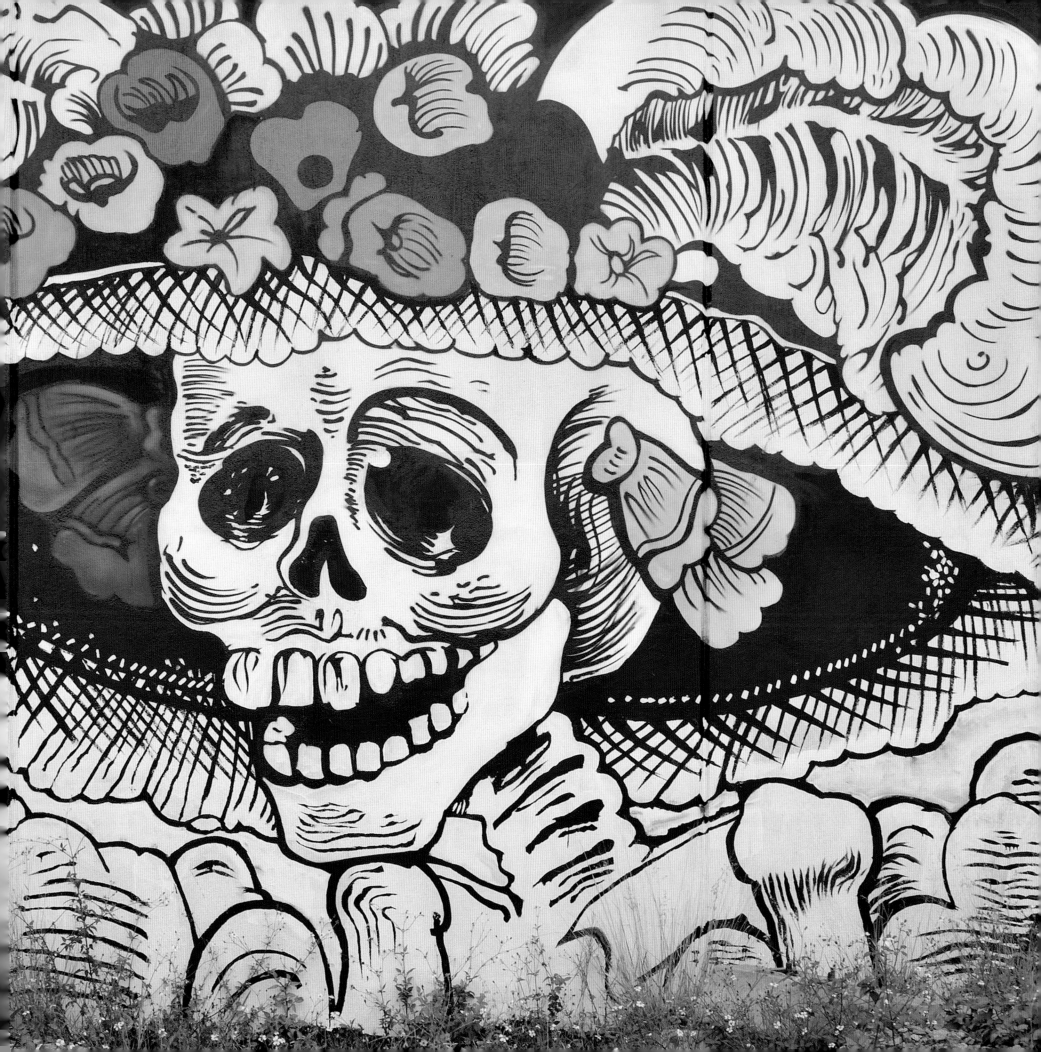

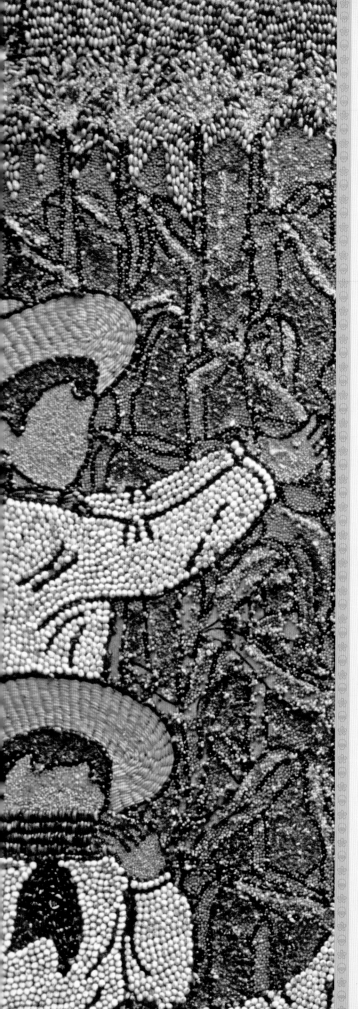

unknown but it depicts many different deities, including those for childbirth, as well as a **sequence of festivals** and a section that allowed priests to determine the likely outcome of a marriage based on the numbers within a couple's names.

THE FACE OF GOD

An especially intriguing and possibly influential page shows the respective gods of creation and death, Quetzalcoatl and Mictlantecuhtli. They are seated, surrounded by serpents, with the page itself bordered by signs representing the days of the Aztec calendar.

The gods are sitting back to back, seeming to almost share a **single spine** and mirroring one another's gestures. One interpretation of the page is to see it as a reflection of the **endless cycle of life and death** in Aztec cosmology: the two are intertwined, each one leading into the other suggesting that they should be viewed equally. It's an **egalitarian approach** echoed in some of the beliefs surrounding the Day of the Dead, which are based around the idea of the death state as a mere extension of life, only on another plane.

Their physical appearance is of even more interest, especially death god **Mictlantecuhtli**. This is no hooded European reaper figure: we see an **energetic, colourful** being in ceremonial regalia, albeit with a skull for a head. The skull itself is **lavishly decorated**, the mouth painted into a leering smile, eyes colourfully highlighted. Mictlantecuhtli gets a similarly skeletal treatment in the *Codex Laud* – it's no great leap from the depiction of these deities by Aztec artisans to the **calaveras** and **characterizations of Death** created by their twenty-

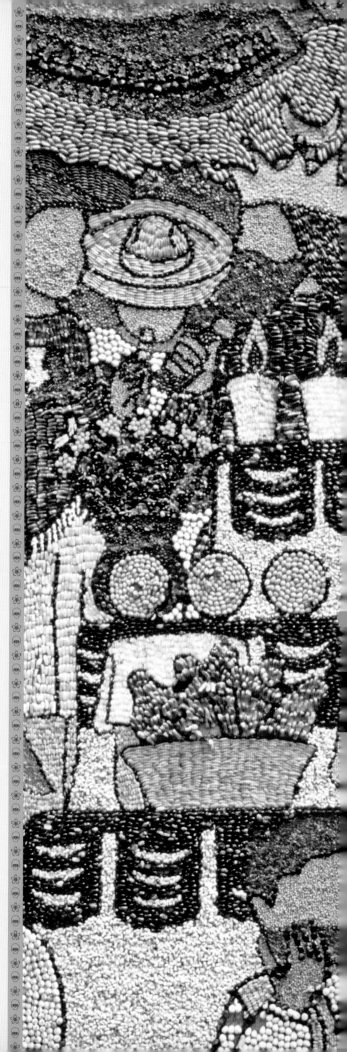

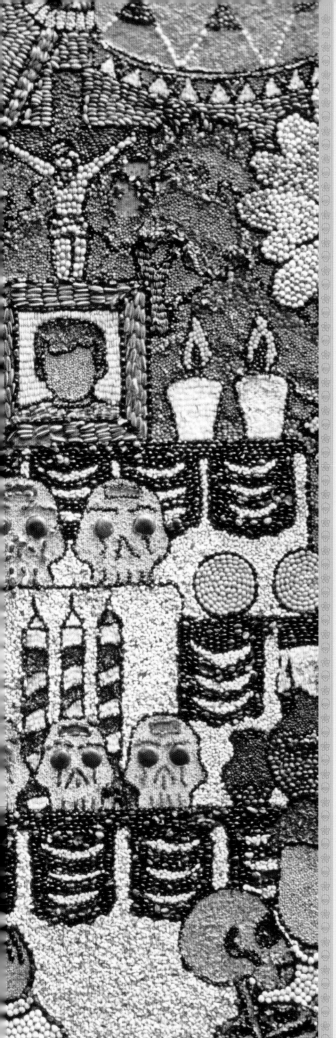

First century counterparts in all manner of mediums. (Probably without using as much rabbit fat.)

POST-CONQUEST ART

The driving force behind art in Mesoamerica once the Spanish arrived was religion. The Europeans sought to consolidate their conquest of the region with the conversion of the **indigenous people** to their Catholic faith – using art and architecture as part of that **evangelical process**. The Spanish used native stonemasons to help build their new churches and monuments, while Spanish artists gradually instructed the natives in European techniques.

Death appears in many forms of **religious art** and the Spanish colonial period in Mexico was no exception, continuing to lay the foundations for the **imagery and iconography** of the Day of the Dead as we now know it, and which our modern artists are so inspired by. An early relief of the **Virgin Mary** produced by indigenous masons at a monastery in Acolman, State of Mexico, has the flat appearance common to the period. At her feet sits what appears to be a **round, toothy skull**, not a million miles away from the countless masks and sugar skulls now seen during the Day of the Dead.

The influence of the baroque style was keenly felt in the years following the Spanish conquest, with copies of **engravings** making their way from Europe and into the hands of colonial and **native artists** – as mentioned in the previous chapter, the **baroque themes** and representations of death are echoed in the work of later artists such as Posada.

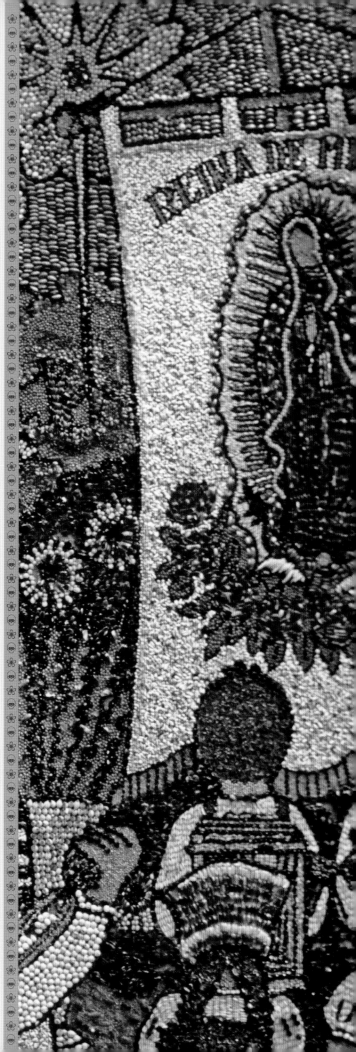

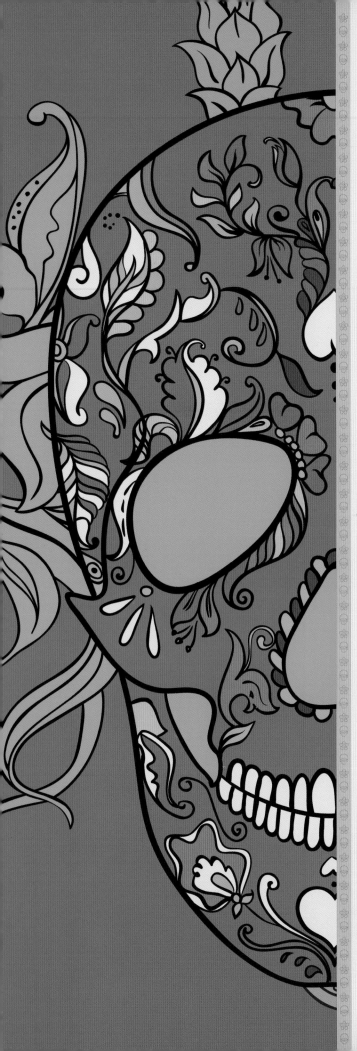

ROYAL DEATH

Towards the end of the colonial period we can even find examples of an attitude to death that is edging near the humorous tone adopted on the Day of the Dead. In 1792 a **friar from Zacatecas** published what might now be considered a work of fantasy literature in Mexico City. In his prologue to *The Portentous Life of Death* Joaquín de Bolaños (1741–96), wrote what could almost be a mission statement for those celebrating the Day of the Dead:

Death is unbridled, but in order to sweeten her memory, I present her gilded or disguised with a touch of jest, novelty, or grace … for I wish to amuse you with a little bit of mysticism, for I also seek to undeceive you; separate the gold from the dross, profit from what is serious, laugh at what is ridiculous.

The text was accompanied by engravings of Death having what seems to be a pretty fine time, **dressing up** and indulging in revels. One plate shows him (or her) dressed in kingly robes and a crown, adopting what can only be described as a **showbiz pose, arms wide**, grinning out of the frame.

Set in a religious context, **death as a skeleton** also features on a catafalque designed for Spain's **Carlos II** (1661–1700). The figure stands atop the tiered structure, triumphant, a reminder that different presentations of death have existed alongside one another over time.

THE NINETEENTH CENTURY

Post-independence, although fine art in Mexico is considered to have hit a stumbling block, the **cartoonists and illustrators** went into overdrive. While

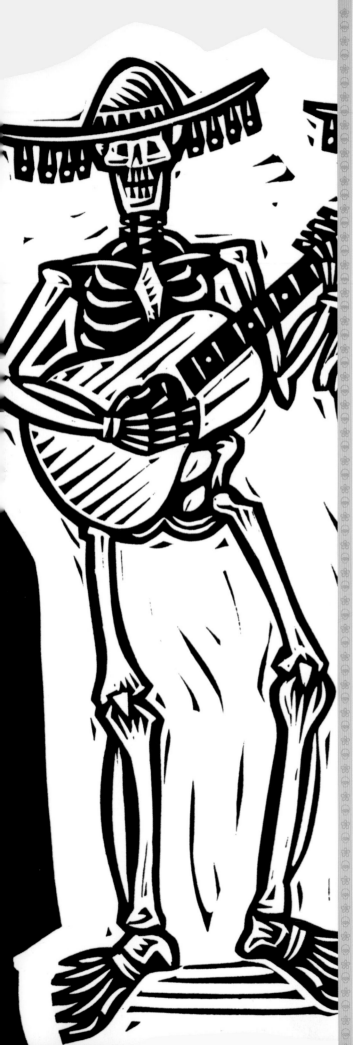

the Day of the Dead was well established as a fiesta, and customs including the giving of sugar skulls, the importance of **ofrendas** and the presence of skeletons more or less everywhere were all in place, a definitive visual style wasn't.

Something as **organic and shifting** as a fiesta that varies from region to region will (hopefully) never reach a point of cultural homogeneity; the variety is partly the point. Yet the Day of the Dead would eventually find the beginnings of the **unique visual thread** that does run through the celebrations and gives them the unifying aesthetic that so many of the artists in this book have embraced.

The importance of the work of **Posada** has already been highlighted in the previous chapter, as have the advances in mass production that gave audiences greater access to his work. However, Posada wasn't the only creator of the **satirical illustrations** that went on to gain such currency with contemporaries and today's creatives.

SKULDUGGERY

His predecessor at the publishing operation run by Arroyo had already started to establish an **eye-catching** and visually articulate style. **Manuel Manilla** (1830–95) created illustrations and engravings that proved to be a fine accompaniment to Arroyo's titles. The subject matter? Skulls and skeletons, of course, in the finest traditions of Holbein's *Dance of Death*.

As we've seen, the skeleton (and the skeleton as Death's avatar) was well established as a character in **Mexican art**, and had already gone some way towards acquiring the sense of humour that moved it away from the

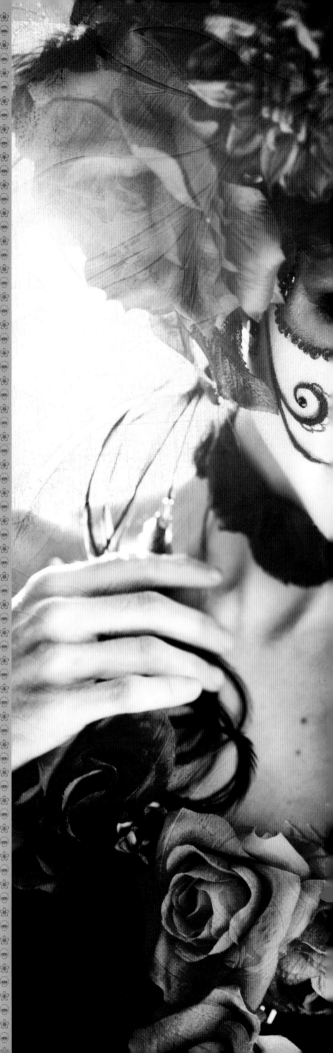

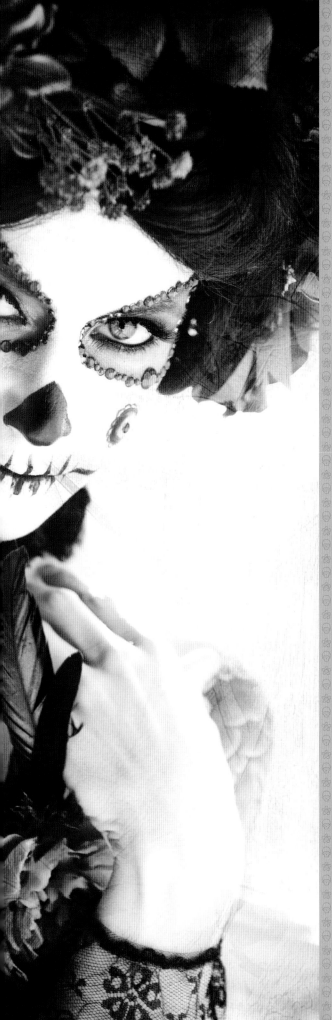

gloomier traditions found in Europe. In Manilla's hands, the skeleton moved on apace though, and it's hard to see how Posada could have made the leaps he made without the groundwork laid by Manilla.

Consider just a few of his engravings to see how they helped set the tone for the **skeletal shenanigans** that followed. One shows a carefree skeleton on a skeletal horse, riding nonchalantly into a village as its residents run away in terror, **arms flailing wildly**. Another a group of bullfighters dancing around a charging bull – only all are skeletons.

Others show the **calaveras** in more subversively day-to-day roles: a father **smoking and drinking** while his son peers over his shoulder; an undertaker with the tools of his trade spread out before him and a coffin on one shoulder.

DRY BONES

Some of Manilla's skeletons tap the vein of humour that characterizes the Day of the Dead: the everyday skeletons doing everyday deeds poke fun at both the living and the dead, removing some of **death's terror** with the **absurdity** of some of the situations.

Yet there's also a stream of **mordant, creepy wit** present in some of the engravings that sits outside of the **cheerier Day of the Dead** style. For a start, these skeletons do sometimes interact with (and terrorize) the living, chasing them around their villages or spooking them in **graveyards**; in another, a teetering pile of bones and skulls forms a catafalque-esque tower above a suited gentleman, the **looming presence** of death grim and

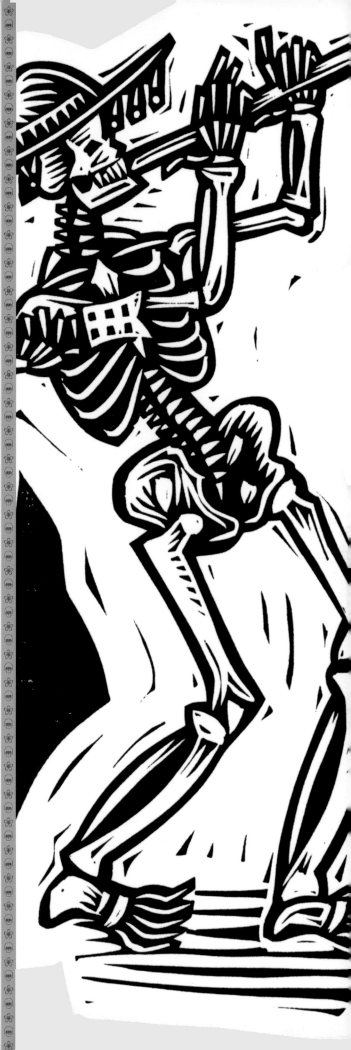

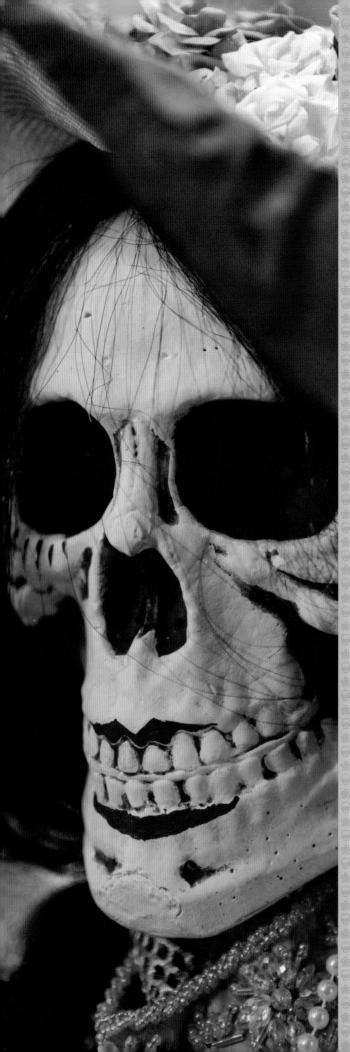

mocking; or a hungry **calavera** with a **hairy, monstrous body** that seems to have scuttled straight from under the bed of your **darkest nightmares**.

Evidently not all of these characters made it into the Day of the Dead canon – who's going to feel good about the triumph of life over death when confronted with a skull-headed **six-limbed monkey demon**? But they clearly occupy an important place in the evolutionary chain of Day of the Dead. And for those contemporary artists who like their Day of the Dead art with a shot of **sharp darkness** on the side, Manilla's is the vintage to pour

COMING BACK TO LIFE

Posada's debt to Manilla is widely acknowledged. An important footnote to the **story of Posada**, though, is that were it not for the intervention of artists who came after him, his work may well have **languished in obscurity**.

The artist himself died in poverty; his engravings had been fashionable, but fashion can be **cruelly fleeting**. They (tens of thousands of them) remained largely unknown outside of Mexico (or even Mexico City) after his death until picked up by French artist **Jean Charlot** (1898–1979). During a trip to Mexico visiting fellow muralist **Diego Rivera**, Charlot noticed Posada's prints being sold and was immediately struck by their style.

Going back to the original publisher, Charlot recovered Posada's **printing blocks** from the workshop and helped bring about the publication of the first catalogues of Posada's work. This helped to bring his art back into the **public eye**, as did Charlot's enthusiastic promotion

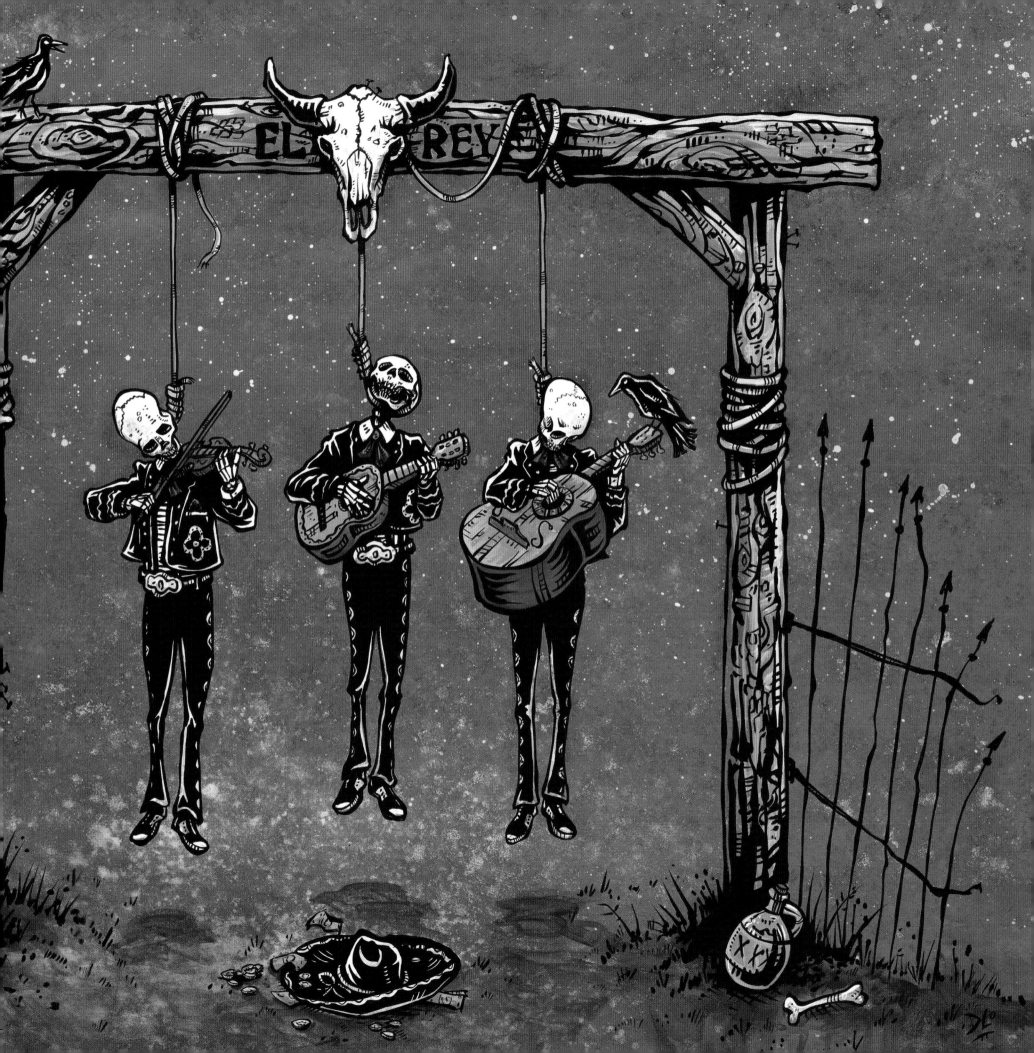

of Posada to his fellow artists. Ultimately Rivera was to hail him as 'an engraver of genius' and the 'greatest' of those Mexicans producing popular art, in an introduction to a collection of prints. In time Rivera's contemporaries would all come to acknowledge their debt to Posada and further cement his position as a legend of Mexican art.

OFF THE WALL

Posada himself might not be considered an 'establishment' figure – his work was largely concerned with sending skeletons to mock it, after all. Yet the tone of his pieces and the personality of his calaveras did sit comfortably in the robes of traditions and customs – including the Day of the Dead – that seemed to define the Mexican national character.

After the revolution of 1910–20 it wasn't surprising, therefore, that his work would be appropriated by the new socialist government to promote their agenda of redefining Mexicanidad on the world stage, rejecting European style and affectations (as Posada had) along the way.

The government recruited Mexican artists to help with this grand scheme, which was overseen by Secretary of State José Vasconcelos (1882–1959). His idea was to reform and refresh the national character with a loud and very public assertion of the spirit of the new Mexico. To achieve this he commissioned artists in 1921 to create works in and on public buildings, glorifying the revolution and bringing the country's indigenous people to the fore, along with their beliefs and traditions. While Vasconcelos himself remains a controversial figure, this

initiative gave rise to the **Mexican Muralist Movement**, which in turn had a huge impact on the **artistic representations** of the Day of the Dead (and on wider Mexican culture).

A RIVERA RUNS THROUGH IT

Diego Rivera (1886–1957) was a key figure in the movement. A **classically trained** artist, he was born in Mexico but was living in Paris around the time of the revolution, producing work in the **blocky, geometric Cubist style** as well as making forays into **Post-Impressionism**.

None of this particularly impressed **Vasconcelos** when Rivera returned to Mexico to meet him, but the politician saw potential and redirected Rivera's focus to questions of Mexican national identity. The two travelled to the **Yucatán** and to **Tehuantepec**, where Rivera began creating work influenced by the figures of the indigenous people he saw – naked female bathers in particular – and gradually honing a message **rooted in the stories** of the Mexican people.

Rivera also explored the **pre-conquest** history of Mexico in his work, his murals explicitly criticizing the role of **European influence**. A piece in the *Palacio Nacional* in Mexico City (1929–45) around the theme of the exploitation of Mexico by Spanish *conquistadores* shows death and brutal subjugation all around. The faces of the natives are largely obscured as their identity is smothered by the European arrivals, who **torture, whip, hang and humiliate** them while exchanging bags of coins or brandishing crosses.

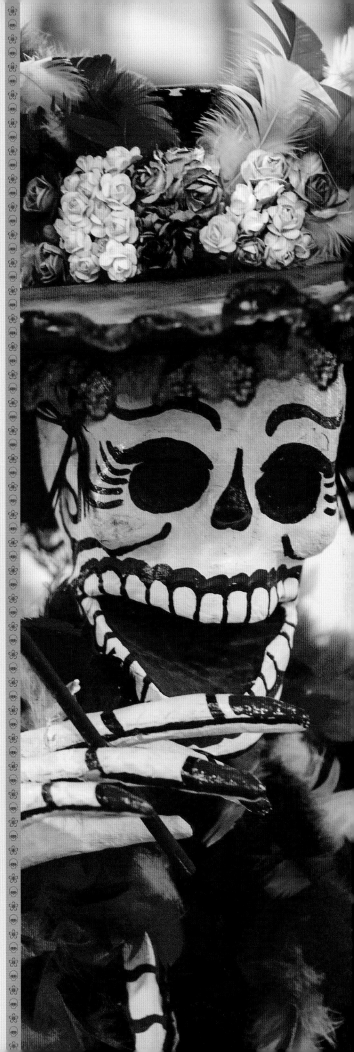

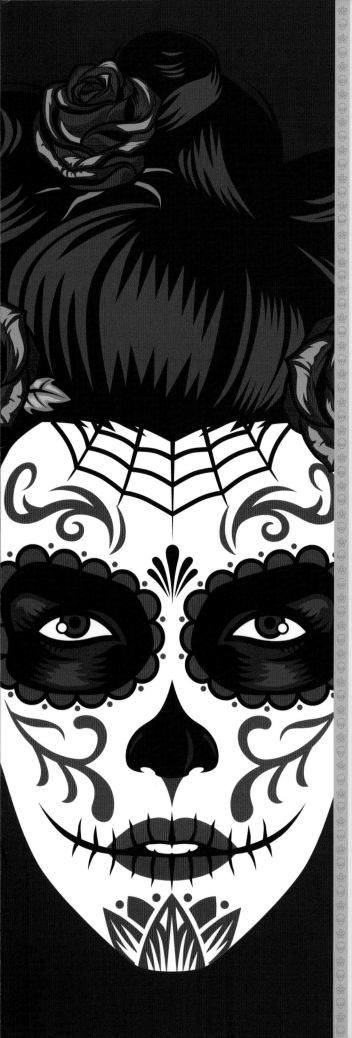

LAZY SUNDAY AFTERNOON

Death is ever present in such pieces, but not the whimsical incarnation of the Day of the Dead: this is the **furious, tragic, desolate death** that arrived on ships with the Spanish. Rivera pulled no punches as he sought to establish a tradition that owed nothing to Spanish or North American influences but was **uniquely Mexican**, speaking to the most and least literate members of society alike about their shared history.

This approach reached its apotheosis in 1947 with a mural painted for Mexico City's Hotel del Prado, entitled *Dream of a Sunday Afternoon on the Alameda Central*. It was on a grand scale, 15 m (49 ft) long and 5 m (16 ft) high, featuring some 150 characters and encompassing Mexico's history from conquest through **dictatorship** and to the revolution.

In the centre stands *La Calavera Catrina*. Rivera directly copied Posada's original mocking engraving, elevating the artist to **near-mythic status** in the process, but also bringing Catrina, the **calaca** and the narrative style he had created around the Day of the Dead to prominence. Rivera's fame ensured a wider audience for both Posada's work and the **lady Catrina** herself – both would go on to be centrepieces of art surrounding the Day of the Dead from that point onwards, as a satirical means of mocking the bourgeoisie, a **philosophical aid** to contemplating death, an inspiration for countless artworks, and of course as a defining characteristic of Mexican art and identity.

OTHER ALTAR EGOS

Rivera also immortalized other aspects of the Day of the Dead in his work. *La Ofrenda* (1923) captures a family group

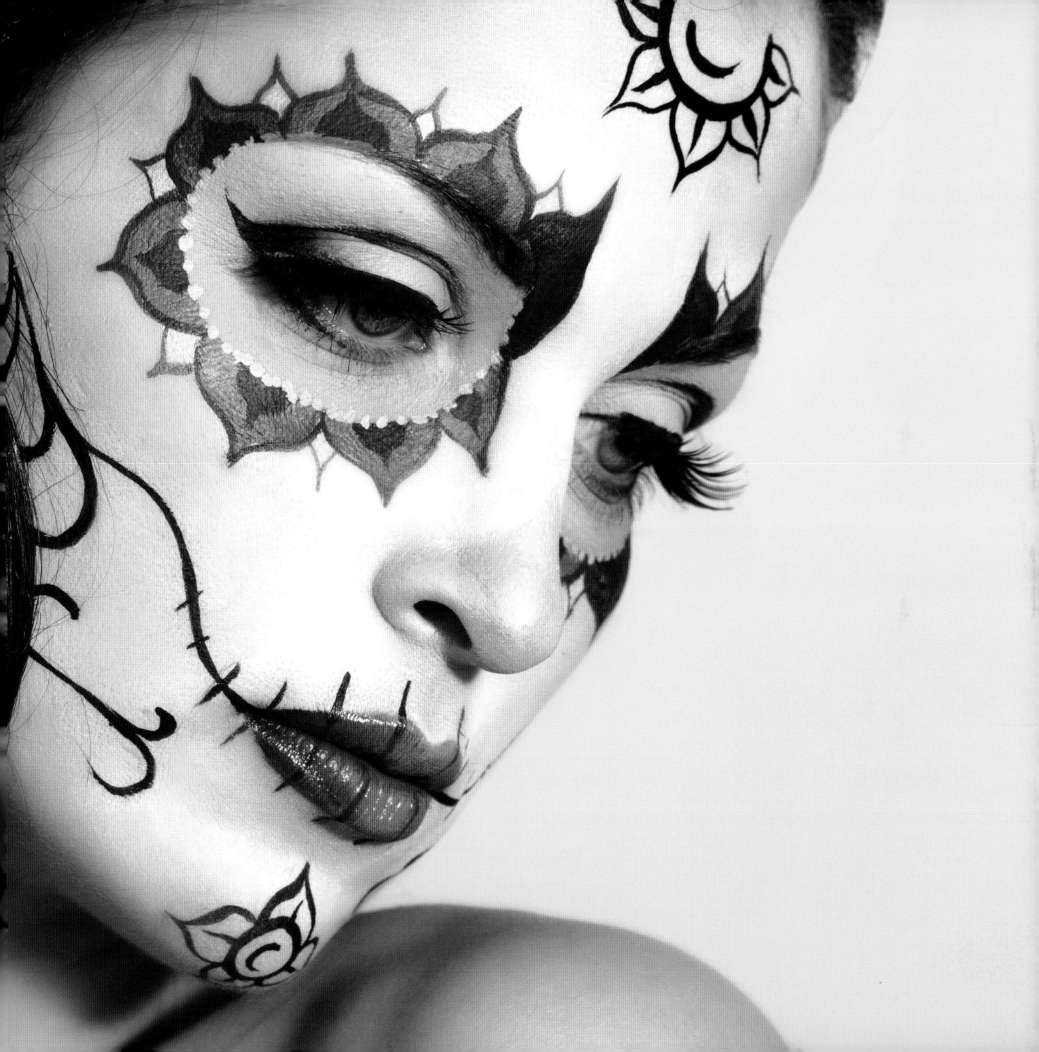

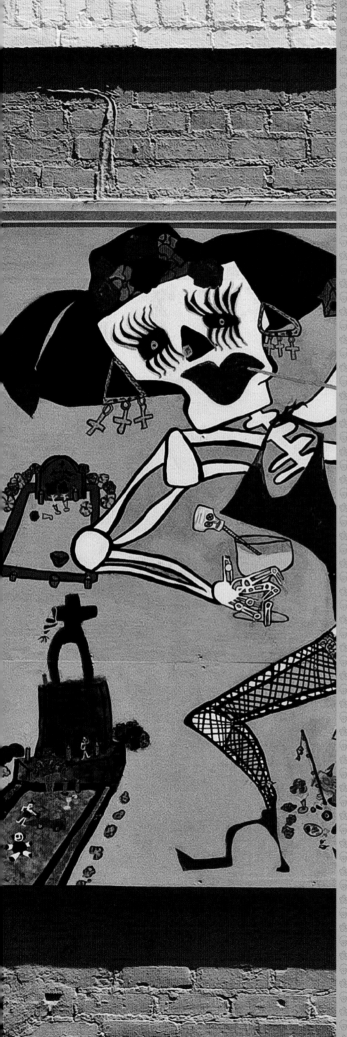

gathering around their altar, complete with decorative arches and **bunches of bright marigolds**. Candles flicker as they bow their heads and make their offerings.

More candles and a bowl of smoking incense are prominent features of *The Day of the Dead* (1944), an oil painting that emphasizes the communal nature of the fiesta. Set in a cemetery, the scene goes back and back – **graves disappear** off into the distance and the more we look, the more figures appear, silhouetted against even more candles. The **idealized image** reinforces the idea of gathering together to spend time with the spirits that lies at the heart of the Day of the Dead.

Much more rowdy is another *Día de Muertos*, this time from 1924, which captures a noisy-looking crowd at the business of celebrating. There is drinking, **music, a busy market**, skull masks and above everything a group of grinning *calacas*, strumming guitars.

All of these scenes evoke another side of the fiesta, the side that can be more considered and reflective (although not morbid), or even spent **celebrating in daylight**; it's a reminder that the Day of the Dead is about togetherness, community, family, and can encompass all manner of emotions beyond chattering skeletons and **withering sarcasm**.

DEATH BECOMES HER

On the theme of family, as both creator and subject of Mexican art and wife of Rivera, **Frida Kahlo** (1907–54) is emblematic of both the native Mexican and the female experience, her work often also intimately bound up with themes of **isolation, illness and death**.

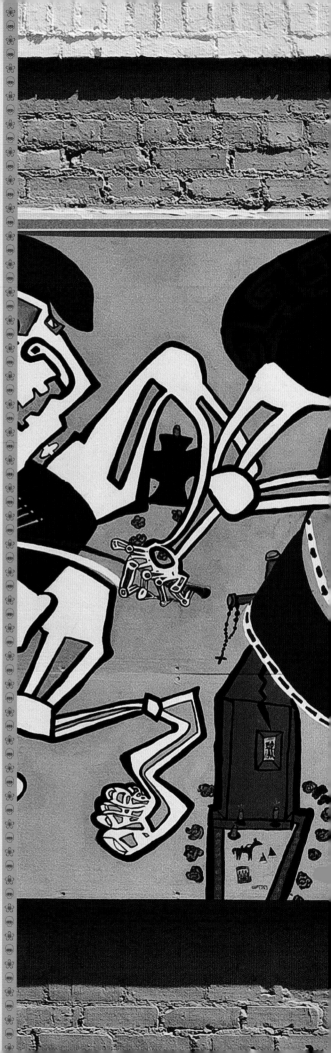

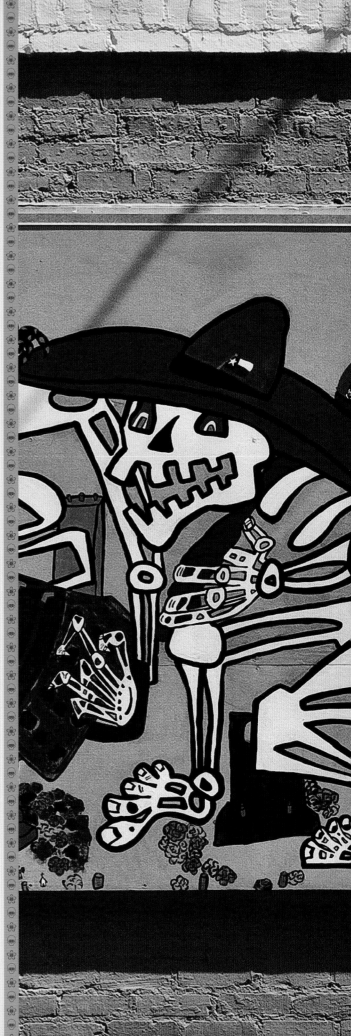

Like Posada she did not receive **international acclaim** until after her death; also like Posada, her influence is now widely felt throughout the Day of the Dead. In Kahlo's case she is more talismanic, though, and it is the artist herself who features, rather than the images she created, during the festivities. As a **symbol of Mexico** and Mexican folk art her portrait is invoked with affection, even appearing as a life-sized **calaca** outside the **Museo Frida Kahlo** to join in with the celebrations.

Not all of Kahlo's depictions of death and mortality are explicitly linked to the Day of the Dead, of course, and nor is death her sole preserve. However, her steady gaze at it is certainly in keeping with the wider attitude of the fiesta and her **self portraits** and physical appearance have been appropriated by others and reimagined within the context of the *Día de los Muertos* – Kahlo herself was drawn as a **calavera** in a 2008 illustration by **José Pulido**, for example, bringing two iconic symbols of Mexico together.

MORE MURALISTS

Two other artists – **David Alfaro Siqueiros** (1896–1974) and **José Clemente Orozco** (1883–1949) – formed the foundation of the Muralist movement and have contributed to the aesthetic that informs some contemporary artwork around the Day of the Dead.

Siqueiros' life story is as lurid and energetic as the pulsing, muscular pieces he painted. A Stalinist and member of the **Mexican Communist Party**, he joined an attempted assassination attempt on Trotsky (facing exile as a result), and was deported from the US for political activity and imprisoned on false charges of **political dissent**.

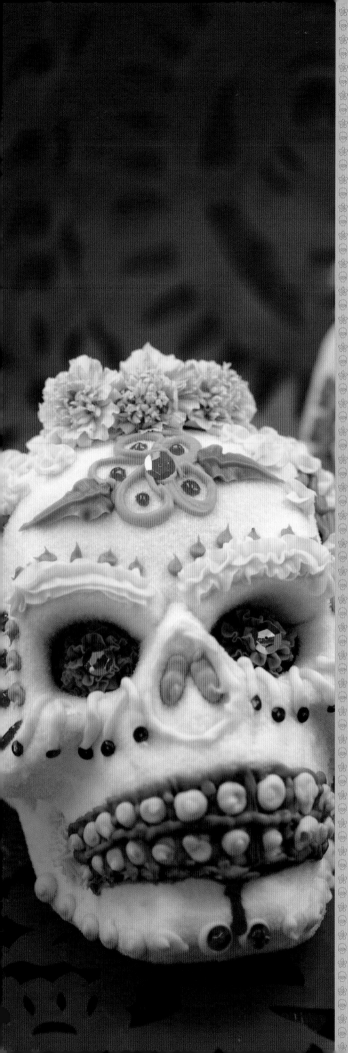

When not getting up to this kind of anti-capitalist mischief, he created murals whose intention was to be **accessible to all**, however well or poorly educated the viewer might be. His themes tended to be those **championing the worker**, often incorporating mythological elements to further this story rather than to celebrate them in and of themselves. The Muralists' style was modern but their scenes drew on pre-Hispanic culture, including the altars and observances of the Day of the Dead, to celebrate Mexican national identity. Occasionally pieces like Siqueiros' *Sentimental Friendship* (1959), which shows two skeletons in an ambiguous pose that could be **hugging, dancing or fighting**, also brought the shifting relationship with ever-present death to the fore.

SYMBOLIC SKELETONS

Orozco drew more on symbolism than his contemporaries did and his **murals' meanings** become slightly more opaque as a result. Their power isn't diminished, however, as a glimpse of the mural *Gods of the Modern World* (part of the *Epic of American Civilization* at Dartmouth College, New Hampshire, 1932–34) demonstrates.

Clearly drawing and elaborating on Day of the Dead conventions of presenting skeletons in poses from life and work, a group of **calacas** in academic and religious garb look on as another births a skeletal foetus in a **mortar board** from a larger skeleton, made up in equal parts of bones and books. It's a hideous and barbed critique of a **lifeless educational system** that does nothing but produce still more lifeless students (more of which are displayed in **sterile jars** around the scene), all the while turning its back on the troubles of

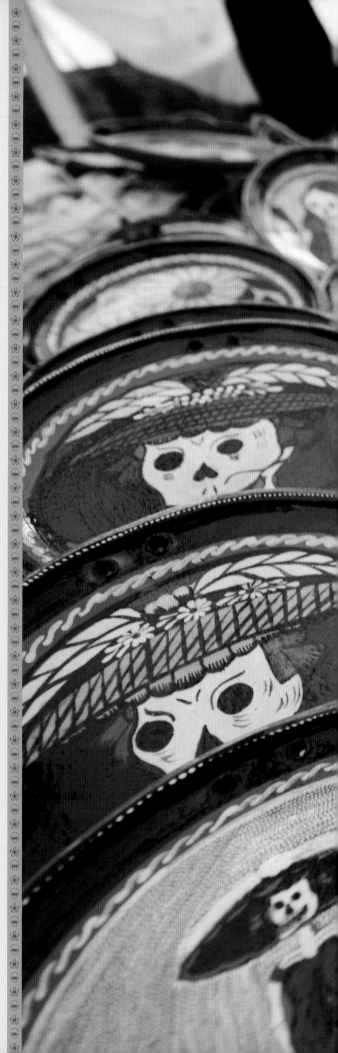

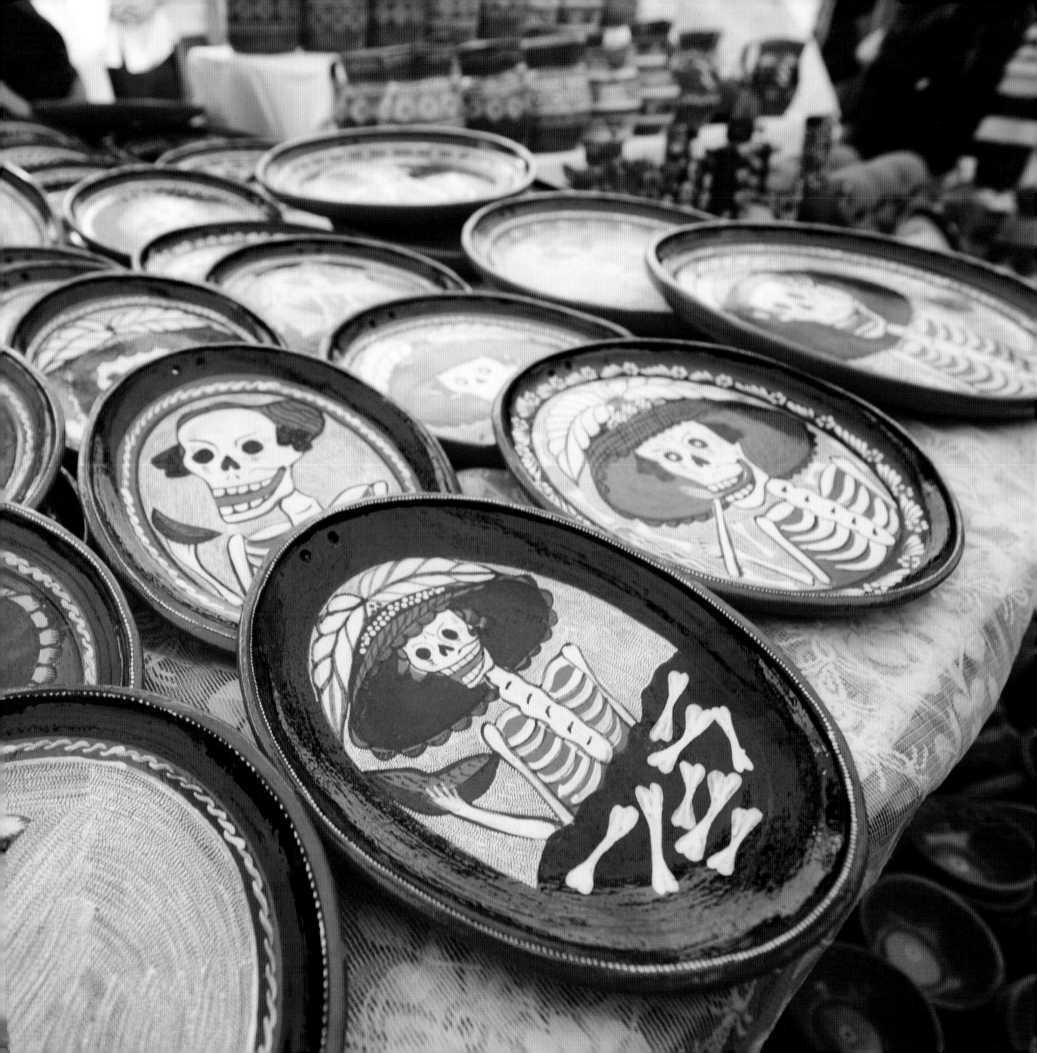

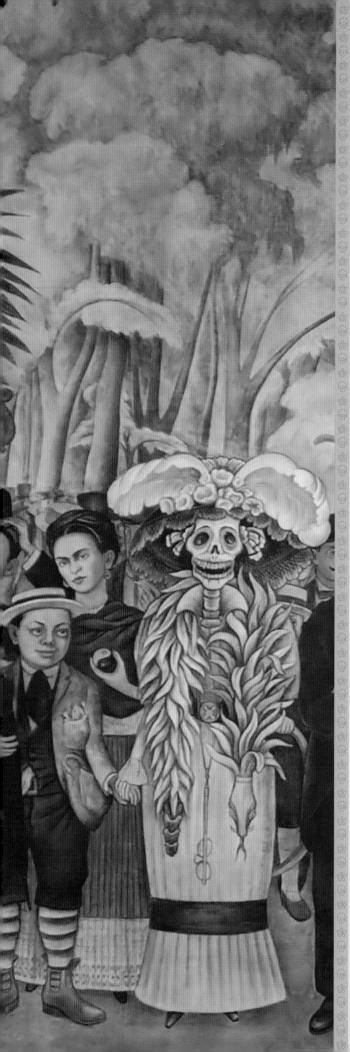

the world beyond the school doors: the skeletons are hemmed in by fire, to which they seem indifferent.

Orozco's work on panels like this has links back to the more **gruesome** aspects of the **Dance of Death** as well as the dark comedy styles of Manilla and Posada. While not directly relating to the fiesta itself they are certainly in the tradition of the art surrounding it, and their descendants can be seen in the **contemporary incarnations** that fill these pages.

ART IN THE BONES

The skeletons of the Day of the Dead have made their way into all manner of artwork since Rivera brought Posada on to the **international scene** and the muralists began creating their work. Liverpool poet and artist **Adrian Henri** (1932–2000) transposed the Day of the Dead on to Hope Street in Liverpool, complete with a grand parade of **calacas** and a crowd that included writers **Malcolm Lowry, Allen Ginsberg, William Burroughs**, and – of course – the artist **Frida Kahlo**.

Henri was fascinated by the Day of the Dead and the piece is at once exotic and mundane, juxtaposing vivid flowers and **extravagant costumes** with the everyday street furniture of a British city, including 'Road Closed' signs, yellow parking lines and grey tarmac. There's an incongruity to the sight of skeletons, **celebrities and spectators** mingling happily as they march along playing guitars and seeming to call to one another against this backdrop, but none of the wit or levity of the fiesta has been lost in translation.

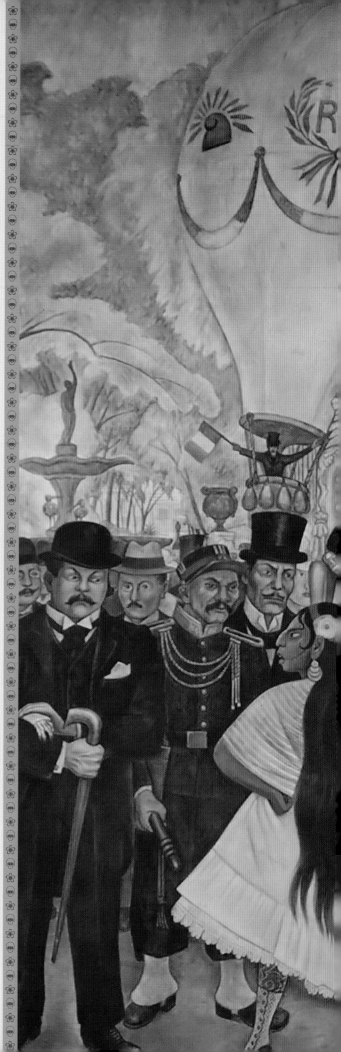

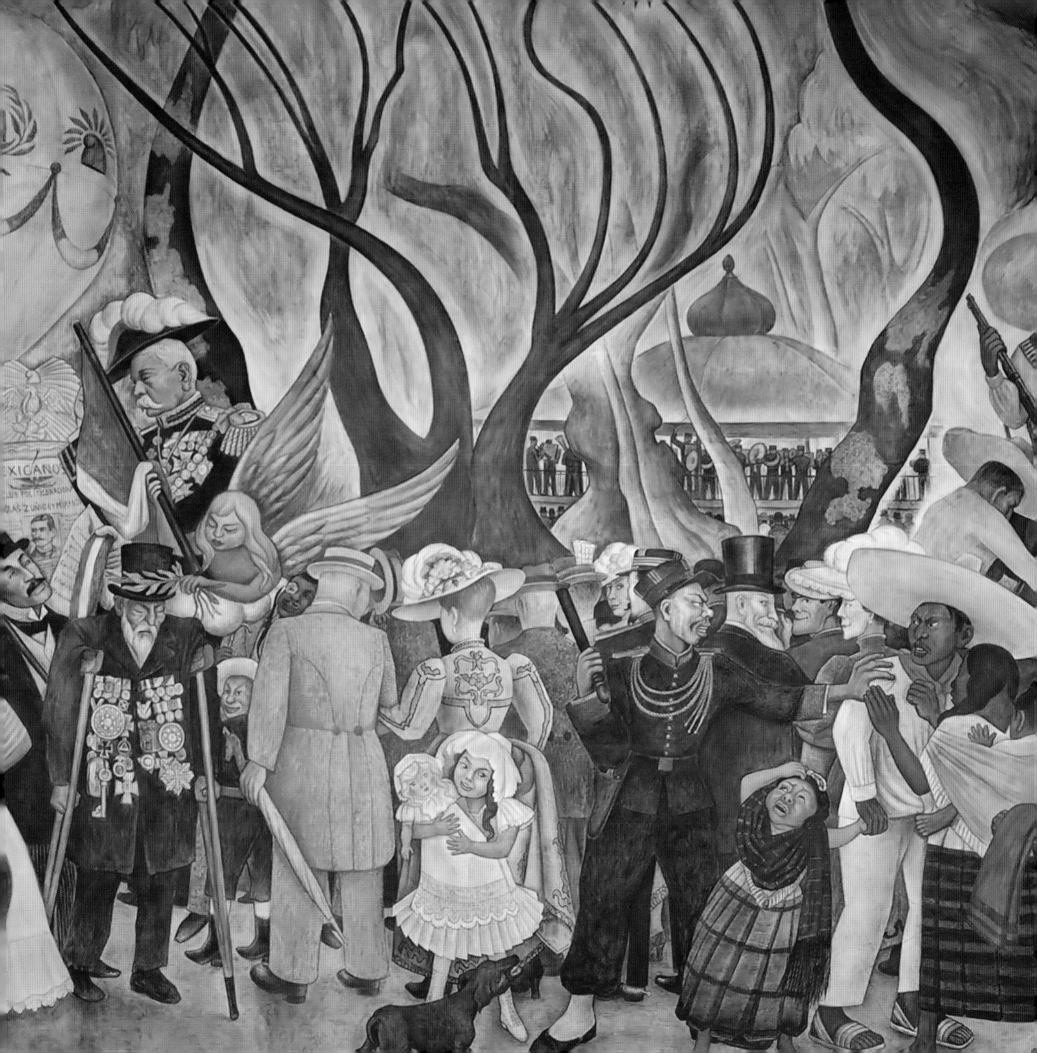

Henri's accompanying poem speaks of 'the rattle of firecrackers / **raucous chords scrawled** / by bony fingers / above high strings / the pure clear sound of a viola', until the carnival departs leaving a quiet street and **trampled flower petals**, as any carnival always does. It's an intriguing alternative vision of the Day of the Dead.

THE CONTEMPORARY CALACA

As Henri's painting shows, the **mischievous skeleton** is the most **persuasive and adaptable** ambassador of the Day of the Dead to other cultures and types of art. A piece doesn't need to illustrate the Day of the Dead (as Henri's does) for skeletons to feature prominently – they can be summoned for all manner of purposes.

Yet their presence can immediately invoke some of the tropes and customs of the fiesta: the tone becomes irreverent, or **satirical**; death can suddenly be recognized and mocked; even well-known personalities can be seen in a new light once given the **calaca** treatment.

What makes them such flexible models, apart from the obvious lack of constricting **muscles and flesh**? In one respect it could be their very emptiness that makes them such fine candidates to **fill the frame**. Skeletons are the great blank canvas of human life; it is their unadorned slate on to which each and every one of us is sketched, after all, so they can **reflect anything and everything** we do.

But as a **calaca** or **calavera** they possess more personality than an indifferent set of bones would: they are always up to something, carrying with them a constant **hint of the macabre** – inevitable, given what they are – but also acting as **instruments of mirth** and off-kilter entertainment.

122

FUNNY BONES

Artists taking their inspiration from the imagery of the Day of the Dead can infuse their work with all kinds of humour, from **slapstick** to the **sick and surreal**. Some pieces can raise a chuckle thanks to their own inherent absurdity; others from a deeper prompt to laugh at both death and ourselves.

In some cases Day of the Dead staples come together to create amusing characters. **Jorge R. Gutierrez's** *El Muertito* ('Little Dead Guy', 2010) goes charmingly overboard, his **moustachioed calaca** covered from head to toe in ornamental curlicues and **calavera** markings, swamped by an **enormous sombrero** from which even more **calaveras** dangle. He is the tourist who's bought all the baubles; or perhaps the celebrant who embraces every custom and cliché in the book. Either way, his arrival on the page can't fail to raise a smile.

Other artists will snatch away death's sting with judicious juxtaposition, such as a bony **calavera** in an angel of death guise fondly stroking a pet puppy (*I Love You*, José Quintero). Or they may impose the iconography of the Day of the Dead on to *memento mori* practice to come up with art that is life affirming, sternly morbid and **blackly comic**: 'Enjoy it while you can,' advises a strict-looking skeleton in a piece of the same name from **Chema Skandal**, while surrounded by celebratory confetti.

FOLK DEATH

Folk art and **mixed media pieces**, perhaps aided by their touchable solidity, can summon even greater levels of whimsy and weirdness. They might be created exclusively

123

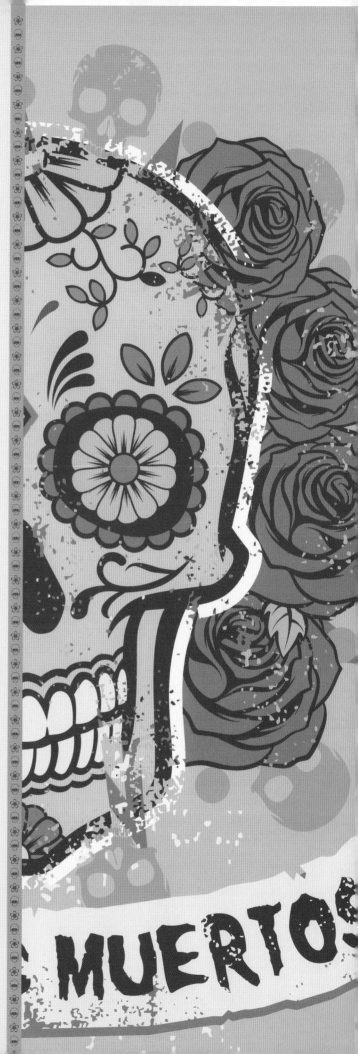

for market stalls on the days on and around the Day of the Dead, or aimed at galleries (and there will be those who **curl their lips snobbishly** at either activity, not that the *calaveras* would care), or simply for their own sake.

The imperfections and handmade forms of folk art inspired by the Day of the Dead can, ironically, give it even more life. As ever the skeleton is the go-to figure, but materials vary wildly. You're just as likely to find a **dark-eyed, red-cheeked calaca** crafted from coconut as you are a brightly painted wooden figure, ribs delineated by simple black lines against an **all-white body**.

More ribald examples include **papier-mâché models** of skeletal dogs tugging at the trousers of bony postmen, or **manic calacas** banging drumsticks against a skull. The fact that these are all meant as toys or brief **decorative distractions** only adds to their appeal – they are ephemeral pieces, quick jokes to be enjoyed and forgotten and not taken **too seriously**, in much the same way as many aspects of the Day of the Dead. It's never a bad thing to be reminded to lighten up, even if it is by a **skeleton riding a dead donkey**.

CUT IT OUT

Keeping the **handmade aesthetic** and paying a little homage to the engravers – Posada, Manilla – who bequeathed their *calavera* creations to the wider world, some contemporary artists employ traditional techniques such as **linocut and woodcut** to create their work.

This tends to produce bold pieces that get their message across with thick lines and lots of monochromatic contrast. Yet they retain the edgy energy that so characterized

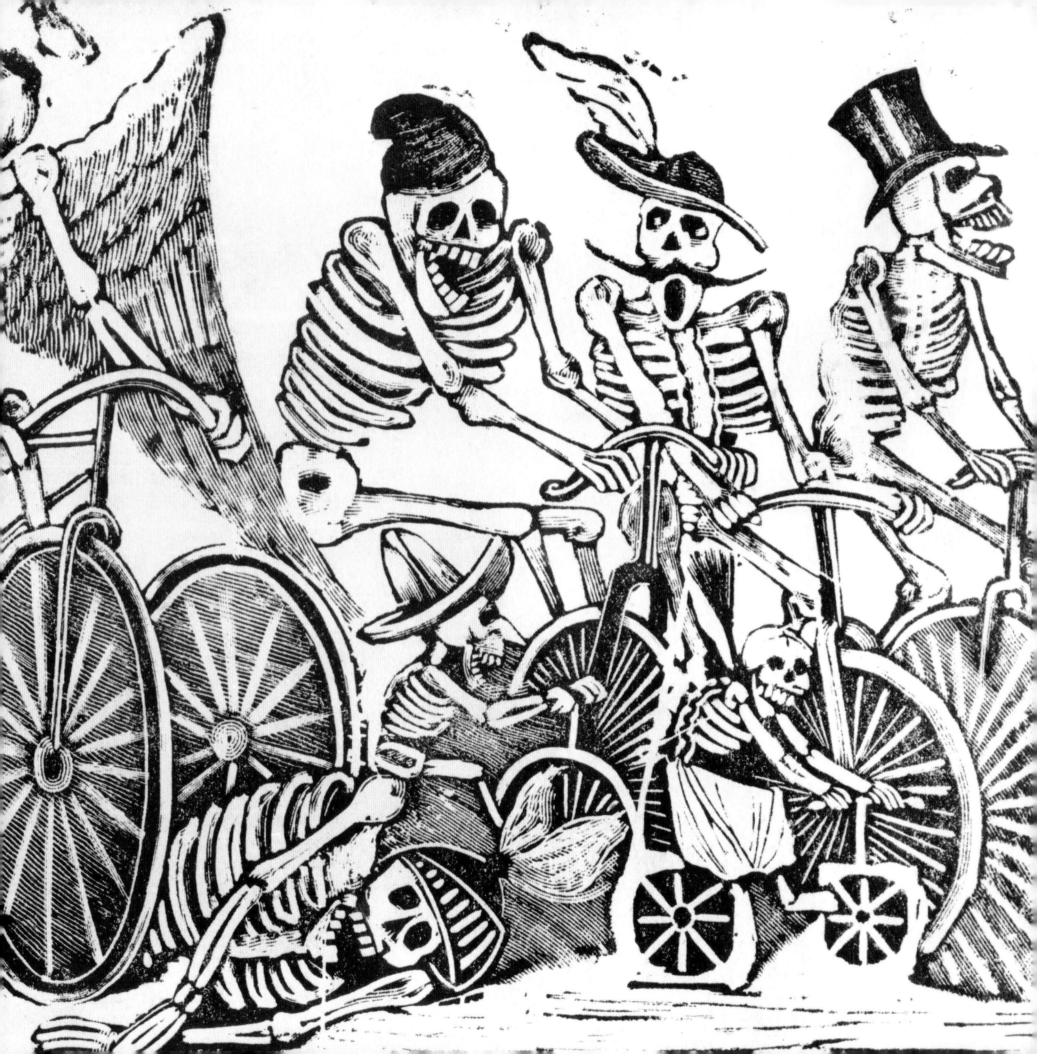

the lunatic skeletons of Posada and even Holbein. 'Life is fragil [sic], love it or leave it', warn the **chattering skulls** and skeletons of **Artemio Rodriguez's** *Life is Fragil*. His linocut creations have a clear link to the *calaveras* of the Day of the Dead, from the **cartoony vibe** of the skulls to the life-affirming messages they share.

Other artists update the approach taken by Posada by throwing in **modern touchstones** and revelling in the resulting anachronisms. *Industrial, cyberpunk, sadometal*, a scratchboard piece from Sergio González Santamaria, features two seated figures (human) in traditional clothing, surrounded by sunflowers. Lovely, but the serenity is somewhat spoiled by the **mohawk-sporting** *calaca* punk between them, standing like some kind of bastard son from another time who has come to ruin the family portrait. It's the **wicked and wild** side of Day of the Dead-inspired art.

THAT LOVING FEELING

Death might love his dog and the *calaca* punk his parents, but romantic love also comes under the sometimes baleful gaze of artists working with the **visual toolbox** of the Day of the Dead. Love is both subject to and defiant of death, as it can be compromised by and transcend it in equal measure; in the tradition of the Day of the Dead, the **beloved dead** can also be reunited with the living once a year when they return on 2 November

Art in this vein might despair at the ultimate futility of love given the **power of death** or mockingly undermine the notion of loving someone 'for ever' by depicting a living groom next to a chilling *calavera* (as in an untitled piece by artist Dr Lakra). The proximity of love, sex and

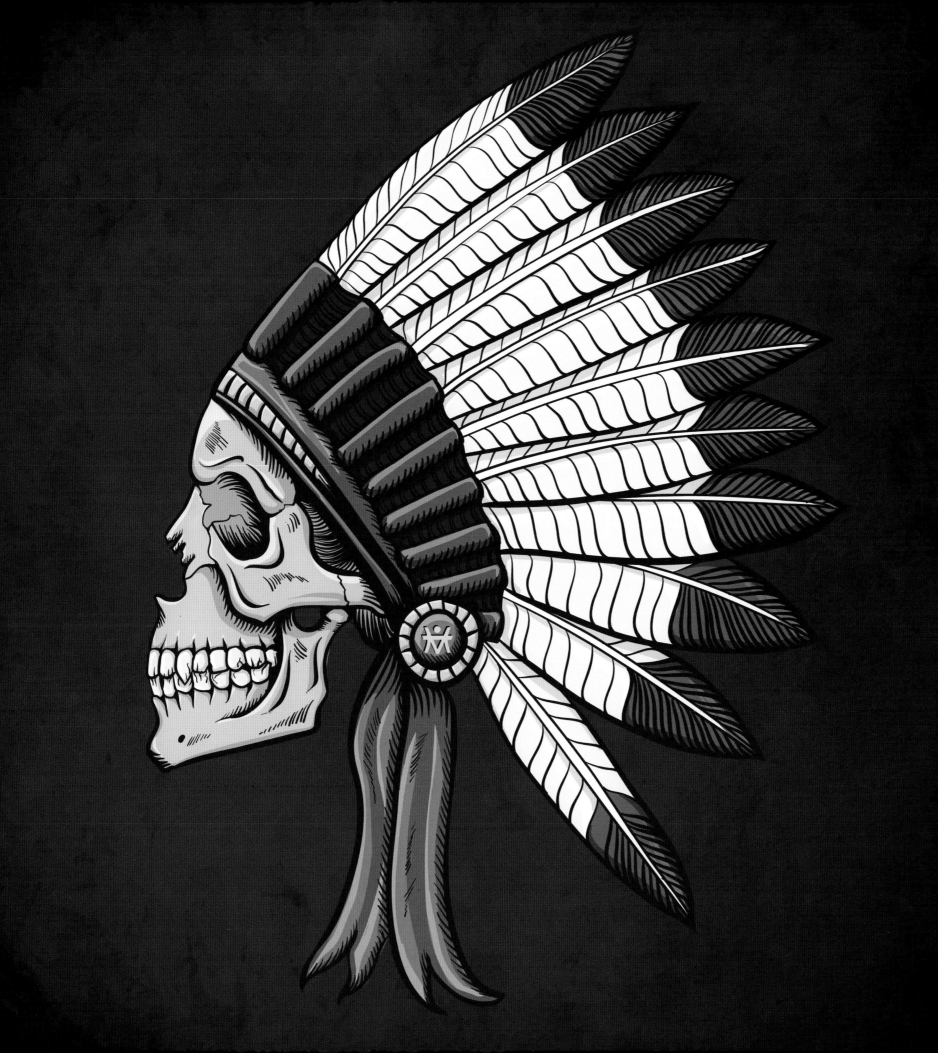

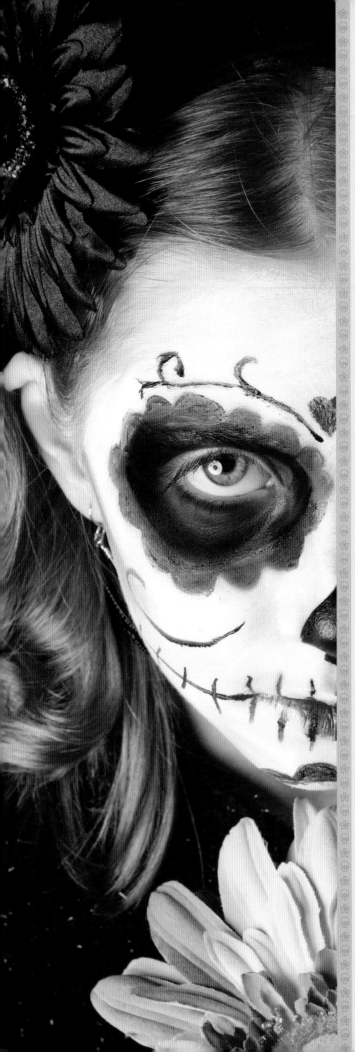

death is suggested elsewhere, the brief empty haze of orgasm and the long-term blankness of death **bumping uglies** in the form of a couple lying, sated, on top of a *calavera* (Sergio Mora, *La Petite Mort*).

On the other hand, some versions of the afterlife espoused in **Mexican culture** suggest that the dead continue much as they did in life, so lovers may ultimately be reunited, or the dead could fall in love – folk art figures showing *calacas* as bride and groom might be romantic, rather than wretched.

SKULLS! SKULLS! SKULLS!

Perhaps unsurprisingly it's the skull that really seems to fire the imagination of **contemporary artists**, whether it's the sole focus of a piece or appearing as an accessory. The skull has been a constant in art, as we've seen, and modern **Day of the Dead** works are no exception.

There are enough kinds of skull inspired by the Day of the Dead to **mark off the days** between one fiesta to the next one. Even within the categories of skull – sugar, sinister, satirical – there are seemingly **endless variations**, reflecting the fact that no two human skulls can ever be the same.

Sugar skulls have a right to be regarded as **folk art** in their own right, in some cases. Of course, some are mass-produced by machine, but some are made by artisans using techniques learned from family members that go back through generations. Some moulds are **decades old**, the recipes used to form the candies a **closely guarded secret**. They can take many months to make and decorate, and the results can be spectacular, a chorus

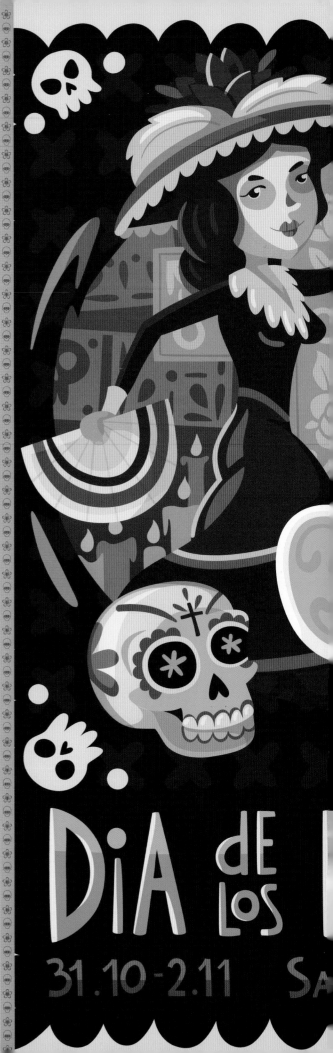

DÍA DE LOS

31.10-2.11 SA

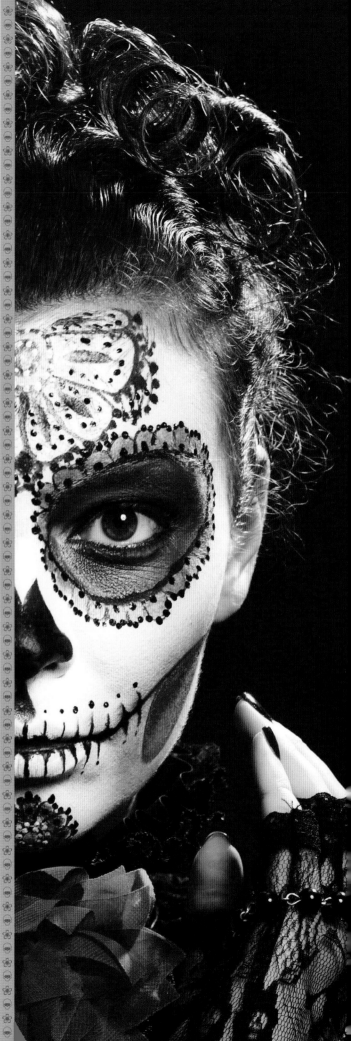

line of **rainbow-tinted calaveras** as worthy of being dubbed 'art' as any rendering on the wall of a gallery – and probably tastier too.

HEADS UP

Other folk art skulls aren't for eating, made again from papier-mâché or carved wood and decorated with the same **distinctive markings** and colours that single them out as belonging to the Day of the Dead. Each is unique, with a curious parallel to the colours of **traditional clown makeup** – worn by similarly tragic and comic figures – which were also one-of-a-kind designs used only by their creators.

The sugar skull has transcended the Day of the Dead and is now found in the work of artists everywhere, at any time of year. They might take the **psychedelic form** of the blazing skull prints of Thaneeya McArdle, which combine **brain-melting patterns** and colours with an effervescent happiness that can make you feel an instant **sugar rush**, without ever quite losing a faint note of spookiness. Printed on t-shirts or pencil cases, this kind of design has a decorative function but also reminds us of the message of the **Day of the Dead** – to love well and approach mortality with a twinkle – all year round.

Other skulls are stark and staring, yet unmistakably born of the Day of the Dead tradition. They glower unblinking from the frame in pieces by **Dr Alderete** and **José Quintero**, still brimming with the sketchy energy of the *calaveras* of Posada but redrawn courtesy of smooth digital lines or **uncompromising black inkwork**. You may smile at death, skulls like these say, but death will never stop smiling back (and you'll have to look away sometime!).

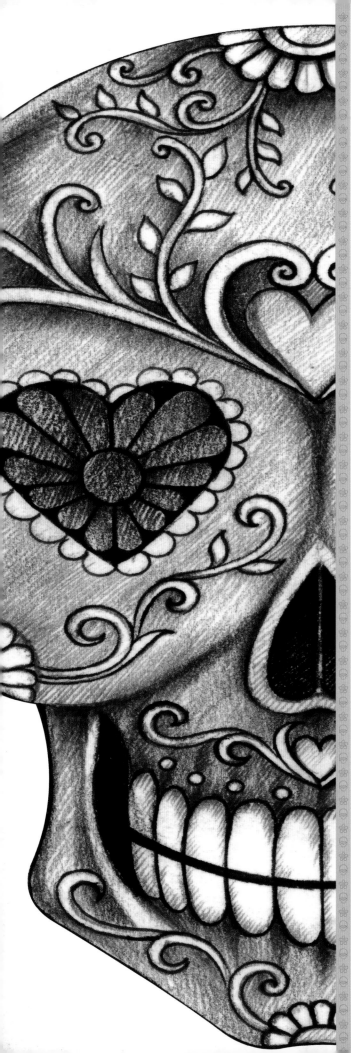

PLAYING DEAD

Skulls and skeletons appear in toy form as **ephemeral folk art** around the Day of the Dead, yes, but they can also be given a more lasting corporeal presence in the form of **vinyl art toys** (which may be for serious collectors, but probably just want to be played with like toys everywhere).

Some have a subversive agenda. *Cristeleto* (Little Christ) by **Andrés Amaya** is a vinyl *calavera* with unmistakable Day of the Dead heritage, offering a goofy gaze up to the viewer. But it is also wearing a loincloth, striking a cruciform pose and displaying the nail-holes of the crucified Christ in its hands and feet – a deliberate **collision of the secular** (or perhaps pagan) tone of the Day of the Dead with Christian iconography, the blood red of the loincloth against the black and white skeleton providing a visceral, combative contrast.

Other toys are there to be beautiful. Kat Caro takes Blythe dolls and dresses them up in full *calavera Catrina* garb, with colourful dresses and gorgeous, delicate skull features. The end result is **hypnotic and subtly creepy**, especially with the outsized eyes and facial features of the dolls further emphasized by the *calavera* markings. Other playful souls have used Lego figures to create animated shorts about the Day of the Dead, or imagined those iconic plastic heads as *calaveras*.

DEATH AND THE MAIDEN

Going one step beyond the chill melancholia of Caro's modified **Blythe dolls**, it's important to acknowledge death as a feminine presence in both Day of the Dead

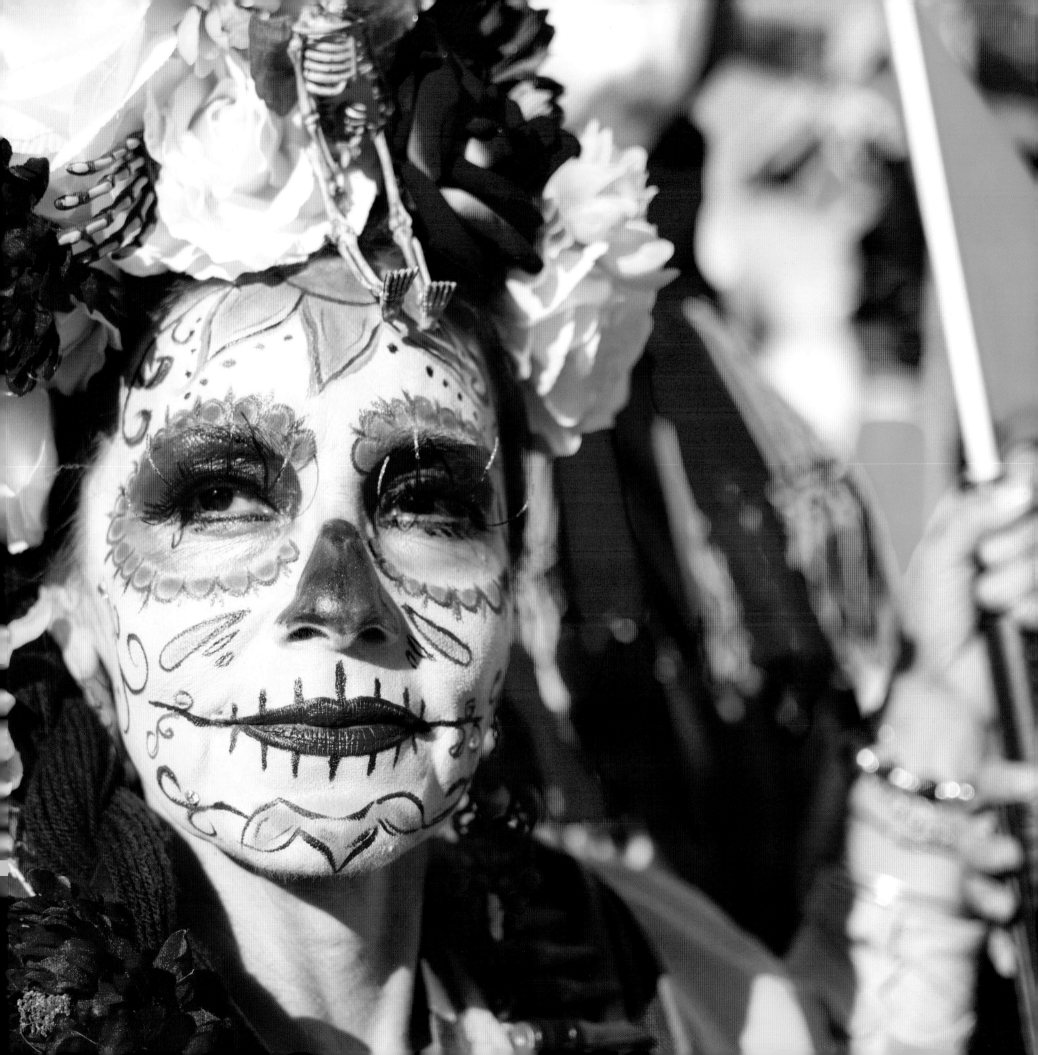

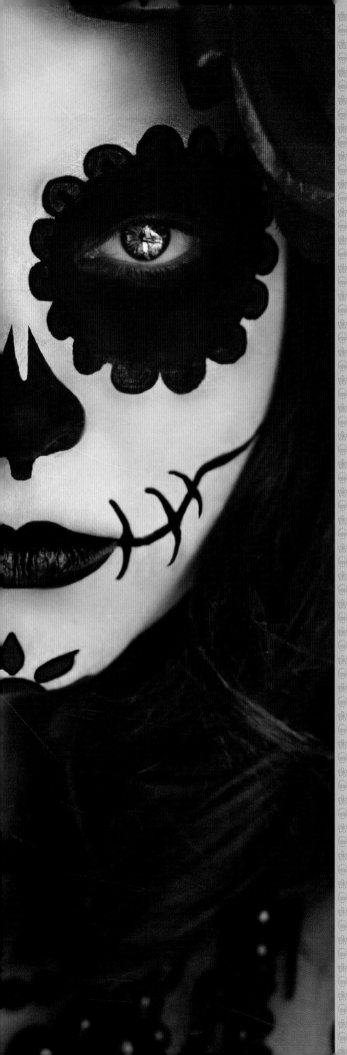

celebrations and wider Mexican culture as well as in art that flows from it.

Death in **Mexican folklore** and beliefs isn't necessarily the gimlet-eyed reaper of the Dance of Death, or the hooded skeleton of European baroque. Death can be a woman, seemingly **alive and a sensual**, even erotic presence: which of course makes her all the more unsettling. There can be no greater horror than feeling the **tug of beauty** when looking at destruction; but might not that same beauty be a comfort at the end of things? She is a supremely troubling figure.

La Muerte, as she is rightfully known, acts as muse and model for artists **channelling the spirit** of the Day of the Dead. She is a constant presence, providing a starting point for photography projects, fine art, folk creations and everything in between. When she arrives she can inspire **devotion or terror, love and hate**, suggesting all the extremes of sex, death and warm-blooded life, plus equally conflicting roles of killer and mother. No wonder artists adore her.

CATRINA LIVES

As the central **female figure** in the iconography of the Day of the Dead since the nineteenth century when she was first engraved by Posada, *la calavera Catrina* is the leading lady in the drama of the Day of the Dead.

As Posada himself put it: 'La Catrina has become the referential **image of Death** in Mexico, it is common to see her embodied as part of the celebrations of Day of the Dead throughout the country; she has become a **motive** for the creation of handcrafts made from

clay or other materials, her representations may vary, as well as the hat.'

Folk artists have rendered images of Catrina in sculpted wood, as a papier-mâché figure (sometimes accompanied by other skeletons), even in sawdust or **delicate pottery**. In contemporary popular art she is seen in **Sergio González Santamaria's** linocuts as a mirror image of Rivera's version, but holding hands with a leather-jacketed punk **rock incarnation** alongside her to put an edgy spin on the Rivera original.

Nor is she immune to the digs and skulduggery of modern Day of the Dead themed art, as **nothing is sacred for ever**. She is variously seen as a rabbit skeleton and even a surfer, her appearance and attire varying wildly from **flowing gowns to bikinis**. Her original role of satirizing the vanities and aspirations of the middle class does not always go with her into modern pieces; but she does always have the hat.

LADY DEATH

La Muerte as a woman also takes many guises. Some works, like Sara K. Diesel's *Lady of the Dead* are classically composed and **heavy with symbolism**. In this image the solemn figure is inspired by the Aztec death goddess **Mictecacihuatl** and appears as both beautiful and terrible. Her hands are heavy with blood and she bears a decorated skull with **smouldering eye sockets**, while her own face is both flesh and blood and marked as a **calavera**, linking her to the traditions of both the pre-Hispanic people of Mesoamerica (think back to the skull-faced Mictecacihuatl of the codices) and the latter-day Mexican Day of the Dead. The associations are made

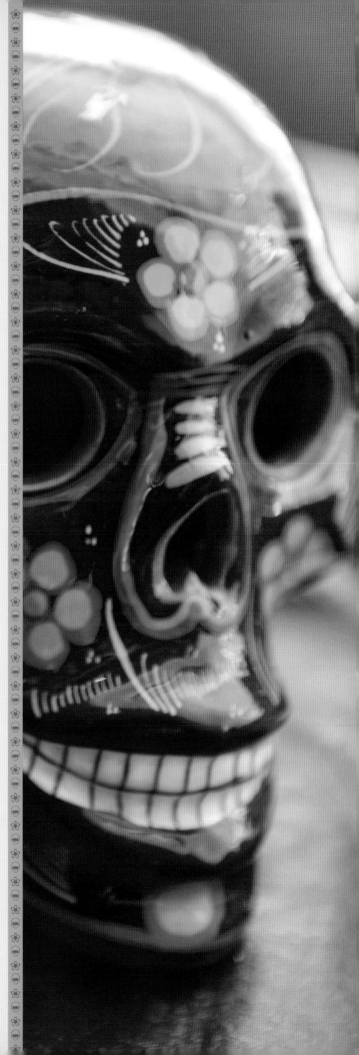

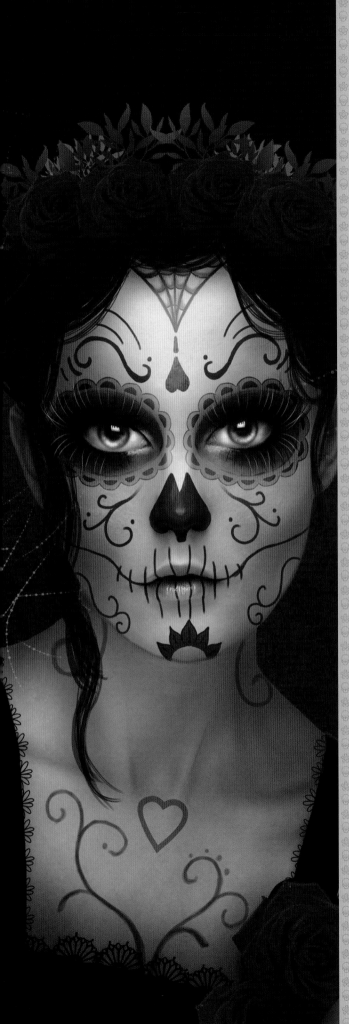

even more clear courtesy of the **marigolds and red cockscomb flowers**, so often found as part of the Day of the Dead *ofrenda*, which garland her hair

Other versions take a more playful approach, such as the bubble-gum **punk pulp style** of some of Aly Fell's women – one image shows Death recast as an emo teenager, ripped jeans and all, popping bubbles in which *calavera*-like skulls are bobbing. Similarly playful, **Jasmine Becket-Griffith** eschews the skull face but surrounds her *Angel de los Muertos* with *calaveras*, flowers and colourful fabrics, with 'sorrowful / kitsch eyes' that seem to echo the Big Eyes paintings of Margaret Keane.

WONDER WOMAN

Other specifically feminine pieces carry a clear sense of *Mexicanidad*, in particular the soulful oil portraits of Sylvia Ji. Her **porcelain-skinned figures** have the same glorious sugar skull visage but none of the giddy glee of the dancing *calaveras* we have encountered in the past – they are thoughtful and reflective, the national colours of Mexico running vividly through the images and acting as a striking counterpoint to the solemn expressions on display.

Elsewhere, art from creatives like John Picacio takes the aesthetic of *La Muerte*, complete with *calavera* face and searching, beckoning eyes, and blends it skilfully with more **Gothic components** – Death the maiden can easily wear both styles, dark eyes and Day of the Dead patterns working with **sinister, bony skulls** and memorial roses to evoke a delicious melancholy.

Other imaginings are tough and punk as hell, showing *La Muerte* variously as a tattooed surfer girl or a hardcore

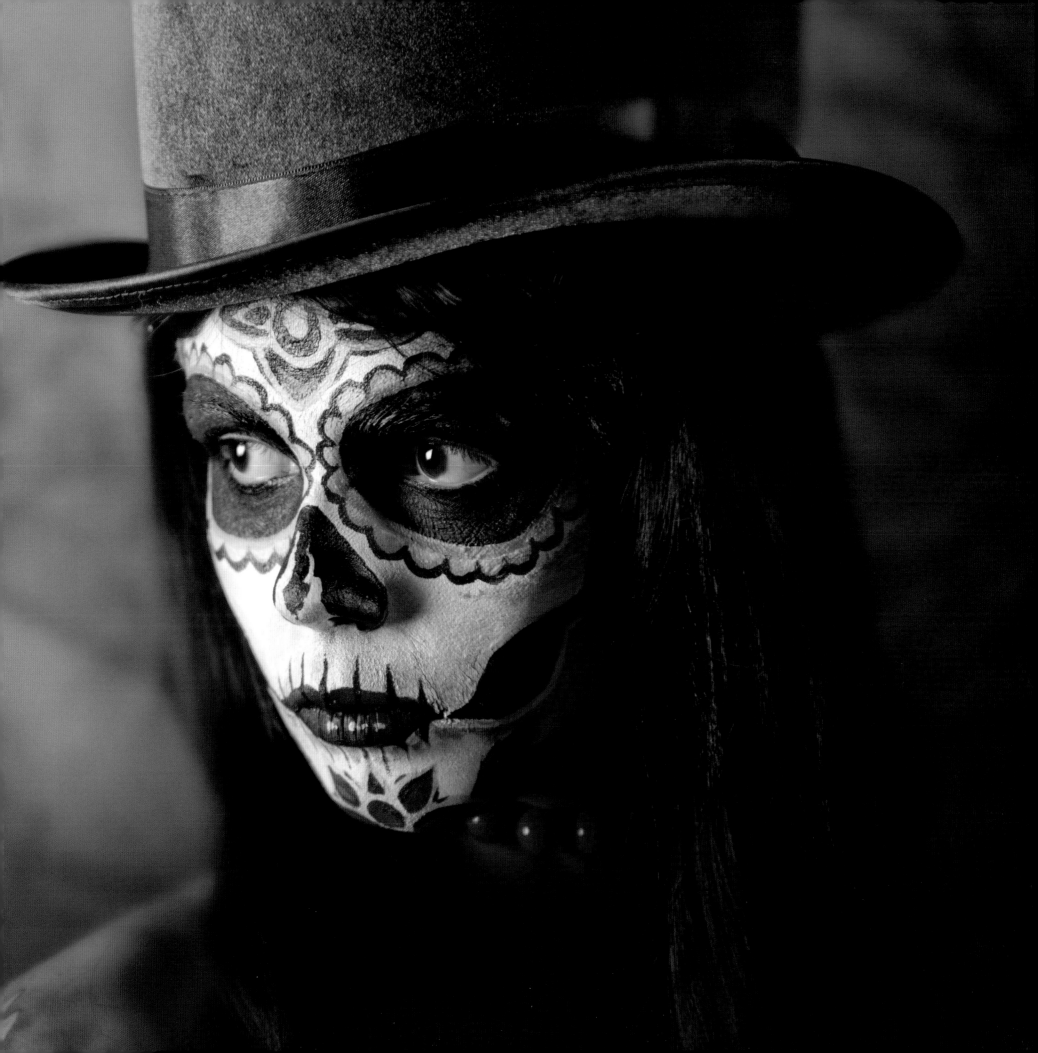

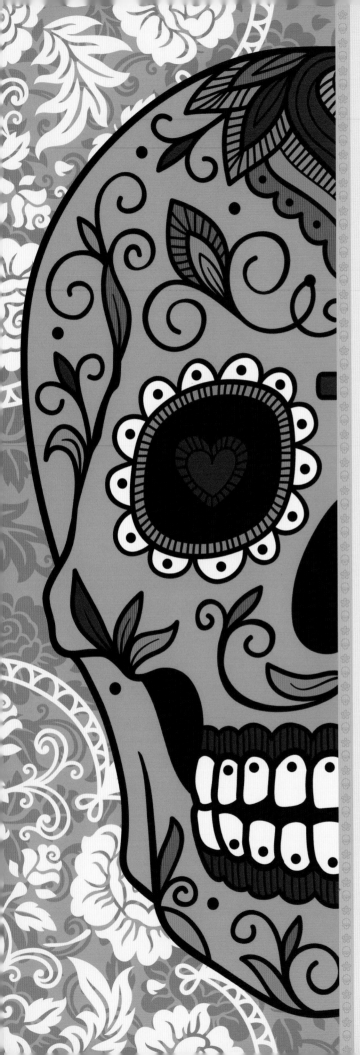

rock chick with **Americana tattoos** and a backing band made up of sax-toting *calacas*. Still more sit snugly in the finest pulp magazine cover traditions – corsets, bosoms and warm colour palettes abound – or ethereal **fantasy, sci-fi and steampunk** aesthetics. In all cases the lady in question is made **slightly distant and mysterious** by her face, which may be decorated, or may be the features of a paradoxically alive *calavera* if she is truly the embodiment of a supernatural being or death itself. Is death painted on, or peering through? That's part of her strange appeal.

LET IT BE

It's worth noting that another **sacred female** – the Virgin Mary, patron saint of Mexico – also appears throughout the Day of the Dead, whether that's during fiesta celebrations or as a figure in **contemporary art** inspired by them.

Her presence is evidence of the ongoing Catholic **influence on the fiesta**, which is after all built in part on the Catholic All Saints' and All Souls' days, however secular the modern-day Mexican incarnation may be in many places. She will often be present as part of the *ofrenda*, a small statue of her accompanying **pictures of the departed**, for example. Folk artists recreate her in papier-mâché or wood around the time of the festivities, too (as well as other holy women, nuns included).

She may also appear in more abstract forms. Some feminine Day of the Dead images seem to combine *La Muerte* and the Virgin Mary into one gestalt sacred entity – Marie Meier's *Sante Muerte* (Saint Death) figure has the halo, shawl and companion angels of Mary herself but she

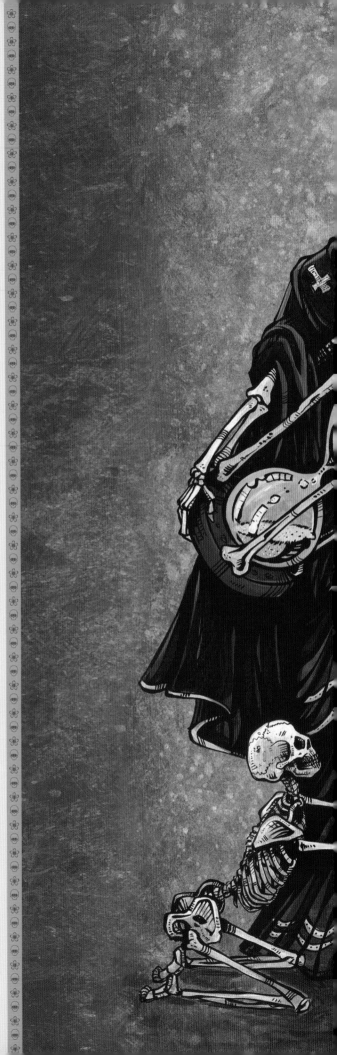

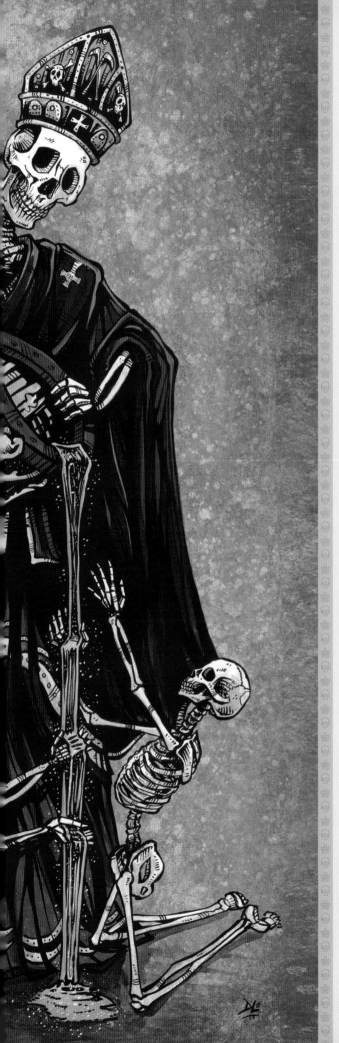

is also a *calavera*, the 'angels' actually bat-winged *calacas* in a deliberate play on the **traditional holy iconography**. Other works follow a similar pattern, taking classical poses from spiritual art – **eyes cast heavenwards**, hands open in supplication, halo glowing – only with the expected gentle face replaced by the deep sockets and bare teeth of the skull.

SWEET AND LOWDOWN

The collision of the female form and the imagery of the Day of the Dead is popular among **lowbrow artists** in particular. The term itself is somewhat disputed – some artists working in the genre find it accurate, others patronizing – and so other options abound, including 'pop surrealism', **'cartoon pluralism'**, 'narrative noir' and 'psychedelic punk' to name but a few. All seem to fit but for now 'lowbrow' is in the ascendance, so we'll stick with it for the sake of argument.

Plus, it's a genre that is authentically fixated on the dusty and delightful **lowbrow corners of pop culture**, so the term seems apposite. Lowbrow artists find joy in the plastic ephemera of twentieth-century American kitsch, the roadside **diners and neon**, the giant cars modded and rodded to wear outsized fins and **supercharged, super-chromed engines** and bodywork.

This is the realm of the tacky Tiki bar in thrall to Polynesian pop; the genuine surfer from the time when people acknowledged that standing on a **heavy board** in a freezing ocean is an odd, tough lifestyle choice rather than just a t-shirt; it's old-school sailor tattoos, rockabilly tunes and **wacky carnival grotesques**, beatniks, cartoons and gruesome gothica. It's all of this and more, a way of life

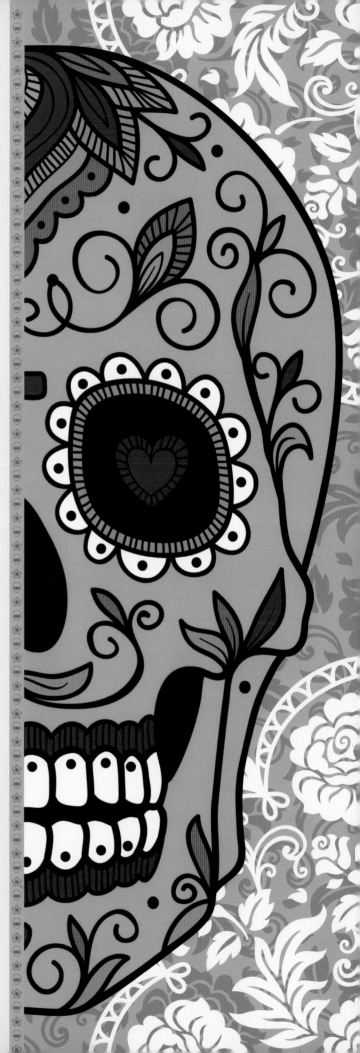

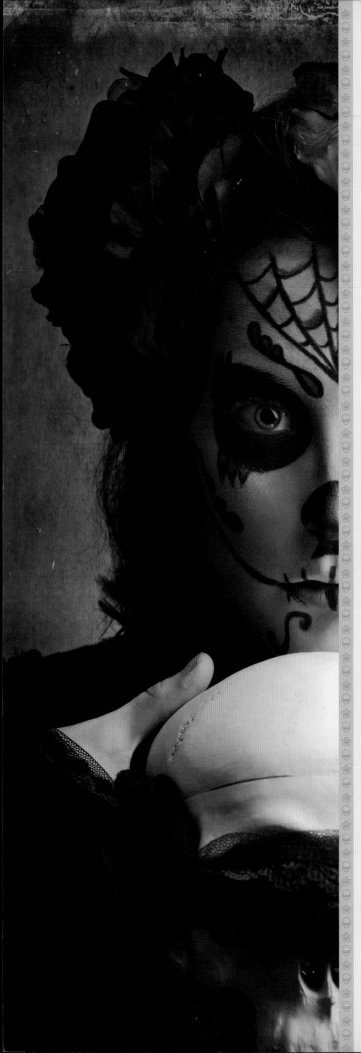

enamoured with **death trends and desolation** as much as it loves a good party. The *calacas*, of course, adore it.

WISH THEY ALL COULD BE CALAVERA GIRLS

The *calavera* and *la Muerte* meet the 1950s pin-up girl in lowbrow art with striking consequences. There's no room for the subdued spirituality of other incarnations here, or the coy or romantic beauty of fine art representations: these are **bold, sexy, empowered figures** and are drawn as such.

Artists draw on different elements of the Day of the Dead and **lowbrow visual styles** to articulate and accompany the personalities of their pin-ups. Some (like **Marie Meier's** *muerte* pin-ups) are confrontational and mired in psychobilly mariachi fantasia, dressed in black with their guitars slung low, while a gang of lesser *calacas* keeps time on banjos and drums around them; skulls abound, but so do more uniquely lowbrow elements – gnarled hound dogs, **magic eight balls and surf pop landscapes** filled with cartoon oceans and palm trees, sharks and surfing skeletons.

Others throw in **pseudo-religious poses** surrounded with the hyper-emphasized flames of classic hotrods or animated corpse hands, or choose to restrain things to a few primary colours and the dot shading of Lichtenstein's pop art. These are **classic, confident pin-ups** with *calavera* faces, tops cut low, fingers adorned with skull rings and looking out coolly with a raised eyebrow and folded arms; seeming to ask **'What are you looking at?'** while simultaneously commanding attention; it's our relationship with death in microcosm, or the start of a very bad night for someone.

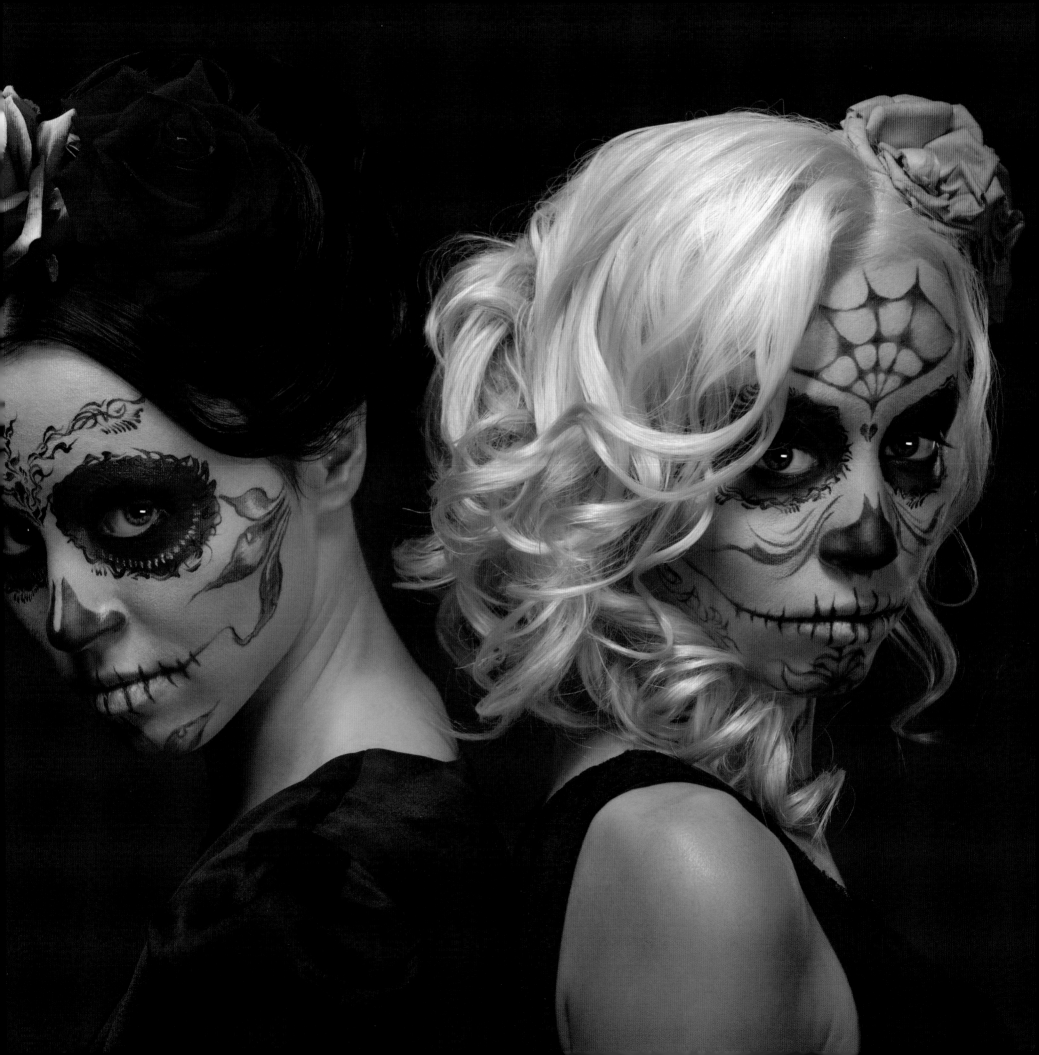

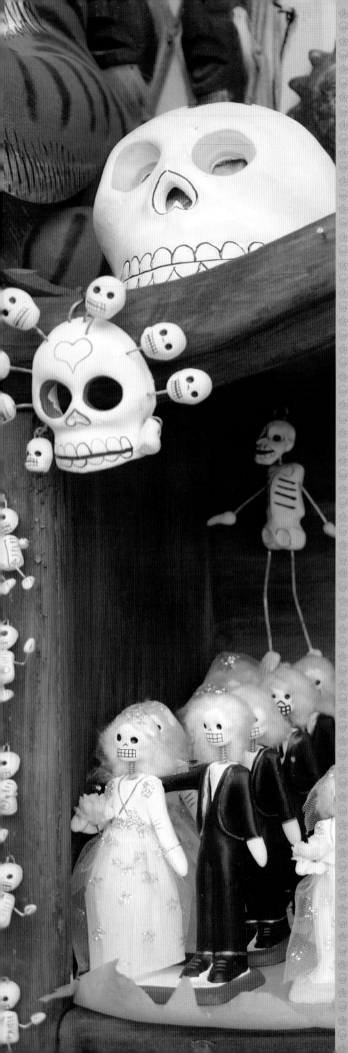

CARS AND CALACAS

Some lowbrow artists abstract things a little more, as seen in the **highly stylized burlesque pin-ups** of Robot Soda, which seem to have been sprayed into the world straight from a 1960s bar in the afterlife – Death the pin-up fluffs her **luxuriant Cher hair**, the cheeky, grooving spirit of the Day of the Dead alive and well.

Cartoons and underground comics are a further essential element of lowbrow art and the Day of the Dead finds its way into pieces embracing their imagery. Gary Baseman's acrylic pieces have the feel of **old-school animation** merged with surrealism, often featuring a playful skeleton who could have wandered in from Mexican folk art.

Joe Coleman, meanwhile, creates intricate fairground and freak-show pieces in which Posada-like elements exist on the periphery. Lurking in the background of his ghost train, **skeletons on horseback** could be riding from the dance of death or the Day of the Dead; there is a humorous tone, but also a true **heart of darkness** beating in the midst of things.

CULTURE CLASH

Other lowbrow art displays just the hint of a brush with the Day of the Dead – it's in the attitude as much as the art. *Death Takes a Holiday*, a piece from The Pizz, is a lowbrow fever dream: a giant hotrod lays down a trail of fire as it rolls out of a **grim industrial hellscape**, smoke skull clouds all around it; the driver, Death, displays just a trace of the **calavera** smile as we glimpse him through the open window. It's a vision of the American scream with a twist of the Day of the Dead.

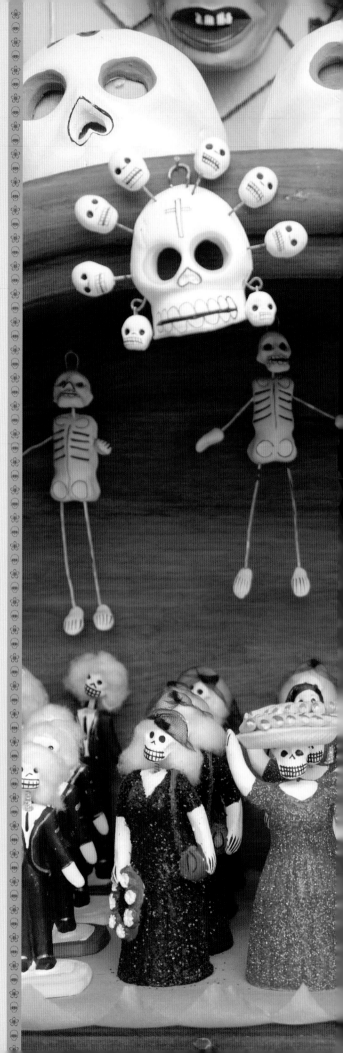

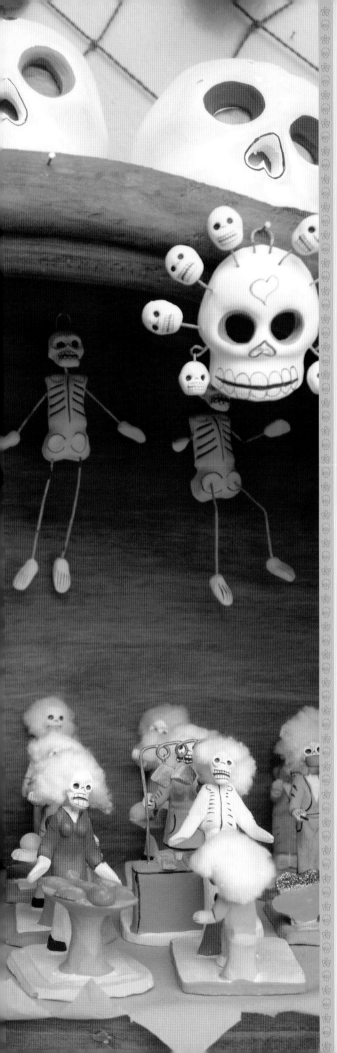

A PORTRAIT OF THE LOWBROW ARTIST

Calacas are front and centre for other artists. David Lozeau is a lowbrow artist who contributed pieces to this book and draws a lot of inspiration from the Day of the Dead as it manifests in Southern California – from marigolds to skeletons painted on **low-rider motorcycles.**

'These are some of my more whimsical paintings,' he says of his work for these pages, 'because I want to convey that *el Dia de los Muertos* is ultimately about celebrating life.'

He creates his **droopy, cartoonish calaveras** through a unique three-step painting process, he explains. 'I utilize acrylics for my background, gouache for my underpainting, and **enamel** for all of my dark line work and definition.' The end result is a glowing piece of art that's **crisp and clear** without ever becoming too dry – his characterful *calaveras* have a huge, warm life.

Why the Day of the Dead? It's an **ongoing source of inspiration** for him. 'I am inspired by the history, people, music, food and art of Mexico and enjoy applying a Day of the Dead filter to other cultures and genres,' he says.

The appeal is partly in the festival itself and its look, but also in the **underlying cultural philosophy.** 'I understand the need to overcome loss, to create a new visual and build **a new narrative** for someone who has passed,' says David. 'I like that the holiday turns skull and skeleton imagery into something **colourful and playful,** expressing with a simple wink and a smile that death is merely one part of life.'

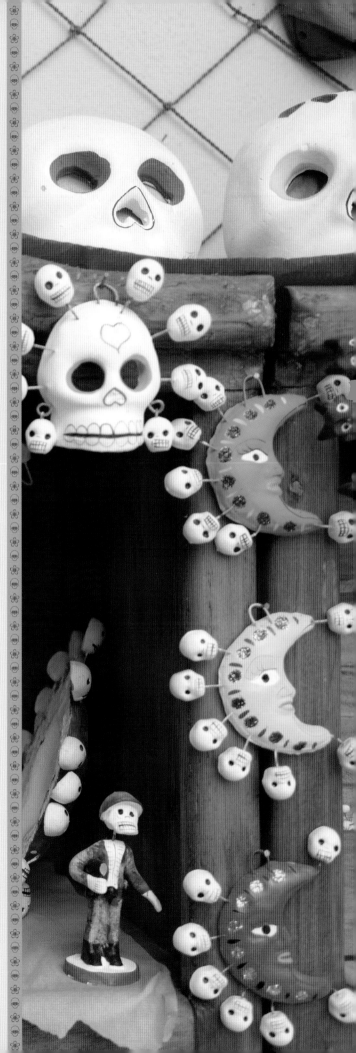

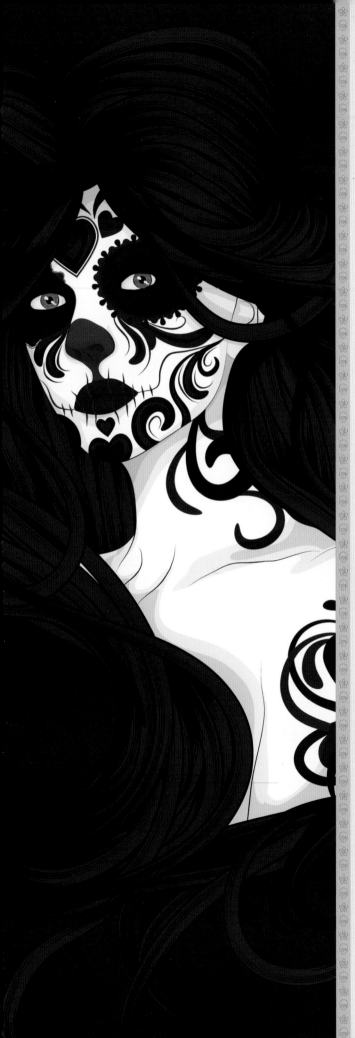

DARK ARTS

While life-affirming sentiment and tidings of **comfort and joy** are generally at the heart of the Day of the Dead, not everything is light. There's no doubt that, however cheerful or satirical they are, a **carnival of skeletons** is going to have a macabre edge. It might not be the wilful **death wish** of Halloween, but that mortal tremor is always present.

Art inspired by the Day of the Dead can go even further than this, **abandoning all pretence** of positivity and appropriating Day of the Dead imagery for its own nightmare purposes. Is this respectful of cultural tradition? That may be down to the individual to decide; but art has always been obliged to ask the **hard questions**.

Dark Day of the Dead art goes all the way back to Posada – some of his engravings, including a **breastfeeding skeleton** with a pitiful skele-baby at her breast, make for uncomfortable viewing. Other artists keep the social aspects of the fiesta but remove the humour, instantly transforming it into a **ghastly gathering** of hollow-eyed ghouls throwing a hideous party. Dr Lakra's augmented photos and postcards, meanwhile, scratch *calaveras* on to the faces of the living, making them into zombie-like fiesta revenants. And not in a fun way.

FILM NOIR

Mexican artist **Marcos Raya** brings a similar approach to his mixed-media pieces, all of which begin with traditional **photographic portraits**, which are then transformed into haunting *calaveras* without so much as the trace of a smile. This is death as a serious business, the antithesis of

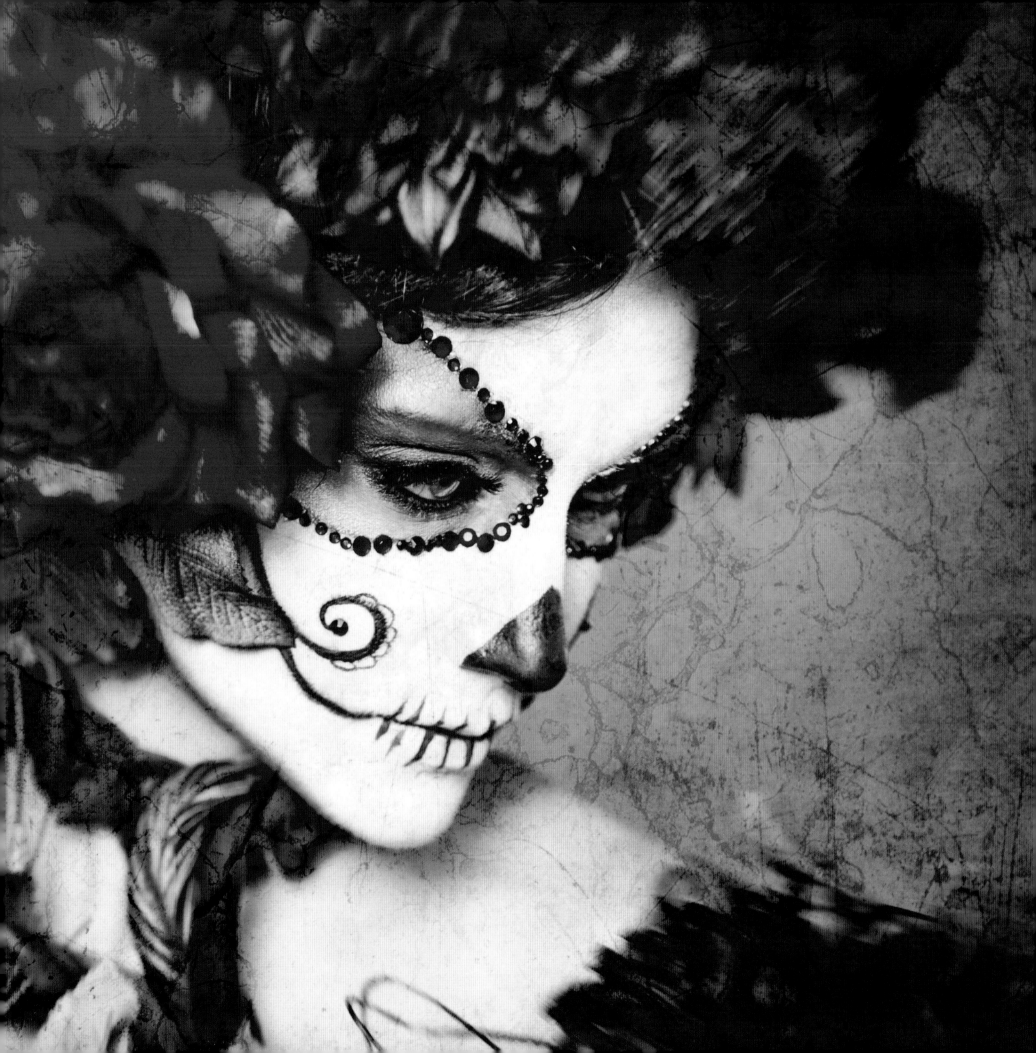

much Day of the Dead themed art. Instead of using death as a means to remember our family with affection, we're invited to use our family as a means to **remember death**, and how close we are to it.

Other photographic projects around the Day of the Dead can have a **thoughtful quality**, if not a morbid one. Dana Salvo's intimate portraits of **ofrendas**, seen without anyone around, give them an added poignancy. It's as if we glimpse them in an unguarded moment, simultaneously bright and cheery and **hushed and respectful**; the combinations of **fruits, flowers and family** portraits are a kind of mixed-media folk art in their own right.

At the other end of the scale, fashion photographer Rankin's *Alive in the Face of Death* collection featured a series of portraits showing Day of the Dead themed masks on models: removed from their **cultural context** and seemingly **stamped into the living skin**, they are harsh, vivid images with a cold edge. Much softer are the many and varied photo collections of models dressed as *La Muerte*, which use *muertos* imagery to offer a sensual vision of death as escapist fantasy.

INKLINGS OF DEATH

La Muerte extends her reach from the page and on to skin in the case of many Day of the Dead-inspired tattoos. Skull and skeleton imagery is an **essential component** of the black and grey horror traditions of tattooing, where they exist to shock, scare, provoke and act as a **relentless reminder of death**.

Not so *la Muerte*, who often combines with the traditional (or old-school) design of a gypsy woman: she is softer,

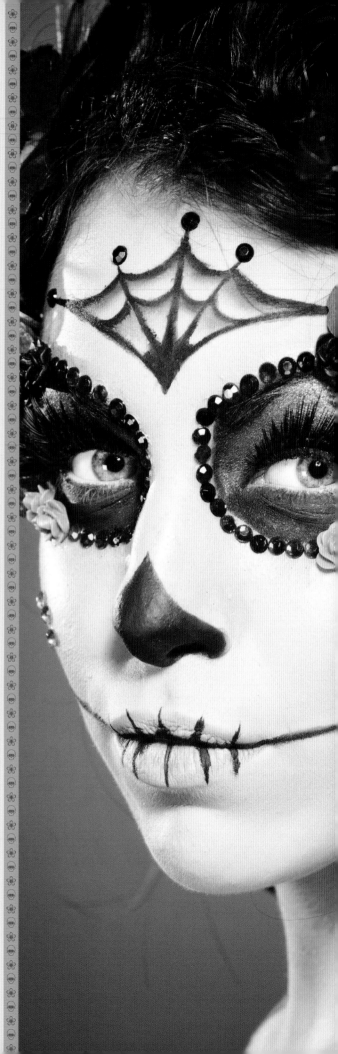

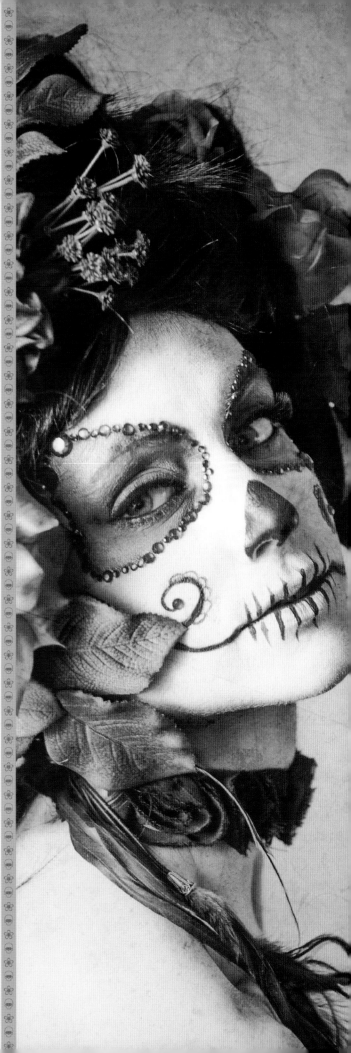

beautiful and much more positive. In many cases, the tattoos are based on a real person, perhaps as a tribute, adding a further **layer of meaning** to the image that ties right back in to the purpose of the Day of the Dead: every time the tattoo collector looks at the ink, they are calling the **spirit or memory** of that person back to visit. It's like having a constant *ofrenda* with you to honour a departed soul and take comfort from their life.

New-school ink, on the other hand, is effectively the tattooing division of lowbrow art. Anarchic, cartoonish, irreverent and surreal, it relies on huge thick outlines and banging **swathes of colour**. Anything can be converted into a new-school piece, so it's common to see *Star Wars* characters converted into *calaveras*, or other pop culture icons transformed into *calacas* in Day of the Dead regalia. They are bizarre and sometimes satirical, always tongue in cheek; perfect vehicles for *muertos*-inspired art.

THIS CITY IS DEAD

As a celebration that relies on a very public element to the festivities in the form of **parades, cemetery vigils and ceremonies**, it's fitting that the Day of the Dead inspires urban public art – or street art, as it's also known.

Urban public art in Mexico has its roots in the broadsides of the Day of the Dead, which were in some cases literally pasted up on to walls, as well as in the **large-scale public works** of the muralists (so *muertos* themes have always been present in it). Latter-day pieces may not be quite as officially sanctioned but carry no less artistic skill – they may be **created with aerosols**, pasted up, stencilled on, sometimes around the Day of the Dead itself but sometimes just playing on the visual themes.

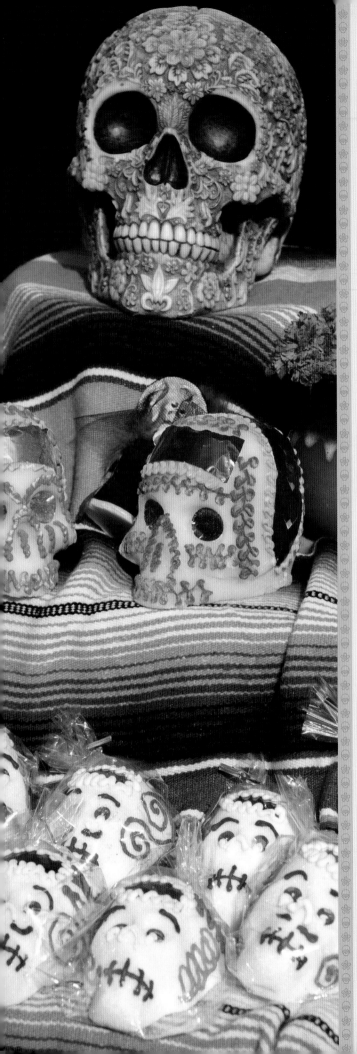

It's the same the world over London street artist Skeleton Cardboard has created *calavera*-style characters in recent years, usually accompanied by **anticonsumerist slogans**, using the *joie de vivre* of the Day of the Dead to remind us all to cherish life by switching off our TVs and not buying for its own sake.

Day of the Dead street art might feature *la calavera Catrina*, *la Muerte* or other aspects of the festival, from *ofrendas* to graveyard gatherings; when graffiti artists create works without consent, they might even be said to be continuing the **rebellious tradition** of the fiesta, which has been used for so long as a means of asserting **identity and nonconformity**.

LAND OF THE DEAD

In fact, the Day of the Dead has effectively infiltrated every form of art in one way or another over the years. **Batman** villain **El Sombrero** even sports a *Lucha Libre* mask decorated as a *calavera*, showing just how deeply ingrained the iconography of the fiesta has become in contemporary pop culture; there's even an argument to be made for the incarnation of the **Joker** in *The Dark Knight* (2008) as wearing makeup inspired in part by a corruption of a *muertos* mask.

Contemporary art around the Day of the Dead does like to take established characters – like the Joker – and dress them up. **José Pulido's** drawings variously imagine **Darth Vader**, **Yoda**, even country singer **Johnny Cash** as *calaveras*, somehow capturing the sense of the original character or personality and also imbuing it with the infectious good nature of the fiesta itself. You

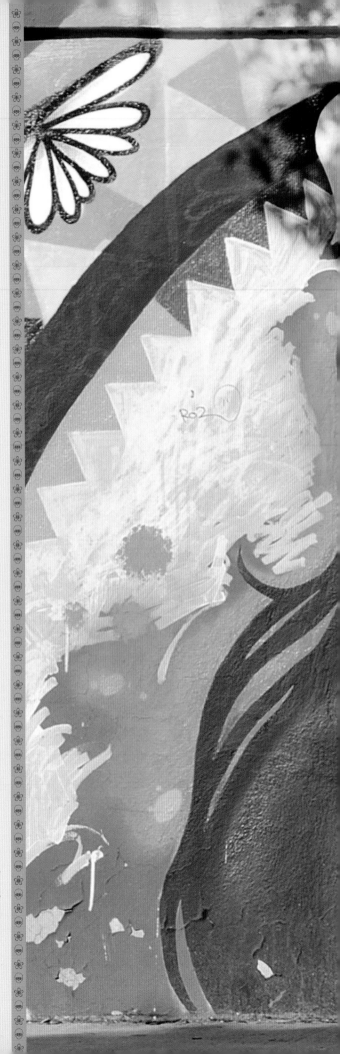

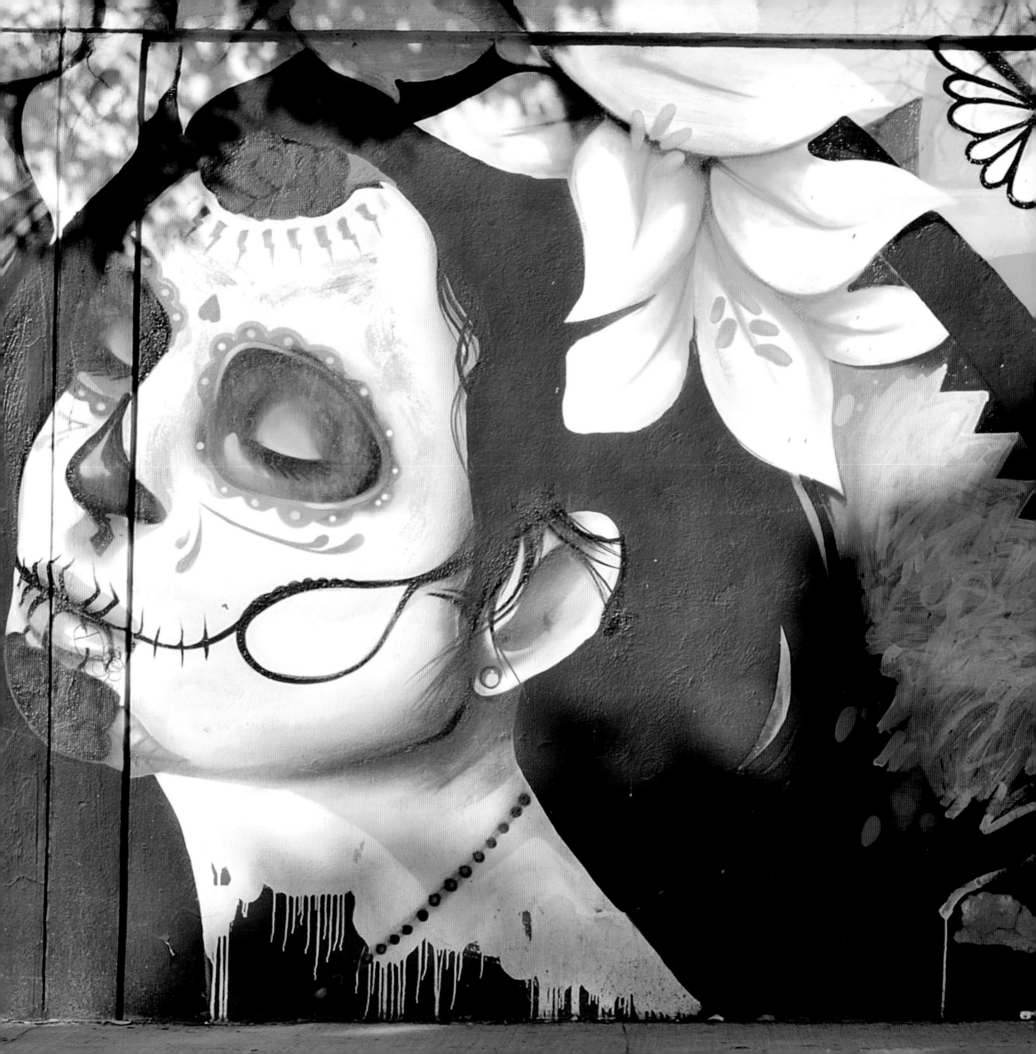

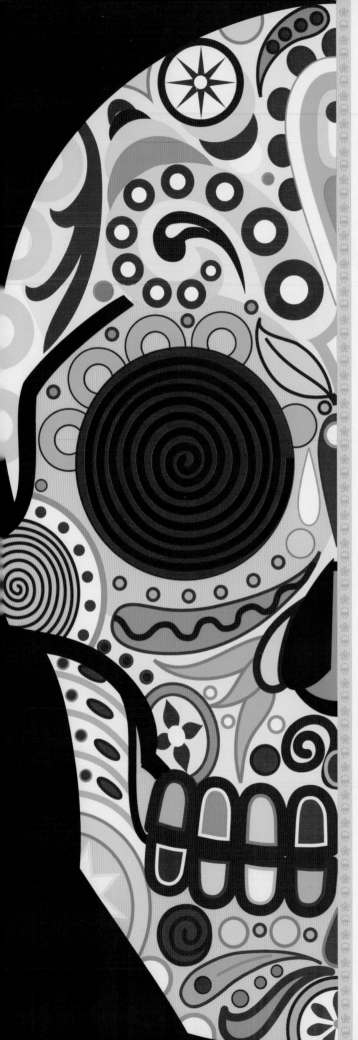

can also find *Star Trek* vinyl toys with a **calaca** vibe to them – live long and prosper indeed.

Some work is gnomic and strange, like Todd Schorr's uncanny *Madame Calivera's Corporate Identity Program*, in which a female **calavera** slings some yuppy types through a hoop of fire. Other pieces take key visual elements and build whole new worlds, like the luminously beautiful concept art produced for *The Book of Life* movie (2014) by **Paul Sullivan**.

IT'S ALL A GAME

World building of a different sort takes place in pieces that are rooted in tradition: decks of **Loteria** cards may be intended for play but they are also miniature, portable galleries of Day of the Dead themed art, full of **carousing calacas** and intricate sugar skull designs.

The game itself is similar to bingo and arrived as a European import in the eighteenth century, at which point it was mainly played by the upper classes (who would have had access to it); it went on to become popular throughout Mexico.

The game itself is simple but it is the cards that prove irresistible to artists with **muertos** on their mind. The 54-card deck bears a character on each card; many of these characters feature in every **Loteria** deck. They include **romantic-sounding** creations such as The Dandy, The Siren and The Devil, as well as more incongruous ones including **The Shrimp, The Umbrella and The Heron.**

Some artists will create an entire **muertos**-inspired deck, showing exactly how flexible the imagery of the

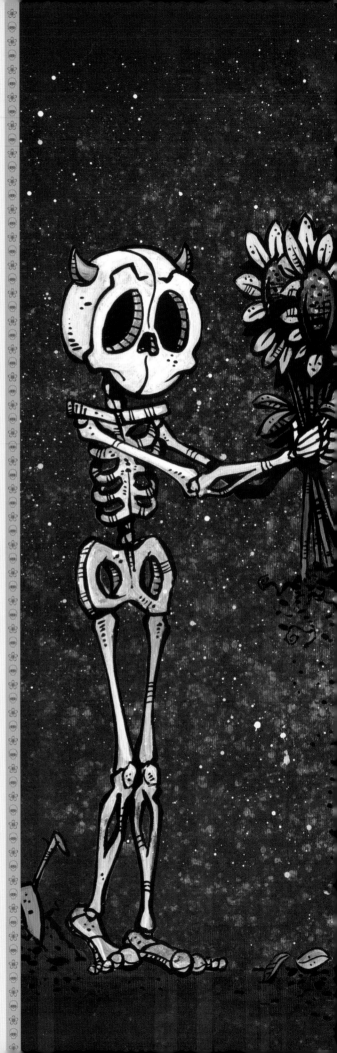

Day of the Dead is (and also how vivid the imagination of the artist, of course). Others will take **principal characters** and play with them, applying Day of the Dead themes and also incorporating external elements: the primary colours, scrollwork and heavy black lines of **traditional American tattooing** seem to work well in this context.

DEATH COMES TO US ALL

Once they've put the cards down, some artists really go out on their own, like **Rankin's stark masks** or the creators of vinyl toys imagining the Borg as **calaveras** (as if they weren't weird enough). Lowbrow artists only require the faintest nudge from the Day of the Dead, mixed in with the cocktail of **pop trash** hooch that they love, to really get going; while the *muertos* influence is there, it's not overpowering.

Other artists like to keep within the conventions of the fiesta but have their own fun with them. So we see **strangely contrasting characters** in a Posada-style woodcut, or even a Posada-themed custom paint job on a car. Margarita Flick takes the idea of **paper cut outs**, integral to the Day of the Dead, and takes them down an infinitely **complex, much darker path**.

There are no rules. Much like the fiesta itself, when it comes to the **Day of the Dead**, artists from all disciplines and from all over the world share a similar philosophy: why let a little thing like death get in the way of a good time? Far from navel **gazing and dwelling** on mortality, from album covers to art galleries, the Day of the Dead in popular art is all about **tipping a hat to death**, but getting on with the business of living.

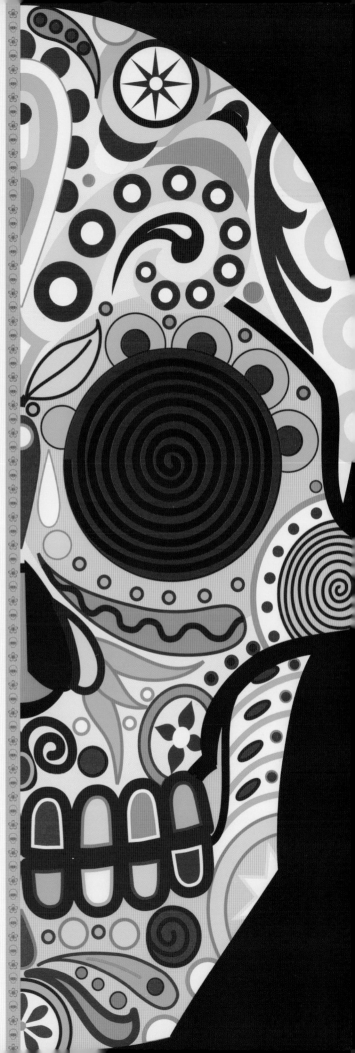

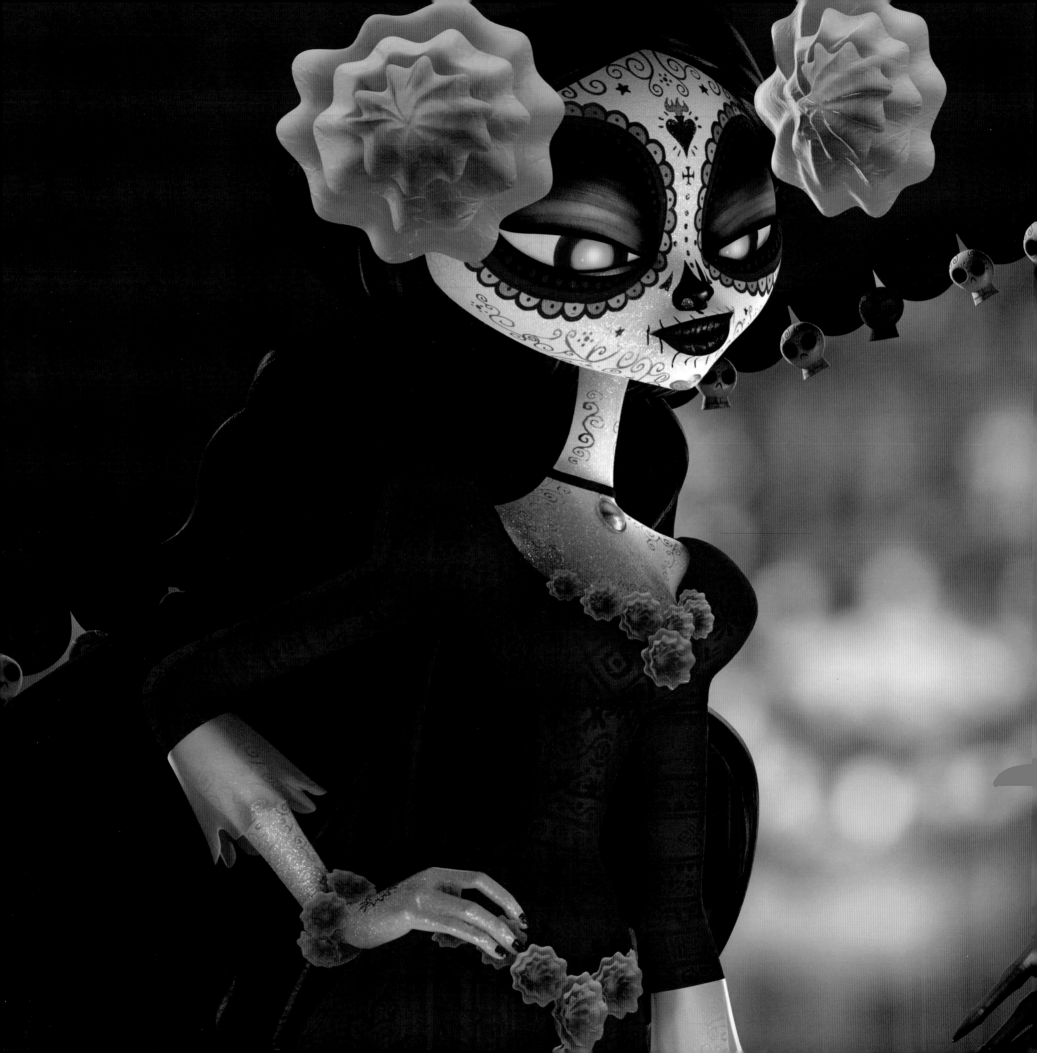

DEATH BECOMES US

DEATH BECOMES US

The ghosts of all things past parade, Emerging from the mist and shade That hid them from our gaze, And full of song and ringing mirth,

In one glad moment of rebirth,
Again they walk the ways of earth,
As in the ancient days …

—J.K. Bangs, *Harper's Weekly*, 5 November 1910

The dead return, walking amongst us. Bangs' poem refers not to the **Day of the Dead**, though, but Halloween, showing in a few short lines that there are definitely similarities between the two **autumn celebrations**. Any survey of the Day of the Dead in popular culture has to include its cosy and sometimes combative relationship with its **bloodied and cloaked** counterpart.

As previously discussed, Halloween and the Day of the Dead share a common heritage in **pre-Christian ritual**, more specifically in Celtic harvest rituals, once observed in autumn: the time of year when crops are gathered in and the world seems to visibly age and fade before the **long deathlike sleep of winter**.

Halloween as we know it has evolved from the Celtic festival of **Samhain**, which coincided with the harvest and marked the beginning of their new year (on 1 November). For the Celts it was a liminal period, a time when the veil between worlds was drawn aside and the dead could return to **roam on earth**.

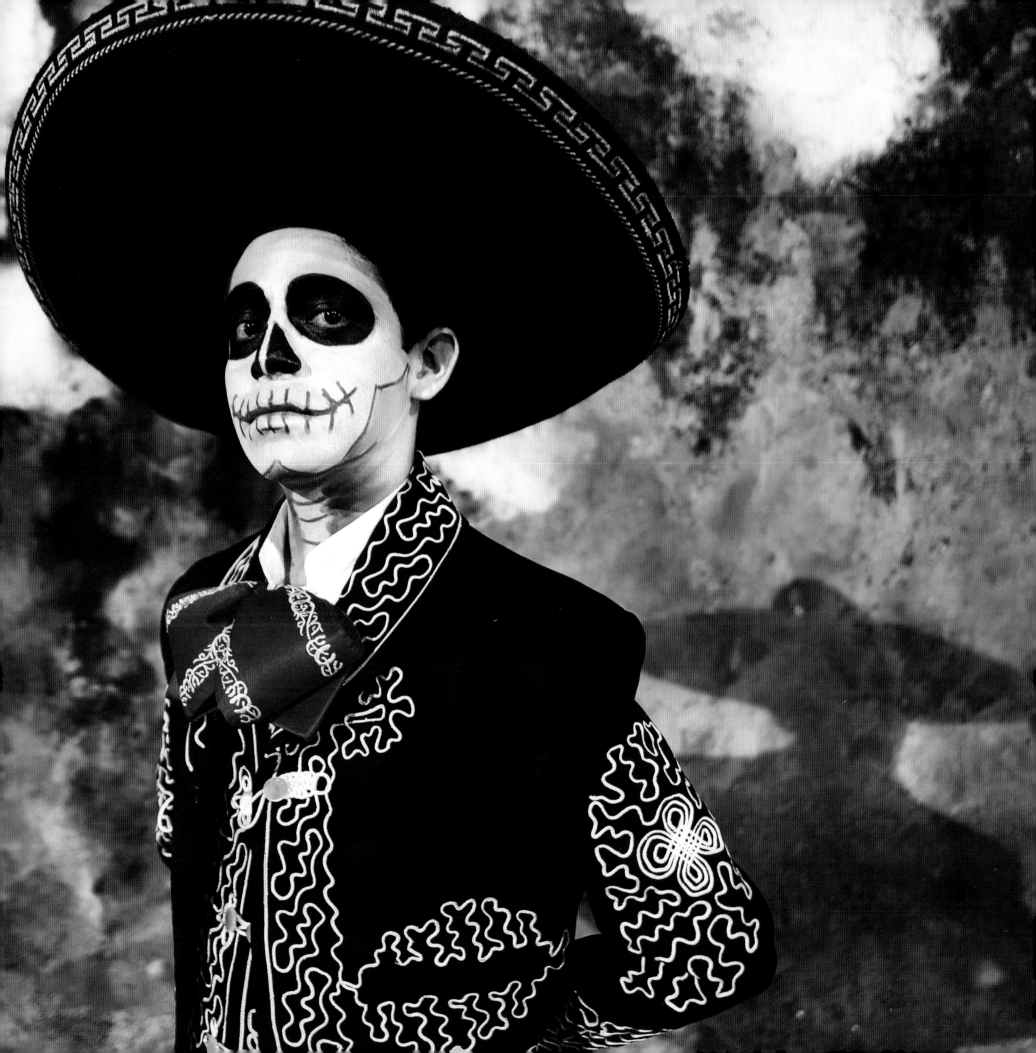

HIDE AND SEEK

Looking to incorporate these **ancient beliefs** into their new faith, early Christians sought to associate Samhain with their All Saints' day, also held on 1 November, and All Souls' day, on 2 November. The two-day period was known as **All Hallows'**, with the night of 31 October becoming All Hallow's Eve, or Hallows Even; from there it was only a short step and a few contractions to 'Hallowe'en', and finally Halloween as we know it.

While it's easy to assume that the dressing up and **demonic** aspects of Halloween are modern constructions fuelled by movies and marketing, their roots are as old as both Halloween and the Day of the Dead. Celtic superstition held that the **spirits of the dead**, along with more malevolent beings, would pass through the veil between worlds on Samhain and wander the roads near their homes. This idea did not thrill them. As a result they began to dress themselves with **masks and other ghostly paraphernalia** in order to hide among the spirits without being recognized – the original Halloween costumes were not meant to scare, but to disguise.

The forms these spirits took would gradually change as the **pagan and Christian festivals** merged, the dark forces taking on a more Christian aspect – the devil, in particular arriving from Christian doctrine to occupy a place in the Halloween roll call that he is yet to give up.

FEAR AND FEASTING

As mentioned before, the Day of the Dead may combine elements of **pre-Christian rites for the dead** with aspects of the Christian All Saints' and All Souls' days (along

with the pagan festivals for the dead that they had incorporated). The same is true of Halloween, which joins different pagan and Christian beliefs into one syncretic whole. Similarly, the practice of **offering food** to the souls of the dead occurred simultaneously in Europe and Mesoamerica before there was any contact between the civilizations, as did the idea of the **spirits returning** to visit.

While they had similar beginnings, the **modern incarnations** of these festivals have travelled down diverging paths. Halloween in the US and UK, despite its religious origins, is now largely a secular occasion driven by **mischief and mayhem**. Its customs and traditions focus around play and fear, employing a cast of **ne'er-do-well demons** and deviants, and revelling in an orgy of gory costumes, horror movies and sugar-fuelled misrule.

(There are exceptions, of course. For **modern witches** and those inclined towards some pagan practices and beliefs the **festival of Samhain** is still very much alive. Their experience on and around 31 October may be much closer to the Mexican Day of the Dead, with offerings to departed relatives and the recall of spirits from the afterlife to this one.)

CROSSING OVER

Meanwhile, the traditional Day of the Dead eschews fear for fun, seeing the return of the dead as a cause for celebration rather than running shrieking from the cemetery looking for the nearest **stake or zombie-killing apparatus**. Skulls and skeletons appear just as they do at Halloween, but these have a dash of mirth in their macabre look. Colour is all around and symbols of life – **flowers, candles, food** – abound.

Some similarities in the customs can be observed. Officially sanctioned begging for food is just one, manifesting as **trick or treating** by children in the US and UK and as a more ritualized process in some regions of Mexico, with some (young men or adults) gathering food from the neighbourhood and taking it to the cemetery to feast. Both have their origins in European alms-giving practices around All Saints' and All Souls' days, as well as in the pagan custom of **leaving food** on the doorstep to **placate restless spirits** and prevent them from entering the home.

Just as in both Halloween and the Day of the Dead the barrier between worlds fades away, so the cultural membrane between the respective festivals has become increasingly permeable over time. Trick or treating in the US sense now occurs among the **children of Mexico** and shops are filled with **monster masks**, werewolf outfits and witch hats. Gothic characters can be seen in Day of the Dead parades mingling with skeletons and **partygoers** in Catrina costumes.

SUGAR SKULL ADDICTS

The Day of the Dead's female icons – *La Calavera Catrina* and *La Muerte* herself – have proved to be the most influential aspects of the Day of the Dead when it comes to Halloween. During US and European-style Halloween celebrations, from trick or treating expeditions to **society parties**, it's now commonplace to see guests dressed as **Catrina** or *La Muerte*. Those seen sporting the wide-brimmed hat or iconic skull makeup in recent years have included supermodel **Kate Moss** and actress **Sandra Bullock**, showing just how global the style appeal of the Day of the Dead's leading ladies really is.

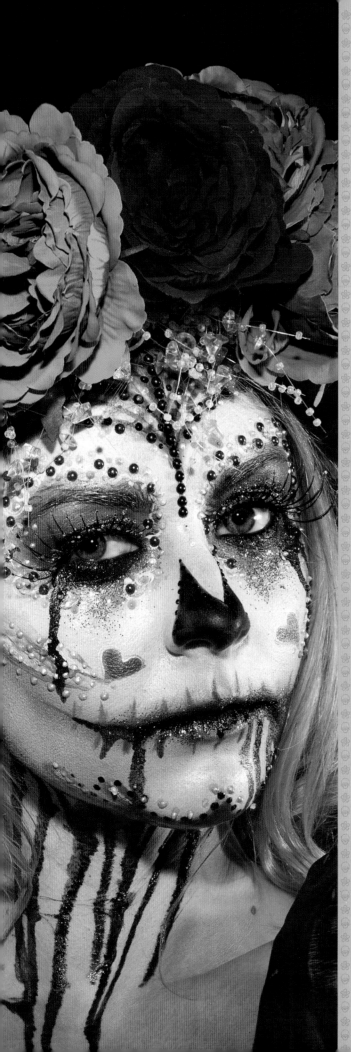

Yet not everyone sees the intermingling of Halloween and Day of the Dead practices (a different process to the **rise of Day of the Dead** celebrations in communities outside of Mexico) as a good thing. For some Mexicans the **slow creep of Halloween** represents a kind of cultural imperialism on behalf of the USA and the process risks diluting the Day of the Dead, something they see as integral to the **national identity of Mexico**.

As Brandes puts it (*Skulls to the Living, Bread to the Dead*, 2006): 'Government officials, journalists, scholars and public intellectuals have successfully promoted the Day of the Dead as a **unique national treasure** and a vibrant expression of Mexico's distinctness. It is to preserve this national treasure … that many of the most vocal Mexicans object to the growing presence within their country of Halloween costumes and customs.'

SPREAD OF THE DEAD

It's a complicated and **ongoing debate**, made all the more interesting by the fact that the Day of the Dead itself is only a very **recent arrival** to some parts of Mexico, with Halloween the incumbent festival of the dead. In Northern regions of Mexico the Day of the Dead was unknown as late as the twentieth century, until government policies aimed at national unity instituted the festival as a **public holiday**.

For border states such as Chihuahua and Sonora, Halloween is a **long-established tradition**; it remains to be seen what role the Day of the Dead might play in the autumn calendar or how the two festivals may merge over time throughout the country (and the world).

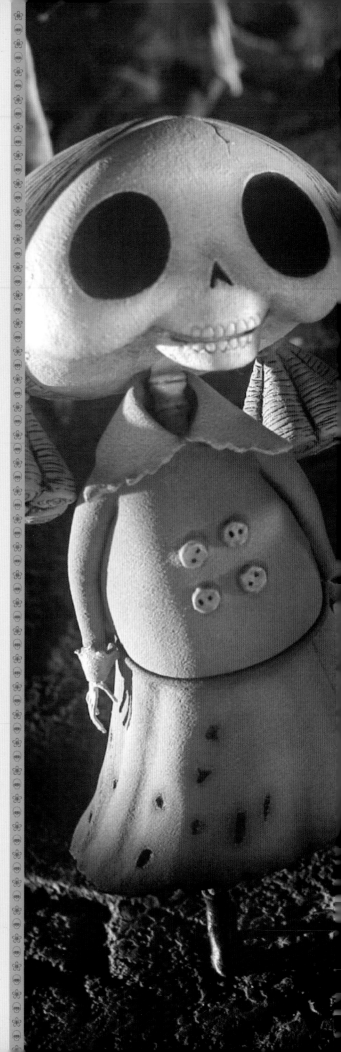

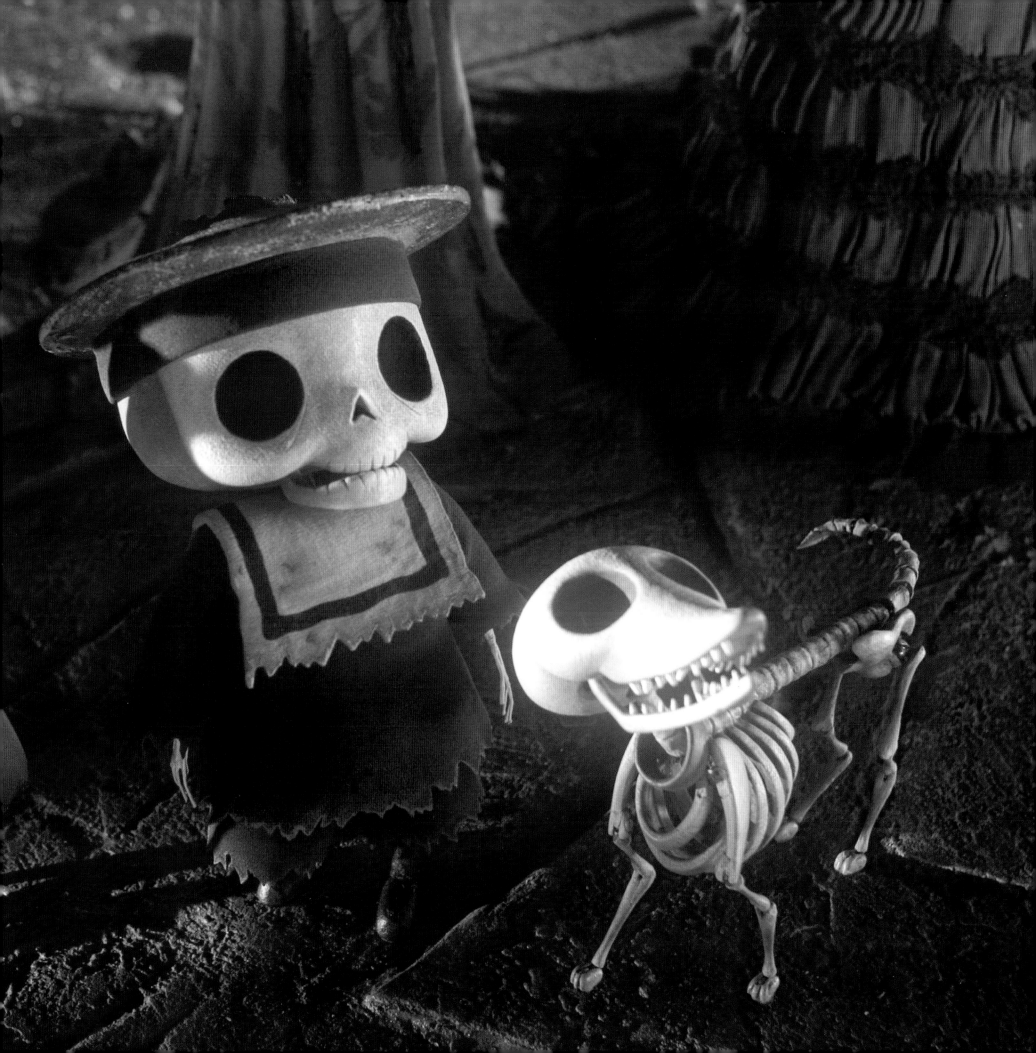

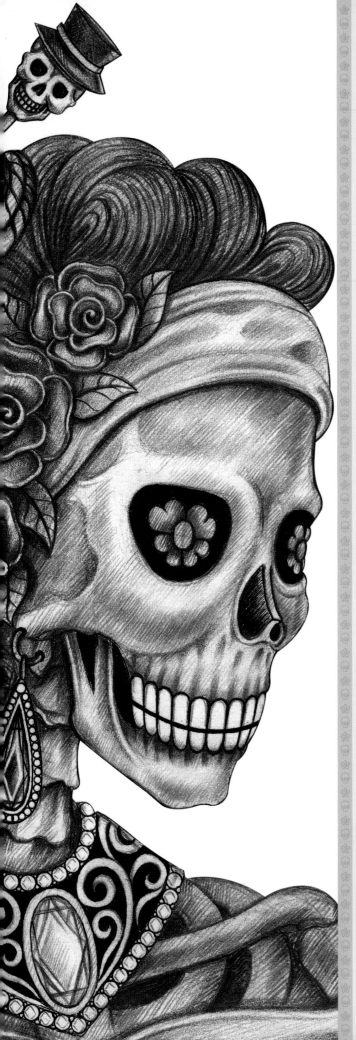

Yet despite the threat Halloween poses in the eyes of some, it does provide money-making opportunities to businesses (and also to children who beg for their 'Halloween', a term that has come to mean small change in this context). **Costumes, toys, accessories** and all the accompanying Halloween ephemera provide additional sources of revenue around the time of the **Day of the Dead**.

The same is also true of the Day of the Dead itself of course: in addition to an **ebullient festival of life** and death, it represents a significant source of income for many and has become a huge **tourist industry** in its own right. The Day of the Dead's great contribution to popular culture means through its own marketing, dissemination and branding it has become a tourist attraction to visitors from **all over the world**.

TOURISM AND THE DAY OF THE DEAD

As the Mexicans themselves say, *somos muy fiesteros*: 'we love a good party'. The extent to which that might be the case is elaborated on by novelist Octavio Paz, again in *The Labyrinth of Solitude* (1959): 'Fiestas are our sole luxury … What is important is to go out, open up a way, get drunk on the **noise, people, colours**. Mexico is in fiesta. And this fiesta, shot through with lightning and delirium, is the brilliant opposite of our silence and apathy, our reticence and gloom.'

Small wonder then, that the bright lure of Mexico is brighter still during a fiesta. Who would opt for a trip to 'reticence and gloom' over '**lightning and delirium**'? (Well, possibly My Chemical Romance, but more of that below). And as **Mexico's biggest party**, it follows that the Day of the Dead is also its biggest tourist draw.

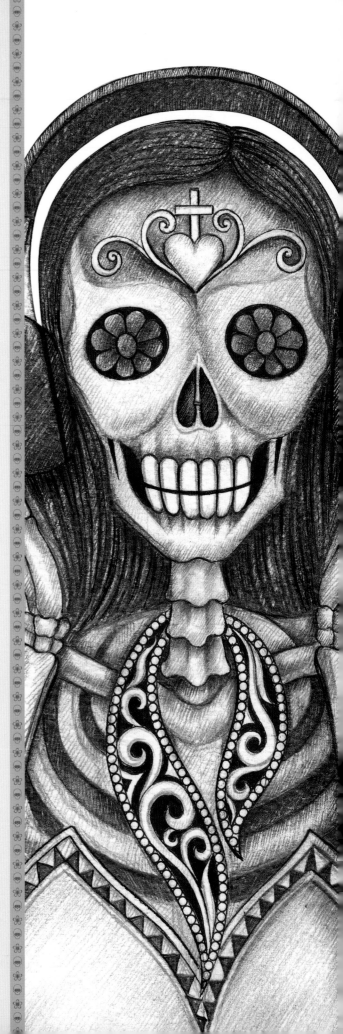

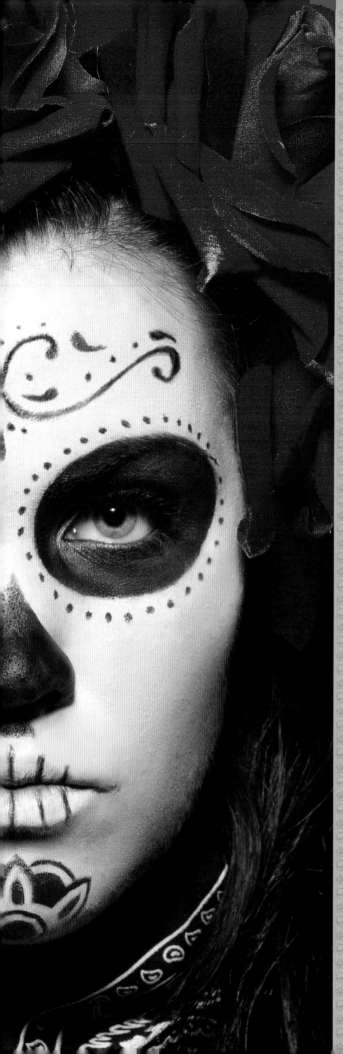

Mexico City during the Day of the Dead would probably be enough fiesta for any visitor. The streets throng with people. Giant parades shut the city down for days at a time. **Huge skeletons** prance and totter along the roads, while at their feet the crowds bustle, dressed as *la calavera Catrina* or sporting outlandish skull masks. In the markets, stalls heave with sugar skulls, the shops burst with **bread of the dead** and the scent of copal incense hangs over the whole scene.

THE HIGHS

Away from Mexico City, other sites have made a name as fine places to celebrate the Day of the Dead. Mixquic, close to Mexico City, is **extremely popular** and travellers come from across the globe just to spend time in the town. Their online journals and reports tell of locals keeping quiet **graveside vigils** while hundreds of foreigners mingle in the cemetery, or report on giant traffic jams getting into and out of the town with **tolerant good humour**; but also of a friendly atmosphere and spending time talking to the locals about the departed souls they were remembering during the fiesta. Again, it's the smell that really **captivates visitors**: the potent blend of flowers and incense is intoxicating.

The popularity of the Day of the Dead with tourists can have significant benefits for towns like Mixquic, traffic gripes aside. It provides a reliable injection of new money into the local economy, for one, and provides people with a captive – in some cases literally, if the traffic jams are bad – audience for **food, souvenirs, tours and crafts**.

Celebrations can also give visitors an insight into the

heart of the Day of the Dead. Seeing the **rituals, altars and gravesides** for themselves, they may come away with an understanding of the fiesta that goes beyond the mass-marketed skulls and skeletons, and reaches the ancient, **many-layered tradition** beyond.

THE LOWS

But of course whether or not it's possible to have an 'authentic' experience is precisely the problem — the very idea of seeking the 'authentic' can be immensely condescending in and of itself. In addition the desire for **true, vivid experiences** — present in tourists to every city, everywhere in the world, often with good intentions — can drive those on the receiving end to play up for the cameras, seeking to capitalize on the demand but eventually creating a waxwork of the original event. It looks like the real thing on the surface, but has **no true heart**.

There's also the question of what constitutes a 'genuine' Day of the Dead experience, and whether or not the act of observing it changes it; or if the arrival of foreigners is just a part of the natural evolution of any public occasion. These are questions that swarm around **popular tourist attractions** worldwide, along with the charms and tragedies of mass tourism — economic boosts, shared experience and **cultural exchange** on one side; petty crime, exploitation and the dilution of the original attraction on the other.

The fact remains though, that the word is out about the Day of the Dead, for better or worse, and as well as **provoking debate**, it's also infiltrating popular culture in exciting, varied ways.

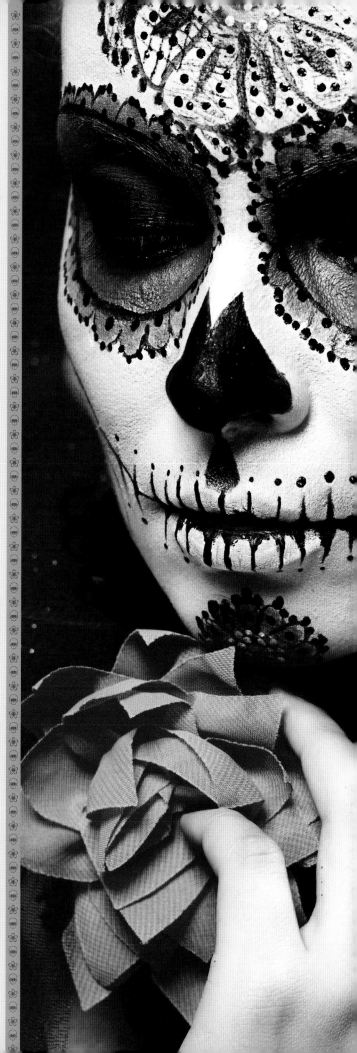

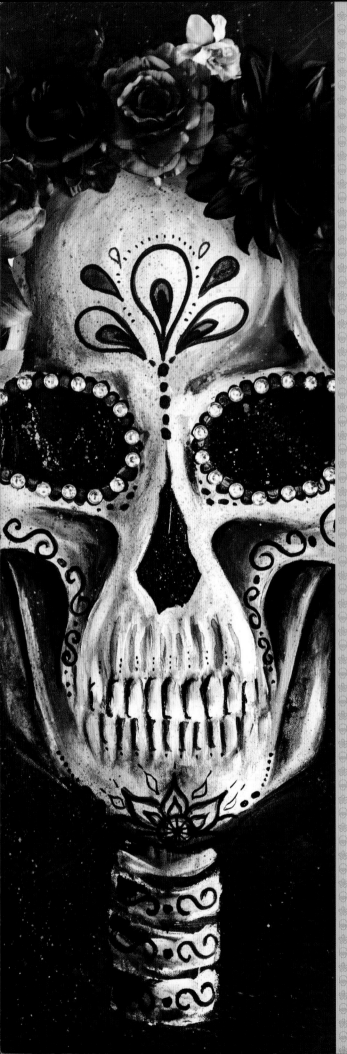

WISH UPON A STAR

You only need to set foot in Paris's **Père Lachaise cemetery** to discover that paying respects to departed **stars, artists, poets** and other famous souls has been a popular pastime for some while now. Fans of Doors singer **Jim Morrison** or writer **Oscar Wilde** have long visited their graves in the ceremony to offer tributes: the tradition was to leave a lipstick kiss on Wilde's tomb, or offer Jim a drink or flowers.

A related sense of commemoration has now crept into the Day of the Dead in some places, with famous **departed souls** receiving the full treatment of **ofrenda** and other customs. This may seem to go against the familial roots of the fiesta, but another way of looking at this **modern twist** is that it allows those who have been affected by the life and works of others to honour that influence on one day in the year. The literal spirit of that person may or may not visit, but the symbolism of the act remains intact, showing care for the departed and a **jovial attitude** in the face of death.

In some cases this may be a **private celebration** by fans at home, but there are public celebrations too where everyone can participate in a vigil for a **famous soul**.

HOLLYWOOD FOREVER

One of the largest Day of the Dead celebrations in the USA takes place at the **Hollywood Forever** cemetery in Los Angeles. Built in 1899, it's the oldest memorial park in Hollywood and the only cemetery in the country to open its gates to allcomers on the Day of the Dead.

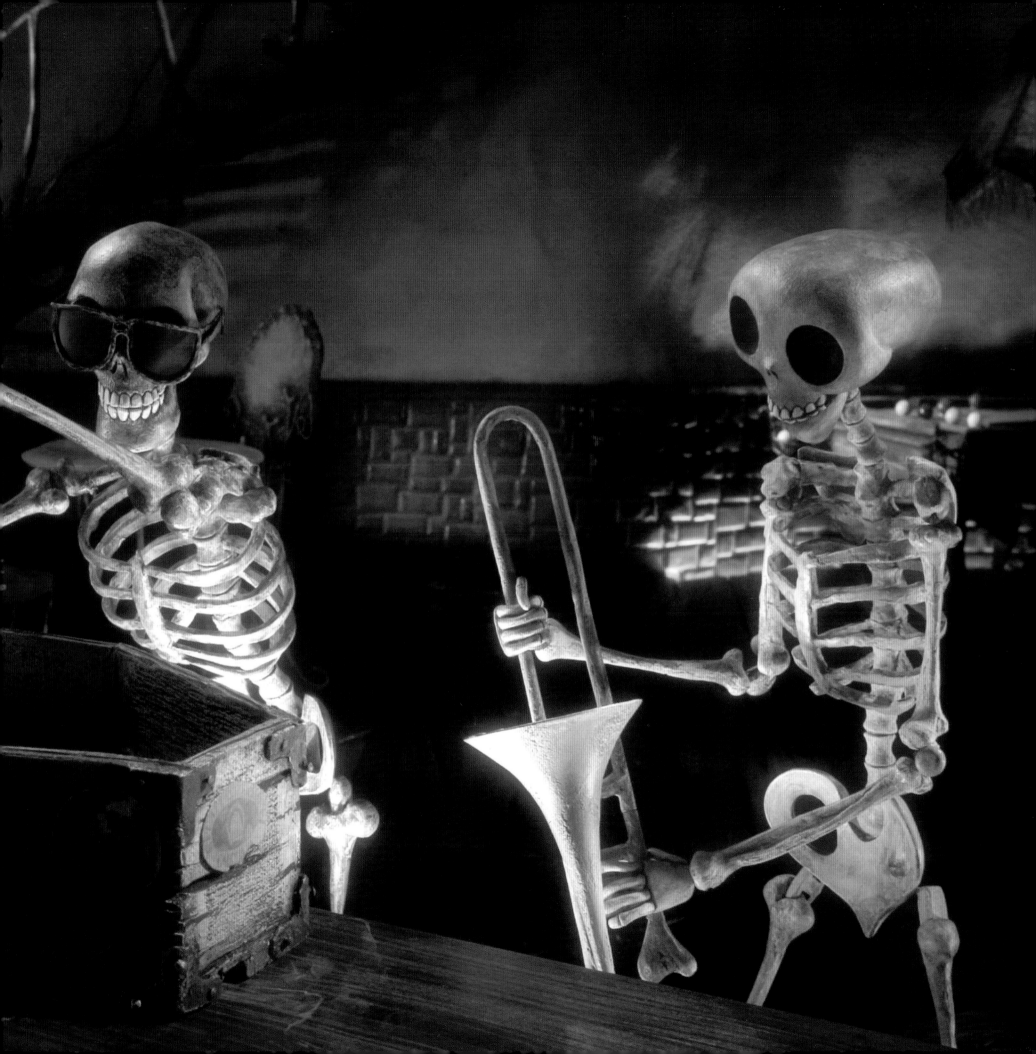

The cemetery itself is the resting place of LA citizens as well as Hollywood luminaries including musicians **George Harrison** and **Johnny Ramone**, voice of Bugs Bunny **Mel Blanc** … even Terry, the dog actor who played Toto in *The Wizard of Oz* (1939). On the Day of the Dead the entire site is turned into a community venue where the fiesta can be celebrated by families who have loved ones in the cemetery, along with **artists, musicians, performers** and members of the public who come together to dance, parade in Day of the Dead costumes, build altars and recognize the **Mexican roots** of the festival while giving it an unmistakably 'LA' feel.

Private altars are constructed and dedicated as they would be in Mexico, allowing those of Mexican descent to honour their traditions as well as sharing the occasion with those from other cultures. And it's also an opportunity to walk among the **returning spirits of departed stars** – in 2014 the memorial to **Johnny Ramone** was garlanded with marigolds and red coxcombs, watched over by sugar skulls, candles and, of course, tens of thousands of fans keeping vigil.

MUSIC AND MUERTE

Staying with the theme of music, while the Day of the Dead has yet to inspire songs that lodge in US or UK pop consciousness in the way that, say, Christmas does (and this may not be a bad thing, depending on your opinion of *Do They Know It's Christmas?*), it has made its presence known in songs and artwork from a variety of musicians. It's certainly possible to compile a Day of the Dead themed playlist.

Setting the tone is **Chavela Vargas** (1919–2012) with an

interpretation of the folk song *La Llorona*. A tale of a murdering woman whose soul is condemned to walk the earth, weeping, it's a **mournful ballad** quite apart from the swing of the Day of the Dead, but helps to establish the mythic, penumbral world of spirits and the afterlife (and potentially religious morality) in which it operates.

Taking things up a notch, dark cabaret musician Voltaire's crazily catchy 'Day of the Dead' (from the album *Ooky Spooky*, 2007) is a **brass-heavy goth-folk** tilt through a fantasized journey into the fiesta – it also accompanies an animation project from Spain's Ritxi Ostáriz, complete with a cast of cut-out *calacas* throwing bony shapes throughout.

MY SKELETAL ROMANCE

LA outfit Ozomatli bring a swaying groove to the party next with 'Cumbia de los Muertos' (1998), a track encouraging celebrants to hit the dancefloor *hueso a hueso* ('bone to bone') with the returning spirits of the dead; but if you'll only leave your seat for industrial gloomcore with a smattering of sexiness, best try **La Minitk del Miedo's** bleepy, throbbing 'Yo te Quiero, Calavera' from 2012. It's **Gary Numan** in a *calavera* suit.

Need a little more disco? Argentine popsters Alto Peru embrace the autotune and unapologetic campy synths with '**La Cumbia de San la Muerte**', complete with lyrics about vomiting on the dancefloor; but if that's simply too silly then Mexico's Teen Bwitches can provide some swirling, dark techno on 'Death and Rebirth' (2014).

Too electronic? Norway's **Los Plantronics** will gladly oblige with the garage surf-cum-mariachi dirge of 'Dia de los Muertos' (2003). But if it's full-fat guitar pomp you

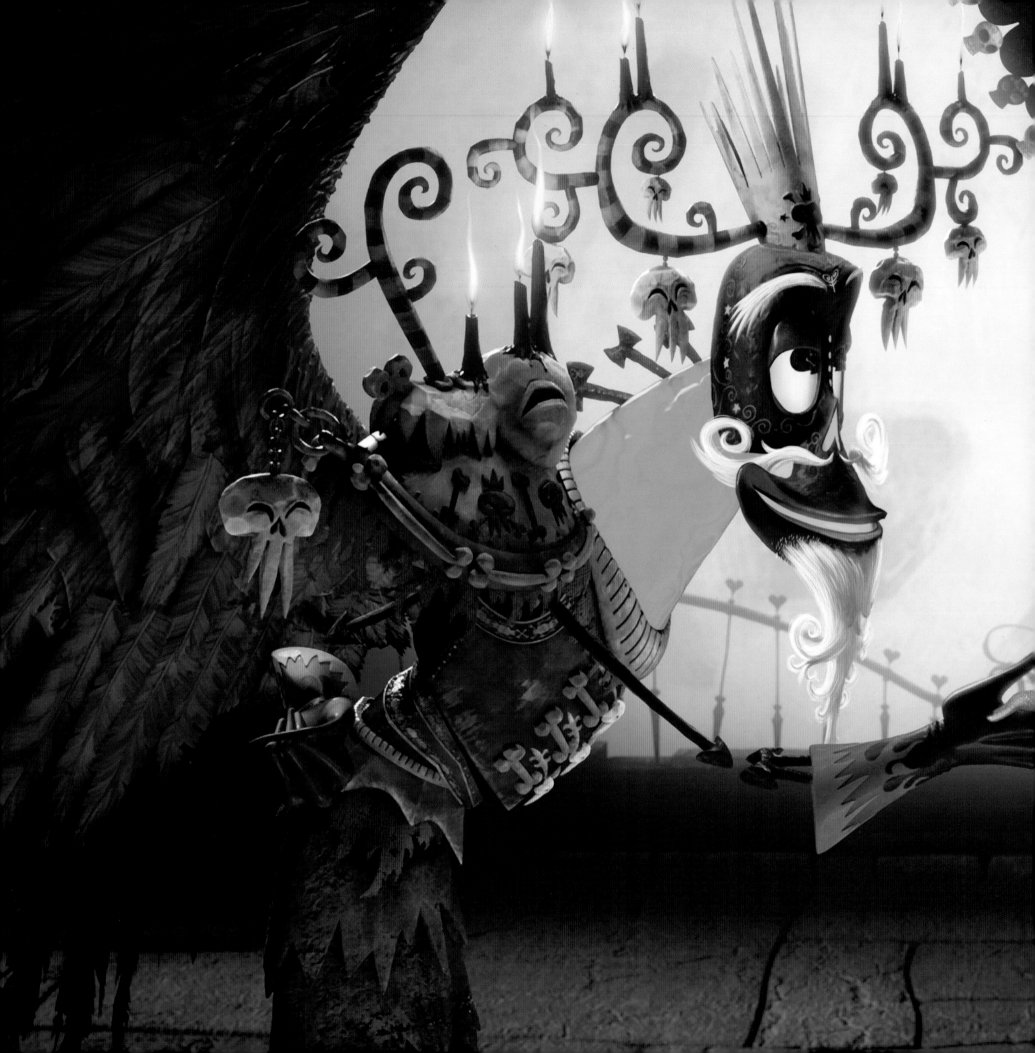

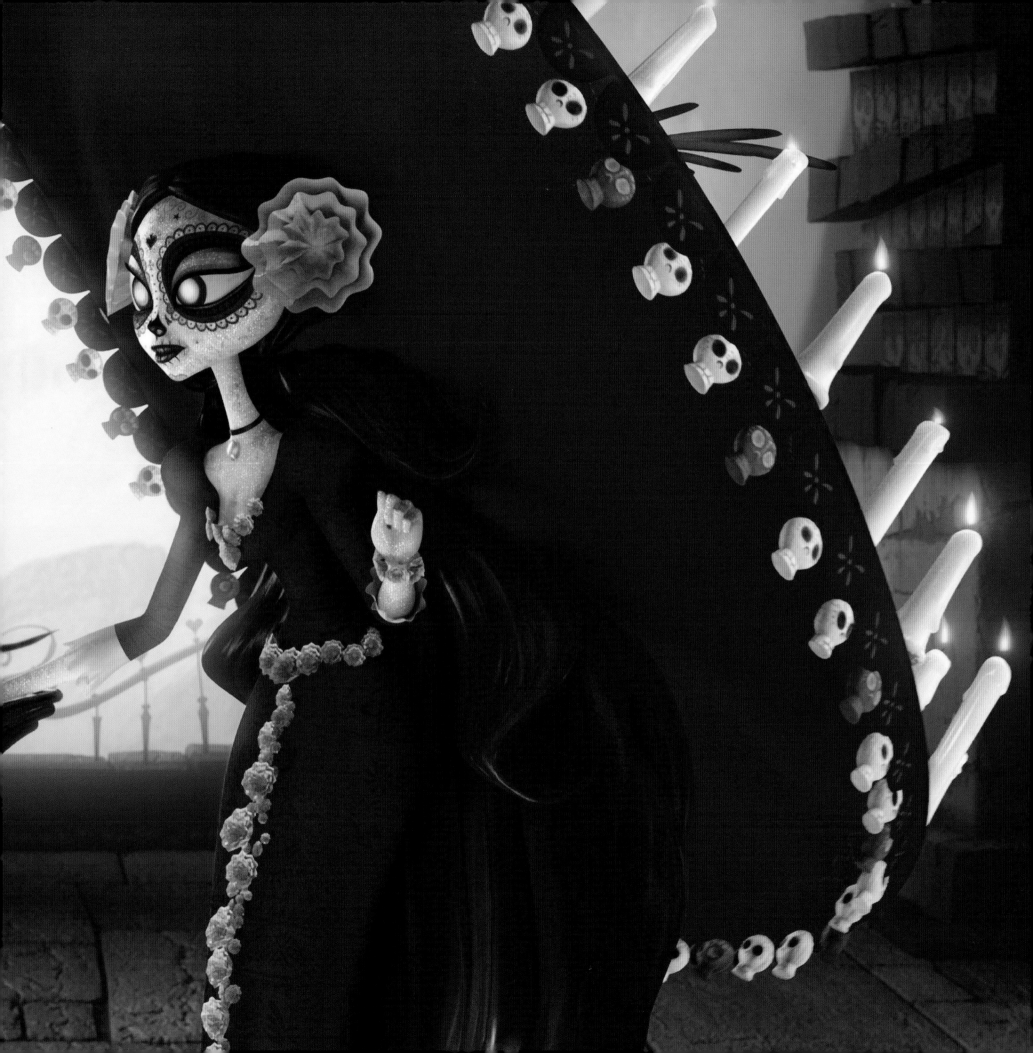

need, better leave it to the USA's My Chemical Romance. Their track **'Welcome to the Black Parade'** (2006) exhorts the spirits not to fear as the living will preserve their memories, while the **Day of the Dead** subtly infiltrates the visuals of both the song and its parent album, *The Black Parade*.

WE'LL CARRY ON

Calavera-like skeletons in marching band uniforms – a fusion of Day of the Dead and North American staples – appear throughout the album's artwork (by **James Jean**), mixed with more European gothic imagery, to create a **dark, theatrical aesthetic** that still has a sense of triumph and fanfare to it – here comes death and we don't care. However it's the video for **'Welcome to the Black Parade'** that really seems to bear the marks of the Day of the Dead.

Costumed by Colleen Atwood, a long-time **Tim Burton** collaborator, it features a **skeleton-faced crowd** parading behind a giant float lined with red flowers (similar to the traditional red coxcomb), which carries a distinctly Posada-esque *calavera* on the front. It's melodramatic, pomp rock pantomime – yet it evokes some of the winningly **macabre glee** of the Day of the Dead.

Whether its influence is felt in **accompanying artwork**, stage shows, band outfits or through the sonic palette and lyrical themes of the songs themselves, the Day of the Dead inspires artists all over the world. From the electro clash pop of Mexico's Kinky ('A Donde van los Muertos?', 2008) to eclectic folk country collective Calexico ('Roka', 2006), the universality of the fiesta's themes of life and death, and its versatile imagery, mean that musicians can feel the rhythm of the Day of the Dead in their bones.

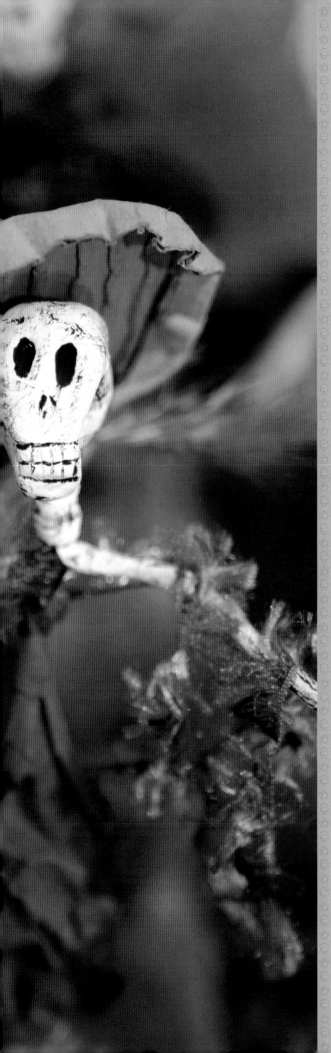

WHAT'S THIS

Musicians are not alone in taking their inspiration from the Day of the Dead. As mentioned before, Hollywood film director **Tim Burt on** is no stranger to incorporating elements of the Day of the Dead into his work (more below); and cinema as a whole has plundered the iconography of the fiesta on numerous occasions.

At the time of writing several **Hollywood blockbusters** were in the process of bringing elements of the Day of the Dead to the big screen: *Batman vs. Superman* (2016) features a crowd of solemn faces in *muertos* makeup gazing up at the man of steel, setting up questions about the role of traditional beliefs once a godlike being has been revealed; while the James Bond movie *Spectre* (2015) features a huge set piece shot entirely during the Day of the Dead celebrations in **Mexico City**, complete with giant *calacas* looming over the action.

As an interesting aside, it was agreed between the producers and the civic authorities that for the purposes of the film, **Mexico and the fiesta** would be portrayed in a positive light – we're back to the role of tourism and how **external pressures** affect the presentation of the celebrations.

Meanwhile, **animation masters Pixar** are thought to have been developing a Day of the Dead film for several years, with current theories suggesting it will be a musical. Given the success of the *Toy Story* trilogy and the emotional heft they managed to add to a story about a plastic space ranger and his tattered cowboy friend, the **mind boggles** at what they could do with the rich emotional currents of the Day of the Dead.

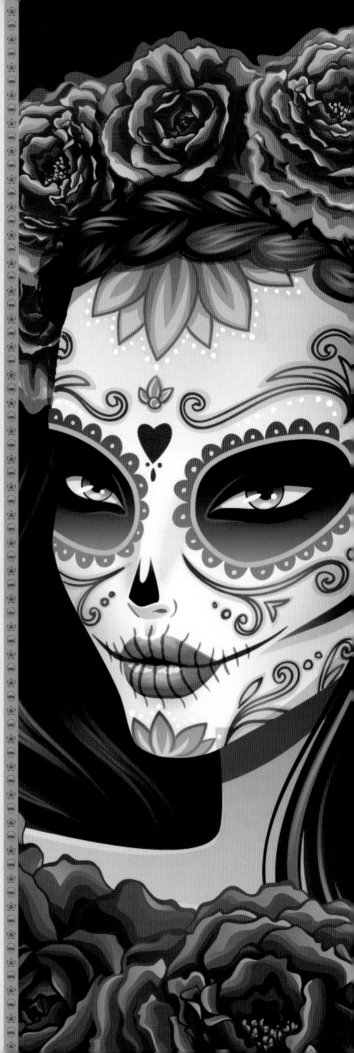

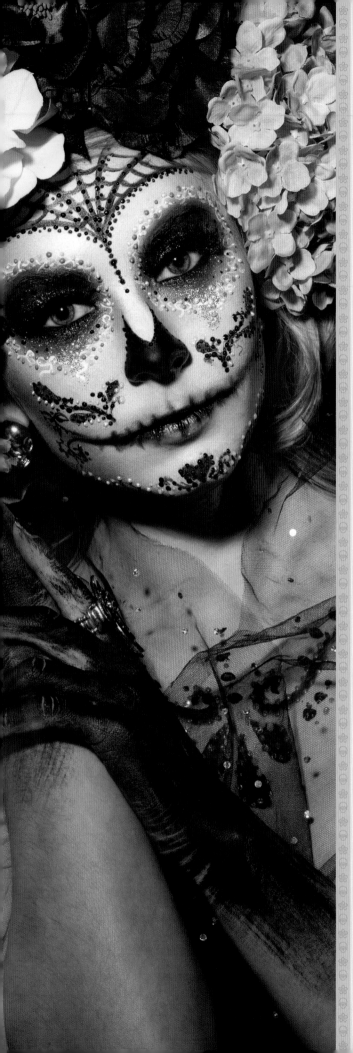

THE DAY OF THE DEAD ONSCREEN

From a filmmaker's perspective the Day of the Dead can be a **powerful tool**. The unmistakable look of the fiesta can conjure all manner of moods depending on the target audience and the story being played out. Seen from the point of view of a character not familiar with the fiesta, for example, a film's visual language might incorporate the Day of the Dead to suggest the exotic or the unfamiliar.

Locating the action within the midst of raucous celebrations could be **exhilarating or unnerving** for protagonist and audience – it might have less to do with the culture of the Day of the Dead and more to do with the sensory overload it offers. If your story needs a disorientating **barrage of sound** and colour (and implied scent) with slightly unreal undertones, the Day of the Dead is only too willing to oblige.

The confusion of a large crowd, plus the fact that much of the celebrating is done at night, can add more to the mix. Night-time visuals might be mournful and candlelit or glaring and cacophonous – *The Crow: City of Angels* (1996) uses both. Crowd scenes are confusing (although the muddled plot doesn't help), while in a more reflective moment the titular **avenging spirit** visits a quiet church to be confronted by a giant **ofrenda**. The mythology of the fiesta is called upon to add some clumsy exposition: " ... some spirits linger too long and become confused," murmurs a conveniently eloquent priest.

THE PUMPKIN KING

While unable to hold so much as a ritual candle to the glum splendour of the original film (*The Crow*, 1994),

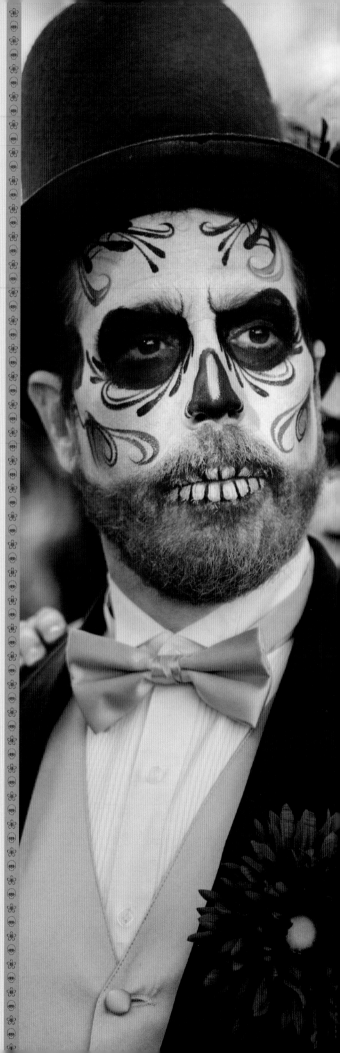

The Crow: City of Angels does some good work with the visuals of the Day of the Dead. The altars cast an evanescent pall over proceedings, while a fleeting glimpse of a dog in a **calavera** mask is both briefly **unsettling and oddly amusing** – sensations very much in keeping with the fiesta itself.

Spectral dogs also haunt *The Nightmare Before Christmas* (1993). The **Tim Burton**-produced animated gothic fairy tale is in essence a parable about accepting ourselves – and others – for who we are, as well as a meditation on what might constitute 'home'. Jack, the pumpkin king of **Halloween Town**, casts an envious eye over Christmas and attempts to usurp it; his denial of himself and his true talents has grim consequences.

The look of the film is naturally heavily influenced by **traditional Halloween iconography** – bats, devils, witches and pumpkins – merged with German Expressionism and the cartoon melancholia of artist **Edward Gorey** (1925–2000). There is also a hint of New Orleans jazz alongside Burton's own wonky, signature style. Yet Jack is also clearly a **calaca** in the tradition of the Day of the Dead – a **spindly, dancing skeleton** with a soulful expression not entirely given over to wickedness.

BONE DADDY

An extensive array of 'Jack-as-**calavera**' vinyl toys are available, alongside similar artwork, suggesting that many people have made this connection and have given it a clearer expression. You can now have a **Jack Skellington** who is made up in readiness for the Day of the Dead, the Halloween icon remade for a very

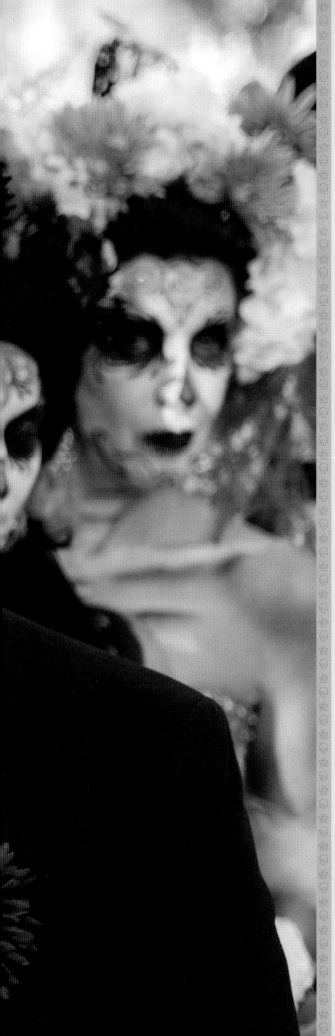

different purpose – an intriguing result of the influence of the festival on a cult corner of **pop culture**.

While Jack carries merely the trace of the Day of the Dead on him, other films have been much more explicitly inspired by it, either featuring the holiday as part of the story, or focusing on an aspect of it. The lyrical, oddball claymation *Hasta los Huesos* ('Down the Bone', 2001) from animator **René Castillo**, runs with the idea expressed by Mexican writer **Carlos Fuentes** (1928–2012) that 'Mexicans don't advance towards death, we return to it, because death is not the end but the beginning, the start of everything: **we descend from death**'.

The film's central character awakens in a coffin, horrified to be buried alive. Falling through the earth he arrives in a ghoulish bar frequented entirely by grinning *calacas*, who are **drinking, singing, making merry** and fighting as in life. *La calavera Catrina* takes to a small stage, singing as the man himself sweats and frets through his nightmare.

GRATEFUL DEAD

Gradually, we come to realise that he is, of course, dead himself and has arrived in the **afterlife** – which in this case seems to have some good tunes (courtesy of a bony band who wouldn't look out of place in *The Nightmare Before Christmas*) and drinks. Slowly he comes to accept his death, guided by the cheery skeletons around him, until he **takes Death's hand** and stands up to dance. The film is less than ten minutes long but its summing up of the role of the Day of the Dead in helping us accept death with a glad heart, and capturing the fiesta's special *Mexicanidad* through its eloquent visual style, won it several awards.

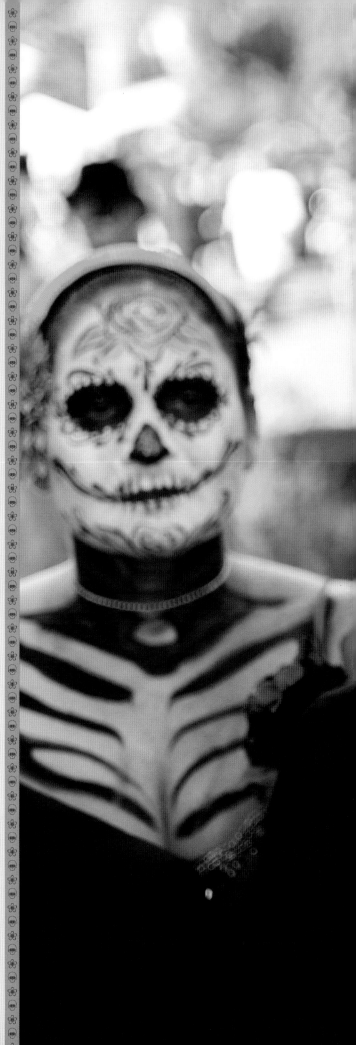

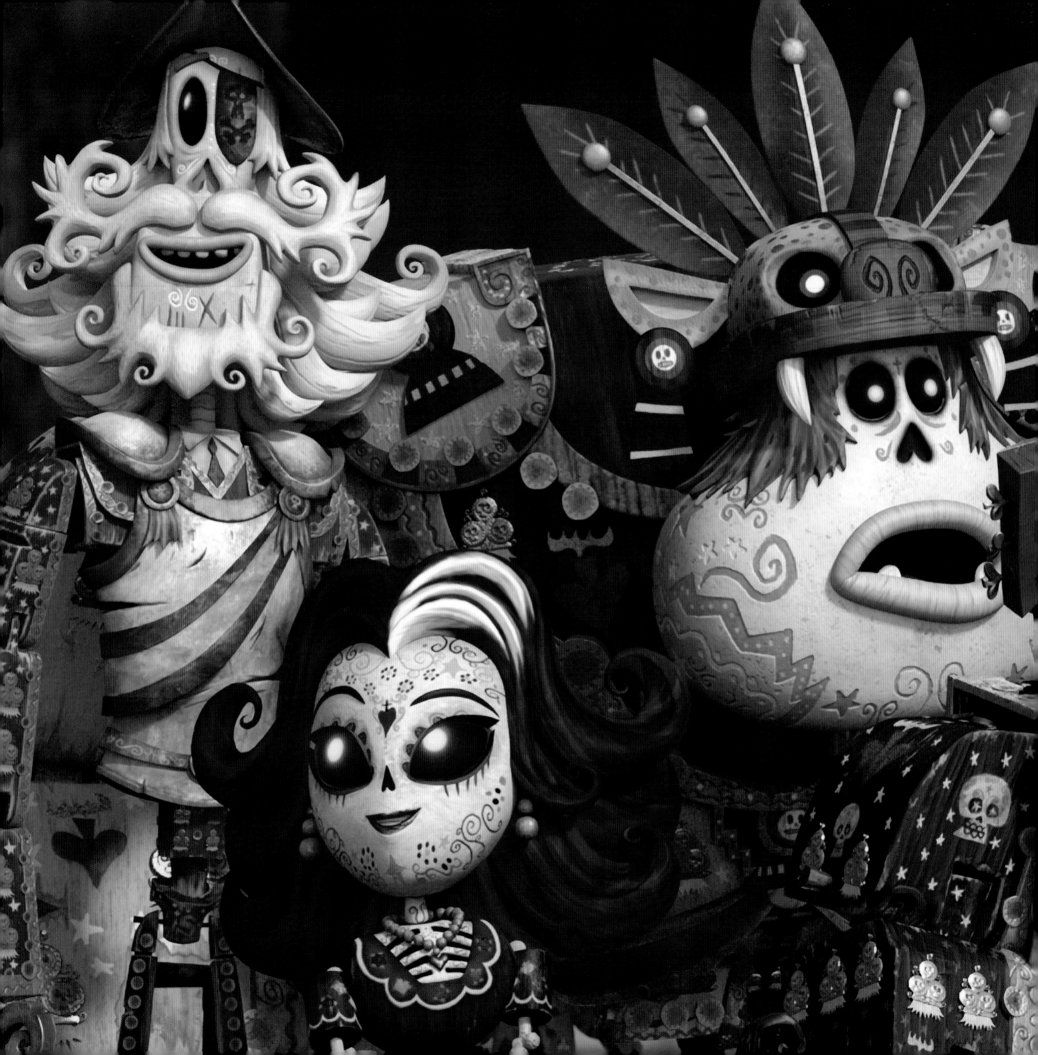

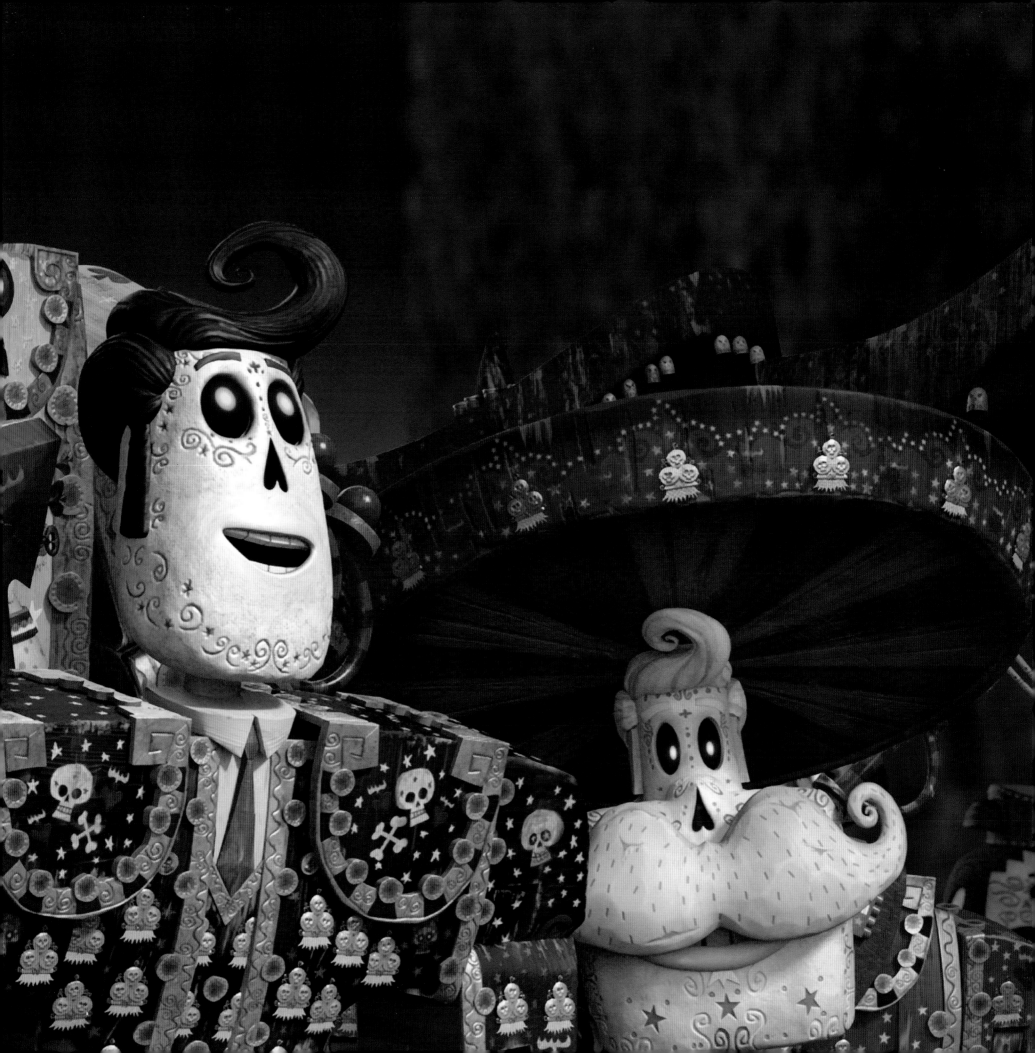

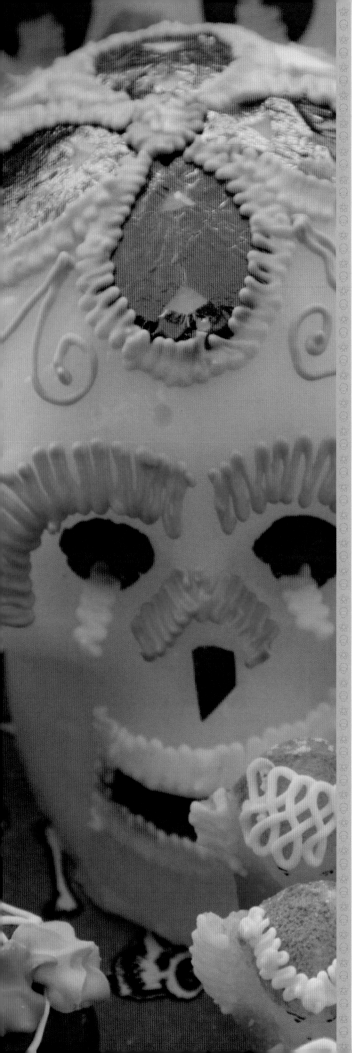

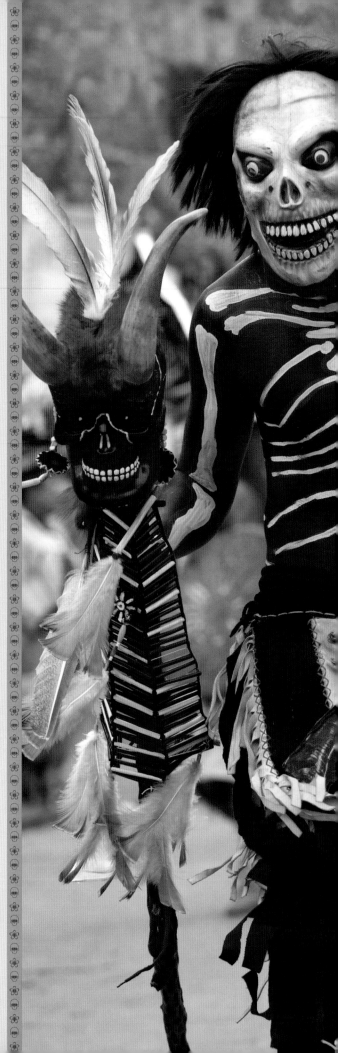

For a somewhat retro but charming and informative treat, designers Ray and Charles Eames (the ones behind the groovy chairs) created *Dia de los Muertos* in 1957 and the short film is a joy. It explores the Day of the Dead on every level and scale, somehow bringing the camera in among a procession of **tiny paper calacas** as they march before pulling back to rooftop levels, surveying the celebrations from the top of a bell tower. It's a **beautifully intimate** portrait of the world of the fiesta.

THE BOOK OF LIFE

The film also makes an explicit connection between the painted deities and skulls of the pre-Hispanic codices and the gaudy **calaveras** seen in contemporary markets, and it's a persuasive argument when the two are placed side by side. It also illuminates the role of sugar animals as part of the **ofrenda**, one interviewee explaining that the return journey to the dead lands is long and tiring after the fiesta – so why not provide the spirits with a ride?

Animals – in this case, **snakes and bulls** – play their part in 2014's *The Book of Life*, a touching, witty and exuberant animated tale that uses the Day of the Dead as a launch pad. Produced by **Guillermo del Toro** and directed by Jorge Gutierrez (with voices from Channing Tatum, Zoe Saldana and Diego Luna) it breathes vibrant life into the characters and customs of the Day of the Dead, bringing them to a wider (and younger) audience in the process of telling a **tale of self-discovery**.

While much of the story revolves around a classic love triangle, the setting is partly in the Land of the Remembered, a **technicolour vision** of the underworld populated by supremely happy souls. It's the ideas and

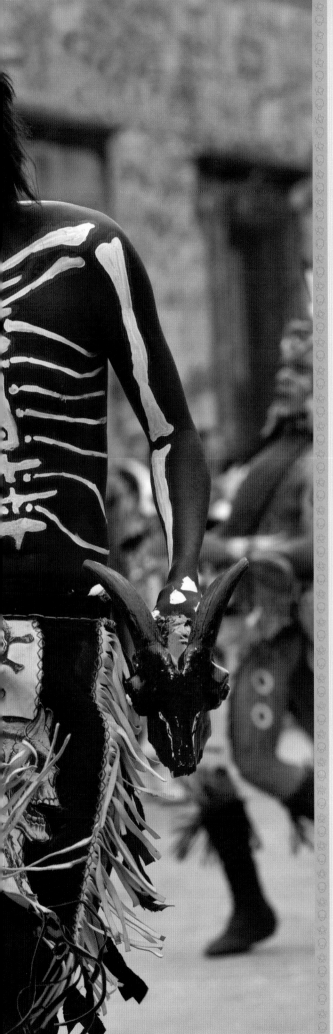

icons of the Day of the Dead incarnate, made possible through the kind of **elegant world** building for which del Toro is famous. Ruling the land is La Muerte (Kate del Castillo), a vivid rendering of the **Mexican female Death**. Her beauty, and that of the film as a whole, somehow achieves the feat of making death (the ending of any story from our own books of life) palatable, again embracing the *raison d'etre* of the Day of the Dead to positive effect.

READ ON

Moving from the *Book of Life* to books more generally, the Day of the Dead can boast of its own literary canon in the form of **literary and poetic calaveras**. But it has also had an influence on other written works, either as setting, plot device or perhaps metaphorical construct.

In *The Halloween Tree* (1972) by American sci-fi author **Ray Bradbury** (1920–2012), the Day of the Dead features alongside other rites and rituals from cultures including the druids, ancient **Egyptians, Romans and Greeks**. As a group of friends pursue one of their companions through time they learn the origins of **Samhain** and Halloween and the role of death in shaping civilization. The tree itself represents the meeting point of these diverse cultures, the Day of the Dead a didactic tool for scrutinizing the function of **spirits and superstition** within society.

Spirits of an altogether more mortal (but no less fatal) kind trouble Geoffrey Firmin, protagonist of *Under the Volcano*, a 1947 novel by **Malcolm Lowry** (1909–57), also made into a film in 1984. Set in the Mexican town of Cuernavaca, the events take place on two separate Days of the Dead,

179

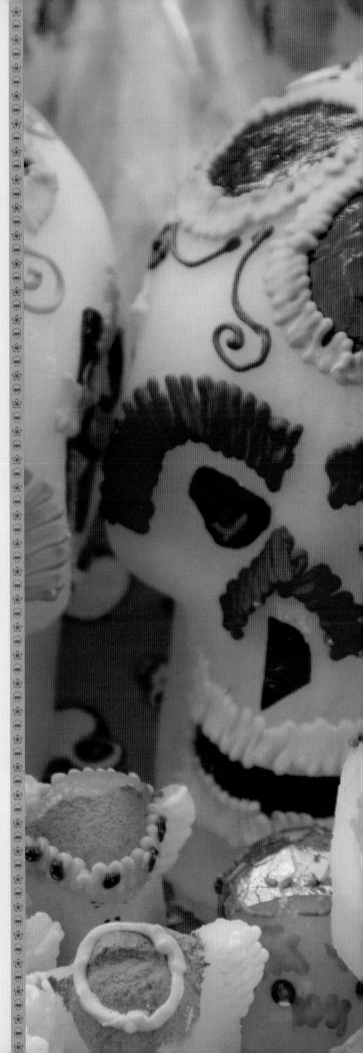

one year apart. They recall – with slowly unfolding, tragic inevitability – the demise of **Firmin** as he self-destructs under the weight of his own alcoholism.

WICKED WORDS

Under the Volcano is laden with symbolism – everything from **Faust**, the Kabbalah and the mysticism of the number seven crops up – and charts both the **agonies of addiction** (Lowry himself was an alcoholic) and human failure. Written in Mexico, the setting on the Day of the Dead itself cannot be accidental in a novel suffused with **symbolic meaning**: death hovers over everything like a cloud of copal incense, while Firmin himself is remembered, as the departed should be on 2 November by friends and relatives – but with heaviness and alarm.

Lowry's novel ends with murder and it's murder that drives the plot of *Days of the Dead*, a 2003 novel from Barbara Hambly. Set in a wild, feverish Mexico City in 1835 the book is part of her **'Benjamin January'** series of murder mysteries and also takes place on the Day of the Dead. Making his way to the city on the eve of the fiesta, January must prove his friend **Hannibal** is innocent of the murder of a prominent landowner's son, but is hampered by the superstitions of the victim's father as the plot weaves through mazes that are both **literal and figurative**, all populated by the spirits of the dead, real and imagined.

DEAD CREATIVE

These are just a few examples of the Day of the Dead's interactions with storytelling mediums. The fiesta does seem to hold an appeal for **filmmakers, musicians and authors** who make use of its exotic 'otherness' as

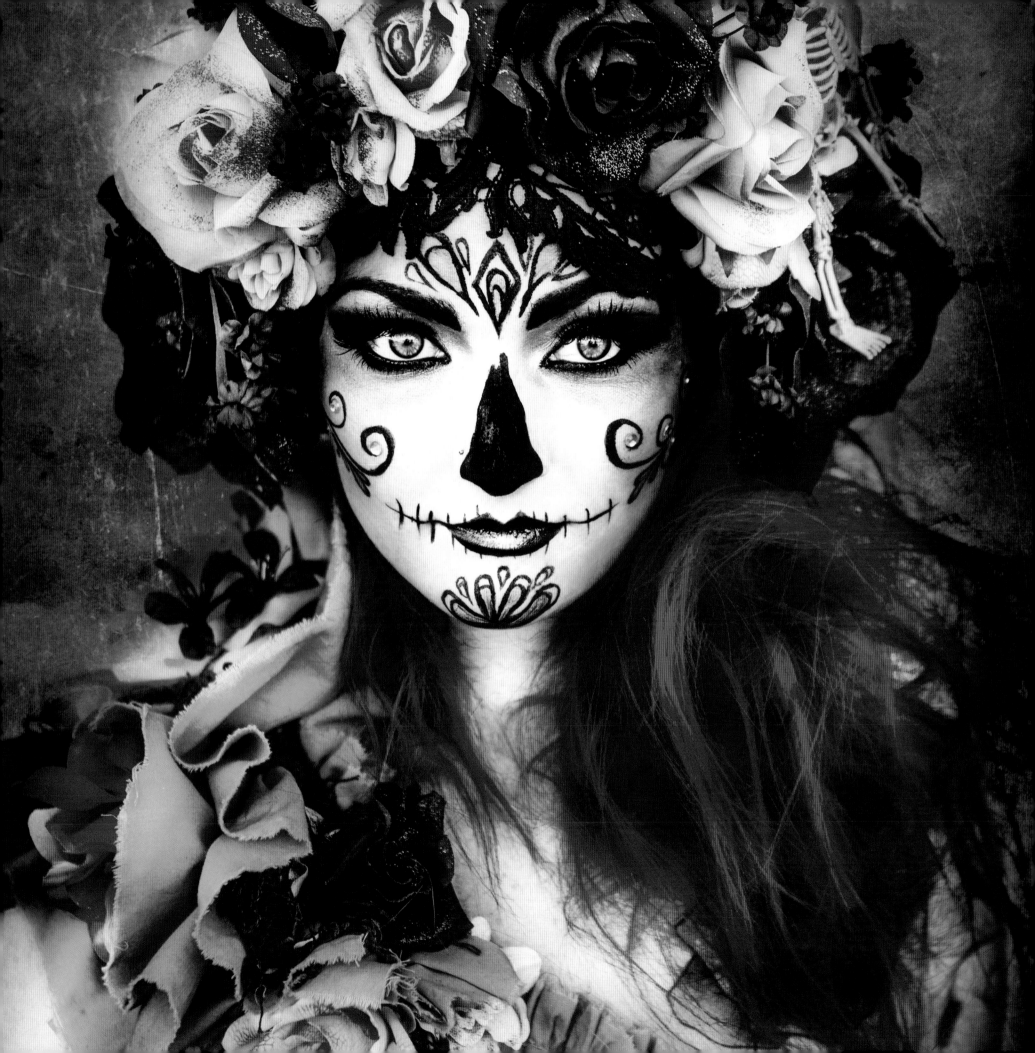

a shortcut to adding **intrigue and mystique** to those stories, the very act of including the Day of the Dead instantly conjuring notions – however accurately they reflect the **real-world incarnation** – of death, restless spirits and communion with the souls of the departed.

Of course, according to custom, the dead do not actually interact with the living, but it's clear that in the realm of the story they have a **powerful, provocative voice** that can add relish, tragedy and even **haunting dignity** to narratives of all kinds. And they can sure as hell make them look good, too.

THE DEAD WEAR PRADA

In fact, making us look good is perhaps the most highly visible effect of the influence of the Day of the Dead on popular culture. The imagery and iconography of the fiesta has proved **irresistible** to fashion houses, photographers and high-street chains alike, so it's possible to see all manner of wild and wonderful examples of Day of the Dead fashion (research for this book uncovered Day of the Dead themed **dog jumpers**. Yes, that's right: jumpers for dogs, covered in sugar skull images).

One designer wearing Day of the Dead influences on his sleeve (and throughout his work) is Mexican American **Mondo Guerra**. Winner of the US reality series *Project Runway* in 2010, his final collection for the show brought the Day of the Dead to the end of the **catwalk** with a piece that featured a large, brightly decorated sugar skull. He went on to design a t-shirt for **World AIDS Day** that also featured a stylish **calavera** complete with bow tie – the skull a reminder of those lost and of the need to live and love regardless.

British designer **Henry Holland** also embraced the *calavera* with a 2012 collection featuring **sugar skulls, bones, flowers** and the bright palette of the Day of the Dead on **bags, dresses, shoes and blazers.** One t-shirt ran with the humour of the fiesta and simply said 'Boner' in letters made up of, of course, bones.

DRESS DOWN WHEN YOU'RE DEAD

Manish Arora, the Indian designer has also used the Day of the Dead as a jumping-off point for catwalk collections. Some elements are explicit, such as a skirt emblazoned with an image of the Virgin Mary recast as *La Calavera Catrina*; others are more subtle, referencing the flowers and colours of the fiesta to create quirky, bright pieces.

In some cases fashion will conflate various aspects of Mexicana into single designs or fabrics. It's possible to find **eye-catching rockabilly dresses** where Day of the Dead, religious and pre-Hispanic icons and images collide, for example. Accessories are also favourite haunts of the ubiquitous sugar skull, which can be found on **bracelets, necklaces and brooches** as well as all manner of **body piercing** jewellery and even nail art (a little skull may well be the thing that's been missing from your thumbnail).

Skulls also pop up on t-shirts for both sexes, but this is not to say that every instance of a skull on a t-shirt (or a **McQueen** scarf) owes its origins to the Day of the Dead. The skull is a borderless cultural standard so its presence might be inspired by gothic or horror culture, or the more European custom of the *memento mori* skull, which appears stark and unadorned to

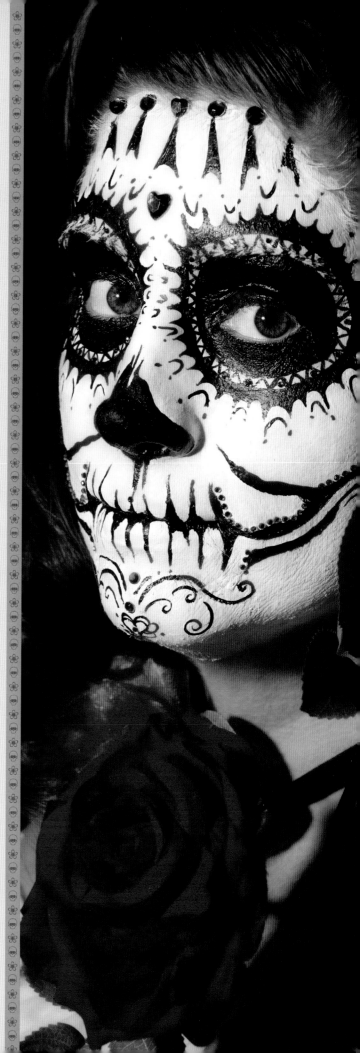

remind the wearer (and anyone looking at them) that we're all the same **grave-bound beings** underneath; which is maybe no bad message for fashion to carry, anyway.

WRESTLING WITH YOUR IMAGE

The sugar skull can send the same message, true, but its appearance is generally more benign and of course it has a much **brighter, more colourful** aspect than its less decorated cousin. You're also increasingly likely to see a **Catrina** image on a garment, or *La Muerte*, the feminine incarnation of death as a beautiful woman with a distinctive *calavera*-like face.

Perhaps less likely to bother the **catwalks of Milan** are *Lucha Libre* masks, a staple of Mexican free wrestling. *Lucha libre* came to national prominence in Mexico in 1933, but the first mask appeared in 1942 on the face of *luchador* (wrestler) *El Santo* (The Saint), who went on to become something of a folk hero in Mexico and a symbol of the struggle to secure justice for the common man.

The masks became a fixture of *lucha libre* (*El Santo* was buried in his). They owe their look in part to **Aztec masks** and reference gods, animals and heroes — and the occasional *calavera* in the case of *luchadores* like The Death Brothers and The Skull Brothers.

Both were tag teams wearing skull masks, the designs bearing the unmistakable look of sugar skulls with the same wry smile, yet adapted, with the slightly more stylized lines of the *luchador* mask.

GAME ON

How much the Day of the Dead contributed to the conception and evolution of the masks beyond the instances of specific *calavera* designs is hard to tell – they may merely share a common origin in pre-Hispanic culture. Either way, each has become emblematic of Mexico and Mexican culture.

Competition of a different kind – through computer games – may not seem like the most likely place to find the fingerprints of the Day of the Dead. But that's exactly what gamers found in *Grim Fandango* (1998), a mystery game that blended *calaca* figures, a *film noir* visual style and hard-boiled gameplay based in the land of the dead. As if to underline the ongoing rise of the Day of the Dead's influence, the game was remastered and relaunched at the beginning of 2015 to critical acclaim.

LIVE FOR EVER

Going one step further you can even experience the Day of the Dead in the online virtual world of Second Life, while social media is enabling us to share our experiences of the **real-world fiesta** more than ever before. Through image platforms like **Instagram** and networks including **Facebook** and **Twitter**, we can plan, learn about and observe Day of the Dead celebrations and rituals wherever we are in the world.

However and wherever we experience the Day of the Dead, the **returning souls** have much to teach us. They can open a window into Mexican culture and show us the centuries of customs and *calaveras* that have helped lead the nation to this point in history, perhaps.

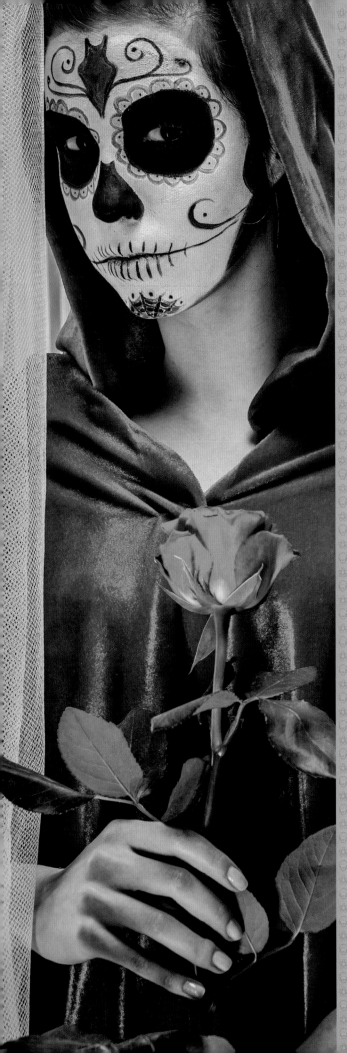

Or they can spend time teaching us how to talk about death – never an easy subject – and how it relates to **Mexican culture**, but also our own as we see it reflected in the Day of the Dead.

We can see their presence as religious (Catholic) or spiritual (existing within the boundaries of some kind of afterlife), or **entirely secular**: they are metaphors for our memories of the deceased, with the notion of their returning suggesting that when we remember and honour those who have left us, they **never truly die**.

THE END

The souls can offer a way to talk to children (or even among ourselves) about death that isn't based in terror or resigned morbidity, but in the more positive light of living life well, because although the concept of death can't be shirked, it can be accepted – with **grace and humour** – as part of the process of living that life.

And they appeal to us because they offer comfort, company and confidence that if we remember our dead, we will be remembered in turn. Our lives may be rounded with a sleep, as **Shakespeare** suggested, but in the world of the Day of the Dead we can awaken the spirits each year and revel in their presence, while casting aside our **mortal worries** and smiling as we tell death, **'not today'**.

Perhaps the key to the near-universal appeal of the Day of the Dead is that it's not actually about death at all, but about life in **full technicolour**. As **Octavio Paz** wrote, 'Our cult of death is also a cult of life'.

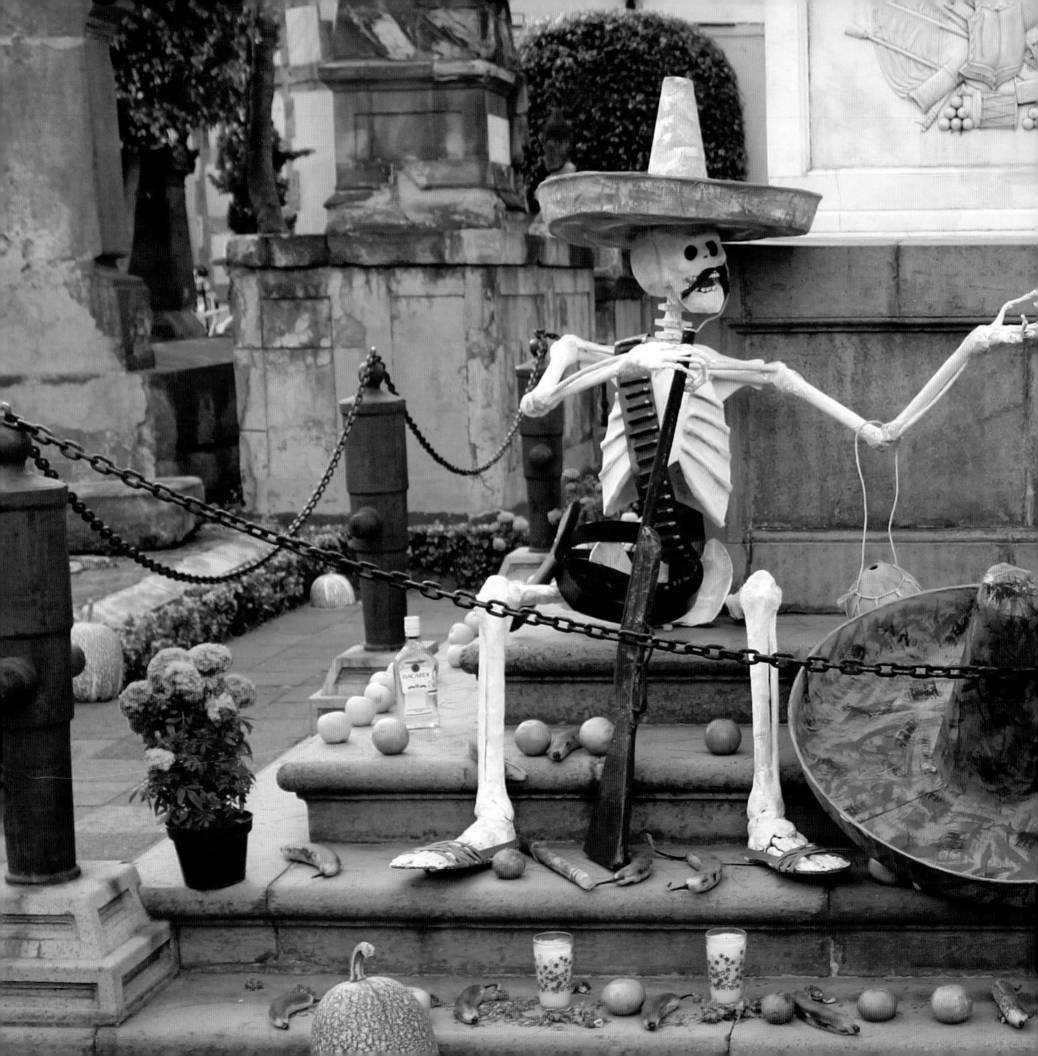

ACKNOWLEDGEMENTS

RUSS THORNE (AUTHOR)

As a boy, Russ Thorne loved reading *Fighting Fantasy* gamebooks, playing Hero Quest and poring over issues of 'White Dwarf', admiring the cover art in the process. Later he studied English Literature and got to know Homer's heroes and a bit of *Beowulf* before beginning a career as a writer and editor. Since then he's published books on tattoo art, body piercing and vampires and writes regularly for national newspapers, including the *Independent*.

DAVID LOZEAU (FOREWORD)

David Lozeau is an American artist with a distinctive Lowbrow style. He creates modern Day of the Dead-inspired paintings by blending fine art technique and illustrative humour to reveal his unique perspective on life, death, and all the gory stuff in between. He has shown his works on three continents, collaborated with Disney and Fender, and been featured in several books and magazines.

PICTURE CREDITS

Special thanks to the artists that have contributed to this book:

© David Lozeau (davidlozeau.com): Birds of a Feather 4, El Guitarrista 6 (c), El Trompetista 33, El Violinista 101, Final Encore 111, TJ Twin 122 (c), Father Time 136 (c), Flowers For You 149 (c); © Jasmine Becket-Griffith (strangling.com): I'm Almost With You 112 (c); © Joana Shino (joanashino.com): Bella Muerte 134.

Courtesy of **Shutterstock** and the following contributors: xstockerx: 3; Christopher Brewer: 5, 52; Andy-pix: 6; Jiewsurreal: 7 (c, b), 130, 160 ®, 160 (l), 189; AGCuesta: 8, 12, 30, 64, 68, 76, 77; NemesisINC: 9, 29; sunsinger: 10, 73, 86; Charles Marker: 12 (c); jeep5d: 14; betto rodrigues: 25, 82, 131, 174; Atomazul: 26; natalia_maroz: 32; alicedaniel: 35, 60; mamita: 40 (c); Elisanth: 42, 135, 152; Brandon Bourdages: 44; kidd717: 48; kravka: 53; Shawn Goldberg: 54; rvulada: 55, 76 (c), 87, 92 (c), 137, 166, 192; Jandrie Lombard: 56; javarman: 59; travis houston: 62; MarushaBelle: 63; tipograffias: 69, 188; Darla Hallmark: 70; Olena Zaskochenko: 81 (c), 129, 156, 163; kiya-nochka: 84; Depiano: 88 (c), 133 (c); Nathalie Speliers Ufermann: 91; Zenina Anastasia: 99; PinkPueblo: 100; Andreas Gradin: 102; Takamex: 103, 107, 147; FCKs: 106; bazzier: 114, 122; Freya-photographer: 115; PSHAW-PHOTO: 120; Blackspring: 126; MastakA: 127; moonkin: 129 (c); Anna Maltseva: 138; Dmytro Zinkevych: 139; Transfuchsian: 142; ladyphoto: 158, 172; Guryanov Andrey: 162; Karina Cornelius: 171; fotogestoeber: 182; Alexander Tihonov: 186.

Courtesy of **Getty Images** and the following contributors: Gabriel Perez: 16, 20, 38, 93, 112, 113; LifeJourneys: 17, 67; John & Lisa Merrill: 18, 36, 46; Nino H. Photography: 22; Mark Murphy: 24; David M. Benett: 28; Mark D Callanan: 40; Gary Conner: 43; Education Images/UIG: 50; Jan Cook: 58; ValaGrenier: 61; M Timothy O'Keefe: 66; Livia Corona: 72; Danita Delimont: 75, 80, 85, 178; Arthur Meyerson: 78; strawcastle: 81; Paty aranda: 88; Richard Maschmeyer: 90; Universal Images Group: 92; Camilo Morales: 96; Renee Keith: 98, 145; Todd Keith: 108 (c); Dave Albers: 108; Witold Skrypczak: 116; John Block: 118; Christian Kober: 119; Sharon Dominick: 128; Lauren Bates: 132; Wendy Connett: 140; Renee Keith: 143, 144, 164; Kurt Paris: 145 (c); Denise Taylor: 146; FrankCangelosi: 148; Renphoto: 181; zorani: 183 (c); Alina Vincent Photography LLC: 183; Alina Solovyova-Vincent: 185.

Courtesy of **Photoshot** and the following contributors: 34, 63 (c), 94, 104, 150, 157, 163 (c), 166 (c), 168, 176, 178 (c); PictureNature: 7 (r), 110, 133, 170; Xinhua: 47; Face to Face: 74; Imago: 153; Collection Christophel: 154, 159, 184, 187; LFI: 161, 165, 173, 180.

INDEX

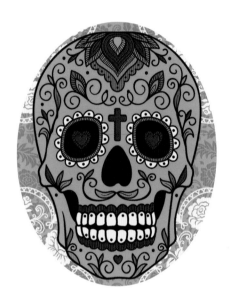

If you enjoyed his book please sign up for updates,
information and offers on further titles in this series at
blog.flametreepublishing.com/fantasy-gothic